The Sculpted Ear

Perspectives on Sensory History

Books in the Perspectives on Sensory History series maintain a historical basis for work on the senses, examining how the experiences of seeing, hearing, smelling, tasting, and touching have shaped the ways in which people have understood their worlds.

Mark Smith, General Editor
University of South Carolina

EDITORIAL BOARD
Camille Bégin
University of Toronto, Canada

Martin A. Berger
Art Institute of Chicago, USA

Karin Bijsterveld
University of Maastricht, Netherlands

Constance Classen
Concordia University, Canada

Kelvin E. Y. Low
National University of Singapore, Singapore

Bodo Mrozek
University of Potsdam, Germany

Alex Purves
University of California, Los Angeles, USA

Richard Cullen Rath
University of Hawaii, USA

The Sculpted Ear

Aurality and Statuary in the West

Ryan McCormack

The Pennsylvania State University Press
University Park, Pennsylvania

Library of Congress Cataloging-in-Publication Data

Names: McCormack, Ryan, 1979– author.
Title: The sculpted ear : aurality and statuary in the West / Ryan McCormack.
Other titles: Perspectives on sensory history.
Description: University Park, Pennsylvania : The Pennsylvania State University Press, [2020] | Series: Perspectives on sensory history | Includes bibliographical references and index.
Summary: "Examines the relationship between sound and statuary in Western aesthetic thought in light of discourses on aurality emerging within the field of sound studies. Considers the sounding statue as an event and as conceptualized through acts of writing and performance"—Provided by publisher.
Identifiers: LCCN 2020011884 | ISBN 9780271086927 (cloth)
Subjects: LCSH: Sound sculpture. | Sound in art. | Statues.
Classification: LCC NB198.5.S68 M33 2020 | DDC 731—dc23
LC record available at https://lccn.loc.gov/2020011884
Copyright © 2020 Ryan McCormack
All rights reserved
Printed in the United States of America
Published by The Pennsylvania State University Press,
University Park, PA 16802–1003

The Pennsylvania State University Press is a member of the Association of University Presses.

It is the policy of The Pennsylvania State University Press to use acid-free paper. Publications on uncoated stock satisfy the minimum requirements of American National Standard for Information Sciences—Permanence of Paper for Printed Library Material, ANSI Z39.48–1992.

For Lyndsey Lee,
the very best of Pygmalions

Contents

Acknowledgments [ix]

Introduction: Elvis Leaves the Building [1]
1. Animation Introduces Animation [15]
2. Breathing Voice into Laocoön's Mouth [36]
3. Imperial Possessions [63]
4. Hearing a Stone Man [87]
5. Aural Skins [111]
6. Now You Have to Go, Comrade [135]
7. Museums of Resonance [161]

Conclusion: I Now Present Sergei Rachmaninoff [175]

Notes [181]
Bibliography [195]
Index [208]

Acknowledgments

I recall an episode of the BBC4 radio program *In Our Time* (on Shakespeare's *Hamlet*) where guest commentator Carol Rutter, during an off-air addendum exclusive to the podcast version, mentions how strange it was that Shakespeare spent so much time revising that particular work with no financial incentive to do so. *This play simply would not let him go*, she concludes. The following book is one that would not let me go, either, and I'm most grateful for its perseverance since that first spark in my mind during the waning days of the summer of 2011. Writing it has given me a sense of scholarly purpose and personal pleasure through a period of professional tumult. And while it may seem odd to give thanks to a book within the confines of its own pages, that which we write is a constant companion, whether we as writers admit it or not. This subject remained sufficiently fascinating for me to endure the fears of inadequacy and the false starts, and the final result reflects the intellectual intimacy that bolstered my resolve to see it through to the end.

Because of the long and rather private unfolding of this project, many of those I wish to thank have already been acknowledged in other works and mediums. Still, I want to highlight the contributions of a notable few. Without their support, what follows would have been a very different text, and most likely would not have come to pass at all. I must first thank the Bulgarian American Fulbright Commission, whose Fulbright IIE Research Grant in 2008 and 2009 funded my opening forays into what would eventually become the chapter on Sasho Sladura. Also of note are the libraries staffs at the University of Tennessee, Tusculum University, and the Knox County Public Library, who processed countless interlibrary loan requests and gave me access to materials and resources I never would have been able to get a hold of otherwise. Veit Erlmann and three anonymous readers with the journal *Sound Studies* helped to shape an article codifying some of the broader theoretical strokes that would eventually, albeit abstractly, find their way into these pages. Mark Smith, the series editor with Perspectives on Sensory History, saw some potential in the first abstract I submitted to him and has been instrumental and unbelievably supportive in shepherding this project to Pennsylvania State University Press. Kendra Boileau, Alex Vose, and the editorial staff at Penn State did amazing work moving the book

through the later stages and into print. James Mansell and Bruce Smith gave wonderful feedback in their roles as readers, and their suggestions helped immensely in refining my introduction and conclusion, as well as the overall structure of the book. Dana Henricks did incredible work copyediting the manuscript. Justin Patch, Mark Lomanno, Daniel Sharp, Sonia Seeman, Jacqueline Avila, Michael O'Brien, Sidra Lawrence, Mary Neuberger, Nick Tochka, Ian Macmillen, Leslie Gay, Rachel Golden, and Plamena Kourtova are friends, colleagues, and mentors who provided commentary and advice on parts of the book at various stages of its long development. Some I have relied upon in times of uncertainty, others have slipped through my grasp as time and space often dictate. Yet their ideas and candor resonate through these pages as much as a sightless vibration galvanizes the material body of any statue.

Introduction
Elvis Leaves the Building

I want to begin by relating a tale about Elvis *leaving the building*. Not the flesh and blood Elvis, who came and left hundreds of venues during his illustrious career. Nor any of the roughly eighty-five thousand impersonators who attend conventions and parties, or appear at one of the many places associated with the King, like Graceland, Sun Studios in Memphis, or the Las Vegas strip. The Elvis I refer to is neither living nor dead. He is, in fact, a statue that resides at Mama's Mexican Kitchen, a culinary staple in the Belltown neighborhood of Seattle. The Elvis statue has been the restaurant's unofficial mascot since 1998, when it was given to owner Mike McAlpin for his burgeoning collection of Elvis memorabilia at the establishment. McAlpin had a friend paint the gray, unfinished veneer to furnish Elvis with a brown leather jacket and blue jeans, as he may have appeared during his earliest recording sessions with Sam Phillips. The refurbished *pièce de résistance* of King chic was then placed against a railing by the front door that fenced in the outdoor seating deck, an ideal spot to feature the statue for maximum exposure to restaurant patrons and passersby on the sidewalk. For years, Elvis welcomed patrons and silently posed for pictures with fans and detractors alike, with little incident save the weathering expected from living outside in rainy Seattle for most of the year. On the evening of March 10, 2013, though, Elvis had more problems than the weather. After

the restaurant had closed for the night, an unknown assailant nonchalantly picked up the unrestrained statue from the railing, carried him off down a side alley, and disappeared without a trace. A witness who saw the abduction did not contact police or alert McAlpin until the following morning, thinking that Elvis was simply being taken for some much-needed repairs. McAlpin took to the streets and the airwaves in search of Elvis, offering to not press charges if he were returned to his spot, no questions asked. After three weeks with no sign, the owners of another neighborhood establishment happened to spot the statue laying under a white sheet at a nearby rummage sale. Upon inspection, they found him relatively unscathed. The proper authorities were notified, and Elvis was reunited with his perch as if nothing had happened. The only evidence of the abduction was a handwritten note the perpetrator(s) had placed with the body prior to obscuring Elvis beneath an uncharacteristically plain cloak. The scrawl, not a ransom but a wink, read, "Thank You Very Much."

Though the theft may have been a mere prank, it was not one to go without a reciprocal response. To celebrate his triumphant return, it was decided to let Elvis have a little fun of his own at the expense of the public. On April Fools' Day, Seattle's NBC affiliate (with the apropos designation KING5) filmed a segment in front of the restaurant detailing a strange habit Elvis had begun to exhibit upon his return. Amidst the noise of construction and traffic on the surrounding streets, some unnamed patrons had claimed that they could hear Elvis *singing*. The KING5 reporter filming the piece painted a mysterious backdrop for the audience. No wires were found protruding from the body, no externally mounted speakers, no obvious source for the incumbent sounds, only a small microphone mounted by the news crew to help amplify any sound over the excess environmental noise. Then, as if he knew that local skeptics would decline to take him at his word, the journalist proceeded to ask people passing by on the street to listen closely to the Elvis statue and describe what (if anything) they heard. Many claimed to hear nothing amidst the urban cacophony. Others seemed struck by the sheer oddity of the question itself ("I mean ... who hears stuff from a statue?" a woman asked with a clear expression of incredulity). Some, though, admitted to catching the faintest trace of Elvis crooning his hits—"Blue Hawaii" or "Hound Dog," depending on when they were asked. Many hearing these sounds espoused a hint of bemusement and wonder, perhaps sensing the nature of the joke. A few seemed genuinely bewildered, unable to grasp the happenstance confronting their own ears. One particular woman, though, betrayed a strange and fascinating aura of

unease. The camera captured her slackened face and exhausted eyes, which may have had nothing to do with her pondering the prospect of a magical, singing Elvis statue haunting the sidewalks of Seattle but certainly added to the dramatic effect of the scene unfolding. After a beat of terse contemplation, as if cued for a perfect cinematic moment by an out-of-frame director, she turned to look at the camera and said, with a hint of dread undergirding a soft chuckle, "It's kind of creepy, actually."[1]

I can think of no better allegory, even drawing from the depths of my own fertile imagination, to capture the web of fascination, ambivalence, and dread attached to the figure of the sounding statue in the Western imagination as the one presented by this publicity stunt foisted upon unassuming strangers. It speaks with wondrous precision to the questions revolving around performativity and being, themselves spinning off the implications of wedding ambiguous sound and anthropocentric form, that I will explore in depth throughout this book. One is hard pressed to find a stranger marriage in Western aesthetics than sound (mobile, ephemeral, heard) and the statue (staid, solid, observed). This is part of the reason why singing Elvis was considered by some to be so jarring and weird, even with an obvious rational recourse to sound reproduction technology available. However, the spectacle of animation that sound represents in the case of Elvis is one small part of a broader and more diverse narrative regarding the relationship between sound and statuary. Examples of sounding facsimiles in the style of singing Elvis are not difficult to find and have deeper roots than one might expect. The more pressing avenue of inquiry, for me, is understanding what drives the complicated history of reception and comprehension of sounding statues, and how Western aesthetic thought has proven lacking when relied upon to explain these phenomena. Discourses on sculpture, much less music, have had little to offer regarding the needling metaphysical quandaries inherent in sounding statues that modernity has been unable to excise. A different way of approaching these issues is needed to more fully appreciate the various cultural manifestations of the sounding statue, one that gives credence to aural reception and an intersubjective imaginary as much as sonic source. Into this breach steps the concept of *aurality*: an emergent term within the area of sound studies regarding cultural histories that embed the act of hearing into specific social and artistic practices, technologies, and the shaping of hierarchies of race, class, ethnicity, and power. Aurality, at base, has been instrumental in critiquing the sensory dominance of vision (embodied through the eye) and orality (embodied through the voice and language),

while turning the ear from an organ of passive engagement to one of active inquiring. It is thus a productive conceptual counterweight to the gravity of an object-centered discourse that pervades the history of sculpture. Outlining the failures of this discourse toward sounding statues, as well as how aurality helps to reframe the needling problems inherent at the juncture of sound and metaphysics, will be the first step in creating a more nuanced history of hearing and querying the relationship between sound and statuary. Yet engaging with aurality also begins to address the privileging given the conceptual viability of the sculpted over the presence of the sonic in occurrences like the singing Elvis. This privilege of the sculpted can even be found at the level of language, where the very use of a term like *sounding statue* subtly reinforces an object orientation, as if the sounds themselves were property of the statue and no other. The case studies that I utilize seek to complicate and nuance this idea. Instead of thinking about the sounding statue as an objective unification between disparate parts that Western aesthetics has had difficulty placing together, I understand it as an event that occurs in the encounter between sound and statuary, something that extends beyond that encounter into the imaginative unfoldings of performance and cultural discourse.

The word *event* may seem, at first thought, a rather odd choice from which to proceed. For one, it is a term most at home not in aesthetics or cultural studies but in a speculative ontology that developed from the legacy of René Descartes and Baruch Spinoza questioning the constitution of matter, substance, and the spatio-temporal nature of bodies. And within this body of thought, *event* has often been ontologically defined in contradistinction to the concept of an object. Events occur, permeate space, and take up time; objects exist, occupy space, and persist through time.[2] By these attributes, sound is an event; statue is an object. Yet there are ways of thinking about the concept of event that are not so beholden to this rigid dichotomy with objectivity. A more expansive idea of the event is developed through a lineage of Gottfried Wilhelm Leibniz, Alfred North Whitehead, and Gilles Deleuze, one that rests on a notion of creativity and transformation, instead of being, as the driving forces in an existential metaphysics. Elucidating the broader discourse connecting creativity and event will take more time and space than is available here.[3] Nevertheless, Deleuze offers an intriguing definition of the event *vis-à-vis* the creative spark in his book *The Fold: Leibniz and the Baroque*, one drawn through the thought of Whitehead that is useful for my limited purposes. For Deleuze, an event manifests as a winnowing down of

the possibilities in a chaos of multiplicity, and he identifies four essential components in Whitehead's philosophy that contribute to this formative process. The first is *extension*, in which one element encapsulates separate ones into a common series (the concept of *sounding statue* extending over the presence of sound and the object statuary in space and time). The second, *intension*, constitutes the individual and ascertainable attributes within the extended event (sound has timbre and volume; statuary has measurements, material, and represents something). The third, *prehension*, refers to the ability of attributes within the event to connect and overlap with other attributes based on shared points of contact within their own historical, social, or epistemic milieus (in its simplest form, a recording of "Jokerman" creates a connection to a statue of Bob Dylan, just as a Dylan statue may spark thought of the song "Jokerman," let's say). And the fourth, *ingression*, is the creation of something new and meaningful out of the disparate parts overlapping together within the field of the event (the acknowledgment of a statue making sound as a sounding statue, or any number of performances, ideas, discourses, and ideologies that spin off of the particular event and become purveyors of *affect* in the world themselves). Together, in ways far more complex than my little example can fully capture, these attributes of the event meld together into a ceaseless "opening onto the new" that defines both Whitehead and Deleuze's concept of creativity.[4]

My only caveat is that because their shared notion of the creative also distances from the classic notion of a coherent bourgeois subject, I think there needs to be a way to write some sense of the subject back into the event. Alain Badiou offers an elegant addendum to event metaphysics in this regard. Badiou has argued that while the event manifests primarily within the field of broader ontological mechanisms, the subject alone holds the ability to define its parameters, what he calls a "capacity for indiscernment."[5] Granted, his notion of ontology is grounded in the more materially abstract realm of mathematics, and his regard toward the indiscernible suggests a trait of negation at the center of subjective engagement. Yet his recourse to the indiscernible does much to articulate something beyond the purview of the creativity espoused by Whitehead and Deleuze: how weird and ephemeral many have considered the very idea of the sounding statue. As we shall see, these are difficult events to pin down, often besotted by conceptual doubt and epistemological barriers. And though they may manifest as actual occurrences or throbs of experience, they only gain meaning through the human capacity to define them as meaningful.

I argue that the concept of event gives us a platform through which we can begin the difficult work of uncoupling the relationship between sound and statuary, and its meanings, from the reductive language of sculpture. All the same, we must resist the urge to move too far in the other direction, as working exclusively within the milieu of the sonic does us no favors either. Unlike other projects dealing with sound, there cannot be an assumption that an immersive sonic autonomy can be extracted from a surrounding artifice. On the contrary, these are encounters laden by the impossibility of divorcing the entity of sound from an embodied, representational referent. This quality lends a certain level of odd abstraction not only to the encounters themselves, but to attempts to describe and rationalize them, as well as using them as the basis for performative reimaginings. As the anecdote regarding the singing Elvis tells us, these events present an ontological convergence for which aesthetic thought, even language itself, leaves us unprepared. The impetus, then, should be in creating a way to think about and articulate these events between (and extensions of) sound and statuary in all of their metaphysical, theological, folkloric, political, and aesthetic clothing. Aurality and the ear are as central to this work as the statues themselves, even as one cannot be abstracted from the other. That is why when I utilize the term *sounding statue* throughout this book, I intend for it to refer to subjective or intersubjective constructions of these events as much as to an object as such.

Any history or philosophy of the sounding statue is inevitably a theory of those who shape themselves as vessels to hear them. Singing Elvis, and other similar events, may bewitch us, confuse us, and upset our very notions of the real. But such bewitchment only occurs because we are willing to countenance its possibility, whether consciously or not. To truly articulate this possibility in all of its guises and portals, we must weave together the language that dictates the experience of statuary with a language drawn from the mentality and experience of sound. The sphere in which these languages of concept come together in the purview of the subject is what I call the *sculpted ear*.

I think it best to introduce my reasoning in conceptualizing the sculpted ear through what amounts to a cautionary tale. In 2016, I wrote an article about the Colossus of Memnon, a statue located near the ancient Egyptian city of Thebes that was renowned throughout Mediterranean antiquity as an object that emitted sound in the light of the morning sun.[6] The only surviving evidence that the sound existed at all comes from the litany of testimonial epigrams carved into the surface of the Colossus, writing that

became a driving force in how the totality of this multiepochal discourse took shape. Such was the cultural power of these epigrams that even after the sound ceased sometime in the third century CE, under as mysterious circumstances as its emergence some three centuries prior, the Colossus continued to attract the speculative fascination of scientist and poet alike. A space was thus opened for countless explanations ranging from spiritual possession, crafty hoaxes, intricate machinery, heated gas escaping from cracks—whatever might fit the interests and biases of the speculator. My own take on this discursive thrust was to notice how it has often been constructed tautologically, casting premodern interest in the sound in terms of the vagaries of metaphysics (this is a *voice* coming from *somewhere*) while casting modern interest in terms of the disclosure of the physical sciences (this is a *sound* made by *something*). This reliance on a narrative portraying an ancient gnosis that is banished by modern scientific inquiry fails to capture how the two have been intimately intertwined and articulated throughout the entire range of writing on the Colossus. I argued that this intertwinement could best be captured through the word *phonography*, which references both the origins of modern sound reproduction technology and some obscured ontotheological connections between writing and voice within the diffuse metaphysics of antiquity. My thought was that phonography could serve as a means to epistemologically suture together the ephemerality of sound and the stony permanence of statue, traits often deemed aesthetically and metaphysically incompatible, through the Greek and Roman idea that epigrams were in fact a type of sonic inscription. This alliance produced an intriguing consequence: a manifestation of what Jonathan Sterne saw as the post-Enlightenment project to ground cultural understandings of the sonic through the lens of physical preservation within the unexpected confines of the Roman world.[7] Thus, when thought about in phonographic terms, the Colossus transformed from mere curiosity into something whose existence brought into question the ways in which we have constructed the genealogy of modern aurality and sound reproduction.

What I have come to understand in the course of writing this book is that the concept of phonography is limiting in its own right, while also selling short the implications of the paradigm shift it is meant to encapsulate. Part of the problem lies with the sheer difficulty of disentangling phonography from the cultural pessimism that greeted its spread and influence during the early twentieth century. It was precisely this liminality attached to the phonograph that made it an alluring signifier to capture the disregard

given the sounding statue within the same circles of cultural criticism. When Adorno, for one, cast the phonograph as an object perpetuating a culture of listless aural consumption, he fit all too well in a broader history of continental aesthetic thought questioning the efficacy of the sounding Colossus as a work of sculpture.[8] Yet the danger inherent in constructing this kind of phonographic milieu is that such thinking falls right into the ideological trap that Sterne warns about through his concept of the *audiovisual litany*.[9] At base, this litany serves as a way to chart the various ahistorical dichotomies that have alternatively valorized and denigrated the respective senses of hearing and seeing with regard to one another. But Sterne is also conscious that while the transcendental claims the litany attaches to sound are grounded in easily historicized social and cultural constructions, scientific discourses about sound cannot escape the historical weight of their theological associations. Sterne's solution to this quandary is to historicize the very notion of experiencing sound, and while such a conceptual move to rethink sound itself would carry its own problems for my project, the lesson of hedging upon a decidedly sonic metaphor to describe an event between sound and statue must be duly considered. Regardless of whether it is framed in terms of its technological or ontotheological attributes, phonography is still a concept that by its very nature privileges the ethos of the heard over the seen (not to mention the touched, an important distinction in the phenomenology of sculpture that will be addressed later). A phonographic Colossus, then, truly does become an empty container for a sounded mystery, and nothing more.

The sculpted ear is my attempt to get at the same questions I tried to articulate through phonography while cognizant of the problems that the audiovisual litany presents for any such project. Thus the chapters in this book, in pursuance of articulating a sculpted ear, draw from an expansive notion of contextualized hearing in tandem with an equally expansive notion of the social mobility of statuary. Sounds and statues are less an endpoint than a platform to expound upon subjective, intersubjective, and cultural readings of these complex and richly detailed assemblages. Actual sounds, imagined sounds, desired sounds, inscribed sounds, transcendent sounds, theoretical sounds, and silent sounds come into play, weaving paths from the infancy of Western metaphysics to present-day Chicago. These sonic imprints become associated with actual statues, ruined statues, statuesque objects, allegorical statues, people performing as statues, and statuesque people questioning their statuesque qualities. At the nexus of these assemblages are those whose ears are sculpted, attuned to the possibility of an

encounter with an event between sound and statuary and, in turn, using this attunement to create extensive avenues to perform and perpetuate its efficacy. This is a visage borne from the forge of what Jacques Rancière calls the "sensible fabric of experience," something not beholden to ideology or tradition so much as to the "welcoming of images, objects and performances that seemed most opposed to the idea of fine art," and to a ceaseless repetition aimed at broadcasting the magic of the encounter through alternative means.[10] As those familiar with Deleuze know, repetition and difference share the same table. Although each chapter features a particular event between sound and statuary at its core, the path taken from that event diverges through uniquely crafted philosophical corridors. Some of these concepts and ideas will dovetail into the sphere of other chapters and weave together a brief but potent conceptual sinew. Others will remain more contextualized, capturing the unique qualities of a particular historical moment. By keeping the theoretical trajectory of the book somewhat fragmented, I am trying to avoid replacing one tautology of epistemic closure with another, one that memorializes the sounding statue with the material and craft of intellectual labor. Rather, I want to produce a text that echoes the almost limitless diversity of these encounters, perhaps spurring readers to recount their own encounters with events between sound and statuary, and ruminating upon the extensions of those events and recognizing a sculpting of their own ears that had perhaps escaped notice.

I begin *The Sculpted Ear* within the fulcrum of the anxiety surrounding animation. Because this idea has beset the sounding statue almost from the start, it will first be necessary to address a history where this anxiety was sourced in the possibility of some elusive and all-powerful animating catalytic substance, and the potential consequences inherent in the belief that such a catalyst exists. Chapter 1 will begin this work by grounding animation within discourses on modern aesthetics, sound art, and terminologies of listening/hearing. Central to this grounding will be the argument that an anthropology of the senses represents the best means by which we can elucidate the sounding statue as event. Chapter 2 will continue it through the tableaux of a well-worn aesthetic critique that has carried dire implications for the sounding statue: Gotthold Ephraim Lessing's 1766 essay on the statue of Laocoön. Lessing famously used the stoic mouth on the ancient statue of the Trojan priest to argue that sculpture could not properly capture the emotional fervor of a scream. The essay, in a sense, did much to facilitate the aesthetic silencing of the statue that persists to this day. However,

within Lessing's critique lies a potent conceptual legacy of sounding—the substance known as *pneuma*, a universal medium based in air that informed a litany of philosophical, religious, and scientific cosmologies from antiquity until the nineteenth century. There is a long history implicating *pneuma* as an ontotheological presence suturing together sound and voice in statues, and its declining influence beginning in the Enlightenment coincided with both the broader rejection of the metaphysical vocality of statued sound. By the nineteenth century, *pneuma* was considered no more existentially prevalent than premodern magic. However, there is also a fervent material and scientific history behind *pneuma* that complicates this narrative. Its pervasive power was centered in the inability of premodern science to render *pneuma* in an observable state while simultaneously unable to disprove its existence. As such, *pneuma* holds to important implications for this project. First, because it continually bifurcated the metaphysical and material strata, *pneuma* alters the potential social consequences of the sounding statue. Instead of a mere magical curiosity, it becomes an object that could portend a destabilization of established authority and power through the mechanism of the voice. Second, because *pneuma* was thought to be a central motivator to the entire sensory schema of human experience, it unveils a history where aurality was considered multisensory, intersubjective, and embodied. A pneumatic hearing, then, presaged many of our modern perspectives on what it means to hear, and the sounding statue was one of the most fervent sites through which such a hearing could unfold.

Chapter 3 takes the multifaceted aurality surrounding the relationship between *pneuma* and hearing and juxtaposes it to a particular type of sculptural object: the automaton. More specifically, I seek to challenge the historical status of the automaton as a means to ground the sounding statue as a technological object within the bounds of the Enlightenment's rational aesthetic order. The case I use to demonstrate is an infamous statue/automaton/organ known as Tipu's Tiger, which depicts a European man being mauled by a tiger with requisite screams and growls activated by an assembly of bellows triggered by an external crank. The Tiger was a military spoil captured by the British from Tipu Fath Ali Khan of Mysore in 1799 and has been prominently displayed in various London museums since that time. Its potent notoriety in nineteenth-century Britain, I argue, complicates a prevailing narrative casting the automaton as a more rational, modern cousin of the sounding statue due to its mechanical apparatuses. On one hand, the British public engaged with it as an oddity tied to a sense of Imperial exoticism.

At the same time, many of those people connected the sounding portions of the mechanism to the world of magic and the occult. In hearing the mauling growl, muffled scream, and peculiar organ, the Empire's cosmopolitans were themselves consumed by the aurality inherent in the tiger's seductive power.

Chapter 4 expands the relationship between sound and statuary into another level of representational abstraction, that of humans performing as statues in the theatrical and musical arts. Central to this concept is the relationship between sound and materiality, borne out of the fact that the performer is not made of the material implied by the statue he or she is representing. I argue that this relationship between human voice and performing inanimate material was profoundly affected by the reappearance of the Commendatore in the form of a statue during Act II in Mozart's *Don Giovanni*. Specifically, I hold that the way Mozart wrote the vocal part for the Commendatore reflected an awareness of the material illusion presented by the character: in other words, trying to imagine what an actually existing singing statue of stone would sound like. This awareness carried two broader implications. First, the Commendatore character refigured the prevailing tradition of writing the animated statue in opera (evident in various tellings of the Pygmalion myth throughout the eighteenth century), creating a potent legacy for those wishing to inhabit the sounding statue as a performative trope. Second, and most important, it represented a new perspective in elucidating the interplay between aurality and the ontology of sound within the rubric of the statue. Instead of trying to conceptualize the meaning of a sonic presence by making a statue more human, the Commendatore represented an attempt to understand it by making a human more statue-esque.

Chapter 5 takes the juncture of sound, material, and performance introduced through the Commendatore and expands it into questions of race, gender, and identity in the avenue of self-representation and, by proxy, a sort of hearing-oneself in material composition. I unpack this issue through a contemporary wax sculpture of singer Josephine Baker in a museum at her former estate at Milandes in France. Recent scholarship has attempted to show the ways in which Baker's performing body was constructed as a sculptural object reflecting both the metallic sheen of the modern surface, and the exotic beauty of the black feminine body. The material of bronze would seem ideal to capture this embodied duality, yet she chose to represent herself in the ephemeral and duller material of wax. I argue that this wax body represents an intersection between three interrelated discourses regarding statued aurality. The first is the long and problematic history of

juxtaposing the material bronze with black skin in Western sculpture. The second are literary examples where sonic vibrations emanating from metal statues are imagined to control the minds and bodies of listeners. The third is the use of wax as one of the first materials in the mass reproduction of sound and in the late nineteenth century. Taken together, they create a means to understand Baker's wax visage as an object of sonic memory—obliquely referencing her voice without preserving it as such. Wax, in essence, creates a material apparatus that silently reinforces the presence of her denigrated and silenced singing voice.

Chapter 6 takes the specter of silence introduced through Baker's wax and expands its importance in two significant ways. First, it acknowledges the lack of sound in statues as a trait that is *heard* and given meaning by those who engage with them. Second, it explores how hearing silence in statues evokes a visceral political dimension, as well as a cultural or aesthetic one. In making these points, I consider the bronze statue of Aleksandar Nikolov, a Bulgarian violinist and comedian from the city of Plovdiv active during the early Communist period (ca. 1944–1989). Popularly known as "Sasho Sladura," Nikolov was arrested and killed in an internment camp in 1961, an event still considered tragic by an older generation of Bulgarians. I argue that Nikolov's bronze statue in Plovdiv, which mimetically captures him as he looked during his peak, paradoxically represents his sounded life through the lack of emanating sound. This sculpted silence mirrors the destruction both of Nikolov's physical body, and the attempts by the state to erase all traces of his existence after his death (including arrest records and recordings). In essence, the only means by which the sonic life of Nikolov can be preserved is through the ironically silent form of the statue, and the actual physical silence creates a space of sonic memory invoking the repression and political silencing common during that era of Bulgarian history.

The political resonance of silence in the aurality surrounding statues and the violence it entails has also found resonance in the physical sciences during the twentieth century. Recent work in sound studies has attempted to frame vibration as a field of affect that operates on the body prior to the interposition of signification, often in connection to tropes of state control and aural violence. Chapter 7 critiques this particular stance with regard to the relationship between sound and statuary through the writings of Donald Hatch Andrews, a professor of chemistry at Johns Hopkins University who published several works in the 1960s and early 1970s conceptualizing of the quantum vibrations of subatomic particles in terms of musical sound.

He proposed that every statue carried a unique molecular sonic signature existing beyond the range of human hearing that could be catalogued by machinery and used to create a new music theory based on the temperament of vibrating particles. Though his dream never became manifest, Andrews's work did lay the groundwork for using technology to transform statues into objects of aural performance in the public sphere. And we are beginning to hear Andrews's dream of spaces populated by sounding statues, in sympathetic resonance with the people who surround them, though in a very different medium than he envisioned. Such is the case with Statue Stories Chicago, a program employing actors to record short monologues in the persona of statues throughout the city that people can listen to using their mobile devices. One of the statues, that of Chicago native Bob Newhart at Navy Pier in the guise of his character from the eponymous 1970s television show, has dialogue recorded by Newhart himself. Newhart embodying Newhart with his own voice, I propose, brings the long and troublesome tautology regarding the relationship between sounding statues and the metaphysics of vocal presence full circle. It creates a unique condition in which a living person voices his own representation, an act that turns the relationship between sound and death on its head. This opens up a very different possibility for an anthropology of sounding statues similar to work being done on contemporary sound art, sound installations, and sonic architecture in urban spaces that centers upon the public relationship between object and hearer, rather than the presence of the object itself. It represents nothing less than a move toward making an event-based experience of the sounding statue in the contemporary public sphere an ordinary phenomenon.

At this juncture, I should elucidate my reasons for emphasizing the concept of *hearing*, rather than *listening*, as the cornerstone for aurality that will appear throughout this book. Although the two words are often colloquially synonymous, there have been attempts to delineate important differences between them as means of articulating the perception of sound. These manifest into a kind of *auditory litany*, divided within the realm of the sonic in a fashion not unlike the audiovisual litany developed by Sterne. In the most basic sense, this *auditory litany* unfolds as such: listening is considered active and psychological, while hearing is understood as passive and physiological. Listening is of the mind; hearing is of the body. Following this logic, one would expect listening to encompass the epistemological, thinking ear, and hearing the ontological, resonant one. However, a clear dichotomy cannot be built between them with such ease. The connections

between listening and epistemology can be easily ascertained. Listening depends on an active aural engagement with a sound or an object emanating sound, treating that sound as an object. Listening is inherently directional, focusing on what the subject chooses to hear, and filtering based on preconceived personal, social, and cultural criteria of what is worth *listening to*. Listening is also implicated in the perpetuation of power and surveillance regarding the cementing of social and cultural hierarchies, as well as in acts and mentalities that attempt to undermine them.[11] As such, it draws a certain companionship with rationalizing, thinking sight still at the heart of constructing the sensory subject in the West, making ear into another kind of eye. Or, as Salomé Voegelin suggests, the act of listening generates the meanings imagined in that which is heard.[12] But hearing carries a rich, relevant epistemological life as well outside of its cornering within the bounds of the litany. Hearing lacks the more obvious object orientation, transcends the engagement with physical sound, and basks in its ephemerality. Recognizing the specific lack of object association, Heidegger associated hearing as an engagement with sound (via language) "already underway, without ever coming to be limited to the self or to presence."[13] Hearing goes even further, specifically engaging with the noncochlear unsounds that also permeate the social, historical, and methodological dimensions of sounding and sound reproduction. The kind of hearing that results from transforming the act of *punctuation* (as in periods and question marks) into an act of *auscultation* (applying the ear directly to the body to hear its internal sounds), what Peter Szendy calls the "otology of thinking."[14] This step, into the *thinking sounds that do not sound*, makes hearing the more resonant word when considering the relationship between sound and statuary, separating it from the object presence inherent in *listening to*. In other words, the epistemology of listening is dependent upon the ontology of sonic presence; the epistemology of hearing is self-emergent, growing out of the act of thinking about hearing itself (no actual sounds need apply).

Mapped back upon the subject of this book, such a designation parses the language I use to describe that subject with a dose of anecdotal flair. Consider it a mantra to keep in mind when reading this book, if you will. A sounding statue is an object that you *listen to*; an event between sound and statuary is something that you *hear*.

CHAPTER 1

Animation Introduces Animation

I recall a throwaway joke in the beginning of a *Simpsons* episode called "Guess Who's Coming to Criticize Dinner?" that, in retrospect, may have been my first indication that statues could possibly be something other than silent monoliths. The setup has Lisa and her classmates going on a field trip being chaperoned by Homer, part of the usual first-act machinations that serve to establish the forthcoming plot. Surprised that her notoriously unreliable father is being, well, *reliable*, she queries further with regard to this abnormal behavior. "Dad, it's great that you volunteered to drive," she asks, "but how did you get out of work?" Homer looks to the sky while grazing his chest with half-clenched fingers, wearing a self-assured grin that longtime viewers will recognize as the beginning of trouble coming to Springfield. "Don't worry, sweetie," he tells her with a loveable but slightly condescending tone. "Daaaaaady's got it covered." The scene shifts to his workstation at the nuclear power plant, where Homer has concocted an anthropomorphic avatar out of odds and ends that he has left slouching in a chair. His hurried bricolage should fool no one. A metal pail adorned with oblong, vacant coffee cup eyes and an expressionless streak of red paint for a mouth tops a mop handle; tree branch limbs are capped off by sagging rubber gloves; and two pillows are stuffed under an ill-fitting white shirt, their simulated midriff girth the only aspect properly representing the fidelity of its subject. But to amplify the ruse even further, Homer attached a tape recorder to the chest of the facsimile, playing an inept homemade cover of Donna Summer's "She

Works Hard for the Money." I offer the lyrics to the reader in full to relish all of its misbegotten glory:

> I work hard for the money
> So hard for the money
> Oh-wah something something money
> Come on, give me lots of honey

At that point, C. Montgomery Burns and Waylon Smithers pass the doorway and gaze upon the sounding monstrosity that Homer created. (Good thing he took the clever step of giving the verse iterations enough space that they would not interrupt their conversation.) "Now there's an employee, Smithers," Burns exclaims with his usual sedated glee. "A smile on his lips, and a song in his heart. Promote him!" We immediately cut to a scene at some point in the future, showing the crude figure seated in an executive office, the tape recorder playing a labored distortion of the song as the batteries die. Then, to end the joke in a way most apropos for the aesthetic of *The Simpsons*, the machine explodes without warning in the midst of its death throes, catching the faux Homer and the rest of the office on fire. But not before you can hear the beleaguered voice on the recorder mustering its last reserves to plead for someone to turn the tape over, as if a last-second intervention would prevent the pail-headed homunculus from self-destructing.

A certain symmetry emerges from an animated television program encapsulating the perceived perils about animation in statuary. I mean this as more than a simple rhetorical flourish. As an art that most associate with the prevalence of the eye, sculpture finds that most visceral of violations in animation. Anxiety over the specter of movement in a statue, and the pernicious worlds of possibility that such movement opens, represent an important preamble to the anxious worlds that sound opens up in the same context. And an instance where sound alone provides the animating impulse unearths the root of this anxiety still obscured when only regarding movement. But a more general sense of animation is where we must start. In the previous chapter, I argued that we could best understand the sounding statue through the terms of event metaphysics instead of merely as an object. Getting to that point, though, requires some delicate conceptual tracing back into this history regarding animation that does consider it an object first and foremost. It is a history that articulates where the language supporting a vaporous orthodoxy encapsulated by the word "creepy" would

come from. A history that shows how the creation of modern aesthetics functioned as a response to this language, and why trying to pull sound into this aesthetics as a solution to the problem of the sounding statue created more problems than it solved. And, most importantly, a history impossible to conceive without an ear that works in tandem with the eye. Sound may not always be present in this broader history of animation, but the example of Homer's sounding avatar should make us begin to consider its relative importance in the discourse surrounding that animation, and the doors sound can open that mere movement cannot.

• • • • • • • •

Tales of the sculpted coming to life and walking among the living are as old as the art of anthropocentric sculpture itself, with too many examples in literature, poetry, theatre, and film to count. Embedded within most accounts are numerous archetypal responses, almost as many as the tales themselves: desire, fear, ambivalence, and fascination. The most famous stories fit into or tell a lesson about a particular emotive domain. From Ovid comes the myth of Pygmalion: the Cypriot sculptor whose love for his lifelike ivory statue of a woman culminated in a granting of life by the goddess Aphrodite. From rabbinical traditions comes the *golem* of Rabbi Loew: a being crafted from mud and brought to life with Hebrew incantations to defend Prague's Jewish population from Christian pogroms, only to run amok through the very city it was tasked to protect. More recently, the animated statue has become a trope less imbued with the gravity of desire or religious significance than an object of weird kitsch. Elvis and Homer are merely the tip of the iceberg. One infamous example (and a personal favorite) comes from the opening of John Boorman's 1973 cult classic *Zardoz*, where a floating stone head lectures a group of transfixed men that "the gun is good . . . , the penis is evil" before vomiting a cache of firearms and ammunition from its mouth onto a beach. Some may also remember an infamous 1985 music video by the band Starship where the Abraham Lincoln Memorial leaps from his marble throne and proclaims with Mickey Thomas and Grace Slick that *we built this city on rock and roll.*

The widely divergent tone of various animation fantasies in the Western imagination were charted by Kenneth Gross in his 1992 book *The Dream of a Moving Statue*, a landmark text on the historical and philosophical implications of statues coming to life. Gross contends, among other observations, that the imposition of animation is completely within the purview of the living, leaving the statue with no real agency in the act. Therefore, it is

difficult to construct a unifying principle regarding animation because the motives and cultural predilections surrounding these fantasies are so diverse. But this very ubiquity has allowed the animation fantasy to maintain a consistent resilience throughout a heterogeneity of cultural practices and ideals in the West since antiquity. "There are few ideas that can be more immediately haunting than the thought of a statue coming to life, few that tap a more fundamental wish," Gross writes to give perspective to the animation trope. He continues:

> It is one of our oldest images of the work of magic, one of our most primitive metafictions, something capable of unsettling our accepted versions of the real. But it is also one of the most trite and conventional of our fantasies; indeed, nothing can seem more literalistic, or a better example of what we call kitsch, than the idea of waking up an immobile statue, nothing that enacts a more stupefying violence on certain works of sculpture. The effect of this is that our investments in the fantasy tend continually to be put to the test; the fantasy always invites and continually resists our attempts to make sense of it, to place its motives and seductions.[1]

There is a type of animated statue for all comers, to be sure. But Gross warns that to focus the power of animation on the fantastic and imaginary neglects a darker ethos where the act of animation commits an act of "stupefying violence" on a statue. He connects this violence to that which Charles Baudelaire noticed with regard to the toys of children. The inability of the toy or the statue to manifest the proper response of liveliness, to show they in fact were embedded with a soul, exposed the fantasy as exactly that, leading to a disavowal of said toy or statue as a magical object and potential companion.[2]

Sound presented itself as a potent but troublesome manifestation of this desire for animation. Unlike movement, its source could not be parsed and readily determined by the skepticism of the rational eye, particularly in the age prior to the development of mechanical reproduction. Yet even in the world wrought by the phonograph, any locative supposition would be necessarily beset by doubt, since per Western aesthetics no rational person should consider sound to be an attribute associated with a statue. To this way of thinking the statue was the anti-phonograph: an object where the sonic at best can be an unwanted acousmatic supplement. This is why the relationship between sound and statuary, when considered at all by the modern

mind-set, was often understood in caustic metaphysical terms. Superstition, idolatry, and magic became the *modus operandi* that faced rigorous challenges from the ideals of reason and scientific naturalism. From these lines of inquiry stemmed numerous rationalizations for distancing from sound. Existential denial was common, casting any sonic manifestation as the result of hallucination or overactive imaginations. There was also a bevy of technological explanations, embracing industrial sources and mechanical processes that rendered those objects as mere novelties, or worse yet hoaxes intended to goad and manipulate those who believe in divine manifestations. This thread, in particular, was the source of many intriguing tales of fiction and apocrypha. E. T. A. Hoffman's Nathanael falls in love with the automaton Olimpia and is driven insane once he finds out she is not a real person. Thomas Aquinas reacts to a talking automaton created by his mentor Albertus Magnus by smashing it to pieces (much to the chagrin of the scholarly elder, who worked diligently in its construction). While some sources claimed Aquinas was merely annoyed by the statue interrupting his work, others capitalized on his reputation for piety to claim the destruction was to eliminate a vulgar reproduction of the human voice.[3] Even among the literati, an aural occurrence could incite violence against the body of the statue if understood as evidence of a demonic possession or some other phantasmagorical presence, despite its technological veneer being exposed.

Such metaphysical or technological rationalizing was no doubt connected to the inescapable proximity of the anthropocentric statue with the death narrative. Part of the power behind the animation fantasy was in how it intertwined with the fear that an unanimated statue suspended the human body in a state prior to carnal demise. "We recognize in the statue an image of the fate of bodies," Gross writes, "to provide ourselves with idealized stone mirrors" and provide a wedge in death's door.[4] The cultural utility of this reflective aspect has long been noticed and actualized. When statues of the famous and powerful were made to manifest the bodies of the dead, they not only represented that person as they appeared in life. These statues also became, as Katherine Verdery has aptly noted, the projection of that individual beyond the confines of the physical body into the undead temporal and spiritual nebulousness defining the collectivity of the body politic. "Statues," she tells us, "symbolize a specific famous person while in a sense also *being* the body of that person.... [A] statue alters the temporality associated with the person, bringing him into the realm of the timeless or sacred, like an icon."[5] Erecting them signifies a desire to remember, honor, or preserve

people and happenings, while bringing to mind a field of transcendence for our own ordinary bodies. By contrast, tearing them down displays a desire for erasure, or a symbolic act of violence against someone already dead or otherwise not present, making us think about the mortality of that ordinary body and the "stupefying violence" that may await it. If someone as epoch-transforming as Lenin could be toppled in plain sight and in living color, the thinking goes, what does that mean for our chances?

Because of its perceived qualities of ephemerality and ubiquity, sound often amplified this already present death fixation with statuary into a rather grotesque gloss of performativity. The spectacle of the death scream becomes the expected sonic companion to an embodied object so closely tied to funerary ritual and remembrance, and its howl when attached to the statue could push the Platonic disquiet toward mimetic art to the very limit. Some of the more macabre examples displayed a morbid creativity that would make most moderns feel queasy, to say the least. Bruce Boehrer describes a practice among early modern English Protestants of burning cats within papal effigies to simulate the effect of the human scream, in lieu of going to the trouble of burning actual Catholics.[6] Further afield, documents of questionable historical accuracy but undeniable historical impact perpetuate stories of burning the living to give earthly voice to the transcendent. Several medieval rabbinical commentaries mention bronze statues of the Canaanite god Moloch built with compartments to house animals and children, who were then burned together in a dire polyphony. That such stories evoke a tangible mix of disgust and fascination is evident in the references and adaptations of this story into the aesthetic realm, right down to modern popular culture laden with touches of pagan stereotyping in the service of horror. Who can forget that each incarnation of *The Wicker Man* ends with a man being burned alive (spoilers, sorry) in a wooden facsimile of a human body in accordance with a profane ceremony? The effect is chilling in the 1973 version staring Edward Woodward, and a farcical delight in the 2006 remake starring Nicolas Cage. Still, each presentation of the effigy shares a common affect: the living source of the sound becomes indistinguishable from the material body of the statue containing him, manifesting only as a tortured signifier of that which could not scream on its own.

Even absent the moral repugnance of human immolation, sound was clearly instrumental in making the affect of death surrounding the statue untenable. So one cannot help but understand the intellectual impetus to reframe questions about the ontological status of the statue away from the

death narrative and to recast a proper history of sculpture exclusively in terms of a rational aesthetics. Though this move started in earnest during the Renaissance, it was embraced with particular fervor during the eighteenth century, as the terms of Enlightenment sought to vanquish the profane magic fueling rituals like those associated with Moloch. Essayists on sculpture, such as Johann Joachim Winckelmann and Étienne Maurice Falconet, perpetuated an ideal of pristine beauty and undifferentiated form at the heart of classical sculpture, which was to be the model for crafting statues in the modern age. Falconet, in particular, noticed the limited palette of compositional effects available to the sculptor as opposed to the painter, and he thus championed the aspects of formal austerity and demanding craftsmanship thought to subvert issues of mimetic fidelity.[7] There was also debate over what relationship, at the level of the subject, existed between aesthetic judgment of a statue and the broader sensory engagement with an external object. Are statues, as Locke would hold, objects like any other that imprint through sensation on the "white paper" of the human mind?[8] Or do their human forms uniquely transcend the symbolic to present the purest expression of the human spirit and the ideal of beauty, as in Hegel's view?[9] Or does the anxiety of resemblance in the statue create a middling space, as Kant argues when discussing sculpture's role in mediating the tension between illusion and appearance—where the more animated in texture and hue a statue appears, the more aesthetic pleasure a viewer derives from it?[10]

Perhaps no eighteenth-century text engaged with these questions more fervently than Johann Gottfried Herder's 1778 essay *Der Plastik* (*Sculpture*). The book was noteworthy as one of the first attempts to devote an entire volume to sculpture alone, apart from the other visual arts and architecture. And in general, Herder shared with contemporaries like Winckelmann and Falconet an interest in the sublime bodily perfection of classical Greek sculpture in stark contrast to forms of Baroque excess. He was somewhat unique, though, in lambasting the universalizing and rationalized aesthetics of the Enlightenment that attempted to transplant Greek notions of beauty into the modern age. As such, Herder was among the first aesthetic historicists. But the true novelty of *Der Plastik* was in how he understood the relationship between the senses and the burgeoning field of modern aesthetic philosophy. In previous work, Herder had argued that any proper aesthetics must be delineated toward the sense best capable of ascertaining the art in question. Sight may work for painting, but not as well for music. Expanding upon the empiricist perspective on the sensory accumulation of knowledge,

Herder was one of the first to challenge the conception that the eye was the sole organ through which states of beauty could be ascertained. Instead, he argued sculpture made evident the role that tactility played in ascertaining the beautiful essence of an object in three dimensions—such as the human body—in ways that painting and literature could not. "What is so uncommonly *certain* and *definite* in a sculpture," Herder writes, "is that, because it presents a *human being*, a fully *animated body*, it speaks to us as an act; it seizes hold of us and penetrates our very being, awakening the full range of responsive human feeling."[11] More specifically, Herder acknowledged that the sense of touch allows for a unique perceptive process denied to the eye that allows us to see the statue as two kinds of presence. The first is as a unified body—a presence in the world—as opposed to a simple amalgamation of unrelated surfaces jumbled together. The second is as an entity competing for space among the living, in contrast to the two-dimensional bodies of painting or the tangible lack of embodiment in music. Reception and space were both important components of aesthetic judgment for Herder, and the senses working collaboratively provided the only recourse to accomplish this goal with regard to sculpture.

While the intent behind Herder's proto-Kantian recourse to a multisensory aesthetic paradigm reconciling the discords between Cartesian rationalism and Lockean empiricism was laudable, it manifested with unintended consequences. In the end, he could not move far enough from the narrow ahistorical conceptualization of sculpture from antiquity that dominated his age. Never mind that the Greek concept of sculpture they lionized was far more open toward the possibility of animation (and of sounding) than often thought by Enlightenment writers.[12] A larger issue was that by the height of Romanticism, the austerity of form they prized made statues seem more like pedagogical devices than actual works of art. This idea was no doubt in the mind of American abstract painter Ad Reinhardt when he pithily defined a sculpture as "something you bump into when you back up to look at a painting."[13] The most critical problem, and source of the most formal innovation, was the sculptural primacy given to the human body as object, regardless of the quality of subjective judgment. This problematic anthropocentrism validated by Enlightenment aesthetics was increasingly questioned by a litany of modernist and postmodernist sculptors working throughout the twentieth century. Wildly different in method and craft, they shared in practice a desire to experiment with ideas about embodiment and representation, turning away from the primacy of capturing beauty

expressed by the human form. Peter Gay refers to this attitude toward sculpture within modernist aesthetics as the "anti-mimetic" turn, drawing from the influence of early twentieth-century experimentalists such as Auguste Rodin and Constantin Brancusi.[14] Although both were driven away from the human form by aesthetic concerns, the practices of anti-mimetic sculpture that developed in their wake owed as much to social and political concerns as aesthetic boundary pushing. European sculptors responded to the failure of Enlightenment rationality in wake of the First World War and the rise of German and Italian fascism by turning toward influences from noncanonical places and times.[15] The perpetuation of a social dimension to art continued to gain relevance through the 1960s, as a further fragmentation of form in the work of minimalist and other avant-garde sculptors centered in New York reflected a more general fragmentation in the experience of modernity under capitalism and Cold War anxieties. As the intersections between previously separate aesthetics of form, material, space, and time became diffuse, sculptors began to increasingly experiment with combining them, creating works that would have been unrecognizable to practitioners and aesthetes from prior generations.[16] The very notion of sculpture was continually becoming unmoored from the universal desires of Enlightenment aesthetics, instead becoming a field of possibility driven by attention given to moments, places, and subjective experiences.

The world of art criticism held mixed reactions to these moves. Arbiters of high modernism like Clement Greenberg and Michael Fried greeted this liquidation of formal coherence with a great deal of skepticism. Others embraced the potential this fluidity held for the construction of meaning. One of the most influential pieces in this regard was a 1978 essay called "Sculpture in the Expanded Field," in which Rosalind Krauss mapped some the implications behind this aesthetic shift. Responding to concerns that the entire concept of sculpture had become increasingly meaningless as notions of material and embodiment continued to expand, Krauss argued that the trajectory of sculptural aesthetics since the onset of modernism was defined by an increasing recourse to negation of form as a form in itself. This meant a mediation away not just from ideas about the universal beauty of the body but the very idea that sculpture was defined by its status as an object in space. Within the expansive paradigms popularized during the 1960s, space and object could blur together, manifesting as an ephemeral continuum of possibility drawing in artist and nonartist alike into a historically contingent complex of creation, aesthetic judgment, and experience.

Sculpture, Krauss concludes, "is no longer organized around the definition of a given medium on the grounds of material, or, for that matter, the perception of material. It is organized instead through the universe of terms that are felt to be in opposition within a cultural situation."[17]

Embedded within this blurring of subject and object were the possibilities of more resonant, productive relationships in which statues could become models for an exteriority of habitation and dwelling in a human-built world. If the use of words like "habitation" and "dwelling" seem to echo a Heideggerian stance, this is because an aging Martin Heidegger pursued this particular avenue himself in a short 1968 essay titled "Art and Space." The piece captures Heidegger's attempt to ponder the marriage of sculpture and space as a means to create nothing less than a concept of antimetaphysical art. Rather than thinking of space as a void that the sculpted body fills with rugged autonomy, he understood space as an integral part of the sculpture's extension into the world—and thus the sculpture itself. Sculpture's primary form becomes not the body, but the *extension* of that body, promoting others to think of themselves as extensions in a similar fashion. The word Heidegger uses to describe this elasticity is "radiance," intended to capture the sheer magical qualities of being-in-the-world in ways uncorrupted by the limitless cooptation and production inherent to modernity. What was once the object of aesthetic judgment (the statue) becomes for Heidegger a model for bodily extension into the habitable world.

Despite being written by a philosophical titan, "Art and Space" remains a fairly obscure part of discourses on art criticism. But it is significant in that it creates an epistemic crack through which a mentality surrounding the sonic obliquely sneaks into the sculptural milieu. In his turn toward sculptural questions, Heidegger chose to collaborate with Spanish Basque sculptor Eduardo Chillida, who also viewed sculpture as a limitless melding of body and space. Chillida, though, uniquely framed the elastic aura that sculpture foregrounds in terms of a "vibrational harmony" not dissimilar to musical sound. He intimates as much in a 1967 interview, where Chillida states that "sculpture and music exist in the same harmonious and ever developing space. The volume of musical sound fills the silence with tension; similarly there could be no volume in sculpture without the emptiness of space. In the void the form can continue to vibrate beyond its own limits; the space and the volume together, selecting from all the potential structures inherent in the form, build up its final shape. The rhythm is determined by the form and is renewed with it."[18]

Andrew Mitchell, one of the few Heideggerian scholars to pay heed to the collaboration with Chillida, argues that this vibrational quality between body and spirit is extended to manifestations of bodies in space. These bodies resonate affectively with one another to the point that the subject-object dichotomy becomes fluid and "confrontation" gives way to vibrational resonance. This creates what Mitchell terms a "poetic space of relation": expressions of an intimacy between nominally discreet bodies where the lines between artist, material, interloper, space, and culture become fluid and collaborative. "Sculpture can no longer be viewed as a confrontation," Mitchell concludes, because "a confrontation requires two parties."[19]

At the time of his interview, the musical metaphor planted by Chillida was already becoming anything but metaphorical. For the ephemeral transformation of sculptural practice identified by Krauss and Heidegger coincided with technologies of preservation making sound more material-like than ever before. The consequence was that sound could legitimately enter the realm of sculpture as both a material presence and a spatial delineator, defined as much by its material and object properties as its immaterial ones. The term *sound art* has become something of a catchall designation to capture the variety of practices developed in this wake that utilized sound beyond the confines of music. Early figures like Pierre Schaeffer and John Cage experimented with the capabilities of sound itself as an object, extracted from, resonating with, and commenting upon the environments from which they were drawn. By the 1960s, sculptors began to utilize sound as a means to create variety and genre blurring while in combination with more orthodox sculptural materials, often containing elements of live performance or participatory arrangements.[20] Then there are the large-scale sound installations pioneered by figures like Max Neuhaus combining material, architecture, space, and sound that serve to, as Brandon LaBelle argues, make the visitor "aware of one's own body, as ear canal, as sensitive skin, as vibrating sympathetic vessel."[21] Instead of penetrating the viewer through the idealism of physical form, à la Herder, sound installations penetrated the listener with a tangible ontological force, often for the purpose of producing physiological reactions privileging experience over contemplation. Such engagement outlined the power and allure of deploying sound in sculptural projects, since it could invoke emotional responses with immediacy. Resonating the ear and the body provided a different, more encompassing experience than appealing to the eye alone ever could.

One may think that the mere presence of modern sound art validates and elucidates the relationship between sound and statuary that had troubled denizens of Western sculpture for centuries. Yet sound art is far from a panacea for the woes of the sounding statue. Yes, it has brought together sound and sculptural practice in useful pedagogical and hermeneutical terms. But in this role, where sound becomes an ontological body, sound art only obscures the issues of embodiment and being that sonicity has raised when attached to anthropocentric statuary. For all of its novelty regarding sonic autonomy in space, sound art simultaneously represents another feint to outflank the same troubling and unanswerable metaphysical issues caused by sounding statues. And in this task sound art was as much a vulnerable failure as it seemed successful in its more limited aesthetic endeavors. Even considering its radical gestures toward issues of embodiment and space, sound art still relied upon the same inside-out approach common since the Renaissance: holding identity as an aesthetic object first prior to working within the field of cultural meaning. The names may change, but the problems remain the same.

The seeds of this failure are documented in the myriad of criticism directed at sound art in recent years. These arguments are a wealth of productive negation, exposing the essentialisms that place sound within the same rubrics of art theory traditionally associated with painting and sculpture. Together, they expose the problematic objectification of sound from multiple angles. Some, like Douglas Kahn, think that sound art is too narrow a term for the diverse practices—often consisting of nonsonic elements—of the artists often associated with it.[22] Others, like Alan Licht, hold that the concept of sound art is not particularly contemporary, drawing upon established relationships between the visual and musical arts dating back centuries in the West to cynically postulate that its contemporary resonance is driven by economic concerns.[23] Brian Kane goes further, questioning whether sound art actually extracts the desired object status for itself or merely creates a dichotomy between sound and its sociability that imbues sound art with the same dry autonomy of classical art those championing it have hoped to avoid.[24] And Budhaditya Chattopadhyay criticizes the object-orientation of sound art as a whole, relating that the inherent experience of the sonic privileges a more fluid subjective mix of not only listening, but "memory, imagination, and contemplation."[25] The tenor of these statements suggests that the moniker sound art is simultaneously ahistorical, escapist, even neoclassical. Consideration of a broader history of the sounding statue gives

warrant to push the tone of these criticisms even more. I contend that the propensity of sound art to recast sound within the guise of a material aesthetics derived from the history of sculpture becomes something of a Faustian arrangement. There was, of course, no Mephistopheles of Western art negotiating and cementing these terms through a blood-soaked quill, no smoky backroom to house this haggling. Nevertheless, the way this relationship has unfolded in practice seems surprisingly concrete when considered as a grand bargain. Objectified sound is given an aesthetic recourse to material embodiment and the discreetness of spatial boundary in exchange for a silence that secures the aesthetic efficacy of the anthropocentric statue. The benefit for sound art is apparent. Sound no longer needs connection to the anthropocentric body to become a materially affective phenomenon where spatial presence, movement, and affect become the cornerstone of its aesthetic oeuvre. And if sound can become sculptural, what possible need is there for the statue to allow sound a foothold and bring with it all of its associated cultural anxieties? Far from securing a place for the sounding statue as an art object, sound art becomes a compromise that merely compromises the ability for the sounding statue to escape its liminal aesthetic position and enter the realm of the mundane.

When taking together the twin-sided objectification of classical sculpture and sound art with the transformative sense of embodiment in modern sculpture, sounding statues seem to be left with no tangible place of historical belonging, a specious ontology of nowhere. This is the power inherent in trying to bypass the death imagination surrounding the essence of statuary at all costs. Once sound was attached to that imagination, there was no recourse back into the aesthetic oeuvre without detaching it from the statue entirely. Bringing them back together necessitates an embrace of that which makes the statue unique among the arts in the cultural milieu of the West. And this embrace requires burying the hegemonic presence of the aesthetic while revitalizing the death association and other cultural meanings that statues have held all along. To this way of thinking, the subsummation of the cultural statue in modern thought was fundamentally misguided, and the creation of a hierarchy of judgment toward the statue that valued the aesthetic first and foremost yet another of the Enlightenment's weapons in its endless war against magic. But, to cop a famous if somewhat overused phrase by Bruno Latour, we have never been completely modern in that sense. Crafting an absence for these inherent cultural meanings in statues only serves to illuminate their presence, and make quixotic any hope that

their denial will somehow make them disappear from the modern landscape entirely.

I can think of no better articulation of this critique than a provocative argument given by philosopher Michel Serres in his 1987 book *Statues*, the esoteric second entry in his "Foundations" trilogy. To hammer home that any attempt to disassociate the statue from the concept of death was misplaced and unethical, Serres opens the book's first chapter ("The Rocket") by juxtaposing two seemingly incongruent sites: the 1986 explosion of the *Challenger* space shuttle over Cape Canaveral and the Carthaginian practice of sacrificing children within a heated metal statue of Baal Hammon, a ritual that supposedly inspired the aforementioned commentaries on Moloch and was dramatized to great effect in Gustave Flaubert's novel *Salammbo*. What draws together these two events, Serres contends, is a shared sensibility between ancient and modern cultures for constructing objects of sacrifice in the name of ideals, which are pursued with fervor and devotion that could only be defined in terms of religiosity. Undergirding these events were countless structural and rhetorical similarities. The Carthaginians were sacrificing humans via colossal idol in the name of divine favor and a place in the heavens, all the while denying they were sacrificing anything other than animals. NASA, meanwhile, was sacrificing humans via rocket in the name of scientific progress and a footprint among the stars, all the while denying such sacrifice as anything other than accidental. Serres uses this memorable polemic as a way to articulate an inherent and intractable thread of magic and ritual practice permeating the essence of modern rationality to the core.

> Like the earth that carries us and the sky that contains us, we have inherited millions of years of formation and therefore remain archaic for more than nine-tenths our depth, plunged up to our eyeballs in the tremendously long past of the wait for science. . . . [W]e don't recognize Carthage in Cape Canaveral nor the god Baal in *Challenger*, in front of the same deaths. Nor the statue in the rocket, both metallic and hot, black boxes full of humans. . . . There is a history of science or of these technologies, certainly, and even several, but more profoundly there is an anthropology of them. The humanities teach this anthropology, without knowing it: when they speak of statues, they shed light on those of our museums or cemeteries, but also and above all on torpedoes and missiles.[26]

Statues, for Serres, are less aesthetic objects than receptacles filled to the brim with the echoes of cultural desires. Even structures built without anthropocentric form in mind (like the rocket) encapsulate those forms within its body, of those who build that body, and of those who witness and revel in its cultural enactment. The implication of this thought reaches beyond the scathing critique of modernity that Serres presents. It also indicts the entire ethos centered on using aesthetics to isolate the art object from its lived environment, as Enlightenment writers were so keen on accomplishing. Attempting to do so, Serres argues, would be as doomed to failure as using science as a rational bulwark against the fascinations driving cultural practices.[27] Only by accepting that statues are as beholden to anthropological meanings as much as rational or aesthetic ones can we begin to grasp what statues really are beyond their material guises.

Serres points us toward a more expansive way of understanding the relationship between sound and statuary, one that includes (if not foregrounds) a different face of the *anthro-* in *anthropocentric*. Sounding statues, if nothing else, present moments of impact in which the veil obscuring a sounded history to the living ear lifts and reveals that which had always been there. In doing so, they illuminate the obscured ordinariness of this relationship while taking it seriously in all its various guises—not only the more renowned Laocoöns and Commendatores that populate this text, but the singing Elvises, immolating wicker men, and firearm-vomiting heads that expose the deficiencies within a tradition of aesthetic critique that deems them unworthy of acknowledgment. To put it succinctly, sounding statues are here whether Western art wants them or not. Maybe, though, the machinations of Western art are not the most important arbiter by which to judge their efficacy. Statues may be materially marble or bronze, but they are ontologically *plastic* in the way Catherine Malabou uses the term, holding within their own milieu the potential for metamorphosis beyond the confines of the aesthetic.[28] But this sense of plasticity only emerges when catalyzed by a human element, perhaps the only term upon which we could say that Herder and Heidegger would be in agreement. Sound may be the most plastic of the statue's attributes. And none of this movement is possible without the doubting ear as a first interlocutor, giving tangible experience to phenomena arising from sites from which there is little to no expectation of sound. In other words, getting at this history does not require a more inclusive aesthetics, but a parallel sensory-laden *anthropology*.

A useful roadmap toward such an anthropological move, in the broader context of listening, is provided by Holger Schulze in his 2018 book *The Sonic Persona*. Schulze argues that the focus on the abstraction of epistemology to comprehend cultural objects neglects and obscures the intimate way of knowing that can only emerge from the sensory experience of the body—a very Serresian notion, indeed. This engagement of the senses at the level of the sonic is inherently perpetual. Sound is always already present as the physical constant of the wave and as an expectation, part of an apparatus of spatial habitation that carries Heideggerian undertones. This status of physical and social expectation suggests, for Schulze, the necessity of constructing a theory of listening sourced in those moments of sonic impact, a thinking *through* sound instead of a thinking *about* sound: "Sonic events are not a set of frequencies, of amplitudes and oscillations, of reflection and abatements in a given, arbitrary environment. In contrast, they *are* exactly this present environment in all its highly specific material aspects, its density, its dynamics, its agility and stiffness, its softness and inclination to resonance, its multitude of intertwined layers and zones, mixtures and knots that form the arena, the ground, the substance of sound. This substance of sound translates perceptually into the substance of listening."[29]

In some respects, this passage treads close to a line of recent thought in sound studies regarding the perceived ubiquity of the ontology of sound as an experience of physical force prior to the establishment of a hermeneutical or representation schema.[30] Schulze, though, is highly critical of any attempt to posit an objective science of acoustics covering the experience of sound. In fact, he critiques this very idea through an intriguing exegesis on the nineteenth- and early twentieth-century scientific perspectives on acoustics from figures like Hermann von Helmholtz and Bell Labs physicist Harvey Fletcher. A sonic materialism derived from early pioneers in modern acoustics, Schulze contends, is important not as an endpoint for the experience of sound but as a means to conceptualize a similar materiality in the senses that become the basis for an aesthetics of immersion. He borrows a term from Serres (*syrrhesis*) to more accurately capture the embodied and multisensory experience that defines this sense of immersion and to reinforce the idea that this experience stems from the engagement of the subject as opposed to the affect of the sound. This idea is nicely articulated in the following passage: "As optics are truly different from visual aesthetics, so are acoustics truly different from auditory aesthetics: a technical model for calculating selected, idealized physical effects must not be confused with a

comprehensive understanding of sonic experiences and corporeal effects in humanoid aliens in a given material environment. The analysis of sound in the framework of electroacoustic theories of communicative scarcity provides almost no feasible means for the *syrrhesis* of sound in a framework of technocultural abundance of sensory artifacts. The material senses are one major experiential and generative, one substantially pervasive force."[31]

Sound may be the catalyst for any given event in the sonic milieu, Schulze reasons, but without the human element of a sensory hermeneutic to hold and frame that event within the cusp of consciousness, the event carries no recourse to meaning. In true Serresian fashion, both ontology and epistemology funnel through the mechanisms of sense.

Schulze may frame his call for an anthropology of sense in terms of an aesthetic, but his framework does much to revitalize the obfuscated cultural meanings associated with the sounding statue as well. In essence, his ideas are quite similar to a concept of *ontography*, a term coined by Michael Lynch in the field of science and technology studies during the mid-2000s. Lynch's useful neologism refers to the ways in which the recourse to ontological experience is always mediated by specific cultural ideas, concerns, and frames of reference. Ontographical inquiry dispenses with the metaphysical absolutism implied by philosophical ontology, instead focusing on who perpetuates those ideals and for what purpose. Or, as Lynch puts it, a transition is made from omnipresent "matters of fact" to more localized "matters of concern."[32] Schulze's sensory materialism certainly stretches the intended reach of ontography, which Lynch more narrowly applies to unpacking concerns of social discourse. Yet the emphasis on subject-centered intensities that Schulze calls for opens new ground that plays specifically upon the ephemeral strengths of sound, which carry through even in an age saturated with mechanical reproduction. He reminds us that in the present, technologies of sound reproduction guarantee an awareness about the impact of sound even when it is not physically present or affecting the body in any tangible sense.

Making this anthropological (or ontographical) turn has important implications for the place of sounding statues in the methods and scope of historical acoustemology. The problem of how to frame the experience of sound when that sound is no longer present becomes a key component here. One of the premises associated with acoustemology more generally (drawing from anthropologist Steven Feld's ideas regarding the term in the mid-1990s) is that cultures take shape in part through the sonic environment

within which they develop and thrive. Therefore, the aim of a historical acoustemology is to try and elucidate that process as much as possible in historical contexts, either through analysis of written descriptions of sounds or attempting to recreate the sounds themselves based on those descriptions using contemporary technology. But because statues have not been thought of (at least in Western aesthetics) as objects intended to hold sonic identities, they have fallen outside of the sphere of inquiry typically associated with the area. Drawing them back in begets some interesting questions regarding the value that sounds accrue in the process of historical reconstruction. What does it mean to try and reproduce sound with historical fidelity from a source in which the expectation of sound was, at best, negligible? How does one go about searching for this trace within the anecdotal accounts dotting the historical record? Sound art, I think, casts an unexpected shadow over the ways in which we might go about this work as well. In its modern pervasiveness, sound art has attuned us to the possibility of extracting an already existing palette of sounds from objects and spaces from which we least expect them. This expectation of everything and everywhere sounding inevitably filters into any reconstruction of the historical ear. I will show throughout this book that this mentality manifests as a double-edged sword, as much an opportunity as a reason for trepidation. As heirs to the modern science of acoustics, we have a more tangible understanding of the constitution and behavior of sound than our predecessors. Applied to subjective descriptions of sounding statues, this allows for a broader template of descriptive possibility when attempting to expound upon ephemeral traces located in historical sources. At the same time, the language and concepts used by these accountants to describe their experiences with sounding statues expand the horizon by which the cultural impact of these noteworthy objects can be understood. These sounds were never just sounds unto themselves, but tied into a delicate mix of science, religion, politics, and performance, among other things. What results is an acknowledgment that framing a scholarly understanding of these instances solely in terms of physical sounding is unnecessarily reductive, similar to thinking about statues solely as aesthetic objects instead of dynamic facilitators of cultural engagement.

Further afield, an anthropological move toward sounding statuary brings forth different ways to think about touch, the other sense instrumental in the development and perpetuation of sculptural aesthetics in the West. To touch a statue was as important as looking at one—for aesthetic purposes

as with Enlightenment thinkers like Herder, but also for epistemological purposes (as anyone remembering William Molyneux's famous thought experiment to John Locke can attest). But tactility held an understandably diminished importance within a field where sound itself constituted an ephemeral object. While touch could be incorporated into the performative milieu of sound art, it was no longer capable of functioning (or even needed) as a vigorous sense of aesthetic judgment. Its diminishment became a kind of double estrangement, given the already marginal place of touch in Western art as a whole. Sound art provided the ear with an avenue into the sculptural ideal that could not be reciprocated for the hand through music, at least with the same level of veracity. Touch and hearing, the two senses that Serres thought of as cousins sharing a space outside of the cultural dominance of vision, could no longer be considered on equal aesthetic ground. This conclusion, though, assumes a sensory isolation for touch that bears the mark of the conceptual mind and not the experiencing body. Such is the legacy of thinkers like Maurice Merleau-Ponty, for whom tactility rested as one distinct part of a broader sensory whole. The sense of touch, as with its cousin hearing, carries a wilier and more diverse history than that. It is a history, Constance Classen writes, that "continually overflows the boundaries of any scheme of interpretation, just as the sense of touch overflows its own boundaries and merges with other sensory phenomena."[33] And while a practice like sound art retreats from the potential of that multifaceted history, the sounding statue has long maintained an important if subtle role for tactility throughout its many expressions. Most of the intense sonic experiences attributed to statuary, upon the mediation of reflection and thought, were considered the result of affective contact of some type. The touch of Pygmalion, as we will see later, was a prerequisite to the subsequent sounding life displayed by Galatea when she stepped down from the pedestal in his workshop. Automata needed the intervention of a hand (not quite as magical as Pygmalion's) to activate their perpetual mechanisms and enact their awe-inspiring performances. Even the unseen forces that resonated sound through metal and stone bodies were thought to be touching their objects in some sense. Perhaps a fateful gust of wind, or the breath of God, or the motions of Democratian atoms or Leibnizian monads, or even other sounds moving through the spaces between. Perhaps it was the spatial cacophony of New York's urban noise, which once exerted so much force that it pushed a bronze statue of Horace Greeley in Greeley Park off its marble perch in 1912.[34] Perhaps even a bolt of lightning, touching its object with a

resounding force that it explodes and becomes statue no more, a fate that befell a bronze eagle adorning the spire of the Union Soldier Monument at the National Cemetery in Knoxville during a 1904 thunderstorm.[35] Contemporary sound art was not the site of genesis for the collaboration between touching and sounding. Such a relationship—like the sounds of statues—was always present, if you knew where to feel and where to hear.

Taken as a whole, the move toward a culturally based, sensory-laden history, philosophy, and anthropology of confluences between sound and statuary begins the work of addressing several issues relevant to incorporating these events as viable sites of inquiry. At base, this move begins the difficult work of dismantling the hegemony of aesthetic thought that has been at best unsympathetic if not outright hostile to this issue. Absent the overriding problem of the aesthetic imagination, we can approach these manifestations with fresh ears, granting them an intellectual rigor that Serres, among others, would appreciate. Such a move would be potentially transformative in several different respects. First, it dislodges magic, idolatry, the metaphysics of presence, and technological intervention as problems for aesthetics to overcome or ignore. Instead, these attributes become key devices in ascertaining the mobile and diverse meanings given to sounding statues when imagined or confronted. Second, a new intimacy between sound and statuary can lead to thinking about sounded relationships even when sound is not physically present, a nonperceptual adjacency to sound that Seth Kim-Cohen refers to as "non-cochlear."[36] Though this term comes from an aesthetic context, it proves useful for elucidating a variety of social and psychological states that will manifest throughout the book. Most important, though, is how this move puts reception at the heart of unpacking these manifestations in context. The focus becomes less about the spectacle of Magnus's talking head, of burning cats in effigies, or of a mysteriously singing Elvis. Rather, we can give much-needed attention to why Aquinas wanted to destroy the head, how English Protestants heard these screams as specific signifiers, and what a practical joke tells us about how random Seattle residents hold differing ideas toward the interplay between acousmatic voice and sound technology. Attaching sound to a statue has often carried the consequence of both objectifying and materializing that sound in a way that mediates away the potential of the ear as an organ of ascertainment. Flipping this arrangement introduces a measure of nuance accounting for the diversity of means in which individuals and groups can *hear* to contemplate meaning in the event between sound and statuary.

This focus on hearing within the anthropological fold brings us back to the mad science of Homer Simpson. It is reasonable to suggest that his creation lacks the craft of a Bernini or the single-minded desire of a Pygmalion. You might even say that his grotesque creation should not be considered a statue any more than the work of a child anthropomorphizing an array of carrot and celery sticks on a snack plate. Yet Homer created his sounding, embodied ruse as much out of love as any Pygmalion, and its rapid rise up the corporate ladder, even in a bureaucracy as mismanaged as the Springfield Nuclear Power Plant, is a feat the fleshy brilliance of *Apollo and Daphne* would find hard to replicate. This success may have cheated the imposed confines of anthropocentric statuary through a fortuitous mix of a recorded voice and the cataracts of an elderly man. But the fact that sound can place a heavy finger on the scale of embodied fidelity is precisely the point. The trope of animation in statuary, as we have seen, has long been predicated upon imaginative impulses within those external to the objective fact of the statue itself. Modern Western aesthetics was built to discipline and mediate those impulses as antithetical to the deployment of a proper subjective judgment. Understanding any event between sound and statuary requires an uncoupling and transcending of those limitations. It necessitates an empathy with the existential apparatuses, both microscopic and cosmological, that people create in the moment and in the aftermath of those events to explain their sensorial presence. In essence, we should be less concerned with the form of Homer's creation than the forms of cultural fascination that gravitate from its wake.

Why, pray tell, would anyone seek to silence anything so innocuous as that?

CHAPTER 2

Breathing Voice into Laocoön's Mouth

There is a certain irony in the idea that the lasting blow to the aesthetic veracity of sounding statues in Western thought came from a statue never accused of making a peep. What kind of statue could hold such power, condemning its sounding brethren to the cultural void without even having the courtesy to sound itself? The answer, as with many harbingers of change, stemmed from the ubiquitous nature of celebrity. Unlike the litany of sounding statues that spent their existence on the margins of cultural consciousness, the statue I speak of was not only widely renowned—it was essential to the development of sculptural aesthetics some two hundred and fifty years prior to its use as an instrument of silencing. *Laocoön and His Sons*, as it came to be called, captured eyes from the moment it was unearthed from the grounds of a Roman vineyard in 1506. And its emergence could not have been timed better, arriving during the heart of the Italian Renaissance and a culture of artists searching for embodiments of the classical aesthetic ideal from Greece and Rome. In this respect, the statue was wildly successful. Interested parties thought the group of marble was the same *Laocoön* described by Pliny the Elder in his *Natural History* as "a work superior to any painting and any bronze."[1] The connection was given credence by Michelangelo, and the sculpture was installed in the Belvedere Court Garden in the Vatican as part of the personal collection of Pope Julius II. There, the *Laocoön* became

one of the most fervently studied sculptures of the late Renaissance, subject of hundreds of letters, poems, and facsimiles. It was immediately heralded as a quintessential example of the Pergamene baroque style in Hellenistic sculpture, rare in how complete it remained after centuries in the ground. This fame would turn out to be somewhat disingenuous, as the unearthed marble was later found to be a copy of a bronze original sculpted by three Rhodesians in the late third or early second century BCE. Nevertheless, the marble copy garnered as much attention as any individual original sculpture made during the Renaissance and beyond.[2]

At least some of this renown was due to the dramatic scene the statue presented. The *Laocoön* captures the moment, detailed by Virgil in the *Aeneid*, in which the namesake Trojan priest and his two progeny are crushed by a pair of divine serpents summoned by the god Poseidon—a horrific end brought about in retribution for the priest's sins or a testament to his virtuousness, depending on the source. The statue fixes in time a moment prior to that demise, where the ability of sculpture to capture the essence of human suffering comes into question. And there is much to garner from the *Laocoön* with regard to this representation of pain. From a distance, one may notice the contorted form of the bodies as the serpent interposes its coiled form between Laocoön and his terrified young sons. Closer inspection reveals the anatomical error in Laocoön's eyebrows: overwrought transverse furrows noticed by Charles Darwin, of all people, that may have been accentuated by the sculptors for purposes of expression.[3] But only one part of the entire *Laocoön and His Sons* sculpture became relevant to the fate of the sounding statue—Laocoön's *mouth*. Frozen on the cusp of a scream, the mouth opened a chasm in the relationship between beauty, form, and pain in ideas about classical sculpture, more so than any twisted body or nonidiomatic eyebrow. Indeed, there lies a minute disjunction between the entire piece and the mouth in isolation. While Laocoön's posture and eyes indicate a desire to escape a state of suffering, the mouth communicates a bizarre impression of subtlety, given the mortal circumstance endured by the subject. What precisely is the slightly downturned mouth of Laocoön trying to express to us, and how deeply should we interpret that frozen moment in the context of the statue's broader narrative?

Answering this question was foremost in the mind of Gotthold Ephraim Lessing, one of the most admired writers and intellectuals in eighteenth-century Germany. Primarily known during his lifetime as a librettist for theatrical productions, it was a 1766 essay regarding the *Laocoön* that became

his hallmark, influencing aesthetic criticism well over two centuries after his death.[4] In the work, Lessing famously argued that the rather stoic presentation of Laocoön's pained expression was evidence that sculpture could not depict a moment as vibrant and horrifying as the scream without sacrificing the formal presentation of beauty thought endemic to classical sculpture. This stance, in turn, reflected a larger question for Lessing: whether sculpture was capable of representing any kind of emotional intensity the way he thought inherent to poetry. His answer was a resounding no. Laocoön's mouth became the site through which Lessing crafted an aesthetic theory that systematically cleaved apart the arts beholden to *nacheinander* (time) from those beholden to *nebeneinander* (space).[5] By removing *nacheinander* from the purview of sculpture, he wanted to remove any possibility of expressing the moment captured upon the mouth of Laocoön—the chilling and grotesque sound of the scream itself.

The gambit presented by Lessing was a brilliant attempt to outflank the philosophical problem of the "invitation to idolatry" that sound presented.[6] He tried to circumvent questions regarding sonic presence by embedding a silencing mechanism inherent within the art form of sculpture itself. If statues could not maintain their proper aura while even *representing* a scream in form, he held, then there is no basis to consider the imposition of that sound through the medium of sculpture. The presence and affect of the scream would have to be explored through the more expressive and appropriate oratory arts, where *nacheinander* held sway. The veracity of Lessing's protestations suggests a profound anxiety that sound would find a way to filter into the presentation of the *Laocoön* regardless. Not everyone shared his concern. Other commentators like Jacopo Sadoleto and Johann Joachim Winckelmann were more ambivalent toward what Richard Brilliant calls the "imagined potential of . . . [the] soon-to-be-heard scream of pain, never uttered."[7] Even so, the regime of stony silence Lessing postulated won out for well over two hundred years after *Laocoön* was first published. What Lessing offered, in essence, was a systematic framework arguing that the full artistic potential of sculpture could not be achieved unless its absolute silence was assured. His genius was to transform what had fundamentally been a metaphysical question into an aesthetic one.

Lessing gave sound quite a hurdle to clear in order to carve its way back into sculpture. The anthropocentric form central to sculpture's representational schema was also central to the common charge of idolatry in the aesthetic thought of the Enlightenment. Thus any sound deemed to emanate

from a statue was likely to be interpreted with the identity of that statue in mind. And the interpretation of that sound often assumed the connotation of vocality, a concept already tied to a precarious metaphysics of presence that only enhanced the proximity of the statue with the death of the body. The visual and the aural feed back upon one another, entering into a chain of mutual reinforcement that threatened to eject the statue from any sense of rational aesthetic order. It is easy to understand why sound, for Lessing, gave idolatry another mechanism though which it could erode the proper aura of the art object and imbue it with a magical fancy that would be difficult to overcome through the discipline of reason alone. Better to excise sound altogether, lest it gain a pernicious and damaging foothold on the aesthetic imagination.

Given the formidable barriers that Lessing constructs, it is fascinating that sound nonetheless manages to breathe its unwanted presence into the pages of his essay. This takes the form of the most oblique and momentary of respirations, buried within the confines of language. As part of his introduction into the presentation of Laocoön's staid mouth, Lessing engages directly with Winckelmann's own account of the sculpture in the widely influential *Geschichte der Kunst des Altertums* (*History of the Art of Antiquity*) that had been published two years prior.[8] Lessing sought to challenge Winckelmann's idea that the expression upon the sculpted orifice evinced calm because the Greek ethos of masculine virtue could not countenance an overt demonstration of pain. "The expression of so great a soul goes far beyond a representation of natural beauty," Winckelmann opined about the *Laocoön*. "The Artist must have felt in himself the strength of the soul which he has impressed upon his marble."[9] While Lessing saw a profound wisdom in this observation, he concluded that the show of a so-called "great soul" could not transcend the aesthetic demands of the beautiful form. *Laocoön* fails for him as a work of art not because of *what* it represents, but *how* it represents it. In making this argument, though, Lessing passed over some intriguing implications inherent in the conclusion of Winckelmann's statement: "and [the artist] *breathed* into the forms of [the marble] no common *soul*" [emphasis mine].[10] In fairness, breath was merely an ancillary mechanism to the broader point about representation and perhaps did not warrant additional scrutiny. Yet this quality of ephemera does not render the reference to breath unimportant. The idea of an artist "breathing life" into a creation was well-trodden terrain by the time of the Enlightenment. Statues were no exception, evident in the widely prolific influence of Prometheus creating

humans by breathing into sculpted clay, or Ovid's *Pygmalion*, where divine breath brought an inanimate creation to life at the behest of the artist who molded its body.[11]

Reading Winckelmann's passage in hindsight, one may be tempted to understand the act of breathing a soul into an inanimate object as mere metaphor. Lessing's relative dismissal of the passage in his own work seems to reinforce this idea. Even during the height of Enlightenment rationality and natural science, however, the history behind such a statement would have been regarded as anything but metaphorical. This history tells us of a resonant relationship between breath and soul that carried deep cosmological significance. When invoked with regard to statuary, it summoned forth the famous Platonic dictum about the dangers of mimesis and fidelity in art. Laocoön's scream was dangerous in Platonic terms because it allowed the specter of the voice to become mapped in form upon a medium defined by stillness and silence. The moment the scream became etched in stone, it drove a moment defined by its temporality into a repetitive state of timelessness. A sculptor "breathing soul" into the statue he created was even more dangerous, since that person was tapping into a well of cosmic or divine power that had the potential to animate the statue with the gift of sound and movement. Laocoön's frozen gesture of a scream, if embodying such power, could rupture the artifice of the statue in its entirety and give the pained voice a horrifying and viscerally sonic reality.

What power could facilitate this nexus drawing together breath and soul, sculptor and sculpted with such comprehension, lurking behind Lessing's quest to inscribe silence into the statue with intractable permanence? This medium in question, undergirding the order of things for a period of roughly two millennia, was known by the Greek word *pneuma*. Most often translated as "spirit," "wind," or "breath," *pneuma* was thought to be a multifaceted substance influencing cosmological thinking in religion and science, not limited to Greco-Roman tracts about physiology, early Christian ideas about metaphysics and theology, or early modern atomism, among others. Because of this longevity and mobility, *pneuma* has proven a complex subject to understand with any sense of clarity. It is a material that Giorgio Agamben, in his analysis of the concept of phantasm in the Middle Ages, referred to as "perhaps the most imposing intellectual cathedral in medieval thought."[12] Imposing is an accurate assessment, considering the era of pneumatic viability spanned beyond the period outlined by Agamben, from pre-Socratic Greece until arguably 1887, when physicists Albert Michelson

and Edward Morley failed to detect pneuma's early modern cousin *aether* in a series of experiments. This failure taints the legacy of *pneuma* to a certain extent, retroactively remapping the body of writing on the subject through the absence of sheer physicality. The observational void reinforces the *post hoc* perception of *pneuma* as a jack-of-all-substances, serving whatever function was deemed necessary by whoever was conceptualizing it, and making its presence known only through the mask of observable phenomena. There is an understandable temptation, all things considered, to discard *pneuma* into the positivist dustbin of disproven cosmologies, passing Agamben's cathedral without a second glance and resisting the work of tracing its folds and crevasses.

Choosing to enter the vast cathedral of pneumatology, though, offers alternative and compelling narratives to the source of historical trepidation toward the sounding statue in Western thought. Most notably, *pneuma* offers a more dynamic means to frame the quandary of understanding sound emanating from statues as evidence of a disembodied vocal manifestation. As the most potent signifier of the idolatry that Lessing was trying to write against, voice pointed toward the kind of spiritual inhabitation that was metaphysically problematic because of its acousmatic properties. There was never any sure way of knowing the source of such sounds. *Pneuma*, as the physical manifestation of spirit in the human world, served as the first avenue through which the charge of idolatry against the sounding statue could be circumvented. Even when broader thought on *pneuma* rested upon a metaphysical foundation, its simultaneous designation as a material substance that touched and influenced every element in the physical world remained potent. Whether or not *pneuma* was actually present was not as important as the idea that people believed that it was present and based their ideas about both observable and unobservable phenomena, including the anatomical functions of the body, on its understood existence. Likewise, the understanding that sonic manifestations from statues were evidence of vocal inhabitation should be taken at face value, whether from those who believe in the veracity of such manifestations or skeptics in the cloth of those like Lessing.

While the discourse on *pneuma* reflected a pre-Cartesian synthesis of metaphysical and physical realms, this body of thought also defined *pnuema* by its patterns of movement as opposed to its constitution. More specifically, this manifested through the idea that *pneuma* was a vessel promoting various types of circulation both within and permeating the body. As a circulating

mechanism it connected together discrete forms, while also facilitating the affectation of one form upon another. This included sound in general, and the voice more specifically, as both were thought to be formed and driven through pneumatic circulation. In essence, *pneuma* created a material recourse for explaining sonic makeup and power, producing the sound that gave the voice form and presence, and contributing to its perceived affective influence over external bodies and minds. Nor was this power restricted to deities. Because *pneuma* was a cosmological constant between heavens and earth, the affective power it provided the voice was potentially accessible to anyone.

Ideas about *pneuma*, therefore, transcended the sounding statue beyond the scope of mere idolatry and the power to animate it beyond the realm of the magical. At the heart of the denigration of its sounds within aesthetic rubrics were a variety of ethical and political concerns that those sounds brought to the fore. Who was making these sounds, how were they making them, and for what purpose? Absent an empirical and rational recourse for the eye to judge a substance without visibility, the ear by necessity became the primary organ of inquiry. So the age of *pneuma*, by definition, became an age in which hearing was an active sense of knowledge accumulation, as opposed to one of passivity. And sounding statues, in the fear and curiosity they espoused, were a primary site through which this sense of an active hearing became manifest.

• • • • • • • •

In broaching the vast monolith that constitutes this history of pneumatic thought, I want to start with the scholar who likened it to an imposing physical structure in the first place. Agamben devotes an entire chapter of his book *Stanzas: Word and Phantasm in Western Culture* to tracing the development of pneumatology in the ancient world, for the express purpose of ascertaining its specific connections to love poetry from the Italian duecento. To establish this connection, Agamben starts his analysis with a passage from Dante's *Vita Nuova* (1295), where the Italian poet references how the "vital spirit, the one that dwells in the most secret chamber of the heart, began to tremble so violently that even the most minute veins of my body were strangely affected."[13] Agamben uses this fragment to argue that perspectives grounding Dante's use of spiritual allegories solely within the medical and physiological terminologies of the time are noticeably incomplete. Sans the input of metaphysical pneumatology, these allegories can only be regarded "as we might one of those mutilated statues that time has detached from

Greek temples or from the tympana of Romanesque churches and which now smile at us enigmatically in museum galleries." What follows is a thorough inspection of pneumatic doctrine, starting with Aristotle's famous definition from *De generatione animalium* casting *pneuma* as the material invigorating both semen and the cosmos that was so influential on the medieval physiological discourse in question. Agamben traces this amalgamation of material and metaphysical through its physiological roots in Greek medicine, where the vital *pneuma* housed in the heart is pumped throughout the body via the arteries (while the blood uses the veins) and helps make the body capable of sensation. This vital *pneuma* is coupled with a psychic *pneuma* housed in the brain, responsible for governing the enactment and interpretation of the various senses. He then shows how these physiological threads were subsequently embedded within broader ideas about metaphysics: first, by the Stoics, who conceived of bodily *pneuma* as substantially homogeneous with cosmic *pneuma*; then, by later Neoplatonists, who understood *pneuma* as a vessel carrying the soul from the heavens, becoming the source of the imagination within the body, and facilitating the ascent of the soul back into the heavens after death. In one remarkable paragraph, Agamben lays out how pervasive and interconnected these ideas about *pneuma* had become by the time Dante was writing.

> The synthesis that results is so characteristic that European culture in this period might justly be defined as a pneumophantasmology, within whose compass—which circumscribes at once a cosmology, a physiology, a psychology, and a soteriology—*the breath* [emphasis mine] that animates the universe, circulates in the arteries, and fertilizes the sperm is the same one that, in the brain and in the heart, receives and forms the things we see, imagine, dream, and love. Insofar as it is the subtle body of the soul, it is in addition the intermediary between the soul and matter, the divine and human, and, as such, allows the explanation of all the influxes between corporeal and noncorporeal, from magical fascination to astrological inclinations.[14]

Agamben uses this description in part to lambaste the privileging of scientific attributes within pneumatology to the detriment of its attributes perceived as magical. He understands this move as an attempt to map the rationalist and positivist values of the Enlightenment onto medieval thinkers,

who often thought of science and magic as integrated. More important, though, is the emphasis he gives to the word *breath*—as opposed to *spirit* or *wind*, the other translations often given for the Greek word *pneuma*. This recourse to breath offers three useful starting points in ascertaining the connections between *pneuma*, voice, and sounding statues. First, he establishes the primacy of the body in theories of pneumaticism. While *spirit* and *wind* imply an emphasis on the concepts of divinity and naturalism respectively, *breath* holds the respiratory process as broadly allegorical for pneumatic constitution in general. Second, he recognizes the central role the concept of breath plays at every level of pneumatic presence, from the physicality of reproduction to the metaphysics of divine intervention. Third, and most important, Agamben emphasizes the defining characteristic of *pneuma* as its principle of *circulation*. That is, *pneuma* was never understood as a fixed presence, but one constantly defined by movement both within and through the discrete bodies it contacted. In this sense, breath seems the perfect metaphor for the entire apparatus of pneumaticism: unseen except when affecting other bodies while ever moving, and capable of being *heard* if not explicitly located by the ear.

Where exactly does the breathy prevalence that pervades Agamben's pneumatological framework come from? Answering this question requires a step further back than Agamben takes. While he is correct in stating that Aristotelian descriptions on *pneuma* find root in older Greek thought, this root is even older than the Hippocratic medical texts that he supposes. Most scholars trace the source of pneumatic doctrine and its emphasis on breath to Anaximenes of Miletus, who conceived of a material monism based on the universal presence of air during the sixth century BCE. The emphasis on air stemmed in part from the desire to find a substance of "infinite and indeterminate" status to challenge an earlier cosmology by Thales based on the ubiquity of water.[15] The first iteration of *pneuma* was understood as a particular type of rarefied air imbued with a divine essence that permeated the physical world—thicker than fire, but thinner than water or rock. It was a perpetual substance that was always in a state of motion, holding no traceable source, but most importantly, explained through the metaphor of breath. The cosmos, for Anaximenes, was always breathing. But respiration was also the mechanism connecting humans to this divine power within the air. Breathing reinvigorated an interior soul comprised of air itself moving through the body. In placing a concept of soul within the confines of natural material, Anaximenes established a precedent of how to think about the

central dialectic between soul and body through a system based on physical processes.[16]

Breath would continue to be a central tenet of pneumatic circulation, even as the monism of Anaximenes diffused into the polymorphous *pneumas* that defined later Greek thought on the subject. Aristotle, for example, divided the external *pneuma* of the air from an innate, *a priori pneuma* that resided within the body. He then conceived of this innate *pneuma* as the regulatory mechanism moving throughout the entire corpus, integral to a range of carnal processes from the senses to memory and reproduction.[17] Breathing maintained a central role in maintaining bodily temperament. In the short treatise "On Breath" (*Peri Pneumatos*, in Latin *De Spiritu*), Aristotle held that one of the ways in which the body gained nutriment, in addition to the process of digestion, was from the breath drawing the nutriment out from the circulatory system.[18] Aristotle also used the breath as a means to critique the coterminous relationship between soul and air that was essential to the cosmology of Anaximenes. How can the soul be made solely of air, he wondered, if air was by nature inert? Something in the body must be the catalyst to invigorate this "neutral substance," Aristotle reasoned, turning it into the active principle that circulates throughout. "Surely, if [air] becomes animate or becomes soul, it suffers some change and alteration, and so naturally moves towards what is akin to it, and like grows by the addition of like. Or is it otherwise? For it may be contended that the air is not the whole of the soul but is something which contributes to this potentiality or in this sense makes it, and that which has made it is its principle and foundation."[19] The implication is that breath becomes a powerful site of transformation and a unique marker of embodied distinction, even as it performs the necessary maintenance of bodily functions. Breath of life, indeed.

Aristotle's categorical breakdown of *pneuma* and its various embodied entanglements also gave a tangible, physiological connection between breath and voice. He famously defined the voice in "On the Soul" (*Peri Psuches*, best known by the Latin title *De Anima*) as "a sound that signifies," but Aristotle more specifically understood the concept of voice as a sound attached to the imagination that derived specifically from the *pneuma* in question.[20] That is, voice functioned as part of a mechanism that carried *pneuma* from the sources of higher reason out of the body and into the external world. In this way, voice carried meaning and served as the fulcrum for language through its pneumatic principles. But this movement was not only the vehicle for

speech. The Aristotelian voice, much like the breath, could act as a valve of external release to combat any systemic imbalance that could harm the health of the body.[21] Voice also served as a medium of pneumatic interaction between discrete bodies. Instead of a direct transmission of sound from one source to another, Aristotle conceived of sonic diffusion as a form of echo. An imprint of the original sound, articulated by the voice, moved through the *pneuma* like "ice slowly developing across a lake," eventually resonating with the *pneuma* present in the listener's ear.[22] What the receptor heard was not an actual physical sound that we can call the voice, but a kind of pneumatic trace consisting primarily of *logos*. The grain of the voice—the pneumatic soul—remained safely ensconced within the body.

While Stoics like Zeno of Citium and Chrysippus did not adhere to the veracity of breath and air with the same vigor as their predecessors, they still envisioned a pneumatic cosmology defined by circulation and substantial variation affecting sensation. Stoic *pneuma* manifested within the body with the homogeneous substance delineated by function, taking on specialized tasks related to health and maintenance, which was controlled by the pneumatically derived soul located in the brain, interacting based on precise relationships of tension and release.[23] As with Aristotle, this interior pneumatic system maintained bodily function and temperament. Yet this systemic interaction between internal and external *pneuma* became the basis not only for bodily function and temperament, but also served as the mechanism driving perception. Sarah Iles Johnston provides a thorough description of how this pneumatic process worked with regard to sight.

> Vision occurred when an individual's *pneuma* . . . flowed out of the part of the soul associated with consciousness (the "leader" or *hegemonikon*) into the corporeal eye; once in the eye, the *pneuma* introduced tension (*sunentasis*) into the outside air that lay just beyond the eye, causing the affected air to take on the shape of a cone. When this entensioned cone of air simultaneously was illuminated by sunlight (thus bringing the "outside" air into harmony with the fiery *pneuma* that had emerged from "inside"), the cone became capable of receiving the forms of objects at which the individual gazed.[24]

Stoic *pneuma* maintains the affective power argued by Aristotle, but extends its ability to alter substances outside of the body. Air, remember, had to

be drawn inside of the body for Aristotle to grant it pneumatic properties. While Aristotle granted the voice more leeway of external movement, the innate *pneuma* responsible for the vocal echo remained inside of the body. The example given above shows that the Stoics extended the circulation of bodily *pneuma* to outside of the body, affecting other substances to create the means by which a person ascertained the physical world.

The Stoic voice, like vision, consisted of its own *pneuma* and had a distinct process of circulation within the body. Enacted within the *hegemonikon*, the vocal *pneuma* moved through the larynx into the mouth and was responsible for the motions of the tongue that created diction and speech. This Stoic ideal of the voice was radically different from its predecessors, however. Aristotle understood the voice as noncorporeal, becoming mere echo transporting *logos* between bodies when moving out from the cusp of the mouth. Within Stoicism, since the voice was considered its own part of the bodily *pnuema*, it was itself understood as a corporeal object. Chrysippus outlined this perspective with the blunt yet effective phrase "voice is a body, since everything capable of action and influence is a body."[25] Plutarch aptly expressed the broader implications of this argument in his short essays regarding various Greek conceptualizations of the voice. Writing in response to the Stoic ideal of voice as a body, the Roman philosopher considered the implications of this phrase through the example of the vocal echo. The fact that voice reverberates upon a physical surface and echoes—"as when a ball is cast upon a wall," in Plutarch's parlance—suggests not only that both the voice and affected surface are material, but that hearing is the means by which that materiality can be ascertained.[26] Though not himself a Stoic, Plutarch does articulate a legacy of Stoicism that positions the ear as the organ most attuned to the movement and presence of *pneuma*, a concept we will return to later.

Understanding the voice as something material, fully capable of pneumatic effect upon the external bodies continued to appear in a litany of sources contemporary to Plutarch. Galen, in his medical treatises from the second century CE, offered a tripartite theory of pneumatic movement and transformation indebted to earlier sources. Air taken into the lungs was converted into a subtle type of *pneuma*, transferred into the heart where it became a more potent "vital" *pneuma*, and moved through the vascular system into the brain to become the "psychic" *pneuma* necessary for higher brain function in humans.[27] Galen also opined on whether the vocal *pneuma* stemmed from the heart or the brain, a debate of considerable discord in

medical thought at the time. Medicine, though, was not the only area in which these ideas about *pneuma* were being challenged and developed. Seneca, continuing Stoic orthodoxy into the Roman years, implied that all manner of vocal expression—including timbre and volume—were subject to the properties of pneumatic movement.[28] These ideas carried broader social significance than mere philosophical musing, as controlling pneumatic circulation became central to masculine doctrine. Roman men trained in oration and rhetoric were taught to make their voice sound as deep as possible, as a way to exteriorize the strength of their innate *pneuma* as a performative act.[29] Breaking of the voice was often heard as an indication of diminished virility; thus, abstinence from sexual activity to preserve the potency of innate *pneuma* was also understood to protect the power of the voice.[30] And the voice was still instrumental in maintaining bodily temperament as well, an idea held over from Aristotelian thought. Writing in the fourth century CE, the Roman emperor Constantine compared wine generating froth to the body expelling the excess melancholic *pneuma* from the body via singing, a nod to Aristotle's idea of the voice as a mechanism of controlling body temperament.[31]

These material threads connecting voice and *pneuma* to the body became an important trace as the metaphysical prominence of *pneuma* began to overshadow its physiological dimension during late antiquity. Some of this change was due to the influence of Neoplatonic thought, which posited a radical and complete idealism in which all corporeal things stemmed from the soul and eventually returned to the heavens. *Pneuma*, as Agamben showed, served as the vessel through which this circular journey took place, becoming both imagination and the bridge between sensory perception and the noncorporeal mind in its corporeal guise. Such prominence of the metaphysical extended to emerging Christian and Jewish doctrines during the late Roman Empire. Adriana Caverero notes that *pneuma* was marked in these bodies of thought by the Latin word *spiritus* and the Hebrew word *ruah*—concepts encompassing both the breath of creation from God and the physical force of wind deriving from spiritual force sans the material grounding long associated with the word *pneuma*.[32] That pneumatic metaphysics became so dominant starting in the early Middle Ages reflected a core ontological problem that had plagued materialist ideas about *pneuma* from the start. Simply put, proof of the existence of *pneuma* could only be surmised through what were perceived as its observable affects. Unlike rock, water, or even the air, *pneuma* could not be bottled and subjected to experimental

scrutiny. This state of imperceptibility allowed for a different kind of breath to emerge in this absence, one that placed the divine and unknowable source of *pneuma* back into the exclusive domain of the metaphysical.

As the concept of corporeal *pneuma* became intertwined with the incorporeal *spiritus* in theological discourse, the voice became an important device in finding points of convergence between them. One of the most notable thinkers to use the concept of voice in such a way was Philo of Alexandria, who addressed these concerns some three hundred years after Aristotle. At base, Philo perpetuated a theory of *pneuma* where the substance served as both the center of reason and source of the voice, ideas in resonance with older Greek sources. The third, unique component was the spark of "divine inspiration" from an external, spiritual source that transformed the voice from meaningless sound to sound with meaning.[33] This idea represented a marked change from earlier ideas about vocality, in which the voice was created by a physical reaction within the body and given meaning by the innate soul (Aristotle), or was a pneumatic body unto itself (the Stoics). Voice was now a product of a soul with direct ties to its heavenly source, operating within the body while rendering it a passive vessel and nothing more. Embodiment may not have conceptually vanished as ideas about *pneuma* turned to metaphysical sources, but the body no longer carried the same role in producing breath or voice it once held.

Thomas Aquinas demonstrated the legacy of this pneumatic disembodiment on ideas about the voice in his massive thirteenth-century text *Summa Theologica*. Influenced primarily by Aristotle's thought on the subject, Aquinas attempted to rectify the inconsistencies he saw pervading the Greek philosopher's theory of pneumaticism, particularly with regard to the relationship between breath and the soul. Among other moves, Aquinas declared that carnal breath could no longer be considered coterminous with the concept of *pneuma*. Instead, breath was merely a physical process of a lower order, subsumed within the divine breath housing the "power of the soul" that generated and perpetuated life and was itself the product of "the power of a heavenly body."[34] In other words, anatomical functions were not themselves part of the soul, only enacted and driven by soul. While Aquinas did acknowledge the Aristotelian legacy of bodily *pneuma* by locating the pneumatically derived soul within a chamber of the heart, the ultimate source sustaining that soul through the pneumatic connection was God. Thus Aquinas perpetuated one of the core pneumatic ideas from Neoplatonic thought—the circulation of the soul through the medium of *pneuma*.

Extending this pneumatic circulation to the voice, though, was another matter entirely because of its ephemerally aural nature. Sound, as William Layher points out, was the source of a great deal of ontological angst for medieval thinkers since its source and quality could not be ascertained through observation. Aristotle's concept of the voice as a sound infused with soul provided a useful model for explaining the distinctive qualities that seemed to separate voice from other nonvocal sonic manifestations. Aquinas understood the voice to emanate from the heart, when the soul located there struck air and forced it into motion toward the windpipe. Prior to its discharge from the mouth, the imagination added meaning to the sound in order to emerge as a linguistic utterance.[35] Far from being a body within a body, as the Stoics thought, *pneuma* was now the only body that mattered, traveling an inert and fleshy pathway from heart to lips in its vocal transformation.

When the body was involved in medieval pneumaticism, it was increasingly understood as a potential site for corruption of the soul, the *pneuma* that carried it, and the voice they produced together. To that point, there had been a long history dating from Aristotle of separating vocality from animalistic utterances and noises—sound without meaning and therefore bereft of soul. But the idea that the physical body could be used as a backdoor to the apparatus of pneumatic circulation by external forces was evidence of the degree of abstraction between body and soul pervading Western thought through the influence of Neoplatonic philosophy. Those without the capacity, or with a limited capacity, for soul-laden reason were particularly susceptible, and it is perhaps unsurprising that these ideas often carried a misogynistic bent. Brenda Gardenour Walter notes that Aquinas, along with a number of other late medieval scholars, thought that women could be more easily possessed by demons because of their perceived bodily weakness, lacking the strength and moral fortitude needed to resist inhabitation. These demons were thought to gain a foothold in the female body through cool and moist regions and orifices bereft of invigorating pneumatic circulation. Once inside, these demons corrupted the interior *pneuma*, the senses, and ultimately the soul, manifesting within and on the body in several ways. The possessed were subject to hallucinations, grotesque transformations, and stricken with foul breath and noxious vapors that they could use to summon storms or emit poison. Their voices, stripped of reason infused by the imagination, devolved into meaningless utterances and animalistic noises. Only by reintroducing the cleansing power of divine prayer could this influence be purged, returning pneumatic circulation to normal.[36]

What is so intriguing about this body of thought on corrupted *pneuma* is how, even in its misogynistic guise, it nested the means by which the body could reemerge as an important thread in pneumatic thought. Voices of the possessed, for all of their perceived moral and ethical failings, affected the outside world with considerable force. This power of transformation was still dependent on the circulation and expulsion of *pneuma*, however tainted the substance may have been. The body carried ultimate responsibility for these powers, providing the space through which the corruption nested, circulating through the same fleshy tunnels ideally perpetuating an uncorrupted *pneuma*. In any case, no matter how medieval thinkers like Aquinas tried to connect *pneuma* to the transcendent divine in absolute terms, the physical body could not be completely mediated away. This opened a window through which the idea of a pneumatically affective, material voice resonant with the spiritual connection of *pneuma* could resurface. The aeration, or rerespiration, of *pneuma* had begun in earnest. Some, like John Milton, merely adopted a more fervently materialist conceptualization of the Christian soul, a subtle resubstantiation of *pneuma*.[37] Others utilized materialist doctrine as a critique of the Aristotelian tradition in favor of incorporating fusions of Stoic cosmology with early modern science. Italian naturalist Tommaso Campanella, for example, sought to critique Aristotelian instrumentality by attributing the function of the body to the different corporeal *pneumas* instead of a centralized soul—an idea that influenced Thomas Hobbes, among others.[38] And French mathematician Jean Pena, in a 1557 preface to an edition of Euclid's text *Optics and Catoptrics*, argued for the ubiquitous existence of an "animabilem spiritum" ("animal spirit") composed primarily of air filling the space between earth and heavens.[39]

The most fervent adherents of an airy material *pneuma* tied to the body in early modern thought were those closest to the atomist revival in the sciences. In the Greek imagination, these would have seemed an odd pairing. Atomism, as delineated through an intellectual tradition including pre-Socratic philosopher Democritus and Aristotle's contemporary Epicurus, understood the world as populated with discrete entities working in tandem. This was a far cry from the uniformity and interconnectedness at the heart of Stoic pneumaticism, which developed as an antithesis to many of the atomist doctrines. Yet for proponents of a physical science based upon particle movements working in the mid-seventeenth century, the homogenous legacy of *pneuma* served an important metaphysical purpose. H. Floris Cohen has argued that the resurgence of atomism qua material particles took a turn

toward atheism when associated with thinkers like Hobbes and Margaret Cavendish. *Pneuma*, already carrying a long history of bridging material and metaphysical divides both in philosophy and the sciences, allowed atomism the benefit of spiritual adjacency. This recourse toward *pneuma* created what Cohen calls the "Baconian Brew." Combining the scientific contributions of figures like Robert Boyle, Robert Hooke, and Isaac Newton, and framed within the equally ancient moniker *aether*, the brew cobbled together "generous dashes of Stoic *pneuma* ...[,] Plato's world soul, [and] Descartes' subtle particles of matter ... ground into an extremely fine, all pervasive [material] substance" that could also account for perceived phenomena of metaphysical origin.[40] Instead of being an unexplainable substance accounting for observable occurrences, *pneuma* became a discrete substance accounting for sublime occurrences. In this guise, *pneuma* could bring the materiality of particle science into the realm of spiritual magic. It could also address the problem of the inert hollowness of mechanistic conceptualizations of physiology after Descartes, addressing the problem of soul by attributing it to "forces" instead of tepid "organizations of matter."[41] The form of *aether*, then, provided recourse for the material basis of *pneuma* to survive amidst the scrutiny of what would become Enlightenment natural science, while still maintaining its long-held cosmological connections.

Those considering the affective power of *pneuma*, equipped with this early modern physiological and scientific knowledge unavailable to their medieval predecessors, worked to resuture that pneumatic voice within the carnal folds of the body. Bruce Smith catalogued some of these changes in the specific context of sixteenth- and seventeenth-century England, informed by writings from James I's court physician Helkiah Crooke. For one, nonlinguistic utterances previously thought of as animalistic sounds without soul were considered to be evidence of continuity in human connections to the natural world. Changes in the timbre of the voice were more readily accounted to external changes in air temperature, pressure, and weather that facilitated interior changes in pneumatic constitution or circulation. Most important, though, was the reintegration of the embodied soul into the physical processes of the body, and the effect this had on how the voice was conceptualized. "To early modern ways of considering the matter," Smith concluded, "the word 'voice' meant, first and foremost, a concatenation of bodily members: muscles, gristly tissues, fluids, and 'soul.'"[42] Mirroring the rise of transcendental pneumaticism in the Middle Ages, the embodied pneumaticism of early modern thought still carried threads of the Janus-faced

metaphysics from earlier. There remained a sensitivity to the Aristotelian distinction between voice (as significant sound) and noise (as inconsequential or soulless sound). And the soul was considered as much a physical fact as ever, whether it stemmed from the Aristotelian heart, the Galenic brain, or the Cartesian pineal gland. Yet there seemed to manifest an expansive notion of what the voice *was* during the heyday of early modern science and philosophy, as much respirated physical breath as airless divine breath and connected to the carnal mechanisms of the body like never before.

Even so, the lack of substantial pneumatic constitution that could be observed and measured remained a bothersome trait for some. Foremost among this line of early modern thinkers was the noted English scientist Francis Bacon, for whom observation was paramount to the development of the sciences. Bacon certainly believed in the existence and prevalence of *pneuma*, as he devoted a substantial section of his *Nova Organum* (1620) to outlining its characteristics. However, he was careful to separate what he called pneumatical bodies from those he called "tangible bodies," with a distinct material presence and composition. "[Of] Things, which we call pneumatical, or untangible," he wrote, "no judgment can be form'd of the Distention, or Rarifaction, of the Matter they contain."[43] Bacon threads a tenuous line in his conceptualization of *pneuma*, casting it as a substance containing matter and classifiable properties, yet still something that cannot be tangibly ascertained. This duality between material and ephemera permeated his conceptualization of the voice as well. Simply put, the idea of a pneumatic propellant giving an unseen power to the voice could not be qualified by rigorous experimentation in acoustics. Far from being an agent of affect charged with *pneuma*, the aerated voice in Baconian thought became passive and affected. For one, Bacon thought the voice became substantially altered upon contact with any hard substance. Nor did he think the heat associated with pneumatic circulation could have any ascertainable effect upon the strength (meaning volume, not timbre) of the voice. And because he thought that sound moved in a sphere away from its source, any voice was more likely to move around a solid obstacle than pass through it. At best, sound could penetrate and effect physical objects by utilizing a pneumatic resonance inherent to both. In the section "Of the Passage and Interception of Sounds," Bacon argued that because every material contained "pneumatic parts," or small corpuscles of *pneuma* within hard bodies, a pneumatically infused sound like the voice could penetrate a hard substance by moving through these parts in material resonance.[44] Mere passage was the limit of the

voice's powers, though. Such is the double-edge regarding Baconian thought on the pneumatic potential of voice. Bacon had found a way to preserve the Aristotelian immateriality of the voice in an era where materialism in the sciences held sway.[45] In another, more profound way, he planted an idea that had to that point been unthinkable: that perhaps the voice was not infused with pneumatic power, but simply a physical manifestation of expelled air and nothing more.

Bacon's disempowerment of the pneumatic voice was a portent of change for *pneuma* under the skeptical eye of the hard sciences. The inherent unobservability of the substance would only become more a problem for pneumatology as a whole, as Enlightenment and nineteenth-century science further refined available tools of observation and measurement. Whatever survival *pneuma* endured within the encroaching sphere of modernity could not mask its precipitous decline as an affective force. The innate Aristotelian and Galenic *pneuma* thought to regulate bodily function had faded into obscurity with the rise of modern anatomical models and methods. By the mid-nineteenth century its early modern cousin *aether* had also waned in influence, thanks in part to Michelson and Morley. Atomism, the broader natural philosophy through which pneumatic thought gained second life, moved from indefinite substance to discrete particles through the work of nineteenth-century English physicist John Dalton and the subsequent rise of modern atomic models of physics in the early twentieth century. Even pneumatic theories of sensory perception were undermined as well, replaced by a turn toward physical resonance as the anatomy of the ear became better understood beginning in the mid-seventeenth century.[46] *Pneuma*, something that Max Weber once called a substance that "swept through the great communities like a firebrand," seemed destined to endure only as a historical artifact of cosmologies past.[47]

Judging *pneuma* on the false promise of existence alone, though, fails to account for the pervasive cultural relevance it maintains, even as an object of historical ephemera. This legacy goes beyond the use of the prefix "pneuma-" as an aerated linguistic marker in the English words for respiring machines and respiratory diseases. Even in its conceptual dormancy, *pneuma* still holds a haunting fascination as the quintessential absent presence for ontological thought. Longevity and perseverance are certainly factors contributing to this status. Yet a more potent legacy for *pneuma* lies in its status as the first conceived substance to be defined by movement, ascertained by its affect upon bodies, and irreparably rupturing the idea that objects could

only be what they appeared. Such an effect can clearly be ascertained on the voice, that most ephemeral of quasi-objects to begin with. Frances Dyson has made a compelling argument that *pneuma*, because it was defined by its state of movement and flux, became the "wires" through which ancient Western thinkers could transform the voice from physical sound into a kind of telephonic transmission that was simultaneously "ontotheological" and "audiophonic"—a direct connection to the divine but also a device to move the voice outside of the body.[48] Just as important, though, is the role that *pneuma* played in what the voice could *do* through that network of metaphysical wiring, Bacon and his scientific legacy notwithstanding. It is here that the dual ontology of *pneuma*, as both metaphysical presence and material substance weaving together all things, comes to the fore. The pneumatic voice was, simply put, an object of power. And this power was not limited to voices thought to be of divine origin. The same substance thought to force Apollo's breath into the body of the Stygia at the Oracle of Delphi also powered impoverished Victorian women whose soul-infused song was thought to cleanse the fetid air of industrialized urban neighborhoods.[49] Conditioning and virtue played a role in whether or not the potential of the pneumatic voice could be actualized, to be sure. Yet there existed no obvious ontological barrier to a voice—*any* voice—accessing this power. Quite the democratizing substance, this *pneuma*.

Since Aristotle has been a constant presence in the discourse on *pneuma*, it seems appropriate to express this implication through a syllogism. Because *pneuma* was everywhere, and *pneuma* was the source of the voice, then voices could come from anywhere—from humans, acousmatic sources of divinity—and affect any thing. Given this pervasive reach, one can imagine the pneumatic quandary caused by something like a statue. Already straddling a tenuous mimetic line between animated person and inanimate object, between voice and noise, between living body and preserved corpse, the statue presented a ripe vessel through which *pneuma* could do its phantasmagorical work. What, one wonders, could the pneumatically infused voice possibly do to any objects it encounters?

• • • • • • •

To wit, there have been many instances, even entire cultural practices, attributing *pneuma* as the cause of sounds made by statues.[50] For those intimately involved with these sonic objects, they presented an opportunity to commune with forces beyond their earthbound enclaves. For Enlightenment aesthetes like Lessing, they served as one of the bases for undermining the cultural

veracity of sounded statuary in general, trapping them within a cage of magic and idolatry. But taking the emanation of sound as the extent of the perceived pneumatic influence on statues assumes an artificially narrow perspective on the nature of *pneuma*. It suggests that acousmatic sound represented the only physical trace of pneumatic presence, which could be accepted without question or dismissed under scrutiny. Such a conclusion underestimates the omnipresence centuries of thinkers gifted to *pneuma* as both a cosmological and physiological force. Because *pneuma* was defined as much by its constant and inexorable movement as the traces it left in its wake, focusing on the resultant sounds of the pneumatic encounter puts the cart before the horse. The history of pneumatology is charged with sonic threading at all points material and metaphysical. Voice, though not the only manifestation, is certainly the most prominent one. It constituted the one *topos* in which the vitality of animating breath met the imagination sparked from the pneumatic mind, exiting the carnal body through the guise of the linguistic utterance. Yet the imprint that voice, propelling outward as a sounded object, was thought to leave on the statue was not always grasped within the purview of the sonic. Vocal marking could also take the form of what Jacques Derrida called "natural writing," an inherently pneumatological construct in which the word, articulated in metaphorical terms, maintained close proximity to the voice and the breath that animates it. Derrida, of course, was critical of natural writing and its propensity to exile the nonpneumatological *technique* of writing to the meaningless shell of the body.[51] But those objections do not change the pervasiveness of such writing throughout the age of pneumatology, nor the perceived weight these written manifestations may have carried among those who believed in them.

Consider the relationship between *pneuma* and the epigram, a practice wedding voice, writing, and statues thought to have originated around the time of Homer. As a technique, epigram predates the first philosophical musings on pneumaticism from Anaximenes.[52] Yet these inscriptions were conceived as more than written poetry upon or about a stilled and silent form. Epigrams often took the form of odes to statues in the voice of the writer, but could also be written in the voice of the figure represented by the statue. Critically, as Gunter Gebauer and Christoph Wulf observe, they were composed to be *spoken aloud* in the presence of their object, with the voice of the reader acting as an "accomplice" to help the written text breathe life into the statue.[53] The implication behind these aural performances of epigrams is articulated by Gross with regard to thirty-four surviving epigrams written

about a bronze cow sculpted by Myron in the fifth century BCE. "The energetic, often hyperbolic wit of such poems seems aimed at revealing a power intrinsic in the object itself, and yet they also try to valorize the speaker's own right to confer life and value upon that object, to inscribe and animate the material thing by means of the poetic word. . . . The poetic text thus doubles or supplements the work of the visual artist, taking advantage both of what is visible and of what is invisible in the figure. It is a wonderfully elusive game."[54]

That "invisible" thing to which Gross refers seems quite pneumatic in its description. Statues made in the time of Myron were thought to be full of the substance that pervaded the air, to the point that the display of *empnoos* (breathing) on their embodied form was considered a marker of mimetic fidelity.[55] What was needed to facilitate a connection between person and statue was a spark linking their mutual pneumatic facility together. Writing created the circuitry through which the connection could be made. But it was recitation, as a kind of vocal incantation, that was the mechanism locking the pneumatic circuit into place. These pneumatic connections between sculptor, writer, reader, and statue become even more explicit in later manifestations of epigram writing. An example from eleventh-century Byzantium, described here by Bissera Pentcheva, connected the form of the epigram, the power of the voice reciting it, and the *pneuma* circling between and through them in more explicit terms.

> Thereby the emphatic power of language, its enunciated presence, would have emanated from the body of the spectator as she or he lent voice to the poetry. The *empnous* words would also have simultaneously penetrated the body of the viewer, mixing the pleasure of words with the pleasure of seeing the scintillating agitation of the statues' metallic gaze and coruscating metal surfaces. The *charis*/grace of the *andrias* would join the *charis* of the performed poetry. The epigram had the potentiality of animation, which became realized in speech, in exhaling *pneuma*. At the same time, the Greek understanding of *pneuma* as simultaneously voice, sound, and fire unified enunciated words with the coruscating glitter of metal: the fulfillment of an *pneumatikos andrias*.[56]

The English translation of *pneumatikos andrias* is literally "pneumatic statue," but the pneumatic connections here go beyond the statue itself. It is the

reciting voice that gives fuel to the encounter, triggering the latent pneumatic properties of both written word and bronze statue, connecting the already invisible circuitry always connecting the three together.

The pneumatological aurality embedded into written epigrams was especially prevalent in Renaissance Italy, where a potency of interplay existed between the various arts. Among the most notable examples involving statues was the "Congress of the Wits" (*Congresso degli Arguti*), a group standing in the Palazzo Braschi in Rome centering on a battered Hellenic figure that was given the name Pasquino by locals. The assemblage was unearthed during the city's extensive sixteenth-century urbanization, and carried on conversations with one another or addressed the public utilizing anonymous texts pasted upon their façades. Their playful discourse in one sense reflected the social theatricality and personal gestures in oral performance common in Rome at that time.[57] Yet within that ethos lay a deeper trace to the pneumatic impulse carried in the legacy of that kind of writing. Kathleen Wren Christian, with regard to another group of statues found at the Roman Academy sculpture garden of Pomponio Leto, ties these aural epigrams to the mode of poetics developed during the quattrocento that facilitated the "revelation of *anima* (soul) and spirit" in painting and sculpture.[58] This power of animation, in Christian's formulation, was enacted through the *ingenium* (genius) of the artist combined with the bodily fragmentation and relative anonymity of the ancient statuary with which they engaged. The underlying lesson here was to say that the animating power of *pneuma* was best kept in the hands of the inspired creator, reinforcing the sacrosanct relationship between sculptor and sculpture.

As we have seen, though, the pneumatic potency available to the voice was thought to be ubiquitous, and therefore difficult to keep under wraps. The question became how to discipline those for whom the pneumatic voice would serve only to goad the deadness of their intended objects. Epigrams played a role in this act as well. Christian identifies an example of an epigram crafted about a sleeping nymph statue of which there were several examples in fifteenth-century Rome. The text, far from inviting the reader to enter an aural interplay with the interiorized *pneuma* of the statue, delivers a stern warning against interrupting its prevalent silence. *I sleep as I listen to the murmur of the soothing water. Be careful, whoever approaches this marble cave, Not to disturb my slumber: drink or bathe in silence*, warns the Nymph through the inscription of the written word.[59] This sense of warning was further articulated by a famous 1544 epigram by Giovanni Strozzi,

which broadcast his desire to "awaken" the figure in Michelangelo's sculpture *Night* located in the Medici Chapel in Florence. "Night, which you see sleeping . . . , has life," Strozzi wrote. "Wake her if you don't believe it, and she will speak to you." When Michelangelo responded to Strozzi in the form of another epigram, the sculptor made it known the statue's preference to remain silent and undisturbed. "Not to see, not to hear [or feel] is for me the best fortune. So do not wake me!"[60] These stories suggest the acknowledgment of some deeper power embedded within the act of writing an epigram. Innocuous jokes and political texts on the surface of Pasquino were one thing, but inviting the statue to come alive through the spark of the poetic, pneumatized voice crossed a deliberately placed line. One suspects that Michelangelo's epigrammic response smacks of a paternalistic impulse to protect his creation, while leaving the reasons for enacting that protection enigmatic. Did he have *pneuma* in mind while crafting his response? What does it mean to say Michelangelo "gives the statue a voice and finds an intention to back that voice, but in a way that cancels both the statue's own speech and speech of others," as Gross intimates?[61] And, most important, why bother to nullify the play of mutual speech unless there is something perceived to be empowering about it?

Perhaps the best way to unpack these questions is through an example. Take one of the most famous literary examinations of the moment of engagement between flesh and metal: Aleksandar Pushkin's 1833 narrative poem *The Bronze Horseman* (*Mednyi Vsadnik*). Often read as an allegory about the relationship between empire and citizen, the work is tinged with an unmistakable veneer of gothic Romanticism. It is also nothing less than a direct articulation of the anxiety surrounding the lifelike fidelity of statues. Pushkin's choice of subject was well founded. Falconet, who sculpted the bronze equestrian sculpture of Peter the Great written about in the poem, constantly championed its lifelike fidelity to the point of arguing with those who thought the horse's neck was too thick.[62] But in the context of *The Bronze Horseman*, the horse becomes the least of the protagonist's worries. The story revolves around an impoverished citizen of St. Petersburg named Evgenii, who is caught in one of the Neva River's periodic floods and forced to take refuge on top of a marble lion in the shadow of Falconet's statue. He escapes once the water recedes, only to discover that the young woman whom he intended to marry has perished in the flood. Evgenii goes mad and wanders the city as a vagrant, eventually finding himself in the shadow of Peter's statue yet again. He proceeds to angrily curse it for his

troubles, thinking that the silent monument was a safe object upon which he could air his grievances. With a sudden transformation, an enraged Peter and his horse come to life and vengefully pursue Evgenii down the street.[63] The poem ends with the young man's body floating facedown in the Neva; whether by suicide or murder-by-statue is left unresolved.

The means by which Peter's statue came to life is likewise never fully explained. Evgenii's voice was clearly the flashpoint igniting the Tsar's violent animation, but what exactly did that voice ignite? Did it summon the vengeful spirit of Peter himself, angered at his eternal slumber being disturbed by a wretched nobody? Or did the voice merely tip the balance of life-like into lively sans the spirited subject—a manifestation of what Roman Jakobson saw as the cancellation of the signification gap between animate and inanimate?[64] Perhaps there is value in treating this fictional occurrence as if it were an actual event. If *pneuma* was diagnosed as the underlying cause behind Peter's animation, two important implications could be drawn from such an argument. First, it gives a material tangibility to an event that could be dismissed as magical fancy. And second, the possibility of a material explanation begets a potential trepidation toward that substance as a source of power. Though purely fictional, *The Bronze Horseman* presents an interesting ethical case study on the manifestation of that power. A pervasive material force would also have the potential to be a democratizing one. Were the peasant Evgenii's voice pneumatically fueled, it would raise the possibility that absolutely anyone could manifest the power of animation through the efficacy of breath. Concerns over the misuse of animating powers upon statues by those outside of a chosen handful were part of discourses on divinity and magic as well.[65] But given the long history of understanding *pneuma* as a substance that pervades all things, a pneumatic reading of *The Bronze Horseman* opens the possibility of the most miniscule voices tapping into an essential power, even if in the end the act did not turn out so well for Evgenii himself.

Lessing wrote *Laocoön* sixty-seven years before Pushkin penned *The Bronze Horseman*, and twenty-one years before the premiere of Mozart's *Don Giovanni*, another tale in which the voice unwittingly awakens a vengeful statue that in turn influenced Pushkin's poem. One gets the sense that maybe he saw this coming. For within the aesthetic barriers he wrought, Lessing also (perhaps unwittingly) embedded a commentary on the efficacy of the political voice in the twilight of Baroque representation and power. A notable byproduct of Enlightenment thought regarding the liberated individual

was the idea that access to spheres of power was no longer the exclusive purview of the traditional gatekeepers in the aristocracy and the church. Pneumatic cosmology, while on its last legs in the mid-eighteenth century, still presented a formidable historical presence with the benefit of rational grounding through culturally accepted scientific thought. Could there have been a tangible concern that some force existed—*pneuma* or otherwise—to empower liberated voices, and give some bite to that increasing bark? If so, then *The Bronze Horseman* could also serve as a Lessing-esque allegory warning against engaging with statues as if they were on the cusp of becoming alive. To do so, and tip the tenuous semiotic balance between life and death, would undermine the sense of order that aesthetic boundaries both mimic and reproduce.[66] Taking the breath and sound out of *Laocoön*—and by proxy Peter the Great and any other statue—thus becomes a safety valve against the changing relationship between authority and society brought on by the Enlightenment.

This is, perhaps, a charitable view of Lessing's intentions and legacy toward the sounded statue. Because he chose to use the *Laocoön* as the *pièce de résistance* of his theories on aesthetics, it was impossible from the start for him to escape the cosmological gravity of *pneuma* as a historical concept. And even though the ontological vanishing of *pneuma* became a mark in Lessing's favor, such an obvious *ex machina* only reinforces the failure of his attempt to unsound the statue through the avenue of rigid aesthetic categorization. At base, he falls into the trap that Nietzsche outlined by conceptualizing the *Laocoön* through the lens of his own cultural predispositions. Had Lessing opened his ears to what the Greeks said about classical sculpture and the pneumatic universe embedded in every marble and bronze fold, he would not have put such a burden on the mouth of his protagonist. Guy Métraux makes this point especially clear by arguing that even statues predating the *Laocoön* were thought to be full of respirated *pneuma* whether their mouths were agape or closed, shown by movement in clothing or subtle bodily expressions.[67] The ideal of statuary upon which Lessing built his wall of silence never actually existed. Those statues were never meant to be breathless, or voiceless, or soundless in any imaginable sense.

Interjecting *pneuma* into the sonic encounter between subject and statue, then, disrupts the entire framework through which that encounter has been imagined and reproduced in the work of art. It questions the impulse to dismiss the encounter as an irrational magic, without recourse to broader systems of circulation that fueled the breath through both person and statue.

It elucidates the inability to understand the voice as something other than an inert object devoid of airy presence, in spite of the long history in which voice was itself an affective object with pneumatic ties. Most of all, it centers the *ear* as the organ of inquiry through which to engage with this history, deflecting the commanding aesthetic role of eye and hand for a hearing that carries a social and political bent. By drawing attention to Laocoön's mouth, and emphasizing that he could not possibly be screaming, Lessing inadvertently challenged us to hear that scream with all possible fidelity.

CHAPTER 3

Imperial Possessions

In retrospect, there is a distinct possibility that Lessing's quest to squelch the scream of Laocoön collapsed into rubble for good a world away, among the ruins of the Mysorean capital of Seringapatam on the Indian subcontinent.[1] In the culminating battle of the Fourth Anglo-Mysore War (1799), an East India Company army led by Lieutenant-General George Harris (commander in chief of British forces in Madras) besieged and defeated the remaining forces of Tipu Sultan Fath Ali Khan, the Mysorean ruler who had been in conflict with the company since his ascension to the throne almost twenty years earlier. The dramatic storming of the city on May 4 was followed by several days of looting by the victorious soldiers, and after order was restored, company prize agents set to the task of dividing the vast assets of Tipu's estate. Objects claimed by British officers involved in the siege were among the most splendid and elaborate of the deposed ruler's belongings. Richard Wellesley, the governor-general of India who pushed hard for the campaign from the beginning of his appointment in 1798, received the jeweled sword that Tipu had carried when he was shot in the head and killed. His brother Arthur (later to achieve fame as the Duke of Wellington, conqueror of Napoleon Bonaparte) took a jeweled sporting pistol and a number of short swords and daggers encrusted in emerald and gold. In all, the equivalent of three million pounds of gold was claimed from Mysore's treasury in addition to the usual spoils of gems, pottery, and clothing. The amount of confiscated material was so great that the young Colonel Wellesley noted that some

soldiers were obligated to leave part of their portion behind (most unwillingly, I would imagine).[2]

One object not left behind was a curious tiger sculpture found in a building of the palace complex—the *ragmahal*—devoted to Tipu's collection of musical instruments. Finding such a sculpture was not unexpected, since much of his court iconography revolved around representations of tigers. But this particular tiger was quite different from those adorning the rest of the palace. Consisting of painted wood, its monetary value was negligible compared to other objects in his collections. What it lacked in intrinsic worth, though, was more than recompensed in spectacle. Prone beneath the tiger was a man dressed in European attire, whose neck was precariously exposed to the tiger's revealed teeth. The man's eyes and mouth were painted with a blank expression conveying a dual sense of horror and amazement. Yet, as if the form was not grotesquely mesmerizing on its own merit, the sculpture also incorporated the macabre *sound* of the mauling as well. By simply turning a crank, one could hear pitched representations of both *panthera* growl and human death scream punctuated by the musical accompaniment of a small button organ built within the tiger's torso.

Tipu's Tiger, as the object came to be known, was something of an oddity—a "Man-Tyger-Organ" seen by the British as both "toy and instrument, silly and fierce, a cross between an organ grinder and a player piano, a piece of fine artisanship but hardly an aesthetic object of any standard."[3] On display in London from 1808, it became one of the most magnetic tourist attractions of any object taken from India during the colonial period. This popularity, in one sense, would appear dependent upon the broader, fantastical othering of Tipu Sultan through the literature, art, and poetry of the nineteenth-century British Empire. Indeed, tales of the cruel "Tippoo Saib" even outlasted the company that deposed him (it was liquidated in the wake of the Sepoy Mutiny of 1857) and would continue well into the twentieth century.[4] At the same time, it seems reasonable to assume that the queer sonicity of the tiger almost certainly amplified his aura of otherness long past the time it would have dissipated otherwise. The oddity of the tiger made it an ideal object by which both the East India Company and later the British public could encapsulate the moral justification for a significant and controversial military action in Mysore, and more broadly the entire British colonial project in India—part of what Maya Janasoff calls the "imperial arrogance" of this period.[5]

One aspect defining an event between sound and statuary is how it can transcend humble or mysterious origins and embed within a pan-cultural

circulation of imagination and thought. Yet these events can also manifest within specific intercultural contexts, subject to whims and flights of fancy that speak to more localized and temporalized matters of concern. In this regard, I want to argue that it is impossible to understand the reception of Tipu's Tiger without understanding the ways in which it was imbued with the specific and multifaceted power of an occult imagination rampant in nineteenth-century Britain. This premise is built upon a central irony: that two of the object's inherent components (the automaton and the organ) carry strong ties to the technological rationalism of Western modernity, yet hold powerful and diverse magical histories as well. Together with the tiger's façade, they become part of an esoteric whole threading together the object, its namesake, and the empire that consumed and enchanted that object over the course of two centuries. Such esotericism does more than simply bring to the surface a general cultural unease with the relationship between India and the Empire reflected in the discourse surrounding the tiger's public display. Nor does it merely represent the complicated disposition of Tipu himself: grounded both in traditional modes of Muslim and Asiatic kingship, while carrying a global imagination and a vision for southern India influenced by European modernity yet independent of its colonial structures. The sum, in fact, becomes even weirder than these parts. What these esoteric intersections weaving through the tiger's sculpted and sonic forms really leave is the unmistakable question, in any parlance, of who exactly is accomplishing the act of *possessing*.

· · · · · · ·

Born in 1750, Tipu was the oldest son of Haidar Ali, a Muslim military commander for the Hindu Wodeyar dynasty, a line that could trace its roots in Mysore back to the late fourteenth century. Haidar gained enough authority and prestige throughout that decade to seize power from the puppet Krishnaraja Wodeyar II in 1761, meaning that the young Tipu ascended from general's son into the more affluent role of heir apparent. As a teenager, Tipu experienced the rigors of combat while campaigning against the neighboring Maratha Empire (which included the First Anglo-Mysore War in 1766), at the same time attaining the elite education befitting a future ruler that his father lacked. Through tutors, he was forged in the traditional practices of Iranian kingship and became fluent in Arabic, Persian, and important local Indian languages such as Kannada, Telegu, and Marathi necessary for military and diplomatic endeavors.[6] After Tipu came to power following the death of Haidar in 1782, he utilized this extensive training to

quickly shore up his power base and establish himself at a time of insecurity. Ensconced in the last stages of the Second Anglo-Mysore War, Tipu immediately assumed personal executive, judicial, and military authority and sought to distance himself from the declining influence of the Mughal Empire in Delhi, at that point a puppet state under control of the neighboring Marathas. Not only did he refuse to pay traditional homage as a new king, but by 1786 had adopted the title of *padshah*, which had been utilized by the Mughal emperor in India to that point.[7]

Provocative gestures like this were necessary to establish legitimacy from the start. As the son of a Muslim usurper in a majority Hindu province surrounded by both European colonial powers and rival kingdoms, Tipu understood the necessity of constructing a personal mystique speaking to diverse cultural interests to further his aims in Mysore. His adoption of the tiger as a personal symbol was quite deliberate in this regard. Tigers, as Kate Brittlebank has shown, carried a long history of court power and authority among the Hindu princes, dating back to medieval India. They also marked the influence of the power of the Muslim Ottoman Empire, whose symbolic prestige had long been influential in the states of southern India and whose recognition Tipu had sought from the beginning of his rule.[8] Cultivating images of tigers in art, literature, architecture, and clothing served the dual purpose of grounding his rule within both Muslim and Hindu notions of kingship that helped cement his legitimacy among Mysore's citizens, rival states, and the British and French colonial bureaucracies.

In addition to deploying the power of symbol for political legitimacy, Tipu cultivated an image of cosmopolitan kingship that would have looked strangely familiar to the panoply of enlightened despots holding court in Europe during the eighteenth century. His recognition of the importance of cultural diversity in displays of personal wealth was reflected in his astounding collection of objects from around the world. He had an extraordinary library, featuring over two thousand texts on religion, philosophy, medicine, and science in several different languages.[9] A separate wing of his palace featured glassware, pottery, telescopes, and mechanical watches, accumulated through the recruitment of artisans and craftsmen from the Ottoman Empire and Western Europe during the early part of his reign.[10] His savvy political mind is shown through various letters to British, French, and Ottoman dignitaries seeking economic partnership or political advantage. They also show a remarkably egalitarian disposition across lines of class, gender, and religion, which he saw as part of a history of Indian monarchy that had been lost by

the time of the Mughal Empire, though whether he lived up to this disposition in practice has been a source of considerable debate.[11] Tipu also followed in his father's footsteps and became a student of modern military technology. He facilitated the production of European-quality muskets locally, hired foreign engineers and metallurgists to identify caches of sulphur, silver, gold, and coal for weapons production, and devoted substantial resources to the study and military applications of rocketry.[12]

European accounts regarding Tipu prior to the Fourth Anglo-Mysore War emphasized this nuanced view of his ruling character, as several accounts written during the 1780s spoke of his graceful demeanor, agreeable personality, and keen political mind. Lieutenant-Colonel Russel, an officer in a French hussar regiment working with Haidar Ali during the Second Anglo-Mysore War, wrote in 1782 that Tipu was an "upright, sensible and grateful gentleman" who openly spoke of politics and military matters, especially when out of earshot of his more myopic father.[13] A few accounts even spoke of his cosmopolitanism in racial terms, like Lieutenant Robert Cameron did when he described Tipu as "fair [skinned], with a pleasing countenance" in comparison to the native Indian "blacks" that he ruled over.[14] Governor-General Richard Wellesley, who had significant political reasons for casting Tipu in the dimmest light possible, wrote of his concern for the "example he sets to other [Indian] rulers" with his organizational acumen and declared that "in the long run, such an example can have a disruptive influence on the empire."[15] These descriptions were naturally subsumed by tales of the cruel and despotic "Tippoo Saib" after the fall of Seringapatam, but even as late as 1814 he still maintained a grudging respect in British circles. That very year, Sir Walter Scott wrote that the recently abdicated Napoleon Bonaparte "might have shown the same resolved and dogged spirit of resolution which induced Tippoo Saib to die manfully upon the breach of his capital city with his sabre clenched in his hand."[16]

Scott's allusion to Napoleon was not merely rhetorical flourish. During the 1790s Tipu was often simultaneously complimented and denigrated as an "Indian Napoleon" for both his sense of statecraft, his military prowess, and his perceived arrogance in resisting Britain and its Indian allies. Some have even argued that the posthumous vilification of Tipu was simply an extension of his close relationship with the hated French.[17] But the way in which the British caustically denied Tipu's modernity during the course of the nineteenth century seems to go beyond mere association with France or Bonaparte. Even before his demise, Tipu became singularly synonymous

with an unenlightened barbarity that affirmed the moral basis of the British colonial project in India. The decadent persona of the "Tiger of Mysore" was reproduced *ad infinitum* in the years after Seringapatam, starting with stories spread by soldiers who participated in the campaign and quickly expanding into newspapers and literature. Examples include rumors that circulated regarding Tipu's feeding of captive soldiers to feral tigers in pens and celebrating the act with decadent artwork on his palace walls. Books like William Kirkpatrick's *Select Letters of Tippoo Sultan to Various Public Functionaries* (1811) claimed to give the British public an inner window into Tipu's mind and used his own words to play up his perceived inner barbarity. No less than six melodramas with Tipu as a main character were put on in London between 1800 and 1827, often farces of the sultan's decadent court life. And the same ruler that Scott had lauded for a "dogged spirit" in 1814 had by 1831 transformed into a lecherous villain desiring to possess an Englishwoman for his own nefarious purposes in his novel *The Surgeon's Daughter*.[18]

The British had many political and social reasons to transmute Tipu from an Indian Frederick the Great into the decadent "Tiger of Mysore" constructed by Regency-era popular culture.[19] One reason is that in the aftermath of his demise, Tipu was far more useful to colonial propagandists as a vanquished other who was never really a threat to British interests in India at all. Ashok Malhotra notes that the death of Tipu coincided with a litany of stories and images of dead tigers symbolizing Britain's absorption of India into the Empire.[20] This symbolic killing of the tiger appeared in quite a few practices after Seringapatam. The campaign medal given to soldiers who fought in the Fourth Anglo-Mysore War featured a lion leaping on its hind legs toward a defensively backpedaling tiger. This same period saw a surge in aristocratic hunting parties preying on tigers, spurred by bounties on skins and the desire for trophy heads to display on estate mantels. Tipu's Tiger, the alluring oddity garnished from the deposed sultan's vast collections, was in many ways the ultimate tiger trophy, and it quickly became the central object embodying the historical transformation of Tipu himself in the British imagination. Its mere existence was held as incontrovertible evidence of Tipu's hatred and disgust for the British, displayed in a way thought proper for an unenlightened Indian despot. It also, perhaps, became the trump card by which the British could posthumously emasculate Tipu without inadvertently proving just how worrisome an adversary he was in life: a generous case of *methinks the Empire doth protest too much*.

• • • • • • •

Descriptions of the tiger could be found as early as 1799, in an official memorandum written by Captain Benjamin Sydenham just after the Siege of Seringapatam that was widely published in British newspapers. This, along with an illustration of the tiger drawn by James Hunter in 1800, introduced the British public to the tiger and seeded its eventual fascination with the object. However, the most comprehensive description of the tiger's unique form and mechanisms can be found in an 1835 issue of the London-based periodical *Penny Magazine*. Called a "Man-Tyger-Organ" by the author, the passage is worth quoting in full as one of the few accounts detailing its mode of operation before significant modification of its interior structure by nineteenth-century British craftsmen.

> The handle seen on the animal's shoulder turns a spindle and crank within the body; to this crank is fastened a wire, which rises and falls by turning the crank: the wire passes down from the tiger between his fore-paws into the man's chest, where it works a pair of bellows, which forces the air through a pipe with a sort of whistle, terminating in the man's mouth. The pipe is covered by the man's hand; but at the moment when, by the action of the crank, the air is forced through the pipe, a string leading from the bellows pulls a small lever connected with the arm, which works on a hinge at the elbow; the arm rises in a manner which the artist intended to show supplication; the hand is lifted from the mouth, and a cry is heard. The cry is repeated as often as the handle is turned; and while this process is going on, an endless screw on the shaft turns a worm-worn wheel slowly round, which is furnished with four levers or wipers; each of these levers alternately lifts up another and larger pair of bellows in the head of the tiger. When by the action of one of these four levers the bellows are lifted up to their full height, the lever, in continuing to turn, passes by the bellows, and the upper board being loaded with a large piece of lead, falls down on a sudden and forces the air violently through two loud-toned pipes, terminating in the animal's mouth, and differing by the interval of a fifth. This produces a harsh growl. The man in the meantime continues his screaming or whistling, and, after a dozen cries, the growl is repeated.[21]

Regarding the organ assembly in the wooden body of the tiger, Arthur J. G. Ord-Hume notes similarities to a *barrel organ*—a type of semiautomatic

musical instrument where an external crank rotates a horizontal wooden barrel on the inside of the instrument. In a typical barrel organ, the rotation of the barrel pulls open a set of bellows via worm gear, which then expels compressed air into a series of pitched pipes. Because a series of pins on the barrel dictates which pipe(s) are opened to air from the bellows, various combinations of pins create a simple melodic sequence. The assembly in the tiger differs slightly since the crank controls both the interior organ and the devices controlling the mimetic sounds and movements. The crank is attached to a small shaft that controls an elongated bellows attached to a soundboard, upon which eighteen copper pipes arranged in order by ascending intervals of roughly a semitone are anchored. The compressed air from the bellows is controlled by a series of round ivory buttons that function like the external keys of any standard organ. Though they are not shaped nor patterned like a modern keyboard, there are similarities to a type of small French organ built during the late eighteenth century.[22] As one would expect with an instrument as old and well worn as the tiger, significant portions of the organ assembly were replaced at some point during the nineteenth century, including the chest bellows and most of the individual copper pipes.[23]

Since the tiger was made of wood and brass instead of more valuable materials like gold, it was probably overlooked by looting soldiers who stripped apart many of Tipu's more valuable commodities. Governor-General Wellesley, taken by the symbolic meaning of the object, recommended that the tiger be sent back to England and placed on display in the Tower of London as a treasure of international prestige. But the East India Company was hesitant to allow the Crown to claim its most unique spoil. Instead, the tiger was shipped back to London and kept in warehouse storage until placed on display in the upstairs portion of the East India House Museum. After the British government absorbed the assets of the company, the tiger ended up in the hands of the Indian Section of the South Kensington Museum in London, renamed the Victoria and Albert Museum in 1899. It remained a popular exhibit well into the twentieth century, until it was damaged during the Second World War (strangely enough, from employee misconduct instead of German bombs) and taken out of open circulation for good. After the war, it underwent a massive restoration at the hands of organ maker Henry Willis III and returned to display in the 1950s. The tiger was encased in glass, so that patrons could no longer work its aged mechanism, and surrounded by various artifacts from Mysore that were purchased by the V&A over the years.

For an object with such a rich historical life, few corroborated details exist regarding the circumstances of its creation. Recognition for the actual construction of the tiger has been given to a diverse array of people, none of whom have emerged from the fog of anonymity. The internal mechanisms have been credited to nameless French engineers or Dutch organ makers brought to Seringapatam by Tipu in the late 1780s. The woodcraft of both the tiger and the victim, by contrast, are consistent with similar wood sculptures found in Mysore during the late eighteenth century. The sculptors were thought to have come from a class of artisans known as *chitrakars* common to the city, or from artisans in the nearby town of Channapatna that were well known for creating painted wooden toys.[24] With few tangible details available, speculation on its origins was rampant throughout British circles during the nineteenth century.[25] The most commonly accepted story held that Tipu commissioned the tiger around 1793, on the heels of a massive defeat at the hands of the East India Company in the Third Anglo-Mysore War the year before, with the intent to soothe his bruised ego while having a lark at British expense. Others, however, suggested that Tipu came into its possession secondhand, part of his massive interest in collecting oddities from abroad. In an entry on the East India House in a popular tourist guide of London published in 1840, author J. C. Platt mentions in a footnote on the tiger's exhibition that "the whole machine is very rude, and it is probably much older than the age of Tippoo."[26] His suspicion may have been based on Hunter's illustration, where the sculpted man's clothing looked closer to that of a seventeenth-century Dutch trader than a British soldier. This led to speculation that the tiger was originally built for a different Indian ruler within the Dutch orbit and later repainted with red clothing.[27]

Though the tiger's origins may have been shrouded in mystery, the increasing fascination of the British public with the peculiar object was beyond doubt. From the start, it was one of the most popular exhibits at the East India House Museum, gathering crowds who waited in line to hear its perverse sonic performance and henceforth becoming a staple of the London tourist experience. And its status only grew as Tipu Sultan became more ensconced in the imperial imagination regarding the decadent otherness of India more generally. One British report written just after the fall of Seringapatam claimed that turning the crank was part of Tipu's afternoon ritual to "amuse himself with this miserable emblematical triumph of the Khodadaud ["God given"] over the English Sircar."[28] By the time of Waterloo, claims that the tiger was Tipu's favorite piece among his massive collection of objects

transformed from idle speculation into something approaching common knowledge. Such attachment was taken as evidence of a cruelty toward the British alluded to through decades of rumored atrocities. "A human being," wrote James Forbes in his 1813 memoir, "who could pass his hours of relaxation and amusement in this savage manner [of playing the tiger], may be easily supposed to have enjoyed the death of a European who unhappily fell into his power, whether effected by poison, sword, or bowstring."[29]

Linking together the perceived crudeness of Tipu Sultan with that of his mechanical tiger must be seen as a contrast to a broadening aesthetic sensibility capturing the sense of exotic beauty associated with India since the 1760s. The aforementioned Forbes, who worked as a writer for the East India Company and became a prolific sketch artist during his nearly twenty years on the subcontinent, produced hundreds of representations of architecture and natural phenomenon that circulated widely during the 1780s. Together with James Wales, who created paintings based on Forbes's sketches, these works became instrumental in the connection of the Indian landscape to the idea of the natural sublime. The naturalist exoticism of these works was especially resonant with the concept of the sublime put forth by Edmund Burke, who argued that the exotic images were instrumental in producing the extension of consciousness necessary for sublime feelings.[30] This rubric provided another avenue by which the decidedly "unnatural" tiger, despite its idiomatic façade, was considered an abomination. Yet this emerging interest in the sublime during the first half of the nineteenth century is simultaneously essential to a deeper understanding of the British fascination with the tiger. Not all conceptualizations of the sublime from this period perpetuated transcendence through engagement with the natural. Others took the awe inherent in the Burkean sublime and transformed it into an annihilating force—Kant's paradox of presenting the unpresentable, or Schopenhauer's death of the subject through the power of the sublime, or, most especially, the protagonists of novels by Shelley and poetry by Keats, cornerstones of what Vijay Mishra calls the "gothic sublime." For Mishra, this dark side of the sublime ethos is marked by the shattering of discourse in the gap between meaning and lucidity. All that remains are the nervous fragments emanating from the object (which is "ungraspable") or the mind ("itself highly overwhelmed by the highly overdetermined" experience).[31] It is within those remaining pieces of the object—themselves perhaps more graspable—that meaning, however nervous and suspect, comes to pass.

An aural manifestation of the gothic sublime tied to the aural emanations from the tiger certainly affected its status as an object of sculpture. By the turn of the twentieth century, when a wave of reassessment took place regarding Indian cultural artifacts taken throughout the Imperial period that were housed in British museums, the tiger was notably left out of this aesthetic rebranding. Richard Davis argues that around 1900, a state of what he calls "indophilia"—a rather Rousseauist impulse to cite the perceived spiritual purity of Indian artifacts in contradistinction to the depredation of urban, material culture—began to manifest in a certain segment of the British museum community. Led by E. B. Havell and a group called the Indian Society, a trend developed to reinterpret Indian artwork within the bounds of Western aesthetics. Havell was instrumental in selectively defining these attributes, identifying "idealistic, mystic, symbolic, and transcendental" as characteristics of Indian art—attributes not dissimilar in his mind to the already rehabilitated artistic practices of the late medieval Gothic tradition.[32] The influence of this post-Victorian mentality toward religious sculpture from the Indian subcontinent was profound. After the First World War, British museums began to incorporate objects of religious imagery in their display collections, and by the late 1940s exhibitions at the British Royal Academy of Arts were presenting such works with an attention to form, craft, and beauty not granted these objects in the nineteenth century. The tiger, however, was a notable exception. While it was incorporated into the Royal Academy exhibit, this was done solely on account of its popularity with the public, with little regard to its aesthetic relationship to the other sculptural works on display. A similar situation arose at the tiger's permanent exhibition site at the Victoria and Albert Museum, where curators felt obliged to display it despite the limited space available for their collection.[33]

While Davis correctly identifies the reasons why Tipu's Tiger was left out of the British aesthetic paradigm toward Indian art built during the twilight of the Empire, his argument only captures one important element that fed the tiger's long and complicated cultural life. For one, he does not directly address a similar exclusion of the tiger from modern ideas about Indian art from the *Indian* perspective. The closest he comes is by acknowledging that Tipu's Tiger has never been subject to a repatriation request by the Indian government, possibly because of its association with a Muslim ruler who carried power in a mostly Hindu-populated region.[34] But more problematic is his treatment of the tiger as simply a smaller part of the broader "taxonomic shift" (a term he borrows from James Clifford) in ideas about Indian

art in the British imagination. Rather, I think that the staying power of the tiger rested upon its complete and utter disregard for taxonomic identity of any sort. Though it takes the outward form of a statue, the tiger's relegation to an aesthetically bereft curiosity relies more upon the jacquemart within than the animal without. The façade may have engendered a passing connection with the gothic sublime, but the automaton and barrel organ settled underneath its wooden skin held the deeper and more profound enchantment that made the object so memorable.

• • • • • • •

Tipu's Tiger maintains a stronger historical connection to the automata developed throughout Europe in the late eighteenth and early nineteenth centuries, since most modern descriptions refer to it with that term. The correlation is a bit of a misnomer. In actuality, the tiger is only a semi-automaton, since it lacks a self-perpetuating mechanism.[35] For this reason, it has more in common with Wolfgang Kempeler's chess-playing Turk than Jacques Vaucanson's *Canard* or Henri-Louis Jaquet-Droz's *Musicienne*. Yet the lack of self-perpetuation is not the only aspect that separates the tiger from these more famous devices. Most automata of the period found their roots in the artisanal field of clock making that developed during the late Renaissance.[36] As the spring and gear mechanisms that powered timepieces became more complex during the seventeenth century, clockmakers in France, Switzerland, and southern Germany began to experiment with using these apparatuses to power small facsimiles of birds, small animals, and humans. These technological advances in autonomous clocks also perpetuated some relevant social and philosophical threads that weave through the development of these machines. The first was widespread acceptance of the Newtonian concept that the rational order of nature functioned like a clock, down to the precise physical and mental processes of human beings. The second stemmed from the Cartesian notion of an incorporeal consciousness that framed the bodies of living creatures as soulless machines. This meant that the inherent rationality of craftsmanship could properly represent the carnal representations of animals as well as inanimate objects like clocks and fountains.[37] Vaucanson's *Canard* is often cited as a primary example of this mentality—a duck that quacks, but communicates nothing. Automata representing humans, though, were more of a moral and metaphysical quandary, especially in an age defined as much by the subjective autonomy of Kant as the mechanical process of nature and society. Was the automaton, as Foucault would later argue, simply a new mechanism by which bodies could become "political

puppets" for the ruling class?[38] Or could the metaphysical allegory of the clock provide a conceptual rubric for representing a moving, animate human with machinery in less dire terms?

These questions manifested in unique ways with regard to the tiger, especially given its combination of human with animal. References to its "crude mechanism" in nineteenth-century accounts referred to its lack of technological elegance compared with clock making. And when juxtaposed with the work of Vaucanson and Jaquet-Droz, one can imagine how it might have fallen comparatively short in the eyes of a pronouncing public. For one, the tiger's style of representation, perfectly acceptable within the standards of South Asian artisanal practices at the time, was often judged cartoonish by those comparing it to the desired realism of mimetic sculpture stemming from Greek and Roman influence. The most damning attribute, though, was the mimetic relationship the tiger carried to the sounds that its mechanisms produced. Part of the public appeal for musical automata was the use of sonic ephemerality to mask their identities as machines. Many automata maintained a level of technical precision that allowed even the most skeptical listeners a moment of uncertainty as to whether they were witnessing a "living" performance or not.[39] Naturally, the ruse could not have lasted for very long before listeners realized that they were hearing a machine pantomime a human. Yet even this moment of uncertainty would have escaped the grasp of the tiger. After all, the likelihood of encountering a tiger attack within the urban confines of nineteenth-century London was highly unlikely.

If the tiger's relationship to other automata left something to be desired, its status as a barrel organ did little to improve its reputation. At one time, barrel organs were technological novelties given as high-status gifts between monarchs, like the one that Elizabeth I gave to the Ottoman sultan Mehmet III in 1599. But by the mid-nineteenth century, the reputation of the instrument had declined precipitously—even in Britain, where barrel organs were still produced and played in sizeable numbers into the 1840s.[40] By the height of the Victorian period, the barrel organ was mainly associated with urban street performers and rural churches, hardly the signifier of technological novelty it had been two centuries before. Novels like Edwin Waugh's *Th' Barrel Organ* (1883) turned the instrument into the subject of humor and satire, encompassing the travails of rural, unsophisticated Englishmen having to engage with machinery during the early years of the Industrial Revolution. In 1900, someone writing to the *Musical Times* under the moniker of "An Old Organist" recounted a story from around 1860 regarding a barrel

organ in a rural church that nobody knew how to turn off. The wayward device was taken outside by the four strongest parishioners to complete its musical cycle without disturbing the service.[41] Problems like these were frequent enough that, when including the poor tuning of most barrel organs and their awkward accompaniment of singers, the expediency and inexpensiveness of such devices were less appealing than one might think. A letter written to the June 1834 issue of the *Christian Observer*, for example, declared that he would "advise the introduction of a barrel organ, only where there is a dearth of singers, or a torpidness of musical feeling."[42] By the mid-nineteenth century, after most music halls and urban churches had replaced barrel organs with modern mass-produced upright pianos, they moved to become a quintessential part of street performance, increasingly an element of what Deirdre Loughridge refers to as the "machine-made cacophony of the urban soundscape."[43] Nineteenth-century London was rife with organ grinders, and the city's upper middle class, in particular, suffered from their constant noise. Some spent considerable effort trying to pass legislation banning their presence, or, like Charles Dickens, made a habit of paying itinerant organ grinders to silence their instruments for a time.[44]

What the automaton and the barrel organ ultimately share, and what becomes especially transparent when fused together in the form of the tiger, are connections to occult and magical thinking that belie their reputations as mere machinery. Automata, in particular, carried magical connections long before the development of their modern counterparts, which Enlightenment reason did little to curb. Just as Daedalus was alleged by Aristotle to have built a mercury-blooded mechanical man and Magnus had his mysterious talking head, Vaucanson created his mechanical devices with an ample assist from what he saw as "occult knowledge," much to the disdain of the scientific community of his era (to wit, he even used barrel organ parts for some of the interior mechanisms). At the time of the tiger's introduction for British consumption, E. T. A. Hoffman had written several of his stories involving scientists who invigorated their automata through supernatural means.[45] Moreover, even the most ardent supporters and creators of automata in the eighteenth century questioned and ultimately dismissed their aesthetic value, especially compared to the more historically refined art of sculpture. Vaucanson, for one, took little interest in the aesthetic value of his creations, seeing them only in terms of their contribution to the science of mechanical engineering. Similarly, Jaquet-Droz saw his own mechanical automata merely as a mechanical extension of the clocks he was so

famous for creating. Very few accounts from the period spoke of the sculptural qualities of automata, or regarded them with reference to dominant eighteenth-century conceptualizations of sculptural aesthetics. There is little reason to believe that figures like Winckelmann or Herder would have deigned to bestow automata with the same sublime authority as the yoke of antiquarian marble.

While the barrel organ itself lacked such a far-reaching history with the occult mentality, it gathered a magical charge nonetheless through its social associations. By the mid-nineteenth century, the instrument was becoming associated with Great Britain's growing population of immigrants in places like the East End of London. Middle-class ire toward these musicians was voiced most stringently by Scottish essayist Thomas Carlyle in 1853, when his disdain for the "vile yellow Italian" organ grinder led him to construct a soundproof attic in his Chelsea townhouse.[46] Such immigrants, mostly recent arrivals from rural areas, were often stereotyped as superstitious and thus able to charge their musical performances with magical power (an accusation leveled especially at the highly exoticized Roma). The barrel organ also held an enchanted relationship with the *laterna magica* (magic lantern), an object steeped in the history of early modern occult machinery and other modern performance spectacles like the phantasmagoria. It was to these visual manifestations of the spiritual on the public street that the barrel organ provided the screeching, omnipresent soundtrack much despised by London elites. And these magical connections were only heightened by the more potent occult perceptions toward India in the Victorian imperial imagination. Indian magicians performed to captive audiences in London, and fellow late nineteenth-century magicians from the West sought connections to what Henry Ridgely Evans called the "birthplaces of magic and mystery" as markers of occult authenticity.[47] No less a personality than Dickens cultivated an Indian alias and accompanying blackface for acts as an amateur magician.[48]

These associations should not be excluded or minimized when considering the impact of Tipu's Tiger. However, part of its presence for nineteenth-century audiences lay in the fact that the tiger could not be cleanly channeled into a hegemonic discourse of empire, or even into a structure of feeling integrating the growing associations of the Orient with a type of spiritual knowledge lost to Western Christianity. Cobbled together, the tiger was simultaneously rational and irrational, technological and magical, horrifying and charming—words describing how many in Britain saw Tipu Sultan

himself. It was, to borrow a phrase from earlier, "a piece of fine artisanship but hardly an aesthetic object," something that was omnipresent and yet nowhere in the imperial consciousness. Now you hear it, now you don't.

It was, for lack of a better term, an object that could best be described as *weird*. The etymological roots of the word bear out this interpretation. Originally stemming from the Old English *wyrd* (meaning "destiny" or "fortune"), by the fifteenth century it gained currency attached to the "Weird Sisters" manifesting in Elizabethan drama, characters who had the power of divination.[49] The word gained its current usage, referring to something with connection to the supernatural, in the early nineteenth century, often in conjunction with portrayals of the Three Sisters in productions of Shakespeare's *Macbeth*. However, the supernatural connotation carries only part of the affective power of *weird*. Unlike its common synonyms *odd* and *strange*, there is no sense of passive curiosity embedded in something with the designation of *weird*. Rather, the weirdness of a weird thing becomes what Heidegger would call "ready-at-hand," affecting those around it through sheer power of its fascination perpetuated by the perception of occultish ties. The question becomes how *weird* becomes *ready-at-hand* more specifically through Tipu's Tiger, and what this says about the prevailing notion that the automaton is somehow the modern face of the sounding statue.

• • • • • • • •

There was quite a bit of weird inherent in the consumption of the tiger in nineteenth-century Britain. The magical undercurrents of the barrel organ and the automaton, combined with the imperial fascination with Tipu Sultan and the spiritual interest in India more broadly, created a cultural atmosphere in which the tiger became more than the sum of its parts. In essence, the tiger was turned into what I want to call a *weirdifact*—an artifact, enchanted by the blurred lines between rationality and magic, that feeds upon deep-seated anxieties embedded within the cultural consciousness of those who empower it and are thus encompassed within its enchanted power. What makes the weirdness of a *weirdifact*, at least in the case of Tipu's Tiger, lies partially in its state of technological assemblage. The makeup of mechanical elements with modern connotations cobbled together into a monstrous whole makes the device seem outside the realm of modernity—from a *faux-dernity*, of sorts. Yet a *weirdifact* does not exist merely as a testament to the fact that it *can* exist, like a Rube Goldberg machine. Rather, a *weirdifact* uses the tethering with a magical *faux-dernity* to draw forth a self-perpetuating attachment within a cultural imagination akin to the functional repetition of the machine

itself. Though the crank may turn under the power of human hands, the fascination that fuels the movement of that hand carries a deep cultural presence that cannot simply be ignored or reasoned away.

In this case, the cultural anxieties fueling the *weirdifact* called Tipu's Tiger involved the broadening complications in the relationship between the Empire and the Indian subcontinent. The ties between them were already saturated with the magical gaze of exoticism from the British perspective, a state only exacerbated by the tiger's history and what it represented. And herein lies the weirdness encompassing early attempts to ascertain the *raison d'être* behind Tipu's Tiger. Its value was as a signifier of Imperial dominance for the home front. Yet even though it was captured, put on display, and regarded as a decadent toy, the *weirdifact* cast its spell though the mere charge of presence. Once a patron was beckoned to turn its crank, it became an apparatus of capture that pounced upon the unsuspecting person with its relentless sound. While on open display at the East India House, the crank controlling these devices was turned constantly, much to the chagrin of scholars attempting to use the House library kept in a neighboring room for research. The transfer to the South Kensington Museum after the Mutiny offered no respite. By June 1869, an article on the tiger in the London-based magazine *Athenaeum* gave reason to hope that the noisy behavior would cease. "Luckily, a kind fate has deprived him of his handle," the report tells, "and stopped up, we are happy to think, some of his internal organs, and we do sincerely hope he will remain so, to be seen and to be admired, if necessary, but to be heard no more."[50]

Fate, indeed. Within this statement, and others concerning the oppressive noise of the tiger in public space, lingered a broader concern speaking directly to its most tangible *weirdifact* manifestation. Was it possible that Tipu's Tiger was actually more Trojan horse than trophy, ensuring the survival of the Indian citizen-king's modernity even as the British did their best to suppress it?

There are several avenues through which the tiger has been heard as a *weirdifact*, but nowhere did it manifest more bluntly (and weirdly) than in the idea that the sound it produced represented the death scream of an actual person. The rumored identity of the man beneath the tiger was Hugh Munro, a young Scottish aristocrat who visited India on holiday in late 1792 and had the unfortunate fate to become one of the most high-profile victims of a tiger attack during the entire British presence on the Indian subcontinent.[51] The details are as engaging as they are lurid: on December 23, Munro

was spending time hunting for deer on Sangor Island in the Bay of Bengal with three companions who worked for the company. That night, Munro left the campfire to urinate in the bushes and was attacked by a pair of Bengal tigers, ferociously mauled in the process. One of the companions would recount the incident in a letter to a friend living in Calcutta, later published in the "Deaths" section of the July 1793 issue of *Gentleman's Magazine* and reproduced in dozens of texts throughout the early nineteenth century. "I heard a roar, like thunder," the letter's author recalled, "and saw an immense royal tiger spring on the unfortunate Munro, who was sitting down. In a moment his head was in the beast's mouth, and he rushed into the jungle with him, with as much ease as I could lift a kitten."[52] Munro's companions managed to kill one of the tigers and chase off the other with musket fire, but the young man was mortally wounded. Despite their best efforts to return him to Calcutta on a company ship, Munro died within twenty-four hours of the attack and was buried at sea. Accounts of the tragedy spread quickly from India to news outlets throughout the Empire, no doubt playing on the reputation the Bengal tiger had in the European imagination as a ferocious man-eater.

Tipu's connection to a tiger mauling across the subcontinent in Bengal would seem suspect, but a *weirdifact* has a propensity to draw out and enchant even the most diffuse connections. The Mysorean ruler had no direct connection with the victim. However, Hugh was the only son of Sir Hector Munro, a highly decorated Scottish general who had served in India intermittently between 1761 and his retirement in 1782. The last conflict he served in happened to be the Second Anglo-Mysore War, fought against the East India Company in response to the British defeat of French allies at Pondicherry in 1779. Tipu himself commanded a large detachment of his father's forces in that war, while Hector Munro served as a divisional commander in the company forces commanded by Sir Eyre Coote.[53] Whether Tipu knew or had personal thoughts about the elder Munro is unknown. However, Munro was linked to company forces accused of atrocities against Mysorean civilians in 1782–83, including an attack on the town of Anantpur rehashed for years afterward by the British and French press in which several hundred women and children were allegedly killed.[54] Munro was never directly named in any of these published accounts, but innuendo of his involvement persisted among company bureaucrats living in India at the time. One can imagine a chain of circumstance that could be constructed as surely as the tiger's crank could be turned. The death of the younger Munro

came at a desperate time for Tipu politically, happening mere weeks after his significant defeat in the Third Anglo-Mysore War, in which his youngest sons were given as hostages to the East India Company. Considering his need for a symbolic victory in the wake of an actual military defeat, one can further imagine Tipu hearing the news of Munro's son being mauled by a Bengal tiger with delicious irony that he sought to exploit through an already established apparatus of imagery and symbolism.

Of course, when clearing away the debris of imagination there remains the conclusion that the connection of the tiger to Munro was made *ex post facto* and had little basis in fact.[55] A *weirdifact*, though, does not run on the veracity of truth, only the enchantment of possibility. If the identity of the hapless British soldier was indeed anonymous, then perhaps its death scream could represent something more abstract? For some, the image of the tiger standing over an Englishman spoke to the impotence of the British military in conflicts with Mysore prior to the 1790s—the loss of hundreds of soldiers to capture and incarceration. For the East India Company, prisoners represented valuable bargaining chips that Haidar Ali and Tipu would use to further their own interests at the negotiation table. They also represented a tangible loss of masculine prestige, both mentally and physically. For many prisoners, being forced to live under the harsh discipline of guards that they considered to be racially inferior "blacks" upset the social order to which they were accustomed. Officers, many of whom came from the landed aristocracy, were forced to perform the sort of manual and artisanal labor they felt was ill befitting their class status. The worst affront, however, were the circumcisions undergone while in captivity to mark a voluntary or involuntary incorporation into Mysore's army, accounting for roughly one-quarter of all prisoners taken during the various conflicts. Linda Colley notes that circumcision served the likely purpose of social inclusion rather than punishment, but British circles ascribed the act solely within the significance of the latter. The lost foreskin was not just a piece of the soldiers' manhood taken but also a "national humiliation" and a tangible reminder of the inability of the East India Company to properly defeat Mysore and reestablish British prestige in India.[56]

These personal and national emasculations were mapped onto the tiger in several ways. The scream, of course, could represent the screams of pain uttered by prisoners during their circumcisions (voluntary or otherwise) conducted without the benefit of anesthetic. It could also be heard as a more existential cry of loss, not only of a physical piece of the body but also of

the broader loss of bodily freedom and self-determination associated with being a prisoner of war. There is, however, a more subtle reference found with the tiger's back left paw, which is placed very close to the groin of the prone Englishman. This small detail has only been described by a few of the historical accounts, and none of them ponder a broader significance behind it other than as simply an affront to British prestige. It is certainly possible that Tipu deliberately intended the tiger to place its paw so precariously, knowing his skillful employment of image and gesture for symbolic purposes. Yet there is no evidence to suggest that this is any truer than the supposition that the voice belongs to the deceased Munro.

The kind of social alchemy that grafted Munro's death scream and the humiliations of captive circumcision onto the tiger manifests obliquely in two oft-cited literary excerpts regarding the object from the early nineteenth century. These passages are two of the only descriptions that speak of the tiger's sounding in explicitly vocal terms, thus giving a sense of how central the death voice was to British conceptualizations of it. The first, in Barbara Hofland's travel novel *A Visit to London* (1814), frames an engagement with the abstracted voice through the veneer of ordinary life. Protagonist Emily visits the East India House during an excursion to the city, as it stood among the list of must-see locales on any outsider's trip to London. Once inside, young Emily comes into the presence of the tiger, in what has become an widely quoted passage: "'This thing,' said the Librarian, 'was made for the amusement of Tippoo Saib; the inside of the tyger is a musical instrument; and by touching certain keys, a sound is produced resembling the horrid grumblings made by the tyger on seizing his prey; on touching others, you hear the convulsive breathings, the suffocated shriek of his victim. . . .' 'For Heaven's sake,' cried Emily, clinging to the arm of Mr. Carberry, 'do take me home.' The gentleman, turning to her, beheld her pale and trembling, and lost not a moment in conducting her to the carriage."[57]

Putting aside the fact that the description of the tiger's mechanical workings is fundamentally incorrect, there is much to comment on regarding Emily's sudden and dire response. Supriya Goswami notes that Hofland in part plays upon the sexual overtones, especially toward young Englishwomen of the time, inherent in the tiger's act of "pouncing." This would suggest a visual acuity in Emily's reaction, one that is commented on by her two male companions to the exhibit.[58] However, her sense of dread does not seem to be triggered by the mere sight of the grotesque scene represented by the tiger. Rather, it is the moment that the nameless librarian equates one of the

emanated sounds to a "suffocated shriek" that the young woman asks to be escorted out. Was the idea of the sound representing a death voice simply too much to bear? Or did she somehow know the devious trickery the tiger was about to enact, and wanted to leave before she could be charmed by the fascinating phantasmagoria of sound?

A more ambiguous yet telling reference lies at the heart of the second work, John Keats's satirical poem "The Cap and the Bells" (1819). Here, Keats more directly addresses the metaphysical implications of reproducing the death voice, albeit through a fictional lens. It is speculated that he may have written the infamous passage, which imagines the tiger in the court of a fictional fairy emperor named Elfinan, after a visit to the East India House museum. Keats references the sound in a passage where Elfinan's court magician Hum gives the main character, Eban, a taste of the emperor's sense of "refined vulgarity."

> "I thought you guess'd, foretold, or prophesied
> That 's Majesty was in a raving fit?"
> "He dreams," said Hum, "or I have ever lied,
> That he is tearing you, sir, bit by bit."
> "He's not asleep, and you have little wit,"
> Replied the page; "that little buzzing noise,
> Whate'er your palmistry may make of it,
> Comes from a play-thing of the Emperor's choice
> From a Man-Tiger-Organ, prettiest of his toys."[59]

The fleeting reference to the "Man-Tiger-Organ, prettiest of his toys" as analogous to Tipu's own alleged performance on the instrument has been frequently commented upon, though many also read the reference as critiquing the decadence of Britain's own Regency-era political class.[60] The allusion to Hum's "palmistry" in the preceding line, by contrast, has often been overlooked, yet holds another layer of historical intrigue that binds together Great Britain and India. Palmistry (or chiromancy—the reading of lines in a hand to predict aspects of life and death) had a long history as a popular (if controversial) pseudo-science in England dating back to the Elizabethan period.[61] But by the mid-eighteenth century, it had become highly scrutinized for its association with "gypsies," which had become an all-encompassing term among the English for wandering individuals who engaged in sleight-of-hand tricks or outright thievery. Shortly after Keats wrote "Cap and Bells,"

Parliament passed the Vagrant Act of 1824 that banned the practice of palmistry and declared its practitioners to be punished as "rogues and vagabonds" if caught.[62] When palmistry came back into fashion in Britain during the late nineteenth century, its most famous disciples like the Irish-born William John Warner (popularly known as "Chiero") claimed to have studied the art directly from Brahmin texts in northern India.[63] Keats himself may also have had an interest in palmistry tied to the sense of fatalism he personally developed toward the end of his life.[64] With this in mind, there are several possibilities to consider regarding the meaning behind this passage. Keats is perhaps referencing palmistry to lampoon Hum (the court magician and purveyor of the irrational arts) for ignorantly stating that the "little buzzing noise" came from the mouth of the dreaming emperor. But he could also be foreclosing the possibility of equating the vocal growl with the emperor's "raving fit," deferring it to the machine where its presence is far less problematic. This suggests the possibility that in some British circles, both the body and voice of the tiger were thought of as synonymous with Tipu himself.

The texts of Hofland and Keats, combined with the pithy accounts and speculation from newspapers and magazines, give credence to the idea that some concept of the tiger as *weirdifact* was present during the height of its fame. This awareness begets some interesting possibilities on the periodic restorations performed upon the tiger during the nineteenth century. Beyond simple cosmetic refurbishment, there was a complete redesign of the tiger's mechanisms at some point, perhaps to place some measure of technological mitigation on the overt weirdness of the *weirdifact*. Ord-Hume noted several of these changes during the course of his "autopsy" on the body of the tiger during the early 1970s. For one, he found that descriptions of the human cry from the earliest years of the tiger's display indicated that the bellows controlling that mechanism were much larger and thus pitched higher and louder than their replacement. He also argues that prior to the joining of the automaton and organ bellows onto the crank, the death scream likely operated similarly to the way the growl operates now—filled with air and depressed in a short, noisy burst. The reason behind the change could simply have been to create a more efficient mechanism in consideration of the constant use by museum patrons. The smaller bellows could have been in deference to the scholars working in the library who constantly complained about the noise. However, they could just have easily been to temper the impact of the death scream as described by Hofland and Keats, lest it be mistaken for a facsimile of the real thing. Cutting the volume and

making the noise constant instead of sporadic makes the apparatus sound more weak and parodic, an attempt to defang Tipu's Trojan horse and domesticate it for quiet modern consumption.

If the intent behind the mechanical changes was to reassert some level of techno-rationality upon the tiger through its interior mechanisms, this task must be branded a failure. The tiger's status as *weirdifact* remains largely unchanged, even as its role in enchanting the relationship between the British Empire and India has faded into relative obscurity. Such a fate mirrors that of Tipu Sultan, no longer the decadent "Tipoo Saib" of nineteenth-century British storytelling. Yet the tiger remains on the periphery, too weird and engaging to ever completely vanish from the public eye. Because of its age, the tiger remains exhibited in the glass menagerie of Indian artifacts at the Victoria and Albert Museum, pulled out only for maintenance and to be played by curious researchers and journalists. On those rare occasions that the crank is turned, however, we catch some residue of its enchanting power.

Two recent videos have chronicled such engagements. In the first, BBC television journalist David Dimbleby describes the mechanism with a tone reminiscent of an emphatic nature show host. When he turns the crank and actuates the scream, Dimbleby laughs with an almost childlike glee at its novelty. Just a moment after he asks aloud about the growl, it sounds with a short puff that prompts the veteran journalist to yelp in surprise—no doubt a reenactment of similar yelps from patrons of the East India House over a century prior. The second video, though more formal, features an interesting gesture toward the British possession of the tiger nonetheless. The Victoria and Albert Museum's Conservation in Action series brought in Nigel Bamforth, a specialist in eighteenth-century instruments, to show how the organ would have functioned in prime condition. After describing the tuning and range of the pipes, he proceeds to jokingly play two songs that were no doubt played on the organ many times in the past: "Rule, Britannia!" and "God Save the Queen." When finishing the melody for the latter, Bamforth and the two conservationists helping him with the performance grin widely and slowly turn to look at the camera. Their look of fascination and strange amusement captures the ambivalence surrounding the tiger, while also somewhat continuing the consistent erasure of the subtle, human qualities inherent in the man with whom it is most associated.

These contemporary interactions show how little the fascinating power of Tipu's Tiger has dissipated since it was first unveiled to the eyes and ears of the Empire's citizenry. It continues to evoke a magical presence that has

defied easy and consistent classification. This state of flux has made it easy to dismiss the tiger as anything more than a curiosity, thus preventing any real attempt to judge it as an aesthetic work of any repute. Maybe, though, this opens a space for the tiger that is not necessarily aesthetic or ideological, but alchemical. Being so many individual objects at once through its state of *weirdifact*, each comes to the surface through the attuned interface of the sculpted ear. For some, the object is primarily an organ, imperfectly sounding by nature of the unique casing in which it is housed. For others, a semi-automaton threading a historical needle between magical and rational, as the spectacle of techno/anthropocentric objects were often tasked with doing. Most of all, the tiger preserves some of the aural essence of both Tipu Sultan's cosmopolitanism and the anxieties of an imperial culture that worked so diligently to undermine that inconvenient worldliness. What the Victorians heard as an odd and chilling scream could also be thought of as the last laugh of a long dead and deposed sovereign.

CHAPTER 4

Hearing a Stone Man

Imagine a nocturnal patch of woods where two men laugh. Their mirth is hearty, but not joyful. It sounds much like laughter that thinly papers over a rot of fatigue and despair, the kind that foreshadows the cusp of madness.

Upon surveying the state of their clothing, madness would seem a strong hypothesis. One man wears a fashionable black suit with a matching open-collared shirt, sullied by a copious mix of soil and blood. The other, smaller man dons a dirty white tank top, torn down to the navel, holding a filthy black trench coat that he is in the process of putting back on while they converse. Whatever activities have left their outfits in such a pitiful condition have also marked their faces. Both carry a fallow expression marked by the creases and folds of sheer exhaustion. The man in black is clearly in pain, implying that the blood on his clothes belongs to him; the smaller man twitches his mouth and cheeks with the steadiness of a ticking clock, betraying a mind-set overflowing with anxiety.

Despite this state, or perhaps because of it, they laugh. About a case of mistaken identity involving a woman who mistook one for the other in the midst of an attempted seduction.

Their banter is interrupted by a noise emanating from the darkness. Noises are commonplace in the quiet of the isolated forest. But this is not a snap of a tree limb or the rhythmic chirping of some unidentified species of beetle. It is clearly a voice, uttering a dire warning directed at the man in black.

Quite the surprise, the voice they *both* hear from the depths of the forest. It cannot be a hallucination if they both hear it. The man in black seems intrigued. The other frantically taps on his head with his fingers, as if to drum the presence of the voice from his memory.

The curiosity of the man in black overcomes the smaller man's trepidation. They stumble through the darkness, searching for the source of the interloper.

Again—closer this time—the voice taunts the man in black.

The man in black leans against a tree and chuckles. He points to another nearby tree broken in the middle, with the top frayed in a way that makes it appear to slightly resemble the human form. This, the man in black claims, happens to be the statue of the man whose voice is vexing them so. "Read what it says, " he remarks to his colleague.

A look of fear and confusion cements upon the face of the smaller man. He's already convinced the voice they hear is that of an angry ghost. Now the man in black is playing games. Thinking a tree is some kind of statue? And what exactly is he supposed to read on a tree trunk in the middle of the forest? He pleads with the man in black to reconsider his mad proposition, taking the pragmatic route by claiming that he cannot read in the dim light of the moon. The pleas are futile. The man in black is insistent.

The smaller man walks up to the tree, despite his misgivings. With one hand he raps the thick trunk with his bare knuckles. His other hand caresses some wisps of frayed wood dangling near his face. The smaller man listens, to his credit, with the utmost intent. "Here I await revenge," he speaks, finishing with a chortle as if to mime the possession of his body by the voice of another. It takes the smaller man a moment to finish—"on the godless criminal who slew me"—before backing away from the tree.

The man in black shakes his head and gestures in a way that says *of course, what else would a tree be telling you.*

"The old joker," he remarks while applauding with the type of sincere sarcasm usually associated with aristocrats of a bygone age. "Tell him I expect him at my place tonight for dinner."

• • • • • • •

The scene I describe above, where a dying madman invites a tree to dinner, sounds straight from the narrative of a modern psychological thriller. Its shadowed locale, desperate-looking characters, and bizarre dark humor could easily have come from the typewriter of Cormac McCarthy or the camera of David Lynch. But this scene was not originally written with noir in mind,

nor is it particularly contemporary. Rather, it comes from a modern adaptation of Mozart and Lorenzo Da Ponte's 1787 opera *Don Giovanni*. The man in black is the protagonist Giovanni, the smaller man is his servant Leporello, and the broken trunk in the forest is the "statue" of the Commendatore, the aged aristocrat Giovanni slew at the end of the opera's first scene. This version was the unique vision of German director Claus Guth, premiering at a Mozart festival in Salzburg in 2008 and subsequently revived in Berlin, New York, and several other locales. Guth changed the presentation of his *Don Giovanni* from the traditional eighteenth-century standard in several different ways. For one, he set the action in a foreboding and remote forest, a locale echoing, for critic Rebecca Schmid, the first lines of Dante's *Inferno* ("I found myself in a dark forest").[1] (For me, though, the forest was reminiscent of the gothic German Romanticism saturating the Wolf's Glen in Carl Maria von Weber's 1821 opera *Der Freischütz*.) The only man-made structure was the rusted remains of a bus stop, a far cry from the stately Baroque manors featured in most productions. The characters, as is the case in many modern adaptations, were clothed in modern attire. The murder of the Commendatore was still a central event. However, Guth added the twist of the dying man inflicting his own mortal wound, via gunshot, upon Giovanni's abdomen. In pain and slowly dying, the subsequent actions of a Giovanni contemplating his own demise played against his typical portrayal as an arrogant and unrepentant seducer. And the Commendatore statue was not a statue at all, but a tree fallen in the forest that someone happened to hear.

We will return to the profound moment where the beleaguered servant Leporello struck the tree and listened to its resonant message. But first, some more about the statue for which the tree serves as a proxy. The statue of the Commendatore from *Don Giovanni*, if not the most well-known living statue portrayed in Western literature and theatre, is certainly the most famous to have ever been invited to dinner. Despite occupying a relatively small role in the overall narrative, the statue has cast an outsized shadow upon the Don's exploits. If the raconteur protagonist was an archetype of the radical autonomous subjectivity associated with the Enlightenment, then the Commendatore was the interposition of order and the *ancien régime*. Much has been written about the profound implications of this relationship, which Lawrence Kramer understood as representative of a crisis in the fabric of modernity.[2] Yet the Commendatore has managed to hold an indelible philosophical weight on his own. Søren Kierkegaard regarded the statue as the only character in the opera written with any sense of clarity. In stone, he was

"the outspoken consequent clause" imbued with the power of divine judgment.[3] Others interpreted the statue as embodying the masculine authority of the father, tied both to Mozart's perceived Oedipal fixation with his own father, Leopold, and Freud's patriarchal fascination with the statue of Moses.[4] Magda Romanska best summarized these various threads in a 2015 post on the blog for the Boston Lyric Opera, written in her role as the organization's dramaturg. "The figure of the Commendatore ... was thus rich in meaning," she concluded, "symbolizing at once the authority of the patriarchal father figure, the spiritual transition into the other world, and the Enlightenment's fascination with science and engineering."[5] The statue, in essence, introduced a level of philosophical gravity to the same opera where the hapless servant Leporello recounted his patron's sexual exploits by locale, and Giovanni turned the accompanying orchestra into his personal dinner jukebox.[6]

Such recalcitrance by the Don plays into the memorable circumstances through which the statue emerges. During the eighteenth century, the stone Commendatore served as the moral linchpin for the narrative, a trait shared with most popular adaptations of the Don Juan narrative.[7] In this role as moralizing presence, the statue was not as strictly allegorical as one might suspect. As Malcolm Baker argues, the spectacle of a speaking statue on stage would have been perfectly acceptable within the imagination of a typical bourgeois eighteenth-century European. Such a person would have viewed the statue not just as a "static intermediary between the earthly and eternal," but as symbolic of the mobility in Christian belief during that era of what constituted the presence of the dead in the world.[8] For modern audiences, skepticism toward this interstitial place of the dead has given the appearance of the statue a more ironic tone: Giovanni invites the statue to dinner, and the statue actually shows up—*how weird*! Nevertheless, Mozart and Da Ponte's version still adheres for those modern audiences, in part because of how the statue is presented once he arrives. As an opera, *Don Giovanni* has a distinct advantage in this regard compared to its literary and theatrical brethren. The work welds body, sound, and narrative together in a way that creates a visceral impact upon even an audience most resolute in its cynicism.

While many have commented on the experience of seeing the Commendatore, the aspect of hearing him has been surprisingly underemphasized. Such an interpretation squares with one of the prevailing frames in writing about the Commendatore's presence in the opera: the statue is merely a vehicle of vengeance, borrowed by a ghost for a particular purpose and

readily discarded at the conclusion of that task. The Commendatore is thus cast as an incomplete subject, neither man nor statue, existing in a state of flux. What we absorb when confronted by the Commendatore lies at the very heart of this material incompleteness. We see the statue emerge. We hear his footsteps resound through the orchestra. We understand the gambit he presents to Giovanni. What brings all of this together, and what has been underemphasized in writing about the character, is *how* the Commendatore articulates these aspects, *how* we hear that articulation through sonic gestures of vocality, and—most importantly—how this articulation was crafted musically by Mozart. Superstition and religious dogmatism were not the only drivers of how this voice was heard. Enlightenment science, particularly in the realm of sensory perception, played a part as well. For in Mozart's time, the animated statue was an important mechanism for theorizing sources of natural transformation and transmutation that could be traced through the actualization of the senses.

The motives and influences behind why the Commendatore sounds the way he does may not be entirely clear. But the legacy of how the character statue sounds shaped ideas about the animated statue during the late eighteenth century and continues to do so in contemporary performances of the opera. A material relationship between body and sound that carries through is essential to this continued relevance. "The Man of Stone has furnished critics with many symbols," writes Steven Rumph in his study of Mozart's relationship to Enlightenment thought. "Yet, for Mozart's age, the living statue played the opposite role of a symbol. Its solid, unyielding surface drove the subject back into the body and senses, away from the symbolic order."[9] The voice of the Commendatore would follow this path back toward the body, written to enliven and mimic the stone from which it emanated. He becomes, in essence, a man of stone heard in all of his material splendor.

••••••••

Hearing the Commendatore's material voice is inexorably tied to the broader fascination with statues as models for human engagement in the world starting in the seventeenth century. This movement begins, in a sense, with Descartes's passage in *La homme* about the statues from St. Germain that was instrumental in his mechanistic theory of embodiment. But what was mere novelty for Descartes would take on greater significance for a generation of empiricist philosophers that developed partially in reaction to the Cartesian split between mind and body. At issue was the very nature of sensory perception, in which the practical dominance of vision was starting

to come into question given the anatomical limitations of the eye. Philosophers like John Locke, George Berkeley, and David Hume began to think about the role of the body in space as a means to take up those visual limitations, making perception a process requiring the entire body working in coordination. Statues, this time as paragons of the bodily and sensory influence on epistemology, would again play a central role in imagining how this process could unfold. Locke, in his *Essay on Human Understanding*, used the appraisal of a statue as an example of how words facilitate the imprinting of complex ideas upon the blank slate of the mind. That statue, as a form that could be ascertained through the sense of touch, could be described to a blind person who had never experienced one but had touched other objects with a similar form. Berkeley, in his *First Dialogue*, mentions an example of looking upon a statue of Julius Caesar as a means to indirectly perceive what the actual Caesar looked like.[10] Hume's most direct use of the statue was in critiquing the ethical implications in the transitive process of causality, but he also alluded to the statue as human proxy when noting that the insensibility of deep sleep produces a *de facto* state of embodied stasis, like the state of a marble statue.[11]

Use of the statue as a model for human embodiment took its most profound form in a widely read book by Étienne Bonnet de Condillac called *Traité des sensations* (1754). A prominent French theologian and ardent empiricist, Condillac sought to expand upon Locke's axiom that all knowledge comes from the senses by enacting the deliberate, rhetorical animation of a statue, one sense at a time. In establishing this analytical trope, he asks the reader to imagine inhabiting the statue as its senses are brought to life, creating an invigorating human spirit within the nameless and lifeless stone automaton. His journey culminates in the birth of the statue's subjectivity once the sense of touch is activated, in part to show the inadequacy of the other senses alone in the work of self-realization. For Condillac, touch was the primary means through which the statue—and the person—gained knowledge of both itself and the outside world. These experiences drawn in by the senses stoked the sensations inherent in the mind, were preserved by the formation of memory, and thus became the basis of ideas and the development of the intellect. The innate and transcendental of Descartes were replaced by the emergent and physical, precipitated by the very tactility inherent in the formal aesthetic of the statue that had awakened.[12]

There are two important aspects of Condillac's statue to consider for the broader understanding of animated statues during the Enlightenment.

First is the inherent gradual process of the transformation. The statue does not simply awaken through the devices of magic or divine intervention. Rather, the process maintains a laborious and consistent pace as each sense in turn manifests, and then engages in combination, to give the statue a more profound sense of self and surroundings. Condillac's purpose here is in part methodological, as he prompts the reader to ruminate on the strengths and limitations of each sense in turn. There is also a rhetorical power to this device. In following the journey of the statue as each sense becomes animated, readers are encouraged to reflect upon how their own senses contribute to self-knowledge. The empiricist ideal is thus laid bare as a rigorous examination of the self through the body of another. The second, and more essential for the later exploration of the Commendatore, is the material into which the stone of the statue transforms. Condillac's statue, as Mark Paterson notes, does not only gain awareness of itself and its surroundings through the activation of the sense of touch. In the process of understanding the notions of "space, solidity, and perspective," the statue also becomes less like the stone at its root and increasingly *fleshy*.[13] As the statue gains more sensory awareness of its surrounding world, the transformation culminates in the statue becoming a living entity as opposed to merely a statue enlivened with the senses. This distinction is essential, creating separation from the oracular model of animation dating back to antiquity. Statue oracles were predicated upon the spiritual inhabitation of a vessel wholly separate from the material constitution of that spirit. The soul that emerged with the senses in Condillac's statue was a constitutive part of that body, created by the very process of sensory awakening.

Condillac had provided nothing less than a new way of understanding the animated statue in resonance with the newfound epistemologies of Enlightenment philosophy. No longer was it confined to the divine incarnations prevalent through medieval and early modern sources, nor the raw materialism of Cartesian mechanistic philosophy as represented by the automaton. Animating the statue into a living, thinking subject was the product of natural processes and a gateway to the empiricist affirmation of the sense of touch as the primary gateway to knowledge of the world. A device this potent would not remain the exclusive purview of philosophical rigor. Other writers grappled with its implications, weighing the praxis of nature, divinity, and machine in order to find median ground between all of them. This particular cultural impact of Condillac's statue would be felt most profoundly through the arts, where narrative and image could restructure

the dry functionality of Condillac's writing into tales exploring the moral and emotional implications of a statue's natural animation. And no story provided a better platform for expanding upon these ideas than Ovid's tale about Pygmalion, which found new life during the mid-eighteenth century. The process by which Pygmalion brings his sculpture Galatea to life was ambiguous enough that it offered space for rumination upon the status of the animated statue in the age of rationality and naturalism. Condillac, it should be noted, did not start this new fascination with Pygmalion and was in fact possibly inspired to write his treatise in part because of the story itself. But he provided the philosophical core instrumental to making Galatea the first animated statue to become a *cause célèbre* of modernity.

One of the earliest attempts to articulate the implications of a modern Galatea—one influential on Condillac himself—came from French philosopher André-François Boureau-Deslandes in his book *Pigmalion ou la statue animée* (1741). On the surface, Deslandes was an unusual figure to comment upon the Pygmalion story. At the time of publication, he was best known as a French champion of the Newtonian scientific method. Deslandes had no history as a commentator on statues, animated or otherwise. However, he may have seen in the animation of Galatea a means to ground the concept of metamorphosis under the rubric of science and natural philosophy. Deslandes understood all too well the intersections between magic and science embedded within early Enlightenment thought. This may have been why he tied together the animation of Galatea's senses with documented cases of sensory recovery in people who had been deprived of them.[14] Like those apocryphal individuals who gradually regained use of their eyes, Pygmalion watched his desired creation animate in a series of painstaking steps over a long period of time. But Deslandes left the ultimate source of the animation purposefully obscure. Pygmalion may not have directly animated Galatea through his magical hand, as in Ovid's version. However, the goddess Venus was the muse for the hand that wielded the chisel, and Pygmalion's desire was also surmised to contribute to the natural transformation from statue into a living, thinking material.[15]

Deslandes was not alone among French thinkers in expressing a material fascination within the Pygmalion story. Diderot, writing in 1763 about a statue of Pygmalion and Galatea by Falconet, also sought recourse to the science of the body to describe the magical wonderment elicited by his experience. So lifelike was Falconet's sculpture that Diderot imagined the sculpted Pygmalion reaching out and animating his creation not just by mere

magical touch but by reaching into her chest and galvanizing her heart.[16] The reference carried two obvious connotations. While operating as a metaphor for touching the emotional heart of his desired and transformed love, it also served as a comment upon the anatomical role of the heart, pumping life-inducing blood throughout the body of the statue. And an earlier poem attributed to the young Voltaire also derived a process of animation from natural sources, with the enlivening soul beamed out of the sculptor's eyes and penetrating the surface of the marble.[17] Nor were these ideas solely influential within the sphere of the French Enlightenment. Herder's *Der Plastik*, which was instrumental in linking the sense of touch with the aesthetics of sculpture during the late eighteenth century, carried the subtitle *Einige Wahrnehmungen uber Form und Gestalt aus Pygmalions bildendem Traume*, or *Some Observations on Shape and Form from Pygmalion's Creative Dream*. In less than thirty years, Pygmalion and Galatea had grown from relative obscurity into one of the paragons of Enlightenment subjectivity.

Perhaps the most important figure influenced by the French empiricist take on Pygmalion was Rousseau, whose *scène lyrique* of the same name first performed in 1770 was responsible for popularizing the tale beyond its philosophical life in Deslandes and Diderot.[18] Rousseau's characterization of Pygmalion was in many respects a doppelgänger of the earlier sculptor created by Deslandes. Rousseau cast him as more than a mere artist; rather, he was an artist-philosopher, divinely inspired to create but not requiring divine power to directly animate the marble. This characterization fit well within the prevailing trends that cast Pygmalion as a rational naturalist as much as a magician. Rousseau's *Pygmalion* was also important as it translated the materialist thread of the story onto the medium of the stage, where the animation could be interpreted and enacted by actual bodies. This presented some obvious problems of facilitation, as replicating the sort of gradual natural transformation envisioned by Deslandes would be impossible to reproduce in a theatrical setting. Whatever solution was concocted for the original Lyon performance is unknown, as no known stage notes survive. However, based on the engravings made for the publication of Rousseau's complete works between 1774 and 1783, some suppositions can be made. For the scene in which Galatea emerges from her pedestal to engage with the world as a living being for the first time, an incense burner was included among the stage props.[19] The smoky atmosphere created by the lantern obscures the figures on stage and can be interpreted in several potentially illuminating ways. Fog creates the image of a metaphysical veil,

implying the magical hand at work in addition to the flesh-and-blood hand of Pygmalion, a hand that cannot be shown operating as such. Fog also emphasizes a dreamlike quality to the scene, offering a visual counterpoint to the statue literally awakening from material slumber and gradually feeling out her new condition. Perhaps most important is the way that the fog gives a visual benchmark to represent the process of transformation that cannot be properly shown in space or time. The entire transformation sequence encapsulated one of the most important aspects of Rousseau's staged version: to assure the audience that the enlivened Galatea was, indeed, no longer made of marble. As if to assuage any remaining doubt, the character tells us in so many words. Upon touching her enlivened arm, Galatea remarks, "C'est moi" (It is I). Leaving her pedestal behind and touching one of the many unfinished marble statues adorning the studio of Pygmalion, Galatea says the fateful words, "Ce n'est plus moi" (It is no longer I). Then, upon touching her creator, she responds, "Ah! Encore moi" (again it is I), reinforcing her status as a creature of flesh and no longer the inanimate marble of her statued existence.

Emphasizing the becoming of flesh with the semantics of language served as more than a rhetorical device to simulate material change. It also elucidated an important distinction Rousseau wished to emphasize in the relationship between voice and the sonic body. Daniel Chua notes that Rousseau's *Pygmalion* was in part a response to another version of the tale penned by his great philosophical rival Jean-Phillipe Rameau over twenty years prior. Rameau depicted the animation of Galatea as derived from the concept of *corps sonore*—the natural, musical vibrations thought to emanate from the human body that constituted the first sonic presence intuited by the ear. The orchestral accompaniment broaches the barrier between reality and stage, becoming a pneumatic presence that Pygmalion can both hear and query as to its origin. For Rousseau, this ideal of animation implicated music within the dominion of physical processes and response. Under such a schema, there could be no autonomy and no expression of the necessary presence of the soul. Rousseau's Galatea must possess a soul in order to properly awaken, and she must express her own sense of autonomy to communicate the presence of that soul to her creator and the audience.[20] Yet Rousseau felt that the singing voice of opera could no longer carry the burden of expressing the unmediated presence of the self. Hence, Rousseau left the language of *Pygmalion* unsung owing to the loss of what he understood as the "natural musicality" of the French language.[21] The small accompanying orchestra

was tasked with carrying the emotive content of the characters. Depicting Galatea's self-awakening, more than simply the animation of a statue into flesh, was Rousseau's attempt to show the core musicality at root in the first moments of subjectivity—a perspective he felt long lost by the time of the Enlightenment.

Rousseau was not the first, nor the last, to argue the limitations inherent in *corps sonore* as the wellspring of bodily animation. Condillac, in fact, tackled this exact issue in his *Treatise* as one of the stages of becoming that manifests before the emergence of subjectivity that comes with using the senses in tandem. In the section entitled "Of a Man Limited to the Sense of Hearing," Condillac creates a rhetorical scenario that isolates sound as the only sensory engagement available by which to experience the world. A statue that only hears, he contends, would at first have no sense of itself or the substance of the world surrounding it. Instead it would "become the sensation that it experiences.... Thus at will we transform the statue into a noise, a sound, or a symphony" that resonates with other bodies in proximity.[22] Eventually, Condillac continues, the statue would learn to discern types of sounds and eventually develop a rudimentary aesthetic consciousness based on its experience of hearing. Lacking the ability to produce sound on its own, the statue would be incapable of producing something akin to a voice, much less feeling the auto-affection of its own presence. The moment of its first interaction with sound relies solely on the materiality of the body to create a resonant relationship between the sounds with which it interacts.

The conflicting *ethe* of fleshy becoming and *corps sonore* exposed by the Pygmalion craze were by no means resolved by the time Mozart's Commendatore first emerged onto the stage. Far from it: the statue that Mozart created through musical composition brought forth a deeper dimension of meaning that further fueled these debates. In fact, even more so: the way the Commendatore sounded profoundly blurred the ontological lines defining animated statues in general. In his wake, questions abounded. Was his stone body an artifice, a machine utilized for a particular task and soon to be discarded, or was it part of a continuum in which the statue becomes inseparable from the extratextual identity of the Commendatore?

• • • • • • •

Ascertaining Mozart's thoughts on the emergent ontology of animated statues and how those may have influenced his writing of the Commendatore has proven suspect at best. It is doubtful he would have been familiar even with Diderot's treatise, much less those of Deslandes or Condillac. "We

may be tempted to assume that the young Mozart grew up with an awareness of the breadth and scope of the international Enlightenment, somehow absorbing its essence at each port of call," writes David Schroeder, "... [but t]he Enlightenment of Mozart's early experience was the distinctive one of Salzburg and his father, and its inseparability from authority figures made it fairly unappealing to the boy with one of the most fertile minds of his generation."[23] Nevertheless, there are enough breadcrumbs scattered throughout his biography to make the case for some tenuous intellectual connections. The Salzburg of Mozart's birth was the most intellectually open place in the Catholic part of Germany, including a Benedictine university that was instrumental in the development of influential thinkers like Leibniz.[24] Later, Mozart was embedded within circles of socialite intellectuals in both Vienna and Paris, including Da Ponte, who would have exposed him to commonly discussed ideas about philosophy and aesthetics.[25] And he certainly would have known about Rousseau's *Pygmalion*, which premiered in Vienna in 1772 and influenced several works from Viennese composers throughout the decade that were themselves influential on Mozart.[26] Still, nothing in the composer's own letters and correspondence affirms any of these connections. We only know, from Da Ponte's memoirs, that the prospect of writing music for a libretto of *Don Giovanni* "pleased [Mozart] greatly" for reasons unelaborated.[27]

While we cannot know for certain how Mozart regarded the spate of animated statues populating the European stage, *Don Giovanni* was not his first foray into the trope. *Idomeneo* (1781), an earlier *opera seria* collaboration with librettist Giambattista Varesco, also featured a sounding statue, albeit one with different attributes than the Commendatore. The subject of the opera, written when Mozart was twenty-five for a commission from the Elector of Bavaria, fits well within a trend in *opera seria* of drawing plots from Greek mythology, in this case the Trojan War. It also presents an overt theme of patriarchal discord that would become an important aspect of Mozart's later operas. The plot begins with Idomeneo, the aged king of Crete, trapped aboard a ship during a storm. Desperate for salvation, he offers to sacrifice the first man he sees when returning to his kingdom in exchange for safe passage. That person, in a classically Greek contrivance, happens to be his son Idamante. What follows are a fairly typical set of *opera seria* plot conventions: a love triangle; a series of misunderstandings; a sea monster attack. The action culminates in the third act, when the Cretan high priest, wary of the devastation caused by the creature, demands the identity of the

intended sacrificial victim. Idomeneo admits the sacrifice is supposed to be his son. Upon hearing this, a duty-bound Idamante demands that the ritual be carried out. He is joined by Ilia, a captive Trojan princess who chooses death as a display of her love for the Cretan prince. At the moment in which Idomeneo is about to murder Idamante with a poised axe, the voice of the god Neptune interrupts to pass judgment on the wayward king. "Love has triumphed," the deity thunders, credited in the libretto as *la voce* (the voice). "Idomeneo shall cease to reign; Idamante shall be king, and Ilia his bride. Then Neptune be appeased, heaven contented and innocence rewarded."

Mozart located this final confrontation between the characters underneath a massive statue of Neptune in a temple. Elaborate sets designed by Lorenzo Quaglio for the 1781 Munich premiere included a constructed facsimile of the statue placed on stage for the vital scene. The voice that puts a stop to the execution of Idamante is presumed by the characters (and the audience) to emanate from the statue itself, becoming an inhabited vessel in the tradition of Greek oracles. This created an interesting staging problem for Mozart and Quaglio. How could they convincingly simulate the aura of a speaking statue being portrayed by an inanimate piece of wood? Their solution was a common one for eighteenth-century opera productions: placing a vocalist offstage and out of sight to furnish the deity's bass-laden declaration. The voice of Neptune becomes what Michel Chion called, in the context of cinema, a visualized acousmatic sound, where the identity of the sound is known even if its ultimate source and location are not.[28] The audience sees the statue of Neptune, hears the offstage voice identifying itself as Neptune, and connects the two manifestations together within the context of the production.

There is a temptation to read this staging choice as an implicit nod to the metaphysical presence of Neptune's vocal appearance. But the act of intending offstage voices to carry metaphysical weight was an uncommon practice in German opera until Wagner.[29] Instead, Mozart may have intended the accompanying orchestra to give a sense of metaphysical resonance to the offstage voice. Acousmatic voices with divine origin were often scored with an accompaniment of trombones and horns, a timbre utilized during the late eighteenth century to emphasize the ethereal or supernatural disposition of a character.[30] The final scene of *Idomeneo* employs this trope quite deliberately. Preceding the entrance of Neptune's voice is a series of homophonic chords played by the orchestral brass that halts the action on stage. The vocal silence that follows reflects the awestruck disposition

of the characters as they prepare for the intercession of a deity into their earthly affairs. This aural backdrop continues as Neptune makes his declaration and lingers long after he finishes and presumably fades back into a transcendent realm. Silence is broken by the entrance of a small group of woodwinds, followed by a distraught Idomeneo ruminating in an aria about the horror of his intended actions.

Mozart employed this orchestration technique to similar effect in *Don Giovanni* during the graveyard scene in Act II that first introduced the Commendatore statue. Prior to the moment of the fateful dinner invitation, Giovanni is recounting via recitative his attempt to seduce a woman on the street who had previously been with Leporello. The Don laughs at the prospect of the woman being Leporello's wife and is interrupted by the statue of the Commendatore, who lectures Giovanni on his malfeasance and warns of the inevitable comeuppance. As with *Idomeneo*, brass homophony underlies the stern words of the statue. But Mozart adds some subtle folds to the trope he first employed six years earlier. The Commendatore and his accompaniment enter simultaneously, jarring the listener with a contrast to the jaunty recitative of Giovanni and Leporello. After announcing his presence, the statue sings twice more during the course of the scene. The first occurs when Leporello reads the inscription on the base, a screed swearing revenge on the Commendatore's killer. The statue taunts Giovanni, calling him a scoundrel and telling him to leave the graveyard in peace. This leads to the famous dinner invitation, first issued by a hedging Leporello under threat of death from his master, in the form of a short duet ("O, statua gentilissima"). The statue does not respond with vocal assent. He merely nods, breaking an already unnerved Leporello and further provoking the incredulity of Giovanni. The Don then makes a more forceful invitation, to which the statue makes his second vocal utterance—an unambiguous "yes." Giovanni understands the source of this response without doubt and leaves the graveyard with the spooked Leporello, wondering if the statue will make good on his acceptance.

The undeniable similarities in the musical accompaniment between the temple scene of *Idomeneo* and the graveyard scene in *Don Giovanni* suggests more than a mere *idée fixe* of an animated statue. It also opens the possibility that the weight representing the supernatural ethos of these statues fell primarily upon these musical cues instead of the actors portraying them. Music, in this understanding, saturated the narrative by functioning as an amalgamation of archaic necromancy and modern special effect. Orchestral

accompaniment became a signifier to the audience that the person they were seeing on stage (or not seeing, as in *Idomeneo*) was otherworldly. Laurel Zeiss argues that this interpolation was common in many eighteenth-century operas needing to communicate the "permeable boundaries" between the earthly and metaphysical to a listening audience.[31] And Mozart was nothing if not conscious of prevailing trends that he could utilize in his own work. Yet this metaphysical thrust provided by the orchestra—particularly in the case of *Don Giovanni*—also transformed the aesthetic burden carried by the performer embodying the sounding statue on stage. By relieving the voice of responsibility to communicate the supernatural aura associated with the statue, that voice is free to signify other performative aspects. And since the physicality of the Commendatore's voice does nothing in itself to disclose the power that voice holds for both the Don and the audience, it circles back onto the properties of its source.[32] The statue, in essence, is given an opportunity to be heard for its material properties, while through the orchestral accompaniment, the Commendatore's voice, as Kierkegaard writes, "is enlarged to the voice of a spirit."[33]

We can hear sound as a mechanism shaping this sculpted materiality from the moment the Commendatore appears during the dinner scene. While the orchestra carries the load of supernatural representation via the stunning return of a D minor chord first introduced in the overture, the voice emerging from the Commendatore's mouth labors under the weight of the marble from which he was chiseled. "Don Giovanni, a cenar teco m'invitasi e son venuto" (you invited me to dinner, and I have come) he sings, while the orchestra continues to hang upon a rhythmically constant and harmonically unceasing strain. The statue sings with wide leaps of perfect fourths and octaves, outlining the base harmony with little subtlety. After the exchange of pleasantries about food and much pontification from a cowering Leporello, the statue comes to the point. And for the moment that his words need to carry the most metaphysical weight, the statue sings in his most statuesque register. "Tu m'invitasti a cena, il tuo dover or sai" (You invited me to dinner, now you know your duty): the Commendatore repeats a single note with a constant, unceasing, and wholly affective rhythm, ending with a wide leap to punctuate the irony of his appearance. "Rispondimi: verrai tu a cenar meco?" (Answer me: will you come to dine with me?): the sequence repeats, transposed higher as the Commendatore poses his gambit to the Don. "Rispondimi, rispondimi": the repetition of his demand is articulated with a repetition of his phrase-ending vocal leaps, transposed ever higher.

At every point, the stone body makes its material presence known through the channel of the voice. Even if the source of judgment comes from beyond the earthly realm, the gravity it enforces upon Giovanni and the audience emanates from that voice, which transforms the flesh of the performer into stone before our very ears.

This understanding of the Commendatore's voice is a departure from other sources casting it as another manifestation of a transcendent, moralizing presence—"a Catholic ghost who knows where to draw his fire," as penned by Michael Steinberg.[34] Many have heard the seeds of that fire within the sound of the voice itself. Zeiss, for one, contends that these "*sostenuto* utterances" reinforce the supernatural aura of the statue in that the "ghost of the Commendatore does not 'speak' in normal tones."[35] This implies that the limited range and movement of the statue's voice served as a means to tag it as a manifestation from beyond, less dynamic in death than the voices of its living counterparts. Others have pointed to a metaphysical role enforced by the contrasting voice of Giovanni. Gary Tomlinson has argued that because the character of the Don was built from the sensuality coming into vogue during the late eighteenth century, such a dynamic sensory quality needed a staid counterpoint in the stony authority of the Commendatore.[36] Indeed, the melody sung by Commendatore during the dinner scene is unornamented and monophonic, in stark contrast to the mobile *coloratura* employed by Giovanni.[37] The comparatively limited range would fit within the way Da Ponte wrote the character as an arbiter of moral judgment. As the stone of the body echoes the stone of the law, the character sings only as much as necessary to deliver its mandate. Michel Poizat noticed such an equation of staid tonality and aristocratic authority in *Idomeneo, Don Giovanni,* and other characters like the oracle in Gluck's *Alceste* as the "agency of the superego." He goes so far as to call the "*recto tono* or quasi–*recto tono*" style of singing associated with these characters as a "stereotype" that can only be answered with the trope of the *cry*—as both Mozart and Don Giovanni provided.[38]

Yet there already exists an intriguing thread linking the Commendatore to the very regimes of sensuality often reserved exclusively for the Giovanni character. Movement and touch, rather than the voice and sound, have been central to these particular understandings. (The requirement that Giovanni join hands with the Commendatore as a final act of absolution, for example.) But the foot has played as much a role in this tactile presence as the hand that emerges later. Peter Szendy understood the footsteps of the Commendatore in structural terms, emphasizing how the statue's gait heralded the

reintroduction of musical order in the form of the overture, bringing both the narrative and the fate of Giovanni full circle.[39] Stephen Rumph, who more than anyone has linked *Don Giovanni* to the intellectual fascination with touch during the eighteenth century, takes this musical linkage of the feet even further. In *Mozart and Enlightenment Semiotics*, he contends that the heavy footsteps and incessant ostinato in the accompanying orchestra meld together "bodily rhythm and prosody, translating footsteps into poetic feet."[40] Voice becomes an assemblage of the entire sculpted body, part of the inexorable forward momentum of the animated statue. The Commendatore walks toward Giovanni while outlining the dire choice confronting the Don and bringing the narrative closer to its conclusion. In this sense, the voice becomes a manifestation that requires an anchoring in the realm of materiality in order for its full effect to be felt by both Giovanni and the audience. That voice must be understood as a clear and present danger, not a mere product of the overactive imagination. Timbre and rhythm, it follows, need to carry the same weight as the stone of the body and the words of the plea to repent. This register is not forced upon the Commendatore by powers divine; it is a register that he adopts of his own will, using the fact of his material body to outflank the raconteur.

When this material side of the Commendatore's voice is extended to include the presence of the statue throughout the entire opera, then we can begin to hear a state of becoming reminiscent of Condillac and Galatea. His dinner intrusion may carry the most impact, but the phantasmagorical presence of Pygmalion in the shadows of *Don Giovanni* fully manifests when taking the graveyard and the feast *in toto*. In the graveyard, the Commendatore has only just awakened from slumber: hence the lack of immediate response to Giovanni and Leporello, the nonexistent vocal range, and the labored movement of the head in agreeing to come to dinner. Time passes before the fateful meal, and offstage the statue has gained more of his senses. By the time of his confrontation with Giovanni, he can now walk with a burdened but authoritative gait. He can make vocal leaps in octaves and perfect fifths, while the smaller intervals are somewhat troublesome and sparsely used. Everything about the Commendatore's body and voice suggests something other than the instantaneous possession of a ghost in the machine. From standing to walking, from singing utterances to developing phrases, from shallow range and staid rhythm to diversified melody—the Commendatore is slowly becoming acclimated to the world of the living once more, even if only to enact his vengeance upon the soul of Don Giovanni.

Suggesting the prevalence of material signs in the Commendatore's voice is not an argument against the supernatural and theological overtones with which that voice has often been associated. On the contrary, both material and supernatural are necessary components to understanding the allure of the Commendatore statue between the eighteenth century and the present. There is no replacing one paradigm with another. What makes the Commendatore unique in this regard is how the statue manifests as both stone and ghost, never fully inhabiting one state or the other definitively. Its voice can thus become whatever the listener wants to hear. Such ambivalence may not have been incidental on Mozart's part, given his nuanced understanding of prevailing cultural trends mentioned earlier. In other words, there was an expectation that the possession of statues was not only possible, but that representation of those statues in art should reflect the fidelity of that possibility. The sensualist aspects of the statue take a supporting role while maintaining an undeniable presence. As the sensualist paradigm of German *naturophilosophie* became more influential in the early nineteenth century, the Commendatore transformed into a figure shaped by the embodied presence of sight and sound for which Mozart had already laid the groundwork. Rational skepticism of an animated statue was more pronounced, but the Commendatore became a model for what such a phenomenon would be if it actually *did* exist. Such a responsibility necessitated that voice and statue be joined together onstage, not acousmatically separated as with Neptune's statue in *Idomeneo*. As a consequence, the need to express the metaphysical nature of the Commendatore becomes less pronounced. In 1822, Giacomo Meyerbeer suggested simulating the supernatural veneer of the Commendatore by having a silent actor pantomime the part on stage while the vocalist sings from offstage through a megaphone.[41] By the time Victor Hugo references the statue in his epic *Les Misérables* forty years later, the sonic line between phantom and stone has become more opaque. "Another few minutes went by. Then from the direction of St-Leu the sound of footsteps could be heard distinctly—regular, thudding, numerous. This sound, faint at first, then clear, then heavy and reverberating, approached slowly, without cease, uninterrupted, with a calm and terrible continuousness. Nothing else could be heard. It was at once silence and the sound of the Commendatore's statue, but that tread of stone had something tremendous and manifold about it that gave rise to the idea of a throng and at the same time the idea of a ghost."[42] The "tread of stone" becomes a necessary precursor to the "idea of a ghost," implying the preeminence of materiality in understanding what

constitutes an inhabitation of that object. The concept of becoming appears in this passage as well: what starts out as something barely heard emerges as a cacophony that cannot be ignored.

The apparent disjunction between Meyerbeer and Hugo regarding ideas about the Commendatore would continue to take on greater importance. Even if Mozart's crafting of the voice attached to a piece of Baroque funeral statuary was driven solely by musical concerns, that voice also became the site of a new life for the Commendatore within the fluid intertextuality of modernism. Or, to put this another way, the qualities that made the character of the Commendatore seem like a real statue gained an important prevalence lacking before. This new model Commendatore was not strictly beholden to the instrumentality of aristocratic and divine power, a mere tool to rein in the sensual subjectivity wrought onto the world by Giovanni. Instead, the Commendatore had the capacity to become a sensual, modern subject unto himself. Between the graveyard and the dinner, he had grabbed some of the mantle of the sensual from Giovanni and made it part of his own embodied milieu. The cold stone hand, as with the unornamented timbre of his voice, showed the process to be incomplete. Yet the becoming was sufficient, as with Galatea, to be seen and heard as something worldly—a "*natural* consequence of Giovanni's recklessness," to recontextualize a statement by Bernard Williams.[43] And if the Commendatore comes across as more like the emergent Galatea, then Giovanni's reaction contains a healthy dose of Pygmalion. Only Leporello seems genuinely superstitious toward the appearance of the Commendatore and treats him as a ghost. Giovanni's first instinct is to offer the statue a drink, an extension of hospitality from one man made of stony flesh to another made of fleshy stone. He, at least, seems comfortable with accepting the personhood of the arrived statue, even if only in curious jest.

Perhaps no one understood this relationship between material becoming and voice surrounding the Commendatore within modernism better than George Bernard Shaw. The Irish playwright's stage comedy *Man or Superman*, completed in 1903 and premiered at the Royal Court Theater in London two years later, demonstrated his intrigue with the complexities of both *Don Giovanni* and the trope of the animated statue. Ostensibly an exegesis on the nature of fatherhood set among the social turmoil of late nineteenth-century Britain, the story revolves around two men—the young radical John Tanner and the aged civil reformer Roebuck Ramsden—as they negotiate their charge of Ann Whitfield, a young woman left in their care by her father's last will and testament. Shaw's play is considered a hodgepodge

of Aristophanes and Molière—not to mention the philosophical tradition of Schopenhauer and Nietzsche evident in the title.[44] What makes *Man and Superman* so distinct, though, is how Shaw addressed the most direct source material for his story. Shades of allegory toward the Don Giovanni character appear throughout the play. But in a more radical gesture, Shaw writes an entire scene in Act III that distances away from the established characters and setting. The sequence, a play within a play in the style of Shakespeare, is framed as a mutual dream sequence between Tanner and his friend Mendoza as they fall asleep listening to Mozart. At the start of the dream, the actors playing John and Ann are engaged in a philosophical discussion. They are not portraying their counterparts from the rest of the play, but dreamy manifestations of Don Juan (Giovanni) and his object of affection Doña Ana. Once the latter leaves at the conclusion of their discussion, a third character appears amidst a lengthy description by Shaw. "From the void comes a living statue of white marble, designed to represent a majestic old man. But he waives his majesty with infinite grace; walks with a feather-like step; and makes every wrinkle in his war worn visage brim over with holiday joyousness. . . . His voice, save for a much more distinguished intonation, is so like the voice of Roebuck Ramsden that it calls attention to the fact that they are not unlike one another in spite of their very different fashion of shaving." The reference to the voice of the statue seems an odd divergence to end the description of its form and character. But that voice becomes the means through which the imagined Don Juan greets the entrance of the imagined Don Gonzalo (the Commendatore, named by Shaw in the play as "The Statue").

"Ah, here you are, my friend," welcomes Don Juan. "Why don't you learn to sing the splendid music Mozart has written for you?"

"Unluckily he has written it for a bass voice," replies the statue with Ramsden's voice. "Mine is a counter tenor. Well: have you repented yet?" Shaw offers a thinly veiled parody of the booming entrance offered by the Commendatore in the dinner scene of *Don Giovanni*, one that sets the tone for the rest of his presence.

Reference to the voice of the Commendatore also appears later, when The Devil appears to engage in the philosophical discussion. "Oh, by what irony of fate was this cold selfish egoist sent to my Kingdom," he says. "We had the greatest hopes of him. You remember how he sang?" On cue, The Devil sings in French with an operatic baritone similar to that of Mozart's Commendatore. The statue chimes in, with a voice of higher quality but also

in the range of the countertenor established earlier. "Precisely," The Devil remarks at the statue's voice. "Well, he never sings for us now."[45]

What is notable about Shaw's imagined version of the Commendatore is how the presentation differs profoundly from the one offered by Mozart and Da Ponte. The Commendatore in Ramsden's body walks with a "feather-like step" and sings with the same dynamic tenor as his counterpart, Giovanni. Missing is the thunderous baritone, matched by a deliberate gait suggesting the great effort required to move the heavy stone legs, that characterizes the statue in *Don Giovanni*. The implication is that on the ethereal plane in which Tanner and Mendoza's dream takes place, the statue can fully become that which it cannot while confined to the earthly realm. This becomes another indication that the Commendatore we see and hear at Giovanni's dinner is an incomplete subject, a work in progress, something between the stone of its origin and the person that the statue represents.

Shaw's long fascination with the Pygmalion myth (sans statue) was already well established by the time he wrote *Man and Superman*. And a hint of that interest in becoming something else became etched into the character of the statue. Simply put, the dream statue of Shaw's play-within-a-play was no longer the vengeful stone body of the Commendatore's earthly inhabitation. His revenge accomplished, the Commendatore was now free to pursue other states of being in the ambiguous beyond. He cast aside his early modern Venetian garb for the late Victorian trappings of Roebuck Ramsden. He was willing to let bygones be bygones, conceding that the younger Don was the better swordsman and that no murder took place since he died in a duel. Most important, he had transcended beyond the need for his voice as Mozart wrote it—a gravely, dire material thing—and could sing in the much higher and mellower countertenor that he presents in the play. The Commendatore need not please The Devil or anyone else with the stony intervallic leaps and repetitive pitch for which he had become so famous. Shaw may have considered the entire exercise of the parodic dream as a "trick of the strolling theatrical manager."[46] Nevertheless, he displayed a nuanced understanding of the stone guest absent from more sober-minded narratives entranced by the libidinal pyrotechnics of Giovanni.

This inherent modality between stone and flesh readily exploited by Shaw was central to the modernist existence of the Commendatore character. Animated statues were more productive as allegories than actual phenomena in the modernist ethos. But they had become so intertwined with the Don Juan mythos that alluding to, if not outright incorporating, an animated

statue became necessary. Modernizing the setting of *Don Giovanni* thus requires addressing the modern skepticism toward the idea of an animating statue, since recourse to neither eighteenth-century superstition nor the creative naturalism that informed Rousseau's *Pygmalion* would do the trick. There have been many creative examples attempting the address this problem. Shaw, of course, planted the statue in a dream, since his turn-of-the-century London had no avenging statues to be found. In James Joyce's *Ulysses*—a novel filled with oblique references to *Don Giovanni*—both Stephen Daedelus and Leopold Bloom confront their own versions of stone guests. These encounters are abstracted through different characters and objects that they encounter throughout their day in Dublin. Yet they adhere together through what Roy Carlson notes as a thread of defining materiality in conjunction with "the insistent absence of the supernatural." The statues found throughout Dublin are all "cold and stony," even when they are not made of stone at all.[47] The materiality that grounded these modalities carved into the texts of Shaw and Joyce required the figure of the statue as a spark, regardless of the direction and the objects onto which the Commendatore was mapped.

Nowhere has the necessity of addressing the Commendatore's status as a *statue* been more salient, though, than for contemporary opera productions like the one by Guth with which I opened this chapter. A change in scenery, so common in many of these versions, both facilitated and funneled a radical reconceptualization of the Commendatore's object status. And Guth's creative setting for the opera presented a unique problem: no graveyard, and therefore no locale in which to encounter a funerary statue for the Don to invite to dinner. His solution was to foreground the psychological impact of the setting and circumstances. Stranding Giovanni and Leporello in the woods at night, while under great stress, served as a fruitful device to elicit the slow destabilization of rationality and sanity—particularly from the nebbish Leporello. As for Giovanni, a character written with almost pathological confidence, Guth undermines this trait with the convenient stomach wound inflicted upon Giovanni during his duel with the living Commendatore. By the time the two characters reach the moment in which the dead Commendatore reveals himself, neither man can fully conceptualize what they are hearing: an actual voice in the wilderness, or the phantasmagoria of a shared hallucination.

The encounter with the broken tree that Giovanni calls a "statue" reflects in part the pathetic condition plaguing both characters. But it also stands as

a testament to the latent material power that undergirds the statue of the Commendatore in the imagination. As a tree, the Commendatore is stripped of any embodied signifier referencing his human form. The object is only identified as the Commendatore at Giovanni's insistence. Claiming the tree is actually a statue, in one sense, provides a semantic veneer of signification that ties the scene back to the original context of the graveyard in *Don Giovanni*. Leporello's subsequent actions, though, are what transform the arboreal into the statuesque in a more material sense. When Giovanni forces Leporello to "read what [the tree] says," his response is to *strike the trunk with his hand and listen*. This miniscule action carries a long history in the process of understanding what makes statues sound. The act of striking more broadly ties into the complex of resonance, vibration, and voice tied to material conceptualizations of *pneuma, aether, corps sonore,* and other physical mediums that were thought to embody the sonically disembodied. In essence, Leporello treats the silent tree as many others have treated the sounding statues they have encountered, thereby reinforcing the tenuous threads between tree and statue.

These statuesque threads extend into the dinner scene, where the Commendatore is shed of his arboreal guise and manifests exclusively as a disembodied voice whose source can only be seen by the audience. Neither Giovanni nor Leporello look at the Commendatore beckoning his will from the background. Whether this implies a kind of supernatural transcendence or psychological shattering (the voice being a mutual hallucination of the dying Giovanni and the mentally deteriorating Leporello) is up for interpretation. But that voice maintains a noticeable physical effect upon the characters, who shake and flail as if they can feel the sonic impact of the voice within their bones. This presents another scenario in which the Pygmalion-esque tropes of transformation and emergence are key. Phantom Commendatore emerges from the staid physicality of the tree to inhabit the more mobile and affective materiality of sound itself. Again, perhaps an indicator of the character's burgeoning death subjectivity: he casts aside the limited vessel chosen for him by Giovanni and Leporello to sculpt his own body, one of pure sonic movement.

Guth's production is but one example among the hundreds of adaptations that populate the long performance history of *Don Giovanni*. However, its wide divergence from Mozart and Da Ponte's original vision for the character reinforces the ageless power the statue holds. Even though Guth utilizes no actual statue beyond references from the libretto, the character maintains a

sculpted depth through the various guises he does inhabit. Absent a statue, the aspects of vocality—timbre, rhythm, and range—that define this statuesque quality gain further exposure and subsequent importance. Their prevalence speaks to a material gravity that the Commendatore manifests no matter the context. How he articulates his vengeance drags listeners into his grasp and down to the depths as surely as it does the onstage Giovanni. In this sense, the metaphysical status of the dead Commendatore becomes mere fodder for speculation. A ghost may indeed inhabit the machine, but the physicality of the machine and the grainy sound it perpetuates make the inhabitation impactful upon those in its presence.

CHAPTER 5

Aural Skins

When famed African American performer Josephine Baker bought the Château des Milandes in 1947, her intention was to create a place that would serve as both her home and a means to build her legacy. The estate, nestled in the Dordogne countryside of southwestern France, featured expansive grounds and a stately fifteenth-century castle that was the ancestral home of the Caumonts, an important aristocratic Huguenot family who lived there until just after the French Revolution. The castle fell into disrepair during the nineteenth century, underwent an extensive restoration between 1900 and 1914, and at the time Baker purchased it was in need of a postwar touchup. Baker had the estate remodeled to include a resort, a museum dedicated to her long performance career, and an "African village" to house the château's staff. Once renovated, Milandes became central to Baker's late-career aspirations. The resort and museum were an immediate success, attracting nearly one million tourists over the course of the 1950s.[1] And when her pleas for racial tolerance while on a 1954 tour of Latin America brought questions of communist sympathies, Milandes became a refuge from the public spotlight as well. After returning to France, she and then husband Jo Boullion began to adopt children of various racial and religious backgrounds that would form the backbone of her "Rainbow Tribe"—a family intended to live the ideal that Baker was no longer free to preach abroad due to the geopolitical concerns of the Cold War. Her desire was laudable, even if her financial acumen was not. Baker's dream of constructing a permanent place that both reflected

and controlled her performance legacy ended when she was forced to sell the château in 1969 after attempting to barricade herself in the kitchen to prevent its loss. But the legacy of her modern association with the ancient property continues to this day. Recent owners have done much to reconstruct the spectacle of Milandes and restore its status as the tourist attraction it was under Baker's ownership, just as Baker had resurrected the estate from obscurity once before. "Les Milandes wasn't merely a home," writes Matthew Pratt Guteri, "it was an engineered landscape or built environment, like a music hall stage, only much, much bigger. Every part worked in service of the story, which was meant to be experienced in person."[2]

One of the most memorable exhibits telling this story at Milandes during the height of its popularity was a wax museum called the "Jorama." Depicting thirteen different scenes dedicated to Baker's life and travels, the exhibit also reflected her developing religious sensibilities, which had become increasingly important after the Second World War.[3] Among the first scenes presented were Baker's humble beginnings as a child in East St. Louis dancing for her siblings in a basement. Another showed Baker dressed in French military regalia to celebrate her work for the Resistance against the Nazi occupation. Yet another presented a re-creation of her kneeling before Pope Pius XII during her 1950 audience in Rome. The final wax figure in the series displayed Baker at her most Marian, standing before a large cross wearing a simple dress with nine children from the "Rainbow Tribe." Reaction to the Jorama from posthumous commentary has been mixed. While some argue that the exhibit shows how Baker understood the nature of modern celebrity long before more contemporary performers like Madonna, others viewed the wax figures as overbearing and "coercive," a sign of Baker attempting to gain control of her image at a time when she had little control of it outside the walls of Milandes.[4]

Of all the issues arising from the image and narrative crafting inherent in the Jorama, the decision by Baker to cast her life story in wax would seem to be the least noteworthy. Wax museums had been popular tourist spots since the 1880s, thanks to the legacy and influence of Alfred Grévin's Musée Grévin in Montmartre and the Madame Tussaud museum in London. Yet perhaps more than any stage performer from the twentieth century, Baker brings the question of material to the fore. She had built and perpetuated her popularity in Paris during the height of *l'art nègre* by making her body an indexical surface mixing together elements of modern chic and premodern primitivism. Anne Anlin Cheng persuasively argues in her quintessential

study on Baker's relationship to this sense of modernist primitivism that the erstwhile performer created an entirely new series of "political expectations" that surround the body of black women. In doing so, she made her skin fit as much into the modernist desire for "pure surface" as into the reductionist trope of the Venus Hottentot.[5] A statue crafted in *bronze* would seem to be made for capturing this visual experience of Baker in her prime. The sleek sheen of cast metal mirrored her racial allure as well as the sculptural elegance of her performing body. For comparison, a modern replica of a Jorama statue showing Baker during the prime of her career featured her wearing a floor-length white gown and standing in front of a piano. While certainly well crafted and lifelike, one can see how it failed to capture the glow of skin that Baker became famous for in film and photographs in the 1920s and 1930s.

Equating Baker's body with the metallic sheen of bronze makes the choice of the duller, more permeable, less resonant wax to capture her legacy all the more fascinating. Was it simply due to the Jorama being an indoor space? Were there further economic reasons regarding cost of material, or was she simply trying to capture the tourist magic that wax museums held? In asking these questions, I admit the futility in attempting to intuit or read into Baker's own motives for casting herself in this material. Her desires have proven elusive and the interpretation of them controversial in the litany of biographies published in the years after her death.[6] Rather, I want to argue that Baker's construction of the Jorama presents an intriguing confluence of body and sound that, when read through the frame of an event between sound and statuary, implicates the materiality of sculpture in ways rarely addressed. The choice of wax, as opposed to bronze or other blended metals, becomes important in two different respects. The first implicates a pernicious history between bronze and the racial identity of blackness. Though it would seem to capture her skin from an outside gaze, Baker's own relationship with blackness was at best ambivalent throughout much of her career. Moreover, the resonance of both the color and material of bronze has had profound implications toward representations of the black body. It arguably brings in issues of silence and control that manifest as a kind of violence against those whose image bronze sculptures intend to capture. The second involves the underappreciated historical relationship between wax and sound, which share more conceptual similarities than one might think. Both have been primarily known for their ephemeral nature, as soft materials that easily dissipate without the reinforcement of machines. Wax also holds an important place in the history of the modern mechanical reproduction

of sound, occupying the material space as the medium of choice for Edison and Berliner starting in the 1880s. As a material, its mere presence captures the history of preserving sonic traces, even when not mechanically utilized for that purpose. My contention is that by casting herself in wax, Baker attempted to elude the thorny issue of race in her own representations while simultaneously managing to capture the essence and history of her sonic self without using physical sound at all. It is an event constructed from a resonance between material histories rather than from the resonance of an actual material.

· · · · · · · ·

Baker's meteoric rise from a youth of poverty in St. Louis to becoming the talk of Paris during the 1920s has been thoroughly explored in other work and need not be detailed here. The most common narrative held that Baker found little success in New York competing with other African American vocalists such as Bessie Smith and Ethel Waters. Only upon moving to Paris to perform in La Revue Nègre, in a scene bereft of female African American singers and for an audience beholding the black body through a colonial gaze, was Baker able to carve a niche for herself and subsequently build an international following. However, her Paris debut at the Théâtre des Champs-Elysées in October 1925 was fraught with interpretive ambiguities that complicated this narrative from the start. Baker's first performance on the second of October saw her move wistfully and unexpectedly from archetypal minstrel show femininity to an alluring nakedness, clad only in pink feathers and the elegant skin that would become her onstage calling card. The nuance with which many commentators regarded these early performances is somewhat surprising. While some spoke of her performance in the familiar language of colonial exoticism, others found more difficulty pinning down exactly how to articulate Baker's stage milieu. Hence the tone of E. E. Cummings's well-known 1926 review for *Vanity Fair* that cast her as "equally nonprimitive and uncivilized, or beyond time," or Paul Brach's argument that the effect of Baker's spectacle was to breathe life into the postwar malaise and the "grey and tired lives" of the French public.[7] Not to mention the litany of attention Baker garnered from the Parisian avant-garde already grappling with the ambiguity of Picasso's *Les Demoiselles d'Avignon* and Darius Milhaud's *La Création du Monde*.[8] Enrico Prampolini's 1925 sketch of Baker displays some of the results of this process, resembling a "Futurist muscular robot" of steel that seemed purely skeletal, lacking any of her other embodied attributes.[9]

These ambiguities in Baker's embodied performance capital become the building blocks for a different type of gaze than the one constructed through the colonial structuring of race in the nineteenth century. French modernism perhaps presented a unique moment in which the desire of European subjects to escape the aesthetic torpor and disastrous failure of Enlightenment reason met the desire of the modern black subject to carve out a unique cultural space based on a pan-African historical imagination. Such a process created what Cheng has called the "second skin," a *"mutual fantasy . . . shared by both Modernists seeking to be outside of their own skins and by racialized subjects looking to escape the burdens of epidermal inscription."*[10] A "second skin" became a surface irreducible to flesh and thus could not be collapsed into simple discourses on racial difference. Rather, it became a field of possibility and extension in which the limits of historical hierarchies regarding the social image could be sidestepped, deferred, even dissolved. In this way, the "second skin" was mainly a Parisian skin: neither Baker nor any other African American performer could have been invented this way in New York, London, or Havana. This does little to denude its historical and aesthetic importance more broadly for the black body in the twentieth century, and for Baker in particular. Her naked skin, for the French, could be exotically beautiful while simultaneously emerging as the modern surface upon which the aesthetic desire of a modern postwar France could be built in public space. At the same time, Baker could bask in the modern life created by sleek surfaces she portrayed on stage that were recreated in painting, sketches, architecture, and (of course) sculpture. She, in essence, turned herself into material to be sculpted in ways that transcended her own body.

While this process of "second skin" in Baker's embodied milieu may be coterminous with Parisian modernism in its most potent form, it actually draws upon a much broader philosophical discourse on skin often masked by dominant discourses on race and the body. Cheng's arguments bear a remarkable resemblance to a critique from Serres regarding the historical collapse of skin as mere bodily sheath of sense. Skin, for Serres, is much more than simply the body's organ of appearance. It is the means by which the self extends into the world beyond mere appearance, taking the role that Descartes had originally envisioned for the mind. Serres's idea of soul was not that of something extended from its locale within the body, but one only activated by the engagement of sense. He thus regarded skin as the location of something analogous to the soul, which sparks when the skin engages

with the world external to the self, and thus moves constantly as the skin moves. "Body and soul are not separate but blend inextricably, even on the skin," he states, in a clear broadside upon Cartesian mind/body dualism. "Thus two mingled bodies do not form a separate subject and object."[11] This ability of external reach means that the skin is pure extension, and thus not part of the body at all in philosophical terms. Rather, it is a body unto itself—one, to borrow from a popular Deleuzian axiom, "without organs."[12]

In Serres's estimation, color (and therefore race) was simply an ancillary empirical attribute of the skin separate from the role of skin as the linchpin of subject formation. Of course, one can rightly argue that the actualization of such extension has historically been reserved for those subjects bearing *white* skin, making Serres's sense of mobility somewhat ahistorical as pure concept. The problem, as Steven Connor so ably points out in his study on the epistemology of skin in Western thought, is that the color of skin is far from inessential to the imagination of its meaning, even in philosophical terms. Color, he argues, is not merely an attribute of skin that can be shed when considered unimportant, but *is* skin at its most fundamental level. He starts by offering (among other things) an etymology of the word *color* that shows its inescapable linguistic relationship to a notion of skin.

> The word colour derives, via the Latin *color*, from a Sanskrit word meaning the skin on the surface of the milk.... The word "chromatic" derives from the Greek *chroma*, colour of the skin, complexion, style. *Chroma* is related to *chros*, skin, skin-colour, and to the verb *chorizien*, to touch a surface or the skin, which in turn derives from an Indo-European root *gheo*, meaning to abrade, or rub hard against. Colour thus harbours the idea of something that both touches the skin, and is also itself, according to a curious logic of contagious replication, a kind of second skin, a layer, film or veil.[13]

A notion of color is essential to skin, he argues, because it draws skin back into cultural constructions of the colors that are not necessarily inherent in their physical properties of color, a movement that Connor refers to as *chromaticity*. He gives several examples that tangibly draw in the historicity of the Western imagination about skin: diseases like the "black death" and scarlet fever, ideas about white and black skin corresponding with the transparency or opaqueness of the soul, or the change in ideas about yellow from a "bright and affirmative colour" in antiquity to one associated with

"degradation and discredit" in early modern Europe, and even later to prostitution.[14] In drawing his argument back to Serres's assertions, he reframes the notion of mobile and extended skin in a way that draws color back into the realm of sensory engagement. "Colour signifies materiality, the fall of the ideal into embodiment.... [It] is accidental, not essential, and therefore belongs to the outside of things, as the body constitutes the mere casing or superficies of the soul."[15]

Connor also shapes the history of skin by explicating linkages between material and color, showing how the two draw from each other but are in no way culturally coterminous. His fascinating example involves a discussion of the relationship between bronze's blended-metal cousin *brass* and the color yellow. Brass, he argues, had a long reputation as a metal attempting to capture the luster and reputation of gold, yet never attaining the same level of value or prestige. It was, for lack of a better term, "fool's gold," and therefore shared with yellow a deep association with deception in the Western imagination. However, brass as a material manifested a paradoxical kind of honesty, something "superficial without disguising the fact or pretending to be anything else."[16] Brass, like gold, still had a sense of exhibitionism, but one that was not inherent—it had to be crafted and polished. Unlike gold, it was less likely to be metallurgically corrupted by other material. The connotations of brass, then, exuded a kind of workmanlike power and common elegance, as opposed to the decadence of gold. "For all its superficiality," Connor concludes, "brass appears like a deep or fundamental kind of superficies." At the same time, its crafted metallic essence gives it a more tangible association with the surface of skin than mere color, making brass "a skin that acknowledges itself as such."[17]

Connor does not specifically link bronze to the color black or bind it to skin by cultural meanings of blackness. Nonetheless, there is a useful history of cultural constructions between this combination of material and color. Several intriguing instances can be found among African American cultural practices during the early twentieth century, with ideas of skin playing a prominent role. Much of this writing deals with racial ambiguity, grappling with the cultural meanings of skin tones lying between the steadfast racial constructions of Black and White in the United States. John Haynes Holmes, writing in a November 1932 issue of the magazine *The Crisis* (official publication of the NAACP), refers to "bronze" in discussing the fad of beach sunbathing among white Americans, satirically wondering if they will tan to the point of resembling African Americans in skin tone.[18] Issues like

these became especially important for African American women (such as Baker) in the performance industry, where skin tone could mean the difference between high-profile work as a singer and dancer or confinement to the niche market of studio-based race records. Bronze, in this case, could be seen as a marker for an idealized standard of racial beauty desired by performers and audiences alike. One of the most tangible uses of the material for this purpose comes from the Los Angeles–based Miss Bronze pageant, a beauty contest established by Howard Morehead in the 1950s specifically geared toward African American women. Maxine Leeds Craig points out that in the pageant's early years, the rhetorical usage of bronze referred to the lighter, softer features that contest winners often possessed. By the height of the civil rights movement, the concept of bronze associated with the pageant began to hold a wider racial meaning. Since many title winners during this era featured both lighter and darker shades of black skin, the signification of bronze extended beyond narrow concepts of color into a broader cultural trope of black femininity.[19]

In terms of sculpture, the context of associating bronze with blackness most often manifested as the flip side of arguments ascertaining the associations of marble with whiteness. For antiquarian sculptors of marble, issues regarding the racial composition of subjects were not of much concern.[20] Many cases of racial attachment to material up through the Renaissance were anecdotal rather than aesthetic, as with the two bronze *giganti* in the bell tower of the Torre dell'Orologio in Venice who only acquired the nickname *mori* (Moor) as the metal aged and darkened in appearance.[21] Concerns of intentional racialization only began to surface in the early seventeenth century, when European sculptors began to represent African subjects *en masse* for the first time. Head busts of unnamed black Africans began to appear in many parts of Germany and the Netherlands, crafted from materials like bronze and polychrome marble that better captured the skin tone of their subjects.[22] By the late eighteenth and nineteenth centuries, the movement toward the austerity of aesthetic neoclassicism brought the issue of material and racial composition in sculpture to the fore once again. Marble was again cast as the ideal material to capture the transcendent beauty of the human form, all but guaranteeing the reinforcement of whiteness as ideal skin in the Western aesthetic imagination.

In this context, writers and sculptors began to question both the need and desirability of materials like bronze and polychrome marble to represent the color of skin, especially in the United States, where representing

African Americans in the arts took on a lived reality mostly absent in Europe. Charmaine Nelson traces some of these ideas through the writings of James Jackson Jarves, considered one of the foremost American art critics of the antebellum period. Writing in 1855, Jarves utilized the common neoclassical argument that sculpture's primary aesthetic function was to capture form as a means to question whether color interfered with the ability of audiences to ascertain those formal dimensions. Color, he concluded, provoked emotional and sensorial responses that came at the expense of a desired intellectual understanding of the sculpture. Nelson convincingly argues that Jarves's attitude masked a fundamentally racist impulse by appealing to the aesthetic reasoning of "beauty and morality," in part by his use of the term "blackamoor" to describe the results of polychromic processes.[23] Sculpture moving away from this neoclassical ideal by representing the black body, she notes, often did so for reasons unrelated to aesthetics. As an example, Nelson points to the work of Charles-Henri-Joseph Cordier, a sculptor working for the French government who created polychromic images of colonial African subjects for an ethnographic gallery at the Musée d'Histoire Naturelle in Paris. The use of a polychromic blend of porphyry, onyx, and bronze in these works stemmed in part from the fear that the visual precision of photography would undermine the need for sculpture in French ethnographic museums.[24] Coming to the crux of the issue, Nelson argues that, intentionally or not, neoclassical aesthetics thoroughly erased the black body in its adherence to the primacy of the material of white marble. "Just as the privileged signifier the phallus *is* not the penis and is therefore irrevocably bound to the penis, whiteness, the privileged signifier of race-color is not wholly interchangeable with white skin but is dependent on and bound to the racialization of whiteness. The whiteness of the marble as deployed within the nineteenth-century neoclassical canons did not directly represent white skin color but stood in for that which could not be signified. . . . But inasmuch as it signified that which it displaced, flesh, it privileged the European race-color . . . significations."[25]

Nelson shows that separating issues of race from aesthetic representation in mid-nineteenth-century America was impossible no matter how many creative arguments were employed to defend the perceived classical ideal. Even defenses geared toward material explanations for the preference of white marble assumed a troubling ubiquity of whiteness. Nelson mentions one such argument from Edward Hale in his 1861 travelogue *Ninety Days' Worth of Europe*. Hale writes briefly about Welsh neoclassical

sculptor John Gibson's *The Tinted Venus*, an experiment in painted marble that stirred aesthetic circles throughout Europe during the 1850s. Having observed the coloring process up close in the workshop, Hale speaks quite favorably of the process and the fidelity it creates. But in pushing through a perspective that sculptors would prefer working with material as close to skin as possible, he drops in the following phrase with telling resolution: "We work in white because that is the nearest approach we have to the color of the human flesh."[26] A charitable reading might grab onto the use of the word *approach* and suggest that Hale was merely arguing that white is the least difficult color on which to add another, darker shade. Yet such recourse to whiteness as a material template cannot be separated from an American social template that assumed the same of skin. It also brings the question of representing the black body through statuary into sharp relief. If the overwhelming whiteness of classical sculpture was due to aesthetic concerns or feasibility, why (as Kirk Savage argues) were Native American representations in bronze and white marble common prior to 1860, while African Americans were absent from pedestals across the continent?[27] Why could the body of the noble savage be captured while that of the captured slave could not?

What becomes clear is that the problem of representing blackness was not just *an* issue for nineteenth-century American sculptors to grapple with, but perhaps *the* issue. Specifically, the absence of the black body in the monumental ubiquity of white marble was inseparable from the structural ubiquity of white supremacy. The relationship between color and aesthetics was an important component, but the roots tying in the social power of white skin came from a much deeper place. Savage, specifically, identifies the role that designations of race and body type in the natural sciences (and their reinforcement of moral and intellectual stereotypes) played for nineteenth-century theorists of race and identity. In these circles, the idealized masculine form of classical sculpture became a template for the natural superiority of the white male body. The black male body, by contrast, fell short of these standards. Grotesque caricatures reminiscent of the minstrel show fell into the pocket of Lessing's Laöcoon problem, where the statue as paragon of beauty could only be diminished in capturing the undesirable Negro form. The aesthetics of classical sculpture and the racism of nineteenth-century natural science thereby mutually reinforced one another. Savage employs a telling illustration from Nott and Glidden's *Types of Mankind* (1854), where the typical head of the white male is identified with the Apollo Belvedere, known at

the time as one of the quintessential sculpted faces capturing masculine beauty. The head of the African American male displayed below the Apollo, with crested brow and protruding lips, hews closer to a third illustration of a chimpanzee at the bottom. Visual references like these are both provocative and significant. They show how classical sculpture helped establish a taxonomy of whiteness that carried profound cultural consequences. And one of those obvious consequences was the denigration of a particular body, "the black antithesis of classical whiteness," through its absence in sculpted form.[28]

As monuments are wont to do, the statues built from this triumphant narrative about the white body persist. While those needling nineteenth-century questions about whether classical sculpture could properly capture the black body have been long forgotten, the sculpted answers continue to dot the American landscape. Savage understood this dynamic all too well. In response, he sculpts a haunting passage about the need to see these statues not as pieces of material but as representative of ideologies that must be remembered and confronted.

> The irony is that now, in the late twentieth century, we must work so hard to recover that voice [of the statue] once thought to be eternal. If many monuments from the past seem mute to us, they do still have stories to tell. But those stories are not necessarily what the monuments were intended to tell us. To make the monuments speak again we must question the often bland surface they show the world. We must investigate who were the people represented in and by monumental space, and how they competed to construct a history in the language of sculpture and in the spotlight of the public sphere.[29]

If these words seemed prescient when Savage first published his book in 1999, they have grown only more so in light of a tumultuous 2017 for public statuary in America. This was the year that his warning became clear and present. Debates raged in town squares and on Twitter regarding how to grapple with a contentious subset of statuary born from the nineteenth-century efficacy of white marble: the Confederate war memorial. A simmering disagreement as to whether statues of figures like Robert E. Lee and Pierre Gustave Toutant Beauregard represented the legacy of white supremacy or the heritage of fighting men publicly erupted at the prospect of government entities

removing those statues from their long-inhabited pedestals. Municipalities employed a host of strategies to address the social discord their actions were causing. In New Orleans, mayor Mitch Landrieu crafted an impassioned speech against the Lost Cause mythology perpetuated by the statues being mothballed. In Memphis, the city council enacted a quiet discharge of the public land housing another statue (one of notorious native son Nathan Bedford Forrest) to work around state law preventing them from acting—an action against which the Tennessee state legislature later retaliated. And in Charlottesville, the high-water mark (to use a turn of phrase popularized in Civil War historiography) was set on an afternoon in August, as organized groups of white supremacists marched to prevent another series of removals and left the body of deceased counterprotester Heather Heyer in their wake. One could say that the contentious social history marking white marble rarely appeared in the sloganeering, rhetoric, or commentary of those either supporting or against removal. Or that many of the monuments like the vanished Lee in New Orleans and the deposed Forrest in Memphis were made of bronze, and would therefore seem distant from any argument about a pervasive material whiteness. These perspectives assume that color functions as part of the sculptural apparatus and nothing more, as Hale once assumed. They underestimate the ways in which the physical demarcations of race born of Enlightenment science used statues as justification for racial and moral hierarchies, as Nott and Glidden once demonstrated. Most of all, they assume that the ethos of white marble representing whiteness could somehow be separate from the more mundane practice of using bronze to memorialize white bodies.

The veracity of the debate surrounding Confederate statuary puts these ideas to rest. When looking at the form of the deposed Forrest in photographs, every bit the bronze horseman in his own right, the ruddy hue of the statue does little to mask his identity or history as that most violent purveyor of white supremacist ideals. Not to mention the troubles that followed University of Iowa classics professor Sarah Bond, who pointed out the historical connections between marble and whiteness in an innocuous online publication two months prior to Charlottesville and was subjected to copious amounts of right-wing harassment.[30] All of this suggests that Eugene Achike, the brutal Catholic patriarch from Chimamanda Ngozi Adichie's novel *Purple Hibiscus*, was somewhat mistaken. White people do in fact care about "mighty statues."[31]

• • • • • • •

The aesthetic modernism of the early twentieth century must have seemed, if not an antidote, then at least a world apart from these contentious issues of race and embodiment in the public sculpture of the American past that would explode with such fervor in the American future. After all, those concerns emerged from a distinctly American politics surrounding representations of the anthropocentric body. Across the Atlantic, the shifting emphasis toward formal abstraction and non-Western sources of inspiration in sculpture looked to stand in stark contrast to the racial weight of white marble. Picasso's gaze toward African sculpture prior to the First World War was merely the most famous example of this practice in France. Paris would do its utmost to not portend a future that gave us Charlottesville. But the hermeneutics of racial representation and their ideological potency could never be excised in their entirety, in Europe no less than in the United States. If anything, modernism's quasi-reckoning with the racialized veneer of white marble only illuminated the possibility of its opposite, where the material of bronze could serve as a representational schema capturing the black body. Baker, more than anyone else in the first half of the twentieth century, transformed this schema from the pedestal and the ethnographic museum into the realm of performance. As an American in Paris, her very presence challenged the legacy of marbled whiteness as white supremacy, becoming a model for how making bronze the quintessential material skin of blackness could be realized and culturally productive. She was that rare monument, born of sculpted politics on two sides of an ocean, that could actually speak for herself.

Speaking with form, though (as we have heard on many occasions thus far), does not guarantee control of that which vocality perpetuates. When sound finds its way into this material aesthetic of bronze, it carries with it something powerful and easily corrupted. Following this thread, modernism was also the source of a prescient and underdeveloped literary trope where the materiality of bronze statues could become a sonorous envelope of power. Since bronze was a materially blended metal and thus considered more resonant than marble, some writers began to create stories in which the ideological use of the sculpted image was reinforced by the affect of material resonance, influencing those outside of immediate social or political power. A prime example is the essay "Ariel," written by Uruguayan essayist José Enrique Rodó in 1900. The piece is a political allegory that draws on Shakespeare's *The Tempest* to critique the alluring encroachment of American capitalism into Latin America at the turn of the century. The central character

is a teacher nicknamed Prospero (after the aged and temperamental central character in the play) by his students, due to his long-winded lectures on morality and power and his tendency to speak while sitting next to a bronze statue of the nymph Ariel in his study. Roberto González Echevarria notes that Prospero constantly defers the authority of his voice to the image of the statue while lecturing, in essence asking the students not to associate his voice with his own body. In doing so, Echevarria argues, the sculpture becomes a resonant housing for the authority of the lecturer, reinforcing the rhetorical power of language with the affective power of vibration. "Turned into a bronze statue," he notes, "the voice of the master begins to take on an ever more menacing shape; it is heavy, wounding, inscribed . . . the soft voice that cures also wounds."[32] The material of the statue is far from inert material. Instead, it functions much like an amulet, preserving and amplifying the power of the voice not through the presence of physical sound, but the affective memory of that sound.

This confluence of voice, material, and possession demonstrated in Rodó's "Ariel" intersects with the broader issue of bronze representing the black body in a fascinating mid-century short story by Ann Petry titled "Mother Africa," originally published in the 1971 collection *Miss Muriel and Other Stories*. Petry was a prolific African American postwar author, raised by upwardly mobile middle-class parents in the overwhelmingly white community of Old Saybrook, Connecticut. Her upbringing is thought to have influenced many of her works, which often deal with the estrangement of individuals from larger communities due to social differences and the problematic influence of white American values and cultural attachments in African American communities.[33] "Mother Africa" is intriguing because of the way that it layers references to many of the issues discussed so far within the context of one story, and thus it can be read in many distinct ways. Most see the story as an allegory for the complicated nature of African American social transcendence with modernity, a trope common to much African American literature written after the Second World War. But on another level, it reads more like a gothic tale of desire and possession, spawning interiorized questions about control and fascination regarding an object of desire in the form of a work of art. In this sense, the story seems as resonant with Dorian Gray as with James Baldwin.

The plot of "Mother Africa" focuses on the character of Emanuel Turner (called "Man" throughout the story), a junk collector in Harlem whose anachronistic disposition makes him an odd yet endearing staple of his modern

urban community. His world is built out of assemblages, an environment that reflects on his person in the form of tattered clothing, disjunctive language, and a bluesy, improvised sales call that he sings while walking through the neighborhood. One day, Man receives a discarded bronze statue from a wealthy white woman, an object much more polished and formally coherent than his usual haul of junk. He identifies the statue as an object of ideal beauty—a black African woman—that he begins to anthropomorphize and pay attention to obsessively. He places it in his backyard as if part of a shrine. Possession of the statue slowly begins to influence his behavior, and he shaves his beard and changes into more elegant clothes to the point where he is unrecognizable. When the neighbors begin to deface her with clothing every night, he dutifully cleans off her body. Man's dedication to Mother Africa estranges him from the community, but his sense of fascination remains unabated. Then, during a moment when cleaning the statue yet again, he looks into her face for the first time and realizes that she is not the African beauty he thought. Rather, she has the features of a white woman. Thoroughly horrified, Man becomes instantly disenchanted with his Mother Africa. He returns to his old ways, and the story ends with him calling the local metalworks to inquire about selling the statue for scrap metal.

Petry's intention in writing "Mother Africa" is not entirely clear. As one of her more obscure stories, it has generated a limited scope of critique compared to her other work.[34] But there are several threads here worth considering. The first, most obvious, is that Man's attraction to the statue is clearly based on his conflation of the material bronze and epidermal blackness. The implication of this assumption, however, is not entirely transparent. Petry reinforces the classical primacy of form over material in sculpture, since the twist of whiteness is based solely on the statue's facial features. Or, to put it another way: would Man have been enchanted had Mother Africa been constructed of white marble with features more befitting his idealized black woman? Likely not. This suggests a way of reading the story that assumes the interpretation of bronze as black skin to be yet another trick of Western aesthetics intended to disrupt the community ties of the black subject. Roberts sees this primarily as a violation of the tradition of *signifyin(g)* that carries the identity of the statue into the realm of "the oppressors' discourse."[35]

Were the commentary on sculpted blackness the only element that "Mother Africa" brought to the table, it would be interesting enough. However,

the story also draws in, like Rodó, the power of sound as a mechanism that exhibits both transformation and control. Vocality is ever-present in the narrative of "Mother Africa," most notably in the jingle that Man sings when going about his business in the neighborhood. But vocality also marks the stages of Man's transformation throughout the narrative, as he becomes more entranced with the idealized physical beauty of the statue itself. This is apparent from the moment of first contact.

> Thus for the first time he saw the metal woman in the moonlight. He stared at her, moving toward her slowly like someone who was sleepwalking. His bare feet were deep in the soft grass, cool in the soft grass. He reached out his hand, tentatively, and touched her. She did not feel like metal at all. Cool, yes. But she seemed to respond, to come alive, to move under the touch of his hand, to leap with life.
>
> He felt like singing. But he had no song, never had heard of any song, suited for such a moment, no melody that could possibly match the feeling of tenderness that suddenly assailed him at the thought that this big dark woman was his. He had Mother Africa right here in his yard.[36]

Petry does not use the word "skin" directly in crafting Man as a black Pygmalion, but it lies in the subtext of his sense of enchantment, where his tactile hand affects the statue as if it were made of organic material. Capturing this sensation linguistically proves difficult, but even the mechanism of song provides him no reservoir from which to draw. The sublime beauty of the statue's skin leaves him as silent as the statue appears (and is expected) to be.

As the narrative continues, Man's own vocal sensibilities—the basis of his prior self—start to change. The influence of Mother Africa provides him with a more polished, lyrical vocality to draw on. This new sound is but one part of his broader transformation from roughly hewn junkman to a modern black subject, cleanly shaven and clothed in the intellectual trappings of a suit.

> He began to whistle. He whistled a tune that he made up, on the spur of the moment. He whistled it over and over, thinking that it matched the metal woman, was suited to her. It was a young tune, it had a lilt and a lift to it.

Under the spell of this whistled tune, he walked over and looked at himself in the long, cloudy mirror that hung on the door of his bedroom. He did not know why, but he had expected to find in his own reflection something of the beauty of the tune, something of the beauty of the metal woman. Instead—well, he loathed what he saw. There was nothing in his dirty, ragged, unkempt appearance to suggest that he could create beauty, certainly nothing to suggest that he would ever be able to recognize beauty in anything. He looked like a creature born solely for the creation of ugliness.

He suddenly yearned to be clean.[37]

Armed with a new look and a new song, Man reengages with the community that only knew him as a solitary junk dealer. But the transformation that Man undergoes is so vast that he becomes completely unrecognizable. His voice becomes the only tangible link to his former self, but it sounds displaced and unconvincing coming from a different body. "Children, who the day before had leaned against him, their bodies warm, and pressed close as they watched him mend their broken toys, now stared at him distrustfully, as though suddenly confronted by a stranger who had not yet declared whether he was friend or foe. What was more disconcerting, many of the sensitive little ones recognized his voice, and stared up at his face, his mouth, in an awful unwinking appraisal. He suspected that they thought he had swallowed Ole Bottles and, as a result, was now speaking with Ole Bottles' voice."[38] Man's displacement is only rectified through a return to his vocal trace, the work song he would sing while walking through the neighborhood streets. As a narrative arc, it becomes a tangible signification that traces his attempt to reconstitute himself with the community he abandoned to pursue his desire for the statue.

Mother Africa's statuesque form, like that of Rodó's Ariel, is all a ruse. But while Ariel uses its hard material to amplify the authoritative voice of another, Mother Africa takes a more direct route. She, in essence, becomes the sculptor: creating and shaping Man so thoroughly that he becomes a vessel for her own voice that she cannot express herself. Man begins to speak with the polish that she would herself if possible. And he is keen to do so as long as he thinks she is Mother Africa, which gets to the heart of his real transgression throughout the arc of the story. The problem is not that he mistakenly allows himself to be seduced by the trickery of white cultural forms. Rather, it is that he so readily allowed an absent voice of

power to transform his own voice, ceding his own subjectivity and allowing the statue to speak *through* his voice. The implication here is that the statue uses the assumption of its silence as a resonant weapon: unable to manifest its own voice through the reality of its material, it seduces and tricks another by giving him that which he desires most. Man most desired an African queen, and thus the material of bronze could easily become a black body in his imagination.

Reading "Mother Africa" in this way has profound implications for reading Josephine Baker's own sculptural disposition. One can argue that for much of her career she *was* the bronze statue from "Mother Africa"— seductive as a symbol of both black primitivism and black modernity, and utilizing a sense of racial ambiguity to her advantage. The latter point contains intriguing implications, for Mother Africa's underscored oscillation between blackness and whiteness mirrors Baker's own ambivalence toward such markers throughout her career. For one, Baker complained about not getting roles on different occasions because she was considered either too light or too dark skinned.[39] She spoke of instances where she would cover her face in white powder, to look lighter for an audition, or sing songs like the innocuously titled "I'd Like to Be White." By contrast, she would openly recount tales of racist humiliations suffered throughout her career, especially while performing in the United States, and market a line of dark-colored women's stockings advertised as "Bakerskin."[40] Race was in some ways a tactical element that Baker would employ, reflective of a humanist (rather than political) grounding in her civil rights awareness. She was not overtly political like Nina Simone or Paul Robeson, an advantage that her sculpted ambiguity provided.

However, Baker also carried Mother Africa's disadvantageous silence, something that has proven tougher to navigate than her racial disposition. One of the most substantial and underappreciated aspects of Baker's transformation into sculpture in discourses about her performing milieu has been the historical suppression of her singing voice. The quality of Baker's voice was subject to considerable debate during her career and was rarely mentioned in conjunction with descriptions of her body. Early in her career, Baker attempted to emulate the style of established New York singers such as Ethel Waters, but she could not quite match their volume or presence, especially in larger concert halls. Language describing her voice as "thin" or "dwarf-like" was commonly used in reviews of these concerts.[41] The most

charitable descriptions of Baker's voice during her prime were every bit as grounded in exoticism as those describing her dancing. One particular review of a Columbia Records release claimed that her voice was simultaneously "capturing here the sound of a saxophone numb with emotion, there the plucking with vibrato of a Hawaiian guitar, later the manner of an insistent ukulele."[42] Tellingly, no favorable comparisons to the violin or to Maria Callas, historical drivers of a transcendent *jouissance*, were to be found. Instead, her singing voice is grounded as the emission of an exotic object, her body as musical instrument.

Cheng mounts an impassioned and effective defense of Baker's voice on purely pragmatic terms, commenting on her remarkable range in both pitch and style. The "queer" quality that especially American audiences found distasteful, she argues, stemmed from two realities. The first was the diverse field of genres and environments in which she had to perform throughout her career (musical theatre, vaudeville, opera, film, music studios, radio), each requiring a different kind of vocal performativity. In this sense, she was no different from a host of performers working in the music industry during that time. The second, more existential reason was that her voice did not manifest the gravelly "diva-blues" authenticity of a Bessie Smith or an Ethel Waters.[43] Even though her voice was considered unconventional, Cheng shows that it did have a sonorous impact on some who chose to listen, most notably the quintessential French modernist architect Le Corbusier. He wrote about Baker in his lecture series *Précisions*, which detailed a trip to Buenos Aires in 1919 where he saw her perform for the first time. The quixotic description that Le Corbusier writes is, as Cheng admits, "discombobulating," but weaves a thread of intimate attachment through Baker's voice that it was not often afforded. He writes of the maternal affection of her voice, though not an affection borne from the typical sonorous envelope. Rather, it is defined by a "sharpness" that moves him to imagine himself within his own "second skin," in part sculpted by Baker's vocal timbre into a desired "transcendental homelessness." In turn, he transforms her voice with writing from thin veil into a sleek, sculpted surface in its own right. Or, as Cheng puts it, "she makes a diva out of him; he makes an architect out of her."[44]

Though Le Corbusier clearly provides a means to reincorporate Baker's voice into her sculptural milieu, he was one of the few who desired to hear her supposedly shrill vocality in such intimate terms. In fact, her voice

could be considered a contributing factor in the longing to capture Baker's body solely as a sculptural object. Others may certainly have shared in the French architect's sense of reinvention in the rough sonorous envelope. Most, however, would consider this transformation another version of Man being reinvented by Mother Africa—the relationship between affect and image becoming dissonant and unwieldy. In this reading, Baker's silence is necessitated not because as a statue her voice is aesthetically misplaced, but because possessing a voice (even in exile) would make her *too* dangerous an object of affection. If thought about within the social conventions of the time, the possibility of accepting that a black woman could have such a deeply modern seductive effect on a white man would hardly have had widespread acceptance during the interwar years. And the voice has always been trickier to rein in than the body, precisely because it uses the physically ephemeral to its advantage, appearing in places and forms unexpected. Baker being made into a statue, in one sense, is not only a mechanism to invent and reinvent her body, but also a means to control the grain of her voice.

The question becomes how Baker, even posthumously, can respond to this process in a way that brings her oft-denigrated singing voice back into the fold. She does so, like Mother Africa, by becoming a sculptor and finding a way of transplanting her voice into the body of another. The proposition of this process, as we have seen, is laden with violence and subconscious transformation. Baker, though, found another way to become a sculptor, and this is what makes the Jorama so important. Instead of inscribing her voice into another corporeal entity through the allure of form (Mother Africa), or with a resonant amulet (Ariel), she simply casts it within another version of her own body. And just to make sure, that voice is inscribed with a different material than bronze, one carrying a less problematic history with either the raced body or the presence of sound. That material—*wax*—becomes something of a "third skin" for Baker, using material and form to embed a sonic memory within the imaginations of those who may forget her soundings in the act of gazing upon her. In other words, she preserves her vocality without using physical sound at all, but by using a medium historically associated with the preservation of physical sound. Timbre and shrillness no longer an issue, Baker's voice is freed of its critical discourse and becomes the very essence of an absent presence.

••••••••

Wax, in many ways, is the ideal material for this sculptural integration of sound and skin. Derived from organic material, it maintains a closer material proximity to skin than either marble or bronze. When its casting is finished, wax gives the textural illusion of skin and can easily be painted or chromed to enhance that illusion visually. This power of illusion is heightened by the idea that the material was shaped by direct contact with the body that it presents. Wax can also easily incorporate ancillary materials like clothing, which contribute to its presentation as a continuation of the living body. In short, it is the material able to come closest to preserving a person as they appeared in life, making wax what Roberta Panzanelli calls the "ultimate simulacrum of flesh."[45] As expected, most of its sculptural uses relied on this visual proximity to flesh. Versions of ceremonial death masks of important individuals dated back to Roman Egypt, and were common through the Middle Ages in Europe.[46] By the early eighteenth century, precise representations of human organs for anatomical displays were developed to replace cadavers. Full-bodied wax effigies of figures such as the English monarch Charles II were precursors of the waxworks of celebrities pioneered by Marie Tussaud and other showmen, some of which incorporated the hair and clothing of their subjects.[47] This history seemingly vindicates Aristotle's famous metaphor comparing the fidelity of a wax impression to its subject to the integration of body and soul.[48]

Yet this same proximity to flesh is also responsible for wax sculptures having more of a ceremonial and commercial life than an aesthetic one. For one, the fidelity of wax carries the anxiety of substitution or replacement. Various debates over the composition of Vladimir Lenin's body in his Moscow mausoleum, or Hollywood movies like *House of Wax* (1953, remade in 2005), seed the fear that human skin can be permanently encased within a skin-like material from which the subject will be incapable of emerging.[49] In aesthetic terms, wax has often been considered too close to the living body for a viewer to attain the necessary critical distance for proper aesthetic judgment, an objection notably associated with Kant.[50] Moreover, as Georges Didi-Huberman notes, the modular quality of wax as "aesthetically viscous" accounts for as much of its problematic history in Western sculptural aesthetics as its fidelity to skin.[51] Put another way, this recourse to viscosity frames another way in which the material of wax mirrors skin: ephemerality. As a material, wax's malleability means that it lacks the hard permanence of marble or bronze. It can more easily be substantially altered by environmental factors like heat and weather, famously demonstrated

by Descartes when he ruminates about the state of wax put into a fire and melted.[52] The most compelling case against the aesthetic life of wax, though, is in its role as a transient material in the service of other sculptural processes. The most notable example is the "lost wax" (*cire perdu*) method of bronze casting, a cross-cultural process dating back several millennia in which the molten bronze dissolves a wax template in order to take its place.[53] For all of its varied cultural presence, it is perhaps telling that wax has often found its most tangible aesthetic role in the history of sculpture as a placeholder that is melted away for a more permanent material.

The qualities that foreclose wax's aesthetic life—fidelity to skin, ephemerality, utility—are precisely the attributes that frame its deep conceptual relationship to sound. This relationship was perhaps most direct during the late nineteenth century, when technologies of sonic and bodily preservation interacted in the same public spaces. In the 1880s and early 1890s, wax cylinders became the standard technology in early sound recording devices. Alexander Graham Bell's Volta Laboratory in Washington, D.C., developed a wax cylinder–based phonograph that was patented in 1886, based on the inscription process that Thomas Edison had experimented with on tinfoil during the late-1870s. Their "graphophone" was released for public consumption under the Volta Graphophone Company that same year. Though the wax cylinder recorded with greater fidelity than any technology produced to that point, it was exceedingly fragile and thus ill suited for mass production. Only remaining popular for recording until Emile Berliner's more durable shellac gramophone disc was developed in the mid-1890s, the value of wax's legacy in recording was mixed throughout the twentieth century. While the word itself gained cachet among small groups of record collectors, most wax cylinders were deemed only as valuable as the material inscribed upon them.[54] Once their texts were inscribed onto a more permanent medium, the wax objects themselves were often discarded as obsolete and valueless.[55]

For a short period, though, this popularity of the wax cylinder in recording coincided with the spread of waxworks from urban traveling shows to permanent museum spaces after 1860, modeled after the popular Madame Tussaud museum in London. These wax museums were perhaps the primary site through which people could engage with detailed representations of the famous before the development of the motion picture theatre. Perhaps noticing the resonance between sound reproduction and body reproduction, some

wax museums began to experiment with incorporating recording devices into displays. For example, during the early 1890s several Scandinavian *panoptika* began to feature recordings of local celebrities playing next to their sculpted forms. Patrons could even rent out salons at the museum where groups could listen to these assemblages of sculpted body and recorded sound as part of private social gatherings. This turned the late nineteenth-century wax museum, as Mark Sandberg argues, into a "media nexus" where patrons not only expected to engage with various forms of recording technologies, but also gave wax figures "the chance to borrow qualities by implication from the surrounding devices."[56] Sandberg is speaking more generally about sound reproduction devices, and his perspective arguably persists into the present day where recorded sound effects, voices, and music are a staple of the tourist experience at any contemporary wax museum. But there seems to be a special resonance for that brief period when wax bodies could correspond with their own voices carved into the same material—voice imprinted onto the warm, intimate material of skin once again.

Was Baker aware of this historical resonance between wax and sound when she commissioned the wax figurines for the Jorama at the Château des Milandes? Did she somehow understand the dynamics of the sculpted ear, even if not through the window of that term? We'll likely never know the answer to those questions. Nor can we know if she cast herself in wax, particularly as the aforementioned figure that depicts her at the height of her powers, to escape the legacy of her own embodied history sculpted in bronze for many who saw her perform. If anything becomes clearer, it is that the sculptural life of Josephine Baker cannot be simply framed as an intersection between primitivism and modernism at the site of the black female body. She brings together an entire discourse unto herself about the relationship between skin, material, and form that challenges any simplistic notions about her career and legacy. Baker casting herself in wax may have been one way to rectify the chasm between the way she viewed herself and the way others viewed her. It represents a move, one elucidated and expounded upon in so many different contexts by Fred Moten, to embed an irreducible sonic presence into the varied visual and embodied objectifications of blackness, from within and without.[57] We should keep this legacy in mind when engaging with other sculptural manifestations of Baker in the world. For the centennial celebration of her birth in 2006, a French sculptor named Chouski was commissioned to make a statue of the singer to be placed on

the grounds of Milandes. The finished product featured Baker in the bronze skin associated with her prime, but not in the repose of her 1925 premiere with La Revue Nègre. Rather, an older Baker, simply clad, is embracing a young Aiko, one of her Rainbow Children. Reclaiming the woman with the bronze skin, not as an object of desire, but in a moment where she appears at her most resonantly human.

CHAPTER 6

Now You Have to Go, Comrade

Plovdiv's Stariya Grad ("old city") is a central neighborhood built into three prominent hills (called Nebet Tepe, Taksim Tepe, and Dzambaz Tepe) overlooking vast stretches of the city in south-central Bulgaria. As one would expect from any locale tagged with such a moniker, the area carries a diverse and cosmopolitan history dating back prior to antiquity. The hills show evidence of settlement from as early as 4000 BCE. They later housed the Thracian city that became known as Philippopolis (named after Philip II of Macedonia), which stood as one of the northernmost reaches from Hellenic Greece into present-day Bulgaria. When the Romans conquered the region of Thrace in the first century BCE, they renamed the existing town Trimontium ("Three Hills"). During the period of Ottoman Muslim rule, what became the Stariya Grad served as the city's Christian quarter, housing the merchant class that made Plovdiv the most important city in nineteenth-century Bulgaria through the overland trade route between Salonika (Thessaloniki) and Constantinople (Istanbul).[1] Wealth stemming from this economic web filtered into the quarter, helping build the ornate houses in the Bulgarian revival style for which the neighborhood is renowned. Yet the opulence of Stariya Grad masked deeper systemic problems inherent in the late Ottoman city. This attitude was articulated by Liuben Karavelov, a writer and ardent Bulgarian nationalist, who wrote in 1868 that Plovdiv seemed "magnificent and picturesque" from afar but upon closer inspection was filled with

"half-demolished houses, muddy streets, stinking morasses, hopeless filth, lazy and mangy dogs and sleepy human physiognomies."[2]

This double identity of pictorial and squalid, Bulgarian and Ottoman, modern and aged—of which Stariya Grad was part—was slowly transformed after the Liberation of 1878 and the rapid shift toward Europeanized modernity that it shepherded. But while the red Mediterranean tile roofs and cobblestone roads in other parts of the city gave way to the bland gray concrete of modern city streets and Communist apartment buildings, Stariya Grad kept much of its nineteenth-century character. In recent years, many of the buildings that once housed wealthy merchants have been refurbished and incorporated into the burgeoning tourist economy, presenting a piece of old Plovdiv in the middle of the city. The colorful Baroque mansion built by merchant Argir Hristov Kuyumdzhioglu in 1847 has been home to the Plovdiv Regional Ethnographic Museum since the late 1930s. On the opposite side of Stariya Grad, a more sober Baroque structure built on top of a Macedonian fortification wall belonged to Revivalist book publisher Hristo Danov, and it has an exhibition belonging to the Regional Historical Museum. The confluence of modernity and antiquity also manifests with the Akademiya za muzikalno i tantsovo izkustvo (Academy for Musical and Dance Arts, or AMTI), which inhabits a mix of Revivalist and modern buildings near the much older remains of the Antichniyat teatur (The Ancient Theater), a Roman-era open-air stadium unearthed in 1923.[3] Their close proximity shows the patchwork history of Stariya Grad that one encounters within the sphere of a few hundred square feet.

Between the AMTI grounds and the Ancient Theater is an object that tells a quieter, more austere piece of Bulgaria's history. Next to a small outcropping of trees sits a life-size bronze statue of a smiling gentleman with a thin moustache, sitting on a perch and holding a violin to his knee. The man captured in bronze is Aleksandar Nikolov, a popular musician and humorist during the 1950s known colloquially by the name Sasho Sladura (often translated to "Alex the Sweetheart"). He is not well known outside of Bulgaria, yet holds a certain fascination for Bulgarians who came of age during the early Communist era and its Stalinist veneer. Sladura was one of the finest musicians to come out of Plovdiv during the first half of the twentieth century, becoming a featured soloist at the Hotel Bulgaria when it was one of the liveliest spots for Western-style dance music in Sofia.[4] He was equally known for his deft sense of humor, as a gambler, and as a legendary charmer (the source of his nickname). After the Second World

War, at a time when outspokenness was potentially dangerous, Sladura often dispensed humorous criticism of the regime, veiled with wit. He had an incomparable knack for deflecting the worst ire from members of the Bulgarian Communist Party (hereafter BCP) through his personal warmth, considerable charm, and the cultivation of advantageous political allies. His arrest, imprisonment, and mysterious death in 1961 marked him as one of the most famous victims of Communist Party terror in Bulgaria. No less a figure than Georgi Markov, the dissident writer and victim of a ricin-filled pellet delivered via umbrella, codified the importance of Sladura's death for a certain generation of Bulgarians. To grasp the reach of that era's political terror, one "need only mention the fate of the well-known jazz violinist, Sasho Sladura (the charmer)," Markov wrote in his memoir *The Truth That Killed*, "who paid with his life to remain in the nation's memory as an unequalled raconteur."[5]

The statue was commissioned by Georgi Lazarov, a physician, philanthropist, and classmate of Nikolov who emigrated to the United States in 1971. From his home in Baltimore, Lazarov donated money in the late 1990s to commission several statues around Plovdiv capturing artists and personalities local to Plovdiv, including artist Zlatyu Boyadzhiev and street philosopher Milyo Ludiya.[6] Local sculptor Danko Dankov was charged with designing and casting all of the statues, and the one of Sladura was unveiled with a small ceremony in September 2002. Unlike those of Boyadzhiev and Ludiya, the visage of Sladura sits atop a stone that has a small plaque attached to its base. It reads:

V PAMET na Sasho Sladura 1916–1961 i deitsite na kulturata zaginali ot komunisticheskiya rezhim 1944–1989

(IN MEMORY of Sasho Sladura and the culture makers who had perished under the Communist regime)

This inscription, both provocative and direct, was not without controversy. Protests were voiced by the Bulgarian Socialist Party (BSP), the political successor to the BCP, who claimed that the inscription was unfairly biased toward the former Communist government.[7] These types of critiques have been in the minority. Most who know something of the man represented by the statue accept the martyrdom that the inscription articulates. His body, physically mortared into the streets of Stariya Grad, stands as a reminder

of the worst excesses of state power under Communist rule toward cosmopolitanism and bourgeois artistry.

The importance of Sladura's statue can thus be understood in a number of ways: as a bodily allegory of the erosion of interwar bourgeois subjectivity in Bulgaria within Communist everyday life between 1944 and 1962; as a preservation of the bourgeois urban subject that was specifically targeted during the early Communist period; as a source for new relationships with images of the dead, made possible during the comparatively boundless era of post-Communism. The relationship between loss and cultural memory looms large in all of these ideas. Statues have proven ideal objects to perform such work, reinvigorating the bodies of the dead and placing them on display to ensure that they—and what they represent—are not totally forgotten. They become arbiters of expressions that Marilyn Ivy associates with the psychoanalytic concept of *nachträglichkeit* (deferred action), a common term found in the works of Freud and Lacan as a means to articulate how subjects interpret and revise past events to invest them with significance. Ivy's own take on *nachträglichkeit* connects it to the phantasmic nature of loss, where phantasm "is understood as an epistemological object whose presence or absence cannot be definitively located. . . . [T]hat loss can never be known simply *as* loss."[8] The objectification of loss in the way Ivy describes carries with it the implication that it is something that can eventually be recovered through the recourse to its newfound object status, like molding putty into a recognizable shape. One can imagine how the statue of Sasho Sladura—itself a molded shape—functions as an object of *nachträglichkeit*. The inscription alone invests it with such significance. So, too, does the decision by the sculptor Dankov to show Sladura as he would have appeared in life, instead of a more abstract presentation involving disembodied heads that he intended. Placing the statue within the confines of Stariya Grad fulfills this need as well, mirroring the similar work of restoration done to the houses and buildings that echo the intersection between Bulgaria's imagined and actual past.

Silence, ever present in the milieu of statuary, is one potential component to this assemblage of *nachträglichkeit* that escapes obvious notice but becomes worthy of consideration in the context of Sladura's life. The concept of silence, as the phenomenological state created by the perceived lack of sound associated with a particular body, has taken on many different guises within classical conceptualizations of sculpture. In addition to being a self-evident aesthetic construct, silence was also key to constructing the space of contemplation thought necessary for proper subjective engagement with

the art object. It has been, to adopt a phrase from Lacan, a *present absence*. Sound, by contrast, takes on the Janus face of the *absent presence*, more often a vanished than a never-was. But silence can be more than just a negation of sonic presence. It can also serve as a referential marker to that which has gone unheard or been silenced in some way. In this vein, philosopher Don Ihde thought about silence as a "horizon of sound" that creates a border between silence and the sound that it references. At this seam between silence and sound lies an object or concept linking the two together. Ihde, for example, thought that movement served as this bordering.[9] John Cage, who began to consider the musical impact of silence as early as the 1940s, championed the temporal principle of duration.[10] Others have put forward potential borders laden with varying degrees of abstraction and touching on everything from philosophy to music copyright, each taking its own potent and mobile meaning depending on the source and permanence of the silencing.[11]

Statues, too, can become one of these horizons on the cusp between sound and silence. More specifically, statues are potent objects in the transformation of silence from an ontological absence of sound into an epistemological field detailing the spaces and cultures through which a lack of sounding becomes meaningful. Because the statue has maintained such close proximity to the phenomenological ideal of silence, it becomes an object that captures the allegorical ethos of silencing in a powerful way. And the statue of Sasho Sladura provides a potent example of how these horizons can overlap, interweave, and fuse together within the purview of a single object. In Sladura's case, there are the personal silences: the dearth of recordings of his musical output, the tactical self-censorship he employed in his humor, and the obscured details of his death at the hands of the state. These, in turn, speak to a broader series of collective silences: the repression of the prewar bourgeois intelligentsia within a postwar Stalinist-inspired cultural program, and the censorship and scrutiny toward Western popular music, jazz, and those that wrote and performed it. These silences clearly stand on the threshold of the soundings with which they are related. I would take this idea one step further, arguing that one could say that these silences become *soundings* unto themselves—a negation of a negation. Sladura's statue, in being perceived to make no physical sound, broadcasts the story of his sonic essence as powerfully as any technological medium of transmission ever could. In life, he made sounds that are now lost. In death, his body and persona reference those lost sounds, intimately reinvigorating them for those who remember and imagine him. These sounding silences, funneled through the material

guise of the statue, themselves anchor a complex aestheticization of death and the body that has become an integral part of post-Communist life in Bulgaria. It represents nothing less than an alchemy of imagination, romanticism, and myth building that is resonant with those same ideals preserving the neighborhood in which the Sladura statue permanently resides.

But why this statue, and this person, within this book? There are certainly other, more renowned figures from less obscure places and eras through which to conduct a foray into the sounding silences of statues. Choosing Nikolov as my example reflects a deep attachment to his legacy on my part. I have written several pieces on the history of jazz in Bulgaria.[12] Nikolov was one of the most fascinating figures I encountered while conducting research for those works. He remains virtually unknown outside of Bulgaria, and the memory of his persona and exploits slowly vanishes with each passing year. Bulgarian film director Nikola Korabov wrote a script for a Sasho Sladura biopic and tried for years to stir up funding and interest. Korabov was ultimately unsuccessful, and his death in 2016 consigned this project to a permanent purgatory. A novel revolving around Sladura's exploits published in the 1990s by reclusive writer Dimitar Korudzhiev will be referenced later in this chapter. The statue constitutes the most tangible (and arguably the only) ontological trace of Nikolov's life, career, and legacy. I first became aware of him through the statue, and thinking about the implications of his solitary bronze memorial subsequently became the genesis for my conceptualization of this entire book. As such, I owe a scholarly responsibility to Nikolov, one that embeds me within the broader sphere of memory and loss that defines *nachträglichkeit*, and the subtle cultural politics that slips over the dull sheen of bronze.

• • • • • • •

Aleksandar Georgiev Nikolov, the man who would become Sasho Sladura, was born between 1916 and 1918 (depending on the source) in the town of Pleven, not far from the stretch of the Danube River that constitutes Bulgaria's northern border. His father, Georgi, was an engineer from Prilep who helped design Borisova Gradina (Boris's Gardens), the large central park in the center of the Bulgarian capital of Sofia that was expanded as part of the modernizing, European-inspired reforms enacted by Tsar Ferdinand during the 1880s. Georgi later helped design the Kailuka Park in Pleven and Tsar Simeonova Gradina (Simeon's Gardens) in Plovdiv, accounting for the young Aleksandar's presence in those locales. His mother, Katerina Enders, was the daughter of a Swedish ship captain and a Czech pianist whose father

managed the Renaissance castle in the town of Mêlnìk. She and Georgi had met when he was studying in Prague to become a park designer. Because of this multicultural background, Nikolov was able to speak fluently in four languages at an early age. His father's lucrative career in park design and management also afforded him the kind of education available to Bulgarians from affluent backgrounds. As a child in the wake of the First World War, he studied at the recently opened Italiansko uchilishte "Vittorio Alfieri" (Vittorio Alfieri Italian School), which was directed by Angelo Giuseppe Roncalli (the future Pope John XXIII) during his time as Apostolic Visitor to Bulgaria. His teenage years were spent at the laudable Frenskiyat muzhki kolezh "Sv. Avgustin" (St. Augustin French College), a Catholic boys school in Plovdiv that was founded in 1884 and later shut down by the Communist government. These institutions, and his home life in Plovdiv, left Nikolov somewhat isolated from the political tumult that had defined Bulgaria since its humiliating defeat while allied with the Central Powers. This era saw the Bulgarian Agrarian National Union (BANU) government of Aleksandar Stamboliyski overthrown by *coup d'état* in 1923 at the hands of the military and the Internal Macedonian Revolutionary Organization (IMRO). There was also the 1925 bombing of the Sveta Nedelya church in Sofia, an act that drove the Communist party out of the public sphere and underground for nearly two decades.[13] Then there emerged a series of repressive right-wing governments in the late 1920s and early 1930s, in part a response to the perceived threat of political violence from IMRO, and another military coup in 1934, followed by an edict establishing direct rule by Tsar Boris III the next year. By the time the Tsar assumed power, it was common for Bulgarians with wealth to continue their education abroad in other parts of Europe. Nikolov, through connections on his mother's side of the family, arranged to continue his studies in violin at the prestigious Prague Conservatory. In the course of his education, Nikolov became a well-regarded violinist, wrote poetry, and honed his comedic skills through conversations with classmates and friends.

He returned to Bulgaria in 1940, on the heels of the German occupation of Czechoslovakia and the westward *blitzkrieg* into Belgium and France. The country that he came back to was one torn between its relationships to the major powers, weighing the economic dependence and historical ties to Germany against the more opaque territorial promises of the British and the Soviets. After a dispute with the Romanians over the region of Dobrudzha was settled in Bulgaria's favor with German help, the pro-German side won

out and the tenuous policy of neutrality was abandoned. Bulgaria joined the Tripartite Pact in 1941 and fought for the Axis cause until 1944.[14] During the war, Nikolov won an audition to play in the elite Tsarskata filkharmoniya (Tsar's Philharmonic) in Sofia under the direction of Aleksandar Popov. Nikolov quickly gained a reputation as one of the finest violinists in the ensemble, impressing the equally virtuosic Popov—himself considered the best classical violinist in Bulgaria and a former student of the famous Czech pedagogue Otakar Ševčík. After the orchestra was dissolved in the Communist takeover in 1944, Nikolov found work with various dance bands performing at the Hotel Bulgaria, a Sofia institution that American journalist John Reed once called the "one hotel where literally everybody goes."[15] Located on a stretch of Tsar Osvoboditel Boulevard that had constituted the cultural heart of Sofia since the late nineteenth century, the Hotel Bulgaria and its attached restaurant was one of the few remaining locales in Sofia where Western dance music was performed in the late 1940s and early 1950s. Nikolov's most frequent collaboration was as a soloist with the band of Asen Ovcharov, conductor of the most popular Western-style orchestra in Sofia dating back to the mid-1930s. The Hotel Bulgaria would be Nikolov's musical home for much of the next decade, where he began to cultivate the moniker and reputation of Sasho Sladura. It was there that he established his proclivity for female company—so many women, it was said, that he forgot their names and referred to them all simply as *sladka* (sweetheart). It was there that he encountered Russian violin virtuoso Leonid Kogan, who told Nikolov that the same talent Kogan had cultivated through practice was divinely bestowed upon his Bulgarian counterpart. It was there that he entered into a joke competition with Arkady Raikin during the Russian entertainer's 1958 tour of the Eastern Bloc, quipping with such veracity that Raikin doubled over with laughter.[16] And it seems fitting that his reputation—bourgeois raconteur to the core—was built within the walls that carried the withering remains of Bulgaria's prewar elite into the Communist age.

Nikolov's postwar career was cultivated in an environment marked by changes in ideas about Western popular music and jazz within the cultural discourse of the newly empowered BCP. Bulgarian writer and jazz critic Vladimir Gadzhev, author of the only long-form monograph to date on the history of jazz in Bulgaria, writes that after the Communists came to power in 1944, "the concept of jazz did not disappear from the public vocabulary, but was perceived as a conscious reaction against imposing mandatory normative and systematic leveling of emotional experiences."[17] In reality, this

relationship between state and citizen suggested by Gadzhev's statement was far more complicated from the perspectives of the musicians working during that time. The association of jazz within parts of the BCP with unbridled personal expression, irrational and "primitive" behavior, and bourgeois decadence meant that measures were taken to keep an eye on its production and consumption by Bulgarian citizens. Jazz became one of the primary targets of the Komitet za nauka, izkustvo i kultura (Committee for Science, Art and Culture), which had been formed under the Dimitrov Constitution to root out bourgeois influence in Bulgarian cultural life and was headed by future BCP general secretary Valko Chervenkov from 1947 to 1949.[18] However, the Committee's ideological fervor was never quite matched by clear definitions of acceptability, and conflicting interpretations on acceptability led to instances of legal trouble for unsuspecting Bulgarian citizens. Part of the reason for this lack of homogeneity was that despite the best efforts of the BCP to problematize the bourgeois lifestyle, the reality was that even the most stringent application of Stalinist paradigms in everyday life failed to exorcise objects and ideas of Western origin. The primary cause of such failure was the lack of clear ideological definition of what constituted "bourgeois" and how the objects of such designation were to be consumed ethically. For all of the historical conceptualization of Stalinism as a monolithic political and social construction, there was a surprising amount of leeway with regard to individual interactions with government agencies. Vera Dunham and Alexei Yurchak have both written extensively about the paradoxes regarding the value of Western objects in Stalinist-era Soviet literature and youth culture, respectively.[19] This leeway extended to certain kinds of social nonconformity in everyday life under Communism as well. Markov, for example, noted in his memoir that undereducated BCP ideologues who led reading groups of works by Marx, Lenin, and Stalin at a metallurgy factory he worked at in the early 1950s were openly mocked and ignored by audiences of former university students, without significant punishment from administrators.[20]

Despite its vilification in certain quarters of the party, music considered to be jazz was subject to similar ideological slippage. Many professional and amateur Western-style dance bands were still active during the early to mid-1950s in Sofia, Plovdiv, and at the burgeoning Black Sea resorts.[21] These ensembles survived primarily by working in state-run restaurants and casinos, playing everything from tangos, foxtrots, rags, Bulgarian *gradni pesni* (urban songs), and (in some cases) the swing popularized by Depression-era

American bands. This repertoire had, unsurprisingly, changed little from that which had been played in the years before 1944. Bringing in recordings, arrangements, and transcriptions from outside of Bulgaria was difficult, and constant scrutiny of repertoire by the BCP necessitated altering the names of artists or songs titles to disguise their Western origin. Dimitar Simeonov, a young saxophonist during the 1950s, captures this atmosphere of jazz performance during most of the decade when he describes the typical night for his band during a residency at the Hotel Bulgaria during the decade:

> The repertoire required to be known back then [by bands] included classical and modern music. The restaurant had a grand piano, and [the band] Dzhaz na Optimistite (Jazz of the Optimists) played every night from seven to eleven. The first two hours were for symphonic and chamber music, the next two for dancing. We played everything. We had problems with the state because we had invented a composer named "Roze." We played [George] Gershwin, [Louis] Armstrong—everything. And as they asked us what we played, we responded "Summertime, by Roze" or "Rhapsody in Blue, by Roze" again. "What is it?" they asked. *"Rusnak"* (Russian), we replied.[22]

By the mid-1950s, older musicians whose careers started before the BCP came to power were becoming less present in bands like Jazz of the Optimists. Their association with Bulgaria's bourgeois past and extensive education and performance experience outside of the country made them prime targets for the intense scrutiny and limited employment opportunities.[23] While public censure and venue closures were common after 1949, musicians associated with the pre-1944 Tsarist bourgeoisie also became tempting targets for more severe disciplinary measures meted out by the young Communist government.

Their highest-profile target was the popular bandleader and frequent Nikolov collaborator Asen Ovcharov. At the height of the 1949 purges, Ovcharov received an invitation for his band to tour the United States, a significant honor in that his was the first Bulgarian jazz group to receive such an offer. The tour was allegedly brokered by some colleagues from Great Britain with whom Ovcharov had exchanged recordings and sheet music during the brief Allied occupation of Bulgaria near the end of the war. The invitation aroused the wrong kind of attention. Around the time when he would

have been starting the arduous process of acquiring visas and permissions for the band to travel, authorities arrested Ovcharov and officially charged him with crimes against public taste for "jazzing" the proletarian hymn "Internationale." Such arrangements of people's songs was a practice that, perhaps ironically, had been common among Soviet composers a decade earlier as a means of creating popular music amenable to the aesthetic sensibilities of Stalinist ideology. The underlying philosophy behind utilizing aspects of jazz in Communist mass songs stemmed from the ideas of German left-wing composer Hans Eisler, who frequently visited the Soviet Union during the 1930s and had many Soviet contacts. Composer Isak Dunaevskii was one of the leading proponents of such writing, contributing to many different films and revues in Moscow. In fact, mass songs were seen as a potential Communist competitor for mainstreamed American jazz repertoire.[24] Also notable are practices during the Second World War, when music stylistically closer to jazz was more acceptable as long as it contained lyrics lampooning Fascist personalities and themes. American standards such as "Honeysuckle Rose" also appeared during this time with lyrics reinterpreted to support various Red Army causes.[25] In Ovcharov's case, the charge of violating public taste was most likely a convenient excuse to make an example of his perceived collaboration with foreigners, which was interpreted at that time as anti-Soviet espionage. Both Ovcharov and his young wife were swiftly convicted and sent to the *kontslager* (concentration camp) in Tutrukan, where they stayed for a short period before being transferred to the notorious camp at Belene. Upon his release in 1952, he was arrested again and sentenced to six years in prison, which he again served at Belene. Barred from returning to Sofia after his release in 1957, Ovcharov instead settled in Plovdiv. There he spent the rest of his life teaching while battling poor health stemming from his time in prison. Although his career as a major bandleader was finished, he did a few arrangements for Orkestar Sofia (a state-run pop and jazz ensemble led by former colleague Dimitar Ganev) and taught accordion at a small music school until his death in 1967.

For a while, Nikolov was seemingly immune to the censure plaguing his colleagues and friends, maintaining an enviable portfolio of work during this period. After Ovcharov's second arrest in 1952, Nikolov continued at the Hotel Bulgaria and eventually became the leader of Jazz of the Optimists, an eclectic ten-piece ensemble featuring Nikolov on violin and vocals, the aforementioned Simeonov on saxophone, and other musicians playing trumpet, trombone, flute, cello, and bass. Nikolov's experiences studying music

in Prague had made him adept at playing all of the dance styles popular among the hotel's patrons (tango, French *chanson*), and he was able to sing fluently in French. Simeonov recalls that even the group's name came from one of Nikolov's many jokes—upon seeing the ensemble for the first time, he quipped that the group "must be optimists" if they thought they would be able to get any work.[26] Though the group's Western orientation guaranteed limited opportunities to record, a 1954 Balkanton 45 RPM disc of the composition "Samoti" (Loneliness), credited to Mexican film composer Antonio Díaz Conde, shows that the band's sound was similar to other Bulgarian jazz orchestras at that time, resembling the rich, symphonic style of the Paul Whiteman Orchestra, popular in the United States and Europe in the 1920s but long passé in those places by the 1950s. Such an anachronistic sound was not accidental. The music shows none of the technical virtuosity and advanced harmonization of American figures like Charlie Parker, popular across the Atlantic and in Europe during the same period. It lacks even the level of boundary-pushing musicality associated with names of a generation prior—Duke Ellington, Count Basie, even Benny Goodman. Access to these figures, either through recordings or opportunities to hear live performances, was basically nonexistent in early Communist Bulgaria. What few recordings did surface were smuggled in mainly through merchant vessels docking at the Black Sea port of Varna, and no American jazz groups were known to have played in Bulgaria for a period of almost fifty years.[27] While Nikolov could not be considered a trendsetting musician, his abilities kept him in the limelight of the small popular music scene that existed in 1950s Sofia. As his reputation as a bandleader grew, Nikolov began to engage in other opportunities contemporaneous to his residency at the Hotel Bulgaria. Starting in November 1952 he led an orchestra accompanying a variety show in Plovdiv called *Estrada za khumor i satira* (The Humor and Satire Show) that was developed by the editor of the newspaper *Starshel* (Hornet). The show featured sketches by some of the best satirical writers of the time. Despite the show's success, it was closed by order of the BCP Central Committee in May 1953.[28] The closure, in retrospect, was a harbinger of things to come.

By the mid-1950s, Nikolov's veiled criticisms in the guise of jokes transcended his career as a musician, making him an iconic figure among young Bulgarians balancing their desire for Western culture with the nervous panopticon perpetuated by the Communist government. Many of these young listeners self-identified by the gendered designations of *zozi* (for women) or *svingeri* (for men), or collectively by the Soviet designation of

stilyagi, all of which roughly translate to "swingers."[29] *Stilyagi* consumed the available media and popular culture of the West with great enthusiasm, and state newspapers and journals pontificated on the problems caused by these idle, bored youth smoking and loitering, as well as musicians undermining their communities by playing various kinds of "musical barbarity."[30] Nikolov's cool demeanor was an ideal model for their behavior. His attitude was popularly referred to as *Frenski fines* (French refinement), a phrase that can be traced to his thoroughly bourgeois reputation and cosmopolitan background, highlighted by his ability to sing French *chansons* in their original language.[31] As important as his status among the country's disenfranchised youth was, Nikolov's uncanny ability to subtly ingratiate himself throughout various levels of Communist Bulgarian society became his greatest strength. He managed to maintain a great deal of popularity among many of the Communist elite in spite of his jokes aimed at the power of the BCP. Among the frequent patrons of the restaurant at the Hotel Bulgaria were high-ranking BCP officials enjoying the leisure time allowed by their social privilege to drink, smoke, and listen to Bulgaria's finest Western-style dance band. Chervenkov, despite his role in the 1949 purges of bourgeois influence in Bulgarian institutions, was allegedly quite fond of Nikolov despite being the punch line to many of his jokes. This affection was demonstrated by accounts that the first secretary often had Nikolov stay after official gatherings to drink and entertain late partygoers into the night.[32]

The height of Nikolov's success coincided with the first vestiges of Bulgarian de-Stalinization, when Chervenkov gave up his post as general secretary of the BCP at the Sixth Congress in 1954 to serve exclusively as prime minister.[33] Various orchestras took advantage of this cultural thaw by broadening potential performance opportunities both inside and outside of Bulgaria. Nikolov's Jazz of the Optimists took advantage of relaxed travel restrictions and conducted an international tour in 1955, performing in Romania, Hungary, Poland, East Germany, and Finland. They became the first major Bulgarian jazz group to tour outside of the bloc since before the Second World War, setting the stage for lucrative tours by a group featuring saxophonist Edi Kazasyan and vocalist Lea Ivanova starting in 1957. Popular female vocalists like Ivanova and Liana Antonova began to establish international careers as concert singers, while a younger group highlighted by Snezhka Dobreva (as Gina Dobra) and Akhinora Kamanova (as Nora Nova) found their way into the foreign film industry in Austria and Germany, respectively.[34] Other groups used the opportunity to incorporate

a broader range of repertoire past the ears of BCP censors at home. Dzhaz na Mladite (Jazz of the Young), another orchestra active in Sofia during the 1950s, relied on trumpeter Ivailo Peichev to transcribe and arrange pieces from Czech composers influenced by Western popular music. The band also frequently renamed pieces with Bulgarian titles and would occasionally change the surnames of American composers to sound Spanish or Latin American. Even during a time of relative calm, acts of subterfuge remained a way of life.

The 1956 autumn uprising in Hungary that was brutally crushed by the Soviets struck a blow to this period of thaw, and by the next year the BCP regressed to the less tolerant policies of years past.[35] Nikolov was subject to considerably more harassment from the authorities than before. It is not entirely clear why he was so quickly singled out for punishment after the cultural thaw subsided, especially considering how well Nikolov had weathered the purges earlier in the decade. As with all puzzles, there are several pieces to consider. With Chervenkov out of power after 1956, Nikolov lost a sympathetic presence in the upper echelons of the government, or at least someone susceptible to his considerable charms. The new general secretary, Todor Zhivkov, would take a more active interest in shaping the structure and enforcement of cultural policy. Gone was the Stalinst cult of personality favored by Chervenkov, which was subject to easy manipulation via flattery. Instead, Zhivkov quietly—and over some time—adopted a system that rewarded intellectuals and artists for staying within boundaries set by the party, while subjecting those who did not to constant surveillance and punishment. Nikolov, an elder statesman within a small body of transgressive youth, was the kind of aesthete in a position to openly flaunt such measures, raising his profile as a target. The most tangible difference, though, was the appointment of Mircho Spasov as Deputy Minister of the Interior, which included control of Darzhaven Sigurnost (State Security, or DS). As a Communist hardliner, a longtime collaborator of Zhivkov's, and one willing to use violence and murder to achieve his ends, Spasov represented a dangerous and unpredictable element in the enforcement of Zhivkov's cultural mandate after 1956. Allegedly, Spasov had Nikolov on a 1959 list of over a dozen "decadent elements" that he wanted to target for eradication.[36] And he had the tools to accomplish this goal, with boots on the ground in the form of DS, spies throughout the restaurants and cafés in major cities, and a mandate to reopen the *kontslagera* closed during the thaw and make them even more brutal and punitive than before.

More famous, and thus a bigger prize than he had been earlier in the decade, Nikolov was a tempting target for the Communists. And the hammer dropped almost immediately. He was arrested in 1957 on the charge of ideological subversion and spreading vicious jokes and imprisoned at Belene for one year. The term did little to silence Nikolov or even slow him down. Perhaps he knew that it was too late to change even if he wanted, as long as Zhivkov and Spasov were in charge. This interpretation squares with a haunting tale recounted by friend and fellow musician Dimitar Ganev, regarding a trip with Nikolov to the mountain retreat of Vitosha (a peak that dominates the horizon south of Sofia) just prior to the iconic violinist's death.

> We were on an excursion to Vitosha—Sasho Sladura, my wife, and I. It was Sunday. We picked mushrooms, ate lunch, and talked. And at one point my wife said, "Hey Sasho, you are such a talented man, why don't you stop with these jokes? You were already in Belene once. Quit giving people a reason to talk about you." And Sasho says, "No! Stop! No more!" . . . [Later,] I go with my wife [to the restaurant Bulgaria], we sit down at a table and wait for Sasho to appear in the orchestra. It turns out the band starts playing—no Sasho. I ask a colleague "Where is Sasho?" "He's not here," he says. And so, Sasho Sladura disappeared.[37]

The events that surround Nikolov's last arrest in 1961—the one that surprised Ganev and his wife—remain shrouded in mystery. They have become the source of a great deal of innuendo and speculation that has been exacerbated by the ease of such discourse in contemporary media. Such is the case with the most widely accepted account of the fateful moment. On the evening of September 15, Nikolov was gathering with people near the Sveta Nedelya in Sofia, site of the Communist-led bombing in 1925. Nikolov was allegedly joking with the gathered crowd, referring to the Communist Party House as a "burned out circus." Business as usual for the raconteur Sasho Sladura. According to a witness, the comments drew the attention of a nearby police officer, who informed Nikolov that he risked arrest if he continued. Mere minutes after this encounter with the police, a black sedan arrived. Several men escorted Nikolov into the back seat, and he was never seen in public again.[38]

While it is difficult to ascertain if the incident at Sveta Nedelya really happened in the way just described and was in fact the final straw condemning Nikolov to his ultimate fate, the way this story is told almost certainly fuels a

mythical quality that has developed surrounding the event of his death. The collective imagining that there may have been a single *act* of defiance leading to his incarceration feeds the myth apparatus surrounding his posthumous subjective recovery. Existing documentation confirms that Nikolov was one of thirty classified as "political prisoners" sent to the *kontslager* at Lovech that year, the stated reason in his case recorded as *vitsovete* (jokes).[39] Nothing in the available archival literature lists the specific circumstances, particular jokes, or any tangible actions on Nikolov's part that could account for his September 1961 arrest. The identity of who ultimately gave the order to send Nikolov to the *kontslager* will also likely remain a mystery, though suppositions have perpetuated in the popular imagination since the early 1960s.[40] Spasov, the mastermind and administrator of the Lovech camp, has long been a popular choice due to the alleged "eradication list." Others have speculated the order personally came from Zhivkov. Longtime BCP diplomat Bogomil Gerasimov suspected that it was Central Committee member Pencho Kubadinski who gave the order for Nikolov's arrest on the charge of telling anti-party jokes. Geramisov, who knew Kubadinski personally and was also a great fan of Nikolov's, wryly wrote that "if [the arrest order] was true, [Kubadinski] would have to ask for forgiveness from the entire Bulgarian people."[41]

Speculation as to what circumstance may have been responsible for Nikolov's ultimate fate was long subject of rumor as well. Emanuil Doinov, a harmonica virtuoso and close friend, stated in an interview that after a concert in 1961, he and Nikolov found themselves at a banquet attended by Zhivkov and a number of high-ranking BCP members. Well after midnight, no doubt after quite a bit of food and alcohol, Zhivkov apparently asked Nikolov, "Hey Sasho, when are you going?" to which he wittily replied, "We are [going] after a bit, but when will you go, comrade Zhivkov?"[42] Saxophonist Emanuil Manolov offers the same story, only with Chervenkov replacing Zhivkov as the official in question. Another story holds that while filming a movie at the Zlatni Piasutsi (Golden Sands) resort on the Black Sea in 1960, he spent an evening drinking beer with Borislav Chervenkov, brother of the former general secretary. As they began to discuss the meetings between Soviet Premier Khrushchev and President Eisenhower (presumably over the Powers U-2 spy plane incident), Nikolov supposedly asked, "Bore [Borislav], now that the Americans are coming, where will you hide *bai* Vulko?" Borislav's allegedly joking response was "As I bash you, you'll explode and resemble a victim of Hiroshima!" Another holds that one evening a policeman in Varna asked Nikolov what he would do when

a boat full of *frantsuzoiki* (Frenchmen) left port, Nikolov responded that he did not know, but that the Frenchmen had invited him to play a matinee on deck before departing.[43]

The air of mystery and speculation also extends to Nikolov's last eleven days within the barbed-wire fences of the Lovech camp where he died. This was by far the worst of the Bulgarian camps, cruelly nicknamed "Slanche Bryag" (Sunny Beach) by officials after a popular tourist spot on the Black Sea between the coastal cities of Varna and Burgas. It was one of the most brutal and most similar to the infamous Stalinist gulags in Siberia. Of the 1,501 prisoners kept at Lovech between September 1959 and March 1962, 148 died of various causes.[44] Nikolov was not alone in this fate. Although varying accounts have surfaced from prisoners and guards over the years, one of the few versions translated into English is from Nikolas Dafinov, a prisoner at the time Nikolov was first brought to the camp. His account unfolds as follows:

> After being given some new rags, the new arrival was assigned to flatten the ground of the esplande with a heavy roller.... Some of the older Sofians identified the man as Sasha "Dearheart," the famous violinist who played at the restaurant in the Bulgaria Hotel. Sasha Nikolov (his real name) had brought along his violin: clearly, he didn't know where he was being sent. At the evening inspection, some fifteen torturers had a field day. One after the other, they hammered away at the musician as if they were in a relay race. They were absolutely beside themselves. What was the explanation? What had this man done?
>
> We were herded back to the barracks. Those who knew Sasha helped him into bed. Astonishingly, he managed to smile. At a certain point, he leaned up against a pole and asked to be given his violin. He played a bit, enough to remind us of the outside world. Enough to bring tears to our eyes. He then fell asleep, or perhaps lost consciousness—I cannot say.
>
> At breakfast the following morning, it was whispered that the musician was "in the sack." It seemed he had carried his fate with him in the form of an envelope sealed with red wax.[45]

Dafinov's account mirrors a notorious legend that Nikolov was forced by guards to say one hundred jokes about Chervenkov while they took turns

beating him. Yet it also conflicts with other testimonials from prisoners that began to surface after 1989. One, given by a former inmate listed only as "P. L." claimed that Nikolov had allowed a rock trolley to run over his arm to avoid work, later succumbing to the wound's infection.[46] Others claimed that he was lashed to a rock in the Lovech quarry and died from exposure. In this version, his mother supposedly received a telegram stating that he had died of a heart attack a week after his death. Most radical was the idea that Nikolov never died at all: that he was secretly exiled and lived under an assumed identity at an undisclosed location elsewhere in the Eastern Bloc.

Whether he was buried in an undisclosed location, or secretly sent notes wrapped in chocolate candies to his mother while in hiding, the *kontslager* became as much an instrument associated with Nikolov as his trusty violin.[47] In much of the writing about Nikolov from after 1989 there was little separation between him and the institution responsible for his death. And to some, this inability to extricate Nikolov and others from their time in the *kontslager*—forever thought of as prisoners first—was the greatest tragedy of all. Writer Doncho Tsonchev emphasizes this viewpoint in a vignette written about singer Lea Ivanova, who also spent time at the infamous Belene camp.[48] "Already I am sick mentioning this 'Belene, Belene,' but how do you write something about Lea [Ivanova], or about my brother, or about Svetla Daskalova, for example, without mentioning the gulags?" asks Tsonchev.[49] "As if you write about Sasho Sladura (who played until four [o'clock] in the morning on the street in front of the bar, before we split up) and not speak about Lovech and the clubs that killed him."[50] Indeed, this attitude threading together a sounded life with the silence of death pervades many of the subsequent memories of his musician colleagues as well. Several of these testimonials have been recorded in the book *Zlatnata Reshetka* (The Golden Grate) and speak to the inexorable gravity that the manner of Nikolov's death casts over his entire career. For Emanuil Manolov, who called Nikolov a man with "a painful sense of freedom," this takes the ironic use of a term often grafted by the Communists onto the music that Nikolov played. "For him [telling jokes] was natural," Manolov reminisced, "and I think that at home our market's most scarce product is guilt. It's just amazing how such a man can be destroyed by *primitivism*" (emphasis mine). Lyudmil Georgiev remembered Nikolov as a man who always used humor against the excesses of state power, even when it was the Germans or the Tsar himself.[51] One can see the living death pervading these accounts expanded throughout his life in Dimitar Korudzhiev's

1995 novel *Predi da se umre: Fantaziya za Sasho Sladura* (Before Death: A Fantasy about Sasho Sladura), where even the title takes his demise as a conceptual benchmark. A biographical fiction, the book takes the form of a series of disambiguated scenes imagined to take place during Nikolov's life, encounters with various important figures during the 1940s and 1950s. In many of these encounters, the specter of death's proximity layers over the vivid background. It begins with Sasho meeting Tsar Boris III—a man who would himself die under mysterious circumstances in 1944—at the royal palace in Sofia sometime early in the war. Later, he visits the imprisoned vocalist Lea Ivanova at a women's camp near the town of Nozharevo, a powerfully intimate encounter between two of wartime Bulgaria's most popular musicians through the links of a fence. The most apropos scene, however, is the one at the end of the book dealing with Nikolov's own demise. Arrested and transported to Lovech, he finds himself in a room facing the prison official tasked with processing the entertainer into the camp and Shaho, its most brutal and infamous guard. Here, the identities of musician, comedian, and prisoner carried by Nikolov throughout his life meld together in a sequence defined by cold cruelty.

> "Do you believe in God?" he asked, silently forceful, and glanced at the two agents.
> It was the most delicious of his mint candies. For special customers. His fist swelled little by little.
> "I believe."
> "Well, pray to him then. Now only he can save you."
> The black boot kicked the case of the violin.
> "Will you earn something similar?"
> "I am not a slut, mister major. I want a dignified end."
> "And will you not tell us a joke?"
> Later [the Major] realized that he was called "mister." His second question thus remained—without an answer. The blood flowed to his head like a river. And wine. But alone in their terrible noise, he did not understand how the world had come together in such an odious guise—the musician. And in the only name that he remembered:
> "Shaho!"
> Two strokes of the heavy rod toppled Sladura to the ground. The gypsy was tried before the guests. Sasho raised his hands, instinctively counting his fingers. The violin bent and broke. Flames lifted

before his eyes, in them burned the tsar, and the palace, and the prince-virtuoso who had himself gone.[52]

Korudzhiev, as Dafinov does in his witness testimony, places the violin at the center of Nikolov's final living actions. Yet the two differ on how that instrument, the one ultimately responsible for both the fame Nikolov accrued and his subsequent downfall, plays into the end of his story. Dafinov indicates that Nikolov was given the benefit of a final performance, a melancholy tune with the ambiance of the final cigarette given to a condemned person before a firing squad. Korduzhiev, by contrast, makes *not* playing a final request a last act of defiance against the power of the state. That violin is kicked, broken, but ultimately silent at the behest of an owner facing certain death, remaining a loyal lieutenant of the raconteur to the very end.

The significance of the violin in both Korudzhiev's novel and Dafinov's testimony cannot be understated. It becomes not only an integral object in communicating the efficacy behind these tales but an agency-laden presence in the unfolding narratives.[53] The line between these ontologies is negligible. Nikolov's violin somehow manifests as both a part of his body and a body unto itself. It sings with a carnal depth associated with the voice and splinters under force as much as the bones of its partner. Separating one from the other becomes almost impossible, a fact that is subtly reinforced by the form of the statue that captures them. If you focus on the points of contact where violin and human merge, telling where one body ends and the other begins becomes noticeably difficult. On one level, such a feature comes with the imperfect mimetic gesture that remains part of the craft of statue making. On another level, the melding gives a tactile materiality to the relationship between Nikolov, the sounds he made, and the clash between cultures of art and authority that brought about his early demise. All of this makes the embodiment of Aleksandar Nikolov a fulcrum for an obscured body of practices that otherwise would likely remain obscure. Without Sasho Sladura, there can be no memorializing an entire musical culture within communist Bulgaria. And without the memory of sounds lost and the want to revitalize them, there can be no Sasho Sladura to memorialize.

• • • • • • •

Admittedly, all of this personal and cultural history constitutes a great deal of weight for one statue, however idealized its subject, to carry on its own. Can that statue really resonate all of this tragic, compelling, *sounded* history, capturing the silencing of its subject and others through its own tenuous state

of silence? And not just his own violent silencing, but the violent silencing of hundreds of intellectuals and artists penned into the same camps as Nikolov? But if any figure could carry that weight with a warm grin of confidence, how could it not be the great Sasho Sladura? Those who remember him have no difficulty placing such a burden on his shoulders. For them, Sladura was a witty sabot thrown into the gears of a Communist state looking to permanently displace his way of life and those of his colleagues and friends. These narratives construct a figure that in life had already transcended any limitation death could possibly enact. Take the way the stories about him collapse time, space, and detail into the gravity of Nikolov's personality. Never mind whether this joke was about Zhivkov or Chervenkov, or whether the submarine was French or Russian, or whether the excursion to Vitosha took place on a Sunday and he was arrested on a Friday. Crafty and mobile, the way these stories unfold is reminiscent of Roland Barthes's formulation of the relationship between myth and discourse, designed to construct "an ideological critique bearing on the language of so-called mass culture."[54] In the context of Communist Bulgaria, the specter of mass culture folded into the ubiquitous power of the state. The power of selective displacement through storytelling, in the context of a regime that kept copious records of surveillance and imprisonment, was to make the subject of those stories appear in many places at once. Always everywhere in death, he constantly slips through the fingers of those attempting to grasp him, a phantom weaving through the streets of a Bulgaria very different from the one he departed. The phantom of *nachträglichkeit*, to bring back that concept from earlier. And, as Anamaria Dutceac Segesten rightly notes, the economies of rupture, dissolution, and loss that frame post-Communist experience make it an ideal ground for this kind of subjective phantasm via myth to develop.[55]

The question that has preoccupied me for some time revolves around who precisely is undergoing this displacing transcendence: the musician Aleksandar Nikolov or the famed raconteur Sasho Sladura? Two names for one person, an intriguing variation on the dualism of immaterial mind-soul and material body embedded within Western thought since Plato. The difference between the two names is far from merely semantic. For one, the matter of dual identity encompasses the heart of the musical practices engaged by Nikolov/Sladura and his compatriots, tactics of masking for the sake of subterfuge. This is the lived history that the duality of Nikolov/Sladura captures in form. But this duality also captures a power inherent in another set of tactics, the very displacement of Sladura through narrative

that acts as a mechanism of preservation via the technique of fracture. To conceptualize this idea more thoroughly, permit me a small diversion for the sake of clarity. I am reminded of a variation on the vaudeville mirror routine found in the opening credit sequence of *The Patty Duke Show* from the mid-1960s. The bit, as pioneered by the Schwartz Brothers decades prior, featured two different actors in the same clothing mirroring the movements of the other in front of a paneless frame. In the context of *Patty Duke*, one actress (Patty Duke) played two identical characters (the cousins Patty and Cathy Lane). When filming the routine for television, Duke performed in front of an actual mirror, giving the impression that one is watching a version of the mirror routine from within the universe of the program, in which two Dukes exist. Patty Duke and her exegetic relationship to Cathy and Patty Lane becomes a way to think about the Nikolov/Sladura divide. In life, Aleksandar Nikolov and Sasho Sladura shared the same body; as in the mirror facsimile, they appear as one. In posthumous art, Nikolov and Sladura become two people at once; beyond the cusp of the mirror, within death's disembodiment, Nikolov and Sladura take on different roles. One remains dead, a victim of repression, while the other floats as a ghost through the phantasmagoria of cultural memory. Each name points to a different kind of cultural work being performed by what was, and in the guise of the statue appears to remain, one body.

Some further insight can be gained by examining another case where dual naming has turned death mobility into an ethical quandary. In his essay "Walter Benjamin's Grave," anthropologist Michael Taussig recounts the frustrations voiced by Benjamin's close friends Hannah Arendt and Gershom Scholem in attempting to find the German philosopher's burial spot in the French border town of Port Bou, where he committed suicide in 1940 after being denied entry into Spain. In detailing Arendt's failure to find any trace of the grave, and Scholem's declaration of a fake grave based on a photograph, Taussig explains that their mutual difficulty could be traced to the fact that Benjamin was not buried under his own name but under *Dr. Benjamin Walter*, an Anglicized moniker meant to mask his Jewish heritage and gain him entry into a Catholic graveyard. Taussig further connects this dual identity of one body to Benjamin's own idea about the "need to become a thing in order the break the catastrophic spell of things," as Taussig puts it. He then crafts this remarkable passage about how the politics of such name bending point toward the desires of those unpacking and mobilizing death as an object of cultural practice.

It is important to recall such ideas here because with Benjamin's own death strong narratives assert themselves to wrest control of that death, narratives that have little to do with the ideas he laid down in his life's work or that subtly contradict it. Didn't Benjamin himself in his famous essay on the storyteller spend a good deal of time propounding the thesis that it is death that gives authority to the storyteller? ... Taken a step further we might even assert that this is what scares us about death yet tempts us as well, as if the story can be completed yet also amputated by the absence that is death, forever postponing the end to the story that was a life. We want that authority for our own story, nowhere more so than when interpreting a death and, of course, its body. A gravestone or a monument—especially the accusation of a fake one—is just such a story, just such an attempt.[56]

Taussig is hinting at what Michael Ragussis has called the "magic of naming," in which the utterance of identity takes on the playful power of animating the fictional and the dead. Ragussis emphasizes the continuing occultish charge of this magic, which remains potent even as philosophy has attempted to extract it from the broader rational concept of the name.[57] The potency of naming persons, as opposed to naming things, lies in the willingness of others to utilize it to uncouple the dead from their state of thingness. They are transformed, in a sense, into aesthetic marionettes. The drive to engage in this uncoupling, a drive Taussig finds discomforting and indicative of a narrative fascination with death, is the same drive that Ragussis recognizes when saying that the occult undertones of naming the person resist philosophical attempts to demystify those names. In other words, using names to escape the magic of naming is doomed to failure. Dr. Benjamin Walter, an alias that tried to hold off the narrative impulse of the living through subterfuge, ultimately succumbed to the magic of the memorial object pointing toward the body of Walter Benjamin.

The "magic of naming" alone, though, cannot answer why the name Sasho Sladura maintains such unique and transgressive power in a way that Aleksandar Nikolov does not. Something else is needed. As it happens, the magical fluidity inherent in naming connects to another kind of magic that has long permeated the relationship between language and being: allegory, a subject that interested Walter Benjamin himself long before his interment in his border resting place. In his well-known work on Baroque drama from

the 1920s, Benjamin traced the subsuming of allegory (a form that was a dominant representational frame in Baroque aesthetics of seventeenth- and early eighteenth-century Europe) to the dominance of the symbol (which had risen to prominence in the early nineteenth century through the works of Coleridge, Wordsworth, and the Romantics), becoming a cornerstone of early discourse on European nationalism and citizenship. Bainard Cowan, who wrote extensively on Benjamin's theory of allegory, traced this perception of the privileged status of the symbolic to Schopenhauer's stance that allegory represented concepts, whereas the symbol represented the *idea*.[58] Specifically, the symbol presented a field of metaphysical and conceptual coherence that constituted an ideal state of object and being. Allegory, on the other hand, comprised spurious heterogeneous connections of object to world with no basis in a deeper truth or homogeneous unity. Benjamin argued the element providing the symbol with its veneer of desirable unity was in fact an "artificial isolation of the nostalgic impulse" inherent within allegory.[59] The unity of truth promised by the symbol, then, becomes a false promise since the truth of existence lies in its fragmentation, and the human experience of that fragment in creating objects that reflect that experience. In denying fragmentation, "the symbol denies history; ... the symbol masks the imperfections of the real" and perpetuates a mystification that it is somehow beyond both time and space, encapsulating meaning in its purest form.[60] Allegory makes none of these false promises. It is, as Cowan sums up Benjamin's position, "experience *par excellence*: it discloses the truth of the world far more than the fleeting glimpses of wholeness attained in the Romantic symbol."[61]

All of this conceptual movement through naming and allegory brings me back to Aleksandar Nikolov/Sasho Sladura, and the question regarding the exact identity captured by his statue. And here, I return to the idea I planted at the beginning of this chapter, that silence always borders on the sounds that it seemingly and perpetually negates. Statues have a reputation as objects presenting the illusion of ontological and embodied coherence. Silence contributes to that fantasy in many respects, reinforcing the idea that in the guise of the statue, nothing more needs to be said beyond what the statue communicates through its form. When one encounters the statue of Sasho Sladura, the eye sees one statue representing one person, the clean and elegant schema of the symbol. Silence also becomes something to be seen, as much material in its presence as the bronze casting of the body. Knowing the history behind Sasho Sladura's life and career, as well as his

posthumous identity as cultural phantasm, such homogeneity feels strangely incomplete. Silence begins to take on a perverse quality, as a curtain meant to hide something important from view. But where the eye fails to ascertain this something, the ear *hears* this silence and can begin to understand the masking it undertakes. As an organ of inquiry, it ascertains that silence becomes an allegorical entity pointing toward those sounds, physically lost but remembered, from which silence can never fully escape. Nostalgic sounds begin taking back ground in the imagination, pushing the mediating border and subsuming silence into the sonic fold. It is as if, to borrow the rhythm of a famous quote from the poet Sylvia Plath: *silence becomes a sound, like anything else.* The bifurcated naming of Aleksandar Nikolov/Sasho Sladura, then, delineates a becoming for two statues sharing the same body: one symbolic, the other allegorical. The symbolic statue is seen as the statue of Aleksandar Nikolov, its silence memorializing the empty space of loss idealizing the body. This is the statue thought about through the eye. The *allegorical* statue is heard as the statue of Sasho Sladura, its silence carrying the history and possibility of sounded acts obscured but fractiously remembered. This is the statue that is thought about through the *ear.* The power behind the "magic of naming" becomes wholly manifest here. Unlike Aleksandar Nikolov, the name Sasho Sladura becomes as much incantation as identification, his statue pointing to his constant flight even as it keeps the form of his embodied other self anchored into place.

A critique of the fantasy inherent in this kind of allegorizing the dead—of the deployment of *nachträglichkeit*—like that outlined by Taussig with regard to Benjamin's grave no doubt comes into play here. But there are important differences to consider given the contexts. Walter Benjamin could ultimately speak for himself, and did, through copious amounts of writing on both allegory and death. Sasho Sladura, and others like him, did not have such a luxury. Masking and subterfuge, whether by song titles or names, were a way of life for bourgeois remnants in Communist-era Bulgaria. No one was exactly as they appeared. I was once told an old Bulgarian joke about an undercover agent of the Communist state canvassing a coffee house for subversive behavior. A young man sitting at an adjoining table was criticizing the government a little too loudly, so the agent approached him. *You must come with me,* the agent told him. The young man stared back, replying *No,* ***you*** *must come with* ***me***. Turns out they were both agents, neither doing a convincing job of emulating the manner and demeanor of their intended targets, only attracting the attention of each other.

I think of this joke when considering the seeming irony of someone like Sasho Sladura, and the sounding culture he represents, deploying a veil of silence in a sleepy, tree-shaded corner of Plovdiv's historic and tourist-laden Stariya Grad. One looks at his calm, almost winking smile, his suit, his violin, and the feeling of trickery comes into the air, as if appearing in the form of a statue, years after the demise of the Communist regime, was somehow Sladura's last, and most resonant, joke. That his statue (the preferred form of memorializing of the very Communist icons he prodded during his lifetime) was on some level a ruse, a sleight of hand drawing the attention of the eye to the body, the symbolic, and the silence of the object. Meanwhile, Sasho Sladura weaves an allegorical path through the public imagination, having a last laugh at the apparatuses of state that tormented him during his final years. They are the ones, Comrade, who must go this time.

CHAPTER 7

Museums of Resonance

We have been left with the possibility that the silent statue may not be as silent as once assumed. But getting to that point pushes the milieu of the event into those most abstract planes of the sculpted ear, one in which navigation by the self becomes increasingly difficult without a certain level of cultural intimacy. Only a very specific and discerning ear can hear something like the statue of Sasho Sladura as I have presented it. I admit that some may find the mentality required to access this kind of sounding statue a bridge too far, mediating away any notion of an actual object in favor of something existing exclusively within the purview of the virtual. Such a move may be worth it, considering that the politics of silence most often manifests as a dark turn upon the ethos of marginality. That a diffuse extension of the event can redeem and recast silence in the way I have shown can only be regarded as positive. Yet one may wonder if there remains any recourse to pull this necessary revitalization of silence back into the realm of actual things. Are these events, however potent they can become, doomed to remain trapped within the seeds of discourse and the realm of virtuality? Can there be any actual place for these events to emerge from the shadows and folds that obscure them from everyday notice?

An esoteric 1966 article called "The Music of Sculpture" offers an intriguing rejoinder to these questions. Both the full breadth of this piece and its author's identity will be addressed later in this chapter. For now, I want to highlight the opening paragraph, which features a short vignette about a

trip to the museum. Innocuous enough, at first glance. One can quickly tell its origin in the age of counterculture, though, when the author tasks the reader, as prerequisite to their museum experience, with getting stoned.

> Imagine that some Sunday afternoon you go to the Museum of Art to enjoy a quiet hour in the gallery of sculpture. Imagine that you walk through the garden court of the museum on your way to the gallery and there you pass by an exotic plant which has just been imported from a jungle in Haiti. Imagine that as you breathe the fragrance from its flowers your sense of hearing is given an extraordinarily heightened sensitivity. You are suddenly aware of strange music in the air all around you. . . . [T]he effect of the fragrance of the voodoo plant has so heightened your perception that you can hear tones far above those normally detected by the human ear—tones above the range audible to animals, tones far beyond the range perceived by insects. You are now aware that in these very highest, normally inaudible registers all the marble statues possess their own characteristic harmony, while all the bronze statues have their own unique set of harmonic intervals.[1]

This passage takes the concept of the event upon which this entire book is constructed and turns its enactment on its head. It suggests a type of event that is less of a happening at the level of the subject than an ontological constant that the mediated subject steps into through sensory transcendence. There is no need to descend into the realm of the abstract or allegorical to find a sonic thread to weave into the presence of the statue. On the contrary, the statues of this imagined museum are never silent in that most material of senses, whether we are aware of it or not.

This quirky museum vignette offers a deceptively anecdotal means to address a fervent and troubling intellectual trope that has come *en vogue* in recent scholarship in sound studies. There is a way of thinking about the concept of silence that holds that there is no such thing as an actual silence at the level of physical laws. Such an idea has been central to writing about the ontology of sound for years, in the guise of vibration creating perpetual soundings beyond the scope of the human ear. This presence of perpetual vibration carries a deep philosophical legacy, grounded in the ecology of speeds articulated by Spinoza, the "actual occasions" of Whitehead,

and mixed with a healthy dose of Deleuze's concept of the "virtual"—those forces of *differance* operating behind the scenes that drive the appearance of material *difference* in the phenomenal world.[2] The argument often manifests as such: if vibration is physically endemic to every material thing, then not only are all objects perpetually sounding (even if that sound cannot be heard because of physiological lack), but the entire concept of subject and object as discrete entities in space comes into question. Resonance (or dissonance) between nonanthropocentric bodies prior to the advent of perception or signification becomes the most essential site of engagement, and thus a needed avenue of inquiry.

On the surface, the recourse to vibrational ontology does appear to be a nifty diversion of the longstanding aesthetic issues regarding statuary. This, in effect, focuses attention on what statues are prior to becoming the statues we see, making any sonic presence part of the inherent materiality of those statues—a feature resonant in some ways with the philosophy behind sound art and the writings on sculpture by Heidegger mentioned earlier. However, as the links to sound art imply, casting vibration as somehow beyond the purview of meaning, even when the ear cannot engage with the "sound" in question, creates a whole series of issues. For one, the argument can be made that the effect of inaudible vibrations upon different parts of the body still constitutes a form of *hearing*, which is one of the fundamental aesthetic and experiential mechanisms of the modern sound installation. We have encountered this idea already in the writings of Holger Schulze and Brandon LaBelle back in chapter 1. Moreover, the idea that affect always precedes and envelops cognition and the formation of meaning perpetuates a problematic division between mind and body in the act of sensation, an objection brought to bear by Brian Kane in his broader critique of what he calls the "ontological turn" in the field of sound studies.[3] The chapters of this book point toward a similar conclusion, albeit lacking the forthright density that Kane offers. I find it hard to imagine in the quivering wake of *pneuma* and "Mother Africa" that there can be physical vibration beyond the reach of all signification or meaning.

The museum of resonance, while charming to entertain, also shows a path for vibration to maintain an ontological consistency born of science that coexists with the construction of meaning born of art. It does this by tapping into a history of vibrational science in Western thought richer in connections to the magical and the ontotheological than its physical reduction

might suggest. At the same time, the museum reflects a particular desire of its creator to bring these elements together in ways that the broader hearing public could meaningfully appreciate. A museum here is not a metaphor for an abstract space of the mind; it is the possibility of an actual museum in which the event between sound and statuary can be cultivated for the purpose of social engagement. And countenancing its possibility presents nothing less than a way for the sounding statue to step out of the shadows and into the public sphere.

• • • • • • •

As the catalyst through which sound is created, vibration has been central to conceptualizations of sonic ontology in the physical sciences ever since Aristotle declared sound to be the result of the movement of air. Yet it was not until the mid- to late nineteenth century that vibration (and by proxy, sound) would ascend to the level of medium by becoming the site of a last gasp for theories of pneumaticism in the confines of Western modernity. In her compelling book *Senses of Vibration,* Shelly Trower notes that this was a fertile period for theorizing the relationship between vibration and cosmology through both scientific and religious inquiry. While physicists developed new and more complex ideas and technologies to elucidate the extrasensory status of matter, spiritualists took those ideas as evidence that perpetual vibration could manifest as a kind of eternal life for the body in the form of transcendent energy. Among the most widely influential of these emerging models was a wave theory of light, which was demonstrated by English physicist Thomas Young in 1801 and gained traction throughout the century. Light, in the form of a wave as opposed to the particle-base of Newtonian physics, was thought to travel through a medium (*aether*) the same way sound traveled through the air, both leaving trace vibrations in their wake. The result, as Trower explains, was a period in which the perceived motion of sonic transmission became a tangible description for the operations of the rest of the physical (and metaphysical) universe.

> Sound, then, . . . became a model for energy in general, which physicists described as vibratory, imperceptible and infinite. The concept of one kind of universal energy—conserved and converted, transmitted and transformed, but with an underlying vibratory consistency, led to analyses of phenomena as quantitatively, rather than qualitatively different. . . . The identification of waves in space led to analysis of their movement in time, as physicists and other

scientifically informed theorists differentiated between the various forms of energy by quantifying numbers of vibrations in a specific period. In the context of energy with its capacity to take on multiple forms, it was frequently implied that light is sound; sound is light—only light vibrates at a greater speed than sound. By the end of the century a continuum or scale of electromagnetic radiation would define the underlying unity of qualities ranging from infrared and ultra-violet to X-rays and radio waves, all the way up to—at least according to some spiritualists—the frequencies of life itself, extending beyond death into a vibratory afterlife.[4]

This kind of thinking is the ultimate Newtonian legacy: a desire to draw together physics and metaphysics into a steady-state theorization subject to the predictable axioms of physical laws. But the metaphorical conjugation with sound was, in retrospect, a temptation of fate. For as the universe took on more of a sonic character as a means to join together experimental and speculative cosmologies, it also began to mirror the ephemeral and, dare I say, *acousmatic* attributes that the perception of sound held at its core.

Indeed, the ubiquitous modeling spawned through a tenuous linkage between the vibration of waveforms and the analogy of sound began to radically alter by the end of the nineteenth century. For one, the medium through which light was thought to vibrate—*aether*—had fallen out of cosmological favor with the Michelson and Morley experiments mentioned in chapter 2. Then, Einstein's 1905 concept of the photon put a particle-based explanation for light back on the table, complicating the picture even further. Yet the trope of vibration continued *aetherless* into the advent of quantum theory in the early twentieth century, driven precisely by the physical quandary provoked by the light-based photon (later extended to sound by Igor Tamm with the *phonon*).[5] In the ensuing debates over the quantum principle of wave-particle dualism (the idea that molecules could manifest the properties of both waves and particles simultaneously as opposed to one or the other as in classical physics), the metaphor of sound found an oblique wedge in the door of modern physical thought. French physicist Louis de Broglie, in his 1924 doctoral thesis, conceived of an idea that *all matter* could exhibit wave-particle dualism, based on his observation of wave-like behavior in electrons that would merit him a Nobel Prize in 1929. A notable series of critiques on this idea held that these wave properties could only manifest as a theoretical construct based on the fact that they were unobservable.[6] By contrast,

de Broglie argued that waveforms were physically present in relation to the particles themselves. The waveform manifested as the path of projection of a particle, synched together through a concept that de Broglie called "phase coincidence," which he describes in detail here: "I tried to imagine a real physical wave which transported minute and localized objects through space in the course of time.... It was based on the difference between the relativistic transformations of the frequencies of a wave and of a clock. Assuming that a particle possesses an internal vibration, which causes it to resemble a little clock, I supposed that this clock moved in its wave in such a manner that its internal vibration remained always in phase with the vibration of the wave."[7] This concept, known as the pilot-wave theory, was highly controversial upon its introduction in the mid-1920s and remained so even when elaborated and reintroduced by David Bohm in the 1950s, becoming what is now called the de Broglie–Bohm Theory. Regardless, it is important for the way in which it has kept a place for vibration within cosmological concepts, thus providing tangible recourse to the metaphor of a sounding universe that was central to the philosophy of science during the nineteenth century. Or, as Stephon Alexander argues, with de Broglie's ideas "the Pythagorean theory of the harmony of the spheres was realized, but on a microscopic, not macroscopic, level."[8]

I mention de Broglie's pilot-wave theory in detail because of its influence on the ideas of Donald Hatch Andrews, author of the aforementioned vignette about the museum of resonance and a fascinating if slightly obscure individual who emphasized the trope of atomic sound in profoundly unique ways. Born in Connecticut in 1898 and a graduate of Yale, Andrews became a professor in chemistry at Johns Hopkins in 1923 and served as department chair from 1947 until 1963. His main avenue of research during his career was in the thermal resonance of particles at temperatures nearing absolute zero, which sourced a lifelong interest in the concept of atomic vibration. Not long after Bohm revitalized the dormant pilot-wave theory, de Broglie's ideas reemerged into the scientific mainstream for a short time. This coincided with a period of pedagogical focus in Andrews's career, as he began the process of restructuring the curriculum of the undergraduate chemistry program at Johns Hopkins. Bereft of intense research responsibilities during this time, Andrews began to consider how this world of subatomic vibration could manifest in divergent fields of philosophical ontology and aesthetics. Following de Broglie and others, Andrews postulated that the

patterns of waves at the atomic level constituted a "vast and mysterious ocean" of harmony, leading him to the provocative rhetorical conclusion that the universe is "constructed not of *matter* but of *music*."[9] These ideas about the "music of the universe" routed the physical construction of matter into allegorical concepts of melody, harmony, and counterpoint, reflecting a desire to bring together scientific rigor and aesthetic thought into an ethical framework on the nature of life and existence itself. Such an ethical bent was predicated upon the specter of manifesting atomic power in the early years of the Cold War and Andrews's mounting concern about the destructive potential of this power should it be misused.[10] Thus community engagement in various forms became a staple of this ethical turn. He gave lectures at college campuses throughout the Eastern seaboard and appeared on local television programs in the Baltimore area. Topics ranged from rather mundane discussions about the legacy of acoustic experiments in vibration by Chladni and Helmholtz to more creative ones like formulating chords based on the vibrations of chemical bonds and playing them on a piano. In the context of these lectures, Andrews used statues as his object of choice to demonstrate the principles of vibration in three dimensions, progressing in complexity from the rudimentary examples of the one-dimensional string and the two-dimensional metal plate. His choice reflected, in part, the deep sense of humanism embodied within this project. If anthropocentric statues vibrated with a unique molecular signature based on form, then for Andrews the human body carried the same potential homogeneity through diversity.

By the mid-1960s, Andrews was spending his retirement in Miami, teaching part-time at Florida Atlantic and working on his magnum opus on the musicality of atomic vibration that would be released as *The Symphony of Life* later that year. In this capacity, Andrews published his first piece directly addressing his theories of resonant statuary: the aforementioned and striking "The Music of Sculpture," released in the November/December 1966 issue of the journal *Main Currents in Modern Thought*. The bulk of the article details a visit Andrews made to the Baltimore Museum of Art in order to catalogue types of resonant sounds he could coax and record from the statues housed there. This, as one could imagine, took some convincing on the part of a skeptical museum staff. Armed with a rubber hammer, a microphone, and tape recorder, Andrews proceeded to gently strike various types of statues to record the spectrum of sounds that emanated from

their material. He subsequently fed his recordings through a then state-of-the-art harmonic analyzer at Johns Hopkins, a device designed to graph the frequency range of sounds from the human heart. The graphs were then compiled and organized based on attributes ranging from scientifically objective qualities (like size and material) to subjective and rather problematical ones (like the "gender" and "ethnicity" of the figure represented by the statue). His conclusions—that statues of similar shape but different size would resonate with the same harmonic series, and that material affects higher overtones while size affects the lower ones—seem sensible outcomes given the dynamics and scope of the original experiment and the knowledge of acoustical science in general at the time.

But Andrews did not stop with the mere physical conclusions. In later work, he expands upon the Baltimore gallery experiment to argue, in an oblique fashion, for consideration of statues as their own subjective entities based on the footprint of atomic vibrational markers. In *Symphony of Life*, Andrews argues that even though statues of exact shape and differing size resonate with a related series of overtones, each statue maintains its own unique sonic identity on the atomic level. He comes to regard these unique bodies of sound as *voices*, and the sound moving through the hollow resonance chamber within the bodies of certain statues constituting an atomistic act of *singing*. The voices of statues, Andrews opined, would open numerous future possibilities in the field of music, as the resonance of the universe could become a new source for ideas about harmonic theory and structure.

> If this is true, there will be new worlds of harmony for composers to explore for many centuries to come, because the possibilities of scales constructed from the overtones of various geometric forms is unlimited. Not only can these neo-composers compose in the scales of the cube, the parallelepiped, the tetrahedron, the doedecahedron, the sphere, the oblate spheroid, and so on; they can also set up scales constructed from the overtones of the *Venus de Milo*, the David of Donatello, the *Moses* of Michelangelo, the *Thinker* of Rodin, or for a more modern tonality, a *Thing* by Epstein. For each statue has its own set of overtones which can serve as the basis for its own unique scale, and provide its own unique harmony. And if a million years hence, composers have exhausted all the possible patterns of harmony from all conceivable statues, they can start composing in the fourth dimension.[11]

I cannot help reading Andrews's theories of the inherent musicality of statuary and not think of him as a kindred spirit to Italian futurist Luigi Russolo, who proposed a similar framework for the musicality of urban noise in the early twentieth century.[12] And in a sense, Andrews and Russolo share the same failure in how their ideas did not manifest with the potential their creators saw in them. Russolo thought that a music based on the cacophony of modernity would better reflect the quality of life endured by the working inhabitants of the city, a philosophy underpinned by a surprising fascination with spiritualism and the occult.[13] Likewise, Andrews presents a remarkable theory where sounding statues become the linchpin of a scientific humanism, one that brings the parallel developments of vibrational cosmology in physics and spiritualism from the nineteenth century into the modernist orbit. Neither could effectively bring these ideas into practice during their own lifetimes. While the *intonarumori* (noise intoners) that Russolo built never found widespread application in musical compositions after the First World War, the sounding statues Andrews dreamed about suffered from a more fundamental problem. For one, his interpretation of de Broglie may have been based on a common misconception about the French physicist's early theories: that electrons were made entirely of *different types of waves* instead of being particles driven by a wave through sympathetic resonance between them. This mistake, if true, is understandable given that Andrews was a chemist, not a physicist. Yet even if Andrews correctly interpreted the pilot-wave theory for his own use, the vibratory resonance between particle and wave in question remains a theoretical construct and, to this day, an idea remaining on the fringe of mainstream quantum physics. "There was a time when you couldn't even talk about [the de Broglie–Bohm theory] because it was heretical," remarked physicist Sheldon Goldstein in 2016. "It probably still is the kiss of death for a physics career . . . , but maybe that's changing."[14] Given the perpetual maybe inherent in quantum mechanics, the caveat Andrews embedded in his text—"*if this [theory] is true*"—looms over his entire enterprise like a damp blanket.

Although Andrews's dream of a sounding statue (as with so many others) fell short of becoming a reality, his idea of a museum from the vignette in "The Music of Sculpture" in which a bridge between sound and statuary is built through some extrasensory mediation held more promise. Aside from the odd essentialism inherent in his "voodoo plant" from Haiti, Andrews provides a surprisingly nuanced idea about the mediation necessary to bridge the gap between the physiology of hearing and the sounds

existing outside of that capability. The magical flower of transcendent hearing may not exist, but it certainly signifies some future technological device more advanced than anything in Andrews's day that could supplement the capabilities of the ear. Once that bridge of hearing is crossed through a necessary intervention, either chemical or technological, the entire experience of anthropocentric statuary in space fundamentally changes. Each object carries a sonic identity that can be ascertained on its own merits, in line with Andrews's theories about harmonic resonance. Just as important, though, is the collective panoply of sound that would blend together into a chorus within the enclosed space of the museum. In addition to their attributes in isolation, the resonant statues would also contribute to a more productive and engaging resonant whole, reflecting the ethos of humanism underpinning Andrews's entire career in public science. The Andrews museum, in essence, becomes his version of the Platonic cave: a philosophical construct and ethical allegory, in addition to a hearing of a potential future. Like so many other figures mentioned in this book, Andrews tried to reason a way to hear that which would otherwise go unheard, a noble attempt even if the work did not manifest as he intended.

All failures aside, Andrews's imagining of a public engagement with sounding statuary remains a substantial legacy, one that is starting to manifest through technological interventions beyond his wildest dreams. The magnetic tape recorder and harmonic analyzer of yesterday transform into the all-encompassing smartphones of the digital age, and the possibilities of creating interactions between statues and people transform as well. Into this breach steps Statue Stories Chicago, a project started in 2015 to bring sound and voice to thirty public sculptures (both traditional statues and modern, nonmimetic art) located throughout the burgeoning midwestern metropolis. The effort is a privately funded collaboration between the Richard H. Driehaus Foundation, a Chicago-based philanthropic organization centered on arts and culture, and Sing London, an arts collective that has previously put together exhibitions of "talking statues" in several cities throughout the United Kingdom. As with the projects in places like London and Dublin, the Chicago iteration brought in celebrity actors of local origin to provide the voices from some of the statues (Nicolaus Copernicus near the Adler Planetarium is voiced by Johnny Galecki, while Miró's *The Sun, The Moon, and One Star* in Brunswick Plaza is voiced by Shonda Rhimes). Others were scripted and voiced by working Chicago-based actors associated with institutions like Second City and the Steppenwolf Theatre. Once the recordings

were mixed and edited, large placards were placed in the vicinity of participating statues, grafted with a QR code symbol that a person scans with a smartphone to initiate a call. The listener then has freedom of movement while listening to the recorded dialogue, occupying the space around the statue while engaging aurally with the veneer of a personal message. The novelty is not lost upon those creating the voices. "Usually, contemplation of a statue is a one-way affair," remarks actor Gabriel Byrne, with reference to his narrative embodying a statue of James Joyce in Dublin. "In this case, the interaction provides a new kind of dialogue which almost seems to make the statue come alive."[15]

On the surface, there seems little difference between the staging of recorded sound in Statue Stories Chicago and countless other iterations like the singing Elvis in Seattle. But not even the iPhone works as the avatar of disenchantment one might expect. Embedded within the margins of the public engagement constituting the primary mission of Statue Stories Chicago are the very quirky moments of hearing that have intertwined with statuary since antiquity. For some, this means acknowledging a long-held fantasy of hearing that becomes ontologically significant for the first time, as actor John C. Reilly betrays in a quote given for the SSC webpage on the Lincoln statue. "As a native Chicagoan I was really honored to give voice to the statue of Lincoln, a statue I've spent many hours staring up at, imagining what he had to say," Reilly admits.[16] For others, there is the playful simulacrum of conversation shaped by the scripting of the calls themselves. Instead of opening with a typical prerecorded narrative about the statue, as one might expect from a museum audio tour, many of the recordings begin by mimicking the speech acts and rhythm of a typical phone call. At the Cloud Gate sculpture in Millennium Park, colloquially called "The Bean" due to the resemblance of its shape, David Schwimmer politely asks in the guise of the object if you can hear him, before telling you to look into the reflective surface of his curved body and see *another you*. (Among other pithy gems told by Schwimmer's Bean: *"Rumor has it my name is 'The Bean,' which, frankly, I find a bit reductive"*). Another statue, one of comedian Bob Newhart at Navy Pier, presses the illusion even further by cleverly taking into account the space where it resides. Upon scanning the QR code, the call begins with Newhart (who scripted his own dialogue) giving instructions to the listener in the iconic, quiet stutter that made him famous: *"Ah-ah, yeah. Here. (pause) No, no-no, o-over here. (pause, then slightly exasperated sigh) No,* **here***."* Understanding the profound subtlety inherent in this dialogue requires

some more information about the position (and disposition) of the statue. The Bob Newhart at Navy Pier consists of two separate objects: Newhart himself, sitting cross-legged in a chair, and an adjoining couch to the left intended to allow patrons to sit and imagine conversation. The placard with the QR code stands to the left of the couch, meaning that anyone scanning the code will be facing away from the sculpture when doing so. The start of Newhart's narrative acknowledges this position of bodies in space, and attempts to dictate movement and direction to the listener. At this point, the double entendre of the word *here/hear* starts to emerge. The first iteration draws attention to the voice transmitted through the phone (as in, "I'm here"). The second communicates the gap in locality between listener and statue ("I'm located over here, to your right"). The third, though, seems to carry both meanings simultaneously, as if beckoning a skeptical hearer to bear attention of eye and ear toward the statue, who is in fact speaking *to them*. How utterly ironic for Newhart to create a phone call with such depth and detail, considering that his fame rested upon scripting imaginary phone conversations with historical figures living and dead for his stand-up act.

The Newhart statue certainly plays with the medium of technological intervention that drives the Statue Stories Chicago project in a humorous and unique way. But I contend that it is significant and magical beyond even the self-aware performance that Newhart himself gives it. To demonstrate why, I first want to reference an apocryphal story recounted by Greek historian Dio Chrysostom in the first century CE about a statue of a Roman philosopher named Favorinus of Arelate located in the Greek city of Corinth. In order to prevent the Corinthians from tearing the statue down, Favorinus employed the unique strategy of using his *own voice* to speak in the guise of the statue, arguing that even though he—the living Favorinus—was a Roman, the Favorinus statue was just Greek enough to justify its preservation.[17] Such a situation, grafting one's voice upon one's own statue, may not have been a unique occurrence prior to the mechanical reproduction of sound. But like the sound thought to emerge from the Colossus of Memnon, these instances would also be impossible to trace as anything other than an anecdotal echo. Newhart voicing Newhart changes that calculus with an assist from recorded and reproduced sound. In essence, the performance provides a modern spin on one of the deepest metaphysical issues in the history of sounding statues: *someone intentionally giving their voice over to their own physical representation*. Collapsing the gap between signifier and signified,

the long-held fear of what a sounding statue could be becomes manifest at last.

Bob Newhart's statue in particular, and the participants in Statue Stories Chicago as a whole, demonstrates once more how positivism, like aesthetics, fails to offer a tangible escape from the performative gravity of sonic magic. One needs only to recognize the behavioral mystery of quantum mechanics that stymied Andrews to draw that conclusion, even prior to the techno-performativity of a statue calling a smartphone. Indeed, many of the reactions I have observed with regard to the Chicago project border on an odd disjunction in line with reactions to the singing Elvis in Seattle, rather than the incisive rational judgment an everyday intimacy with modern communication technologies might suggest. In 2017, Chicago local television station ABC 7 sent a reporter to Millennium Park to record a story about the Statue Stories Chicago project. One of the interview subjects, a young tourist, had the following to say about Schwimmer's Cloud Gate dialogue: (laughing) "I was a little confused, um, he just kept saying to, like, come closer to The Bean, and to look at it, and there's another *me* somewhere." In the middle of her statement, the woman shimmies her shoulders and looks around, as if unsure where exactly this promised "other her" might appear. She seems to share Don Giovanni's latent skepticism and mild amusement at a statue telling a living person what to do. But for all of the implicit deferral and rationalization suggested by reactions like these, they also index the very moments of hearing that a public performance of sounding statuary has the potential to draw out. And this, more than anything else, carries the most important lesson of the entire book. As I have argued throughout, any history of sounding statuary cannot rest upon the ontology of sound itself. It must emerge from intellectual and social maneuvers that individuals and groups make to try and grapple with what a sounding statue means. And this inevitably happens out in the world, away from the narrow subject- and object-centered framework that underpins the classical ideal of aesthetic judgment: if not the museum Andrews envisioned in which statues resonate with their material voices, then perhaps others, like Statue Stories Chicago, in which statues resonate with cultural voices, an aurality bequeathing a resonant panoply all the same.

For now, while you can, let Bob Newhart (in the guise of a statue that is itself a guise of psychologist Bob Hartley, the character Newhart played on *The Bob Newhart Show*) tell you to have a seat on the bronze couch

beside him and dispense of your worries and troubles. Be warned, though, as Newhart himself will tell you—"bronze is not as comfortable as it looks." Perhaps the couch is stiff and uninviting, but it will not prevent you from hearing his button-down sound with all the comfort and intimacy that Andrews could have imagined for his own museum of resonance.

Conclusion
I Now Present Sergei Rachmaninoff

Throughout this book, I have presented a myriad of ways through which the event between sound and statuary can be conceptualized. They are events whose very possibility has been feared (Laocoön) and that have entranced and laid bare cultural anxieties (Tipu's Tiger). They are events predicated upon realizing the sounds made by the solidity of material (The Commendatore) and exhibiting those sounds inferred by its softness (Josephine Baker). They are events where silence is never silent (Sasho Sladura), where sound can only be heard when mediated (Donald Hatch Andrews), and where mediation can become the crux of a public emergence (Statue Stories Chicago). They are events telling us that to close the ear to the sounding statue, whether for the sake of aesthetic fidelity or rational determinism, misses out on a rich history of conceptual hearing. The sculpted ear casts itself as the crucible of subjectivity upon which this mode of hearing is enacted. It becomes a means to articulate the kind of engagement necessary to dialogue with an event requiring both the mimetic facility of the statue and the dynamic ephemerality of the sonic. By hinging together two sensory paradigms divided by aesthetic fences and walls of *épistémê*, the sculpted ear is nothing less than the mechanism through which the sounding statue becomes possible.

One book cannot possibly cover all of the plausible permutations that can make up the sculpted ear. This is another reason why event metaphysics provides a more dynamic framing in ways that an object-centered ontology does not. For any concept of the object is inherently enclosed by its own physical threshold and those properties that give a sense for how it constitutes itself. Such is the trap of statue thinking. With an event, the possibilities are limitless. It is this sense of the unlimited possibility in the sounding statue that I hope the reader takes away from this book. Andrews, the scientist with the weird dream, was the one who came closest to touching this sense of possibility. Every statue, for him, carried a sounded life just beyond the limit of our listening powers, waiting for us on another plane of the real. But he also knew that something more than mere technological devices would be necessary to get there. One also needed a spark of the old magic, the kind that modernity would rather keep locked away among the dusty tomes of forgotten cosmologies. *Pneuma* was one way of articulating that magic, and even though the material *pneuma* may not exist, the broader sense of magic that invigorated it remains. The magic of the event was the missing link, the last ingredient that I crept ever closer toward over the course of the nearly six years that I worked on this project. I knew that a statue could exist; I also knew that a sound could exist; only when I allowed myself to consider a piece of the magical did I finally find a means of bringing them together.

All told, I can think of no better way to conclude than by yet again putting my money where my mouth is, by offering another experience regarding an event between sound and statuary—my own sculpted ear—lest you think I was somehow immune to the magic of these encounters. If Homer Simpson was the unacknowledged kernel of the idea, and Sasho Sladura the seed of that idea planted, this particular event was the one that opened my imagination to the germinating possibilities that a sculpted ear could entail. Unlike Elvis, who left his domicile via malfeasance, this character reentered the building with which he was associated because of the nostalgia and desire of a community. The statue marking the physical trace of that apparatus of memory was not itself sounding. Rather, the place of the statue within a related sounded performance left an indelible mark upon me, spawning a similar flight of fancy and thought that populated the wake of discovering the singing Elvis. In this instance, my thoughts revolved around a particular question: *if a statue preserves the body in a particular moment, can it also carry the sounds associated with that moment into the present?* To put this

another way, if singing Elvis taught me to think about the sounds statues make, this forthcoming tale taught me to think about hearing the sounds that surround and permeate them.

The root of the encounter begins with a rather ordinary piano recital that took place long before I was even born. On February 17, 1943, Russian pianist and composer Sergei Rachmaninoff arrived in Knoxville to perform at the Alumni Gymnasium on the campus of the University of Tennessee. He was not scheduled to stop in the city during this particular tour, but decided to make the journey from Louisville to make up for an autumn 1942 performance that had to be cancelled. Before an audience of almost three thousand, Rachmaninoff played a program of Bach, Liszt, Schumann, Wagner, and Chopin's "Funeral March" before encoring with his own "Prelude in C# Minor," a crowd favorite and concert staple. Jack Neely, a longtime Knoxville journalist who interviewed several attendees of the concert for a 1984 article in the local lifestyle magazine *CityTimes*, recalled his neighbor and local pianist Evelyn Miller stating that the Knoxville performance was the finest of the many that she had heard from Rachmaninoff.[1] Some noticed that the sixty-nine-year-old virtuoso seemed unusually frail and thin, but his powerful performance seemed to put to rest any lingering concerns about his health. What those in attendance did not know was that the Knoxville concert would be Rachmaninoff's last. The pianist took the train to his next concert stop in Atlanta before abruptly deciding to cancel his remaining performances and return to his home in Los Angeles. Terminally ill with cancer, Rachmaninoff died on March 29 due to complications from pleurisy, just shy of his seventieth birthday and a little less than two months after he and his wife Natalie became naturalized American citizens.

Sixty years later, Rachmaninoff rose from the grave and returned to Knoxville, or at least his image did. This rather ordinary brand of necromancy was courtesy of Russian sculptor Viktor Bokarov, a self-declared Rachmaninoff devotee who created an eleven-foot plaster cast of the pianist with the stipulation that it be erected somewhere in the city of his last concert. The plaster mold was sent to Jack Mullen in Kingston, New York, who cast and assembled the bronze pieces of the statue for his unveiling in Knoxville in July 2003. Rachmaninoff, in his new guise, stands in a small grove near the amphitheater in World's Fair Park, just off the corner of Eleventh Street and Cumberland Avenue, less than a mile from the building where the last concert took place. His bronzed form is gaunt and frail, much like he appeared during his terminal 1943 visit. Dressed in his concert tuxedo,

he bows his head slightly while holding on to the front of a pedestal cast to resemble the keys of a piano. On the opposite side is an inscription with a portion of the plainchant notation and text of the "Dies Irae," the well-known portion of the Roman Catholic Requiem Mass that had been quoted by Rachmaninoff in several of his compositions.[2] The irony is that while the statue itself is carved with one of the most tangible signifiers of death in Western music, the same statue has become an integral part of the revitalization of the park site in recent years, after decades of disrepair left the area void of the modernist charm that it carried during the 1982 World's Fair and ripe for talented popular culture satirists. (No, contrary to the *Simpsons* episode, they do not keep wigs in the Sunsphere. Everyone asks.)

For ten years, the statue of Rachmaninoff stood quietly in its small grotto, piquing the interest of curious tourists and the few devoted fans making a pilgrimage to the site of his last concert. But in 2012, the reanimation of body and place that started with the statue began anew, with greater acuity. For the upcoming seventieth anniversary of the final concert, a partnership between the School of Music at the University of Tennessee and the Evelyn Miller Young Pianist Series, a Knoxville area charitable organization that had brought concert pianists to Knoxville since 1980 and was named after the music enthusiast with whom Neely spoke in 1984, developed a concert of their own. Billed under the title *Rachmaninoff Remembered* (a double entendre of mind and body, to be sure), the concert would take place in the James Cox Auditorium on February 17, 2013—the renovated site of the Alumni Gymnasium where Rachmaninoff played, on the anniversary of his final concert. Playing the part of Rachmaninoff that night would be Russian pianist Evgeny Brakhman, a devotee and interpreter of Rachmaninoff's work who taught at the Nizhny Novgorod State Glinka Conservatoire, located in Rachmaninoff's hometown. The attention to historical resonance was itself a performance and a harbinger of the concert to come.

Rachmaninoff's statue hovered with surreptitious presence over the proceedings, taking on a greater body of meaning as the concert drew closer. The statue appeared in the posters and cards used to promote the event, in lieu of more traditional photographs of the pianist. While the actual statue carried a deep and ruddy bronze hue, the illustration on the poster gleamed with a soft gold, as if to polish his still repose for the coming spectacle. I recall the brief radio promotions, where on-air personalities for university-run WOUT appended each announcement of the upcoming concert with an invitation to *visit* the statue itself as if part of the concert experience. The

statue was even included as part of the concert itself. As if the spectacle of reinvigorating the time and space of the final concert in the present were not quite enough, standing in close proximity to the piano on the stage of the Cox Auditorium was a cardboard facsimile of Rachmaninoff's statue. Though reduced in size from his gargantuan eleven-foot height in World's Fair Park, it was still large enough to catch the eye from the back of the cavernous hall. The reproduced statue image remained on stage throughout the entire concert, arched over in a slight bow as his actual statue. In the park, the bow reads as a culmination, capturing the last bow he would ever give in life in the wake of his final concert. On stage, the bow gave the impression that he was looking across the stage and over Brakhman's shoulder as the young pianist played the compositions that the living Rachmaninoff wrote for his own performance career: *Variations on a Theme of Corelli*, Op. 42; a few of the *Études-Tableaux*, Op. 33 and Op. 39, the latter of which Rachmaninoff played on the same stage in 1943; *Sonata No. 2*, Op. 36. Alan Sherrod, a local music critic who wrote a review of the concert for the now-defunct weekly paper *Metro Pulse*, indicated the feeling that what occurred during the concert somehow transcended the understated performativity of the typical piano recital. "Brakhman's grasp of Rachmaninoff was so conversational and complete that I felt I was hearing a poet reading his own poetry. Clearly, the pianist had long ago accepted the gravity of the event and the gravity of his responsibility, and had become one with it. And, with this acceptance came a performance that emerged from his musical soul and flowed out over the audience almost magically. Magic, or not, something rare and special existed in Cox Auditorium on Sunday evening, and obviously, many in the audience felt it."[3]

I contend that the sense of magic Sherrod identified with the performance permeated these proceedings long before Brakhman ever stepped foot on the stage. Once, I came across a story claiming that in a fit of superstition, Vladimir Horowitz refused to ever perform in Knoxville for fear that the city had somehow cursed his mentor and caused Rachmaninoff's death.[4] For me, there is a self-evident connection between the presence of the statue, the historical weight of the music being played, and the recourse to magic at the point where critical rationality fails to account for what happened. Rachmaninoff's statue—even in reproduction—tipped the balance into what anthropologist Kathleen Stewart (drawing on Taussig) has called "mimetic excess," where "subjects, objects, and events become performers in a spectacle, and the act of mimesis rises to importance as a local 'way' . . .

[articulating] moments of occupying an always already occupied place."[5] And the concert was nothing if not an exercise in mimetic spectacle. The statue became the bridge between recital and *ritual*, between Brakhman's performance and Rachmanioff's *possession* of that performance in the abstract, between sculpted image and music presence. The event even came with its own incantation, in the form of Brakhman's introduction to the stage. *I now present Sergei Rachmaninoff*, the acousmatic speaker intoned, culminating the magical work of bringing image, body, space, and sound together into an act of performance. At that moment, in the space of the auditorium, the temporal boundaries between the 1943 concert and its 2013 reincarnation become fluid, into what Henri Bergson would have recognized as a manifestation of his famous concept of *durée*.

The statue of Sergei Rachmaninoff is no idle object in these proceedings. On the contrary, it is the very object without which this kind of Bergsonian blur would fail to manifest. This is the power that statuary continues to evoke, a power against which modernity, science, and aesthetics are inadequate barriers and sound is a ubiquitous attribute. There remains, I fear, a reluctance to admit this kind of hearing happens, as if doing so allows a disruptive rush of magic into the tidy chamber of modern life. Yet such hearing awaits, one that cornered the individuals and groups throughout this book with a quiet fury and remains the same fury that waits for us if we are so inclined to countenance it. We ignore these events between sound and statuary—in this context, in those that appeared in the preceding pages, and in the unwritten future—to our detriment and at our peril.

Notes

Introduction

1. The video for this evening magazine piece, titled "The Singing Elvis Statue Mystery," has been removed from the KING5 website as of 2019.
2. The entry on "event" in the Stanford Encyclopedia of Philosophy is an invaluable resource in tracing these numerous philosophical threads that I lack the time or scope to address in this book. See Casati and Varzi, "Events."
3. See Robinson, "Deleuze, Whitehead, and Creativity," 207–30.
4. Deleuze, *Fold*, 77–80.
5. Badiou, *Being and Event*, 429.
6. McCormack, "Colossus of Memnon and Phonography," 177–87.
7. Sterne, *Audible Past*, 2.
8. Adorno, "Curves of the Needle," 271–76. Examples of this body of thought regarding the perceived aesthetic lack of the Colossus can also be found in Mason, *Colossal*, 37, and Hegel, "Complete Symbolism," 358.
9. Sterne, *Audible Past*, 14–19.
10. Rancière, *Aisthesis*, x–xi.
11. On this point regarding race and listening in the context of American history, see Stoever, *Sonic Color Line*, 13–18, and Smith, *Smell of Battle*, 9–38.
12. Voegelin, *Listening to Noise and Silence*, 13.
13. Ziarek, *Language After Heidegger*, 178.
14. Szendy, "Auditory Re-Turn," 25.

Chapter 1

1. Gross, *Dream of a Moving Statue*, 6.
2. See Baudelaire, "Philosophy of Toys," 11–21.
3. Magnus's automaton apparently worked as a door guard and asked questions to ascertain whether or not a potential guest would be admitted. Voskuhl, *Androids in the Enlightenment*, 28.
4. Gross, *Dream of a Moving Statue*, 17–19.
5. Verdery, *Political Lives*, 5.
6. Boehrer, *Animal Characters*, 115–16.
7. Potts, *Sculptural Imagination*, 24.
8. Locke, *Essay Concerning Human Understanding*, 33.
9. Hegel, *Hegel, on the Arts*, 87.
10. Guyer, "Beauty, Freedom, and Morality," 149.
11. Herder, *Sculpture*, 80–81.
12. Spivey, "Bionic Statues," 443–47.
13. Quoted in Potts, *Sculptural Imagination*, 1.
14. Gay, *Modernism*, 168–71.
15. French exoticism and Italian futurism, both of which were rooted in practices developed prior to the war, are two of the more renowned examples where artists looked outside the confines of classical aesthetics. One of less repute was a neo-medieval movement among French sculptors in the 1920s, where both the aesthetic and the crafting (including use of the painstaking *taille* direct method of chiseling into stone) drew from local sources dating back to the thirteenth and fourteenth centuries. See Golan, *Modernity and Nostalgia*, 28–36.
16. Richard Serra, for example, critiqued the sculptural process of metal casting with *Gutter Corner Splash* (1969), where he threw molten metal into the crease of a room where the wall and floor met and pried out the finished product into long, jagged strips once the metal cooled.
17. Krauss, "Sculpture in the Expanded Field," 43.
18. Quoted in Mitchell, *Heidegger Among the Sculptors*, 69.
19. Ibid.
20. Gascia Ouzounian gives a prominent example of Tom Marioni's *Sound Sculpture As* (1970), where the artist fashioned a structure that created sequences of tones triggered by urinating into a bathtub. Martha Brech offers Gary Hill's *Cut Pipe* (1992), a piece

that featured two pipe ends covered with membranes projected onto screens, where visitors could both hear and see their hands manipulating the surfaces. See Ouzounian, "Sound Art," 4, and Brech, "New Technology," 215.

21. LaBelle, *Background Noise*, 180.
22. Kahn, "Arts," 2.
23. Licht, "Sound Art," 7.
24. Kane, "Musicophobia," 16–18.
25. Chattopadhyay, "Beyond Matter."
26. Serres, *Statues*, 14–15.
27. Serres and Latour, *Conversations*, 138–42. See also the translator's note on p. 205 for a helpful background for parsing the discussion about the Serres book.
28. Malabou explores the implications of plasticity in several of her texts, but a useful summary of these perspectives can be found in Bhandar and Goldberg-Hiller, "Introduction," 1–34.
29. Schulze, *Sonic Persona*, 75–76.
30. Brian Kane's 2015 article critiquing the ontological turn in works by Steve Goodman, Greg Hainge, and Christoph Cox is essential reading on this subject. See Kane, "Sound Studies," 2–21.
31. Schulze, *Sonic Persona*, 76.
32. Lynch, "Ontography," 444–62. For an application of Lynch's arguments to the ontological turn in the field of sound studies, see Kane, "Sound Studies," 16.
33. Classen, "Fingerprints," 3.
34. King, *How to See New York*, 37.
35. The exploding eagle took most of the supporting marble spire down with it. Lesson learned; the organization responsible for the monument replaced the eagle with a less conductive Union soldier made of marble when the top was reconstructed in 1906.
36. Kim-Cohen, *Blink of an Ear*.

Chapter 2

1. Pliny, *Natural History* 39.4.37, ed. Rackham, 29.
2. There are several areas of controversy that continue to follow the sculpture, including its precise date of origin, whether or not it was commissioned by the Emperor Titus, and whether the marble was a reproduction of a bronze original as Pliny implied. For a reference questioning whether the statue was meant to express the virtuous tolerance of pain or to present a spectacle of suffering as an expression of justice, see Spivey, *Enduring Creation*, 34–36. For a discussion as to whether the *Laocoön* was even considered unique as a virtuosic work of classical sculpture, see Barkan, *Unearthing the Past*, 2–6.
3. Darwin, *Expression of the Emotions*, 141.
4. Lessing was no doubt influential on the relationship between beauty and sculpture that peppered the aesthetic philosophy of figures in the orbit of German Idealism such as Kant and Hegel. See Prager, *Aesthetic Vision*, 17–33, and Roulier, *Kantian Virtue*, 103–6. For a discussion on the legacy of Lessing's essay on the work of modernist figures such as Irving Babbitt, Clement Greenberg, and Theodor Adorno, see Albright, *Untwisting the Serpent*, 10–16.
5. Though Lessing's motives for making this argument have been questioned in subsequent interpretations, it was unmistakably influential among those seeking to preserve distinction between various artistic practices. Some have questioned whether or not Lessing had actually seen the *Laocoön* personally, prior to writing his essay, or simply presaged a broader distaste for modes of ekphrasis in the aesthetics of German Idealism. See Ernst, "Not Seeing," 118.
6. Mitchell, *Picture Theory*, 155. Lessing's disdain for ekphrases and music may also have contributed to the overwhelming sense of silence inherent in the *Laocoön*.
7. Brilliant, *My Laocoön*, 56–57. Fun fact: Sadoleto was part of the sixteenth-century excavation of the statue and wrote a highly regarded poem about it.
8. See Winckelmann, *History*.
9. Lessing, *Laocoön*, 7.
10. Ibid.
11. There is ample reason to think that Winckelmann was alluding to Pygmalion in this passage, since it was a reference he often utilized in his writings about sculpture. See Hertel, *Pygmalion in Bavaria*, 45–50.
12. Agamben, *Stanzas*, 90.
13. Ibid.
14. Ibid., 94.
15. Hack, *God in Greek Philosophy*, 45–46.
16. Benso, "Breathing of the Air," 15–16.
17. Draasima, *Metaphors of Memory*, 25.
18. Aristotle, *Life-Bearing Spirit*, 176–77.

19. Ibid., 7.
20. Aristotle, *On the Soul*, 66. The Greek work *semantikós* as used in this context has also been translated as "a sound with meaning." See, for example, Riethmüller, "Vox Alias Phoné," 83.
21. Wells, *Secret Wound*, 84.
22. Bloom, *Voice in Motion*, 82.
23. Lapidge, "Stoic Cosmology," 168. Stephen Toulmin and June Goodfield give the useful analogy of sound emanating from a vibrating drumhead. Toulmin and Goodfield, *Architecture of Matter*, 96–97.
24. Johnston, "Fiat Lux," 18.
25. Quoted in Grosz, *Incorporeal*, 24.
26. Plutarch, *Morals*, 171–72.
27. Staden, "Anatomy and Physiology," 45.
28. Lokke, "Active Principle," 62.
29. McDermott, *Liminal Bodies*, 61.
30. Chrystal, *In Bed with the Romans*, 76–77.
31. Wells, *Secret Wound*, 84.
32. Caverero, *More Than One Voice*, 20.
33. Bloom, *Voice in Motion*, 80–81.
34. Quoted in Heffernan, *Phoenix at the Fountain*, 77.
35. Layher, *Queenship and Voice*, 29–52.
36. Walter, "Corrupt Air," 15, and *Our Old Monsters*, 63–64.
37. Fallon, *Milton Among the Philosophers*, 102.
38. Neither Campanella nor Hobbes used the term *pneuma* specifically. Leijenhorst, *Mechanisation of Aristotelianism*, 68–70.
39. This preface, Peter Barker notes, shows signs of having been influenced by Cicero's concept of *pneuma* in *De natura deorum* (On the nature of gods), an important text grounded in various tenets of Stoic, Epicurean, and Skeptic thought. Barker, "Stoic Contributions," 143.
40. Cohen, *Rise of Modern Science*, 230.
41. Hankins, *Science and the Enlightenment*, 127.
42. Smith, *Acoustic World*, 101.
43. Bacon, *Philosophical Works*, 3:522.
44. Ibid., 195–206.
45. Bloom, *Voice in Motion*, 83.
46. For more of an overview on the historical relationship between anatomy, resonance, and modernity in Western thought, see Erlmann, *Reason and Resonance*, 9–28.

47. Weber quoted in Koshul, *Postmodern Significance*, 14.
48. Dyson, *Sounding New Media*, 20–26.
49. A fascinating and informative reading of the implications of Delphic *pneuma* comes from Economakis, "*Chasma gês*," 22–43. The reference to Victorian women is found in Losseff, "Voice, Breath, Soul," 9–10.
50. *Pneuma* was key to the Neoplatonic idea of *telestike*, a practice thought to animate images or summon a divine presence into an inanimate vessel. Although the types of images used could include paintings and other works of art, statues represented the most dramatic and lifelike of subjects. Sonic emissions were one of many manifestations taken as evidence of pneumatic influence. Syrian Neoplatonist philosopher Iamblichus wrote in the late third century CE about a summoning practice where a noncorporeal spirit would move through body of the hollow statue, sounding like a "whistling arrow." The statue served as the material link between people and their divine object of worship. While the pneumatic connection through the statue allowed for mortal grasp of a transcendent power, *pneuma* also facilitated the interaction of divine entities through a material amenable to their presence. One can get a sense of how *telestike* could be dismissed as mere idolatry, especially from proponents of Enlightenment rationality who were critical toward Neoplatonism's connections to older religious traditions from Egypt and Mesopotamia. See Berchman, "Rationality and Ritual," 241, and Uzadinys, "Animation of Statues," 118–19.
51. Derrida, *Of Grammatology*, 17.
52. While most of the earliest Greek epigrams were attached to monumental *stele* lacking anthropomorphic form, those attached to statues reinforced a latent egocentrism transcending their object forms. "Mantiklos has dedicated me to the far-hitter of the silver bow as part of the tithe," states a well-known Delphic figurine from the seventh century BCE, "and you, Phoibos, give pleasing compensation." The presentation, argues Egbert Baker, folds in the physical voices of reader, writer, and object into a single performative act. Baker, "Archaic Epigram," 198.
53. Gebauer and Wulf, *Mimesis*, 199–200.

54. Gross, *Dream of a Moving Statue*, 141.
55. Steiner, *Images in Mind*, 27–28.
56. Pentcheva, *Sensual Icon*, 197.
57. Warwick, "Making Statues Speak," 30–32.
58. Christian, "Poetry and 'Spirited' Ancient Sculpture," 109.
59. Ibid., 109–10.
60. Gross, *Dream of a Moving Statue*, 92–94.
61. Ibid., 95.
62. Schenker, *Bronze Horseman*, 276.
63. Alexandre Benois captured the foreboding atmosphere of this moment in a brilliant 1903 illustration, where the shadowed bronze horse rears in triumph with Peter while the pursued Evgenii desperately stumbles to stay out of reach.
64. Jakobson, *Pushkin*, 31–32.
65. One of the most well-known myths of divine animation via breath—the golem—articulates this concern of potential misuse. Rabbi Loew's golem was created by a figure carrying cultural legitimacy, brought to life by divine incantation to protect the Jews of Prague from the blood libel. By contrast, a female golem allegedly created through the same process by Andalusian poet Solomon ibn Gabirol was rejected as an abomination by the community, because Solomon created her to function as his personal servant. Schwartz, *Tree of Souls*, 278–85.
66. Quoting Robert Reid: "Pushkin elaborates this semiotics [of lifelikeness] in such a way that it is impossible to conclude that Evgenii in the Bronze Horseman is somehow an aesthetically correct viewer of the statue. Pushkin adds a preliminary metaphoric semiotic in which Evgenii (and Don Juan) address their statues as though they were alive; it is this provocative communication which animates their statues; or by corollary one may conclude that Pushkin verbalizes the aesthetic criterion of ekphrasis—to be life-like is to understand words." Reid, "Introduction," 9.
67. Métraux, *Sculptors and Physicians*, 43–45.

Chapter 3

1. I will be switching back and forth between the British spelling of the eighteenth-century capital of Mysore (*Seringapatam*) and the more correct transliteration (*Sri Rangapattana*) depending on the context.
2. De Almeida and Gilpin, *Indian Renaissance*, 35.
3. Ibid., 38.
4. In *The Tiger of Mysore: A Story of the War with Tippoo Saib* (1896), popular adolescent adventure novelist G. A. Henty writes of Tipu's "abominable cruelty" left to flower because various governor-generals of India did not crush him early enough, leaving him to cultivate a joy for torture, bloodshed, and forcing "English captives" to train his army in European drill and tactics. Henty, "Tiger of Mysore," 173–74.
5. Jasanoff, *Edge of Empire*, 177–80.
6. Stronge, *Tipu's Tigers*, 13.
7. Ibid., 17.
8. Brittlebank, "Sakti and Barakat," 260.
9. The British Library eagerly incorporated about three hundred of these texts after his death, though many were lost to looting and burning in the first days after the siege. Among those preserved were Tipu's personal copy of the Koran, his dream journal, and some of his personal papers that were later translated by William Kirkpatrick and published as Tipu Sultan's personal memoir.
10. Husain, trans., "Diplomatic Vision," 29. The objects were meticulously organized and catalogued in way that impressed even European observers. One British account estimated the total amount of Tipu's possessions at around "five hundred camels load," which speaks to the awe the sheer amount and diversity of his belongings provoked. *Narrative sketches*, 100.
11. His awareness of international affairs apparently extended all the way to the Western hemisphere, where he saw the American Declaration of Independence as a model for Indian resistance against the British. "What is thrilling," Tipu wrote about the American Revolution, "is that the ancient Indian concept of kingship should come to be transformed into deeds far away . . . , spelling disaster for a colonising, imperial power." Kausar, *Secret Correspondence*, 306.
12. Tipu understood that closing the technological gap with the East India Company would be the only means by which Mysore

could remain politically solvent in the long term. As such, he shaped his army using the best available tactics and weaponry from Western sources. Roy, *War, Culture, and Society*, 77. Mysorean rockets featured a cylinder of soft hammered iron lashed to a stalk of bamboo for stability. The metal structure allowed more gunpowder to be packed in the body, allowing for greater range and accuracy than any rocket developed by Europeans to that point. Accounts of Tipu's rockets appear in several accounts of the Anglo-Mysorean wars, some of which compliment their effectiveness in combat. They were cited as blowing up a munitions pile at the Battle of Pollilur in September 1780, a stunning victory for Mysore that Tipu commemorated with a massive mural in his palace. Their effect was apparently impressive enough for the British army to investigate acquiring the technology and incorporating it into artillery units during the heart of the Napoleonic Wars. Narasimha, "Rockets in Mysore," 5–9.

13. Lafont, "*Mémoires* of Lieutenant-Colonel Russel," 99.

14. Colley, *Captives*, 298.

15. Ibid., 316.

16. Scott, *Complete Works*, 7:198.

17. Tipu worked tirelessly to cultivate a strong military relationship with France, seeking not only weapons and training but a fully formed alliance to check British expansion in India. He went so far as to send diplomatic envoys in 1788, disappointed when they returned with a porcelain tea set from Louis XVI instead of a treaty.

18. Chakraborty, "'That disgrace,'" 58.

19. Interestingly, an account written by a Scottish officer named Innes Munro in the early 1780s favorably compares Tipu's father Haidar Ali to Frederick the Great. Colley, *Captives*, 298.

20. Malhotra, *Making British Indian Fictions*, 33.

21. "Tippoo's Tiger," 319–20.

22. By the standard of instrumental design, the entire apparatus is woefully inefficient. Since the operation of the organ bellows relies on the crank, the only way to reasonably play the instrument is to turn the handle with the left hand while playing the keyboard with the right. The sequential arrangement of the buttons makes it virtually impossible to play an octave with one hand, and the close proximity of keys limits the technical precision a performer can employ. The entire assembly is so nonidiomatic that Willis (who performed the restoration of the tiger in the 1950s) suggested that the keyboard design was intended for a performer of limited musical skill to rake the knuckles up and down the keys rather than play discrete pitches. Ord-Hume, "Tipu's Tiger," 73–75.

23. Ibid., 75. More interestingly, Ord-Hume argues that there is evidence that the entire mechanism underwent a complete redesign at some unknown juncture. He notes, for example, that the crank handle and crankshaft were quite similar in design to those elements found in a London-based barrel organ from that era. The fact that these mechanisms would have been difficult for Tipu to obtain (and do not fit with trends in French or Dutch organ design from the same period) suggests that these parts were added during a periodic restoration in London. He also recorded the myriad of differences in construction and function between his observations and the 1835 *Penny Magazine* description. The most important disparity he noted was that the organ bellows were likely not originally controlled by the crank but were instead independently manipulated by a wire emerging through a hole in the top of the tiger's head. Use of a wire to control air inflation meant that there was no way to blow up the chest bellows and move sound through the pipes simultaneously.

24. Stronge, *Tipu's Tigers*, 40–41.

25. The first is that the documentation was destroyed following the sack of Seringapatam, which is certainly possible given that portions of Tipu's vast records and personal correspondence did not survive. The second is that the tiger was merely one of his many unique possessions and did not carry any sort of profound significance in and of itself. Susan Stronge alludes to this possibility by positing that the tiger may have been built to entertain not its patron but his two young sons after their repatriation from British custody in 1794. Ibid., 41.

26. Platt, "East India House," 64.

27. "Tippoo's Tiger," 320. The Hunter illustration clearly showed that the soldier was painted with a tunic adorned with flowers and had a thin mustache, which may be the source of the speculation that the man was originally intended to be a Dutch trader. Later representations showed the man to have a clean-shaven face and a solid red tunic with yellow cuffs on his sleeves.

28. *Narrative sketches*, 98.

29. Forbes, *Oriental Memoirs*, 185.

30. De Almeida and Gilpin, *Indian Renaissance*, 40–44.

31. Mishra, *Gothic Sublime*, 20.

32. Havell, *Indian Sculpture and Painting*, 25.

33. Davis, *Lives of Indian Images*, 178–79.

34. Ibid., 181.

35. The scream and arm movement are both controlled by a reciprocating wire attached to a small bellows in the hollow chest of the human. As with the organ, the reciprocator works air from the bellows through a pitched pipe attached to an opening in the mouth. The depression of the bellows also pushes a spring trigger that activates a hinge assembly in the arm, periodically forcing the appendage upward and back down again. The growl is controlled by an independent mechanism located on the same shaft as the reciprocators. A worm gear rotates a series of four paddles that strike a trigger, slowly inflating a small bellows located in the head of the tiger. Once the bellows is filled with air, a lead weight depresses it and sends the air through a pipe and out of the tiger's mouth. The device continues to operate for as long as the crank is turned. When working properly, the wail pipe will constantly sound, while the growl pipe will sound every seven to ten seconds.

36. See Solla Price, "Automata," 9–23, and Bedini, "Role of Automata," 24–42.

37. Faulkner, "Musical Automata," 7.

38. Foucault, *Discipline and Punish*, 136.

39. The two other automatons developed by Vaucanson in 1737 resolutely demonstrate the potential of this sonic life. The *Flûteur* was a wooden representation of a human-faun playing a transverse flute, copied from a well-known marble statue by French sculptor Antoine Coysevox. Upon activation, the mechanical musculature of the fingers would open and close the holes on the flute, directing air expelled from a system of bellows built within the body. Even more novel, the sculpture could play one of fourteen (some accounts say eleven) preprogrammed pieces on the flute, independent of direct human control. As expected, the *Flûteur* took the French public by storm. Paul Metzner notes an account in the literary magazine *Mercure de France* reporting that the figure "performs like a master," and that every musical aspect "is executed in good taste." Metzner, *Crescendo of the Virtuoso*, 163. Vaucanson's commercial success with *Flûteur* and its sequel *Tambourinarie* (a French shepherd playing a drum with one hand and a flute with the other) influenced a myriad of other complicated sonic automata. Most notable of these later creations is 1773's *Musicienne*, built by clockmaker Henri-Louis Jaquet-Droz in an attempt to cash in on the automata craze in eighteenth-century France. Jaquet-Droz and his father, Pierre, were two of the most famous makers of decorative clocks in Europe at that time, and *Musicienne* represented an attempt to utilize this skill in another challenging mechanical medium. Built as a nondescript preteen girl at an organ, the automaton could play contrapuntally with both hands, glance between the keyboard and spectators with her eyes, and even bend her body slightly in rhythm with the music. Moreover, the girl was painted and dressed in actual clothing to resemble a living human as precisely as crafting technique allowed during that era.

40. Ord-Hume notes that at the height of the barrel organ's popularity in Britain between 1760 and 1840, over 130 individuals and companies (mostly in London) were producing them. "Barrel Organ," 328.

41. "Stopless Organ," 52. A response from a man named Samuel Reay published in the February 1900 issue (no. 2) questioned the veracity of the original account. He claimed to have heard versions of the same story in his youth, and proceeded to demonstrate why a typical barrel organ of that period would be incapable of playing forty songs as the author had claimed.

42. "Inconveniences of Barrel Organ," 333.

43. Loughridge, *Haydn's Sunrise*, 171.

44. Alpert, *London 1849*, 162.

45. Wills, *Mesmerists, Monsters, and Machines*, 30–33.
46. Picker, *Victorian Soundscapes*, 43. Carlyle's disdain was hardly a minority opinion in London. The popular British weekly magazine *Punch* ran a satirical roundtable in a 1903 issue, featuring luminaries such as novelist Max Pemberton and Lord Byron, where one participant objected to their presence solely on the monopoly of the craft by "undesirable aliens." "Should Organ Grinders Be Expelled?," 350.
47. Evans, "Introduction," 25–26.
48. Goto-Jones, *Conjuring Asia*, 156.
49. Karsten, "Germanic Philology," 12.
50. Desmond, *India Museum*, 22–24.
51. The first modern articulation of the Munro hypothesis can be found in Archer, *Tippoo's Tiger*.
52. Quoted in Brown, *Anecdotes*, 191.
53. At Pollilur, an army commanded by Haidar completely outmaneuvered Munro to join with Tipu and inflict a serious defeat on another British force under William Braille. The Mysorean victory forced Munro to retreat and abandon his supplies, and the engagement was considered by Munro himself to be one of the worst defeats of a colonial army in India. Roy, *War, Culture, and Society*, 84.
54. Colley, *Captives*, 294–95.
55. For one, there are no surviving contemporary accounts from British sources that equate the tiger with the death of Munro. He was certainly not the first nor the last European to be mauled by a tiger in India. Moreover, Susan Stronge demonstrates two further arguments that bring the Munro association into question. The first is that icons featuring a tiger prostrate over a human could be found in Tipu's court prior to Munro's demise, specifically in the form of a silver mount adorning one of his personal firearms dating to 1787. The second regards a line of Staffordshire pottery that depicted Munro's death: it strongly resembles the appearance of the tiger and did not appear until after 1810, while the tiger was on display in London and already a well-known tourist commodity. Stronge, *Tipu's Tigers*, 86.
56. Colley, *Captives*, 288–89.
57. Quoted in Desmond, *India Museum*, 26, and Stronge, *Tipu's Tigers*, 73.
58. Goswami, *Colonial India in Children's Literature*, 67.
59. Keats, *Complete Poems*, 2:347–48.
60. De Almeida and Gilpin, *Indian Renaissance*, 38.
61. Camden, "Elizabethan Chiromancy," 7.
62. "Subtyll and Crafty Devices," 295–96.
63. Chiero, *Palmistry for All*, 4.
64. Plumly, "This Mortal Body," 181.

Chapter 4

1. Schmid, "Claus Guth's Forest-Bound 'Don Giovanni.'"
2. Kramer, *Opera and Modern Culture*, 7–8.
3. Kierkegaard, *Either/Or*, 123–24.
4. Vitz, *Freud's Christian Unconscious*, 119. This father obsession is a view also perpetuated in the Don Giovanni scene featured in the 1984 film *Amadeus*.
5. Romanska, "Don Giovanni."
6. I would be remiss if I did not mention the reckoning Don Giovanni has faced regarding his attempted rape of Donna Anna in recent years. With regard to this, I defer to Kristi Brown-Montesano and her powerful 2017 post on the AMS Musicology Now blog, which summarizes these issues far better than I ever could. See "Holding Don Giovanni Accountable."
7. Tirso de Molina's *El burlador de Sevilla o el convidado de piedra* (1630) includes two dinners, the latter occurring in a graveyard where the statue of Don Gonzalo forces Don Juan to eat a plate of scorpions. "This first Don is damned," notes Ingrid Rowland, "not because he has been a cad, a rapist, or a murderer, but specifically and exclusively because he has first insulted and then dined with a citizen of the world beyond." Rowland, "Don Giovanni," 2. Molière's *Dom Juan ou le Festin de Pierre* (1665) also contained a second dinner invitation from the statue, where the spirit of a woman is the one who tries to get Juan to repent and the statue was merely the instrument of his ultimate demise. José Zorilla's *Don Juan Tenorio* (1844) provided two living statues (one of Gonzalo, the other of his daughter Doña Inés), neither of which was the harbinger of ultimate doom for the protagonist, and the dinner serves merely as an ominous warning of coming

events. *Don Giovanni* is notable in the way it ties the earthly feast directly to dining upon the living soul: statue of the Commendatore is invited to dinner; statue appears at dinner; statue invites Giovanni to his own celestial dinner and whisks the Don away to the nether reaches of the beyond.

8. Baker, "Odzooks!," 68. This attitude was not just limited to the elite urban cosmopolitans that Mozart was writing for. Baker also cites a poem written from the viewpoint of a common Englishman, who upon bumping into a statue of composer George Frideric Handel promptly apologizes vocally to the figure while exclaiming "Odzooks! A Man of Stone." Like the Commendatore, Handel is welcomed back into the social world of the living, a simultaneously mundane and horrifying example of material becoming man. See also Gay, "Father's Revenge," 70–80.

9. Rumph, *Mozart and Enlightenment Semiotics*, 77.

10. Berkeley, *Three Dialogues*, 52.

11. Cohon, *Hume's Morality*, 74, and Marciano, "Historical and Philosophical Foundations," 28.

12. Rumph, *Mozart and Enlightenment Semiotics*, 55–56.

13. Paterson, *Senses of Touch*, 54.

14. Carr, "Pygmalion and the Philosophes," 250–51.

15. Sheriff, *Moved by Love*, 164.

16. Vanderheyden, *Function of the Dream*, 48–50.

17. Carr, "Pygmalion and the Philosophes," 250.

18. Joshua, *Pygmalion and Galatea*, 24–38.

19. Stoichita, *Pygmalion Effect*, 122–23.

20. Chua, "Music as the Mouthpiece of Theology," 146–53.

21. Sheriff, *Moved by Love*, 164. The musical score, written by a close friend of Rousseau's named Horace Coignet, was considered lost until rediscovered in its entirety in 1995.

22. Condillac, *Philosophical Writings*, 204.

23. Schroeder, *Mozart in Revolt*, 21.

24. Till, *Mozart and the Enlightenment*, 9–12.

25. Rumph, *Mozart and Enlightenment Semiotics*, 3. Da Ponte was an avid reader of Mestasio as a child, owned a diverse seminary education from his hometown of Cendeda, and taught Latin, French, and Italian at another seminary in Venice before his expulsion for salacious behavior in 1773.

26. Abert, *W. A. Mozart*, 590.

27. Da Ponte, *Memoirs*, 154.

28. Chion, *Voice in Cinema*, 18–19. For a critical framework expanding Chion's concept of acousmatic sound, see Kane, *Sound Unseen*, 3–9.

29. Daub, *Tristan's Shadow*, 99–100.

30. Osborne, *Complete Operas of Mozart*, 164.

31. Zeiss, "Permeable Boundaries," 118; Osborne, *Complete Operas of Mozart*, 272.

32. Gordon and Gordon, *Sophistry and Twentieth-Century Art*, 24.

33. Kierkegaard, *Either/Or*, 112.

34. Steinberg, *Listening to Reason*, 37.

35. Zeiss, "Permeable Boundaries," 132.

36. Tomlinson, *Metaphysical Song*, 63–66.

37. Zabalo, "Don Juan (Don Giovanni)," 152.

38. Poizat, *Angel's Cry*, 64–65.

39. Szendy, *Listen*, 107.

40. Rumph, *Mozart and Enlightenment Semiotics*, 72–73.

41. Abert, *W. A. Mozart*, 1104.

42. Hugo, *Les Misérables*, 1016.

43. Williams, *On Opera*, 39.

44. Bertolini, *Playwrighting Self of Bernard Shaw*, 29.

45. Shaw, *Man and Superman*, 96–99.

46. Heller, "Mozart's Don Giovanni in Shaw's Comedy," 183.

47. Roy Carlson gives a detailed list of these encounters: "For Stephen, the ghosts he confronts are those of his past: his mother, of course, whose demand for his repentance at the end of 'Circe' mirrors the Commendatore's *pentiti* directed at Don Giovanni, and the many statues throughout Dublin. These are described as cold and stony, even Grattan's, which is bronze, not stone; this is perhaps an error of volition. That the statue in Mozart's opera is *l'uomo di sasso* [the man of stone] recalls the Sassenach oppression as well. The Commendatore's cold stone hand sealed the fate of Don Giovanni, just as these monuments of the Irish and Mosaic Hebrew past seal that of the 1904 Dublin denizens. Further, the French translation of 1929—approved by Joyce—translates 'stone-bearded' as *'avec une barbe de Commandeur,'*

emphasizing the importance of this *Don Giovanni* element. For Bloom, it is the nymph who describes herself as stonecold and pure, but she implodes before rationalist Bloom. What a new reading of Mozart this makes! Don Giovanni eradicates the statue of divine retribution." Carlson, "Don Giovanni on Eccles Street," 391–92.

Chapter 5

1. Jules-Rosette, *Josephine Baker in Art and Life*, 36.
2. Guteri, *Josephine Baker and the Rainbow Tribe*, 108.
3. The original design of the Jorama, reflecting the various stages in Baker's life, was intended to mimic the progression of the Stations of the Cross.
4. Cheng, *Second Skin*, 66; Guteri, *Josephine Baker*, 115.
5. Cheng, *Second Skin*, 4–13.
6. In addition to several texts already mentioned, see Baker and Chase, *Josephine: The Hungry Heart*; Schroeder and Vagner, *Josephine Baker: Entertainer*; Caravantes, *Many Faces of Josephine Baker*.
7. Lemke, *Primitivist Modernism*, 98–100.
8. For Picasso's relationship to African masks, see Richards, *Masks of Difference*, 292–93, and North, *Dialectic of Modernism*, 59–76. For an in-depth critical discussion of Milhaud's piece, see Mawer, *French Music and Jazz*, 99–135.
9. Strozek, "Futurist Responses," 49–50.
10. Cheng, *Second Skin*, 13.
11. Serres, *Five Senses*, 26.
12. Deleuze and Guattari, *Thousand Plateaus*, 149–66.
13. Connor, *Book of Skin*, 151.
14. Ibid., 154–66.
15. Ibid., 150.
16. Ibid., 167.
17. Ibid., 168.
18. Holmes, "Bronze and Plaster," 345.
19. Craig, "Color of an Ideal Negro Beauty Queen," 83.
20. West, "Genealogy of Modern Racism," 298–309.
21. Kaplan, "Italy, 1490–1700," 111–12.
22. Seelig, "Christoph Jamnitzer's 'Moor's Head,'" 199–203.
23. Nelson, *Color of Stone*, 62.
24. Ibid., 63.
25. Ibid., 68.
26. Hale, *Ninety Days' Worth*, 150.
27. Savage, *Standing Soldiers*, 13–16.
28. Ibid., 12.
29. Ibid., 8.
30. Bond, "Why We Need."
31. Adichie, *Purple Hibiscus*, 104.
32. Echevarria, *Voice of the Masters*, 26–27.
33. Like her contemporaries James Baldwin and Ralph Ellison, Petry found a particular niche writing about issues of alienation and the city, though Nora Ruth Roberts notes that the lack of obvious feminist tropes in her writing and characters may have limited her popularity after the 1960s. Nevertheless, her first novel *The Street* (1946), about a single black mother navigating postwar Harlem, became the first novel by an African American woman to sell over one million copies. Roberts, "Artistic Discourse," 32.
34. While Roberts argues that the story is a rumination on "formal artistic discourse" as a white aesthetic and its complicated effects on African American communities, Melina Vizcaíno-Alemán sees it as an intersection of issues of race and gender in those same communities, focused more specifically on the silencing of black women among the presence of white women and black men. Vizcaíno-Alemán goes so far as to compare Man's ownership and selling of Mother Africa in the end to an analogous bodily possession of women evoking the slave trade. Roberts, "Artistic Discourse," 37; Vizcaíno-Alemán, "Counter-Modernity," 134–36.
35. Roberts, "Artistic Discourse," 35.
36. Petry, "Mother Africa," 149.
37. Ibid., 150.
38. Ibid., 159.
39. Cheng, *Second Skin*, 133.
40. Beaulieu, *Writing African American Women*, 36–37.
41. Schroeder and Vagner, *Josephine Baker*, 51.
42. Boittin, *Colonial Metropolis*, 18.
43. Cheng, *Second Skin*, 94.
44. Ibid., 96–98.
45. Panzanelli, "Introduction," 1.
46. Bloom, *Waxworks*, 1.
47. An excellent discussion of the post-Enlightenment history of waxworks in France

and Britain can be found in Warner, *Phantasmagoria*, 25–41.

48. Aristotle, *De Anima*, 9.

49. For an interesting and informative discussion of the use of wax in the facial reconstruction of Lenin, see Yurchak, "Bodies of Lenin," 139–40.

50. Guyer, "Beauty, Freedom, and Morality," 149.

51. Didi-Huberman, "Viscosities and Survivals," 155.

52. Descartes, *Meditations*, 41.

53. A particularly detailed description of the lost wax process can be found in Savage, *Concise History of Bronzes*, 20.

54. In the medium of recording, there is a history of "wax" continuing as an insider term among audiophiles when referring to vinyl records. Bartmanski and Woodward, *Vinyl*, 70.

55. Brady, *Spiral Way*, 62.

56. Sandberg, *Living Pictures*, 40.

57. See Moten, *Into the Break* and *Black and Blur*.

Chapter 6

1. Lampe and Jackson, *Balkan Economic History*, 145.

2. Karavelov, "Plovdiv," 237–38.

3. The theater was originally built between 114 and 117 CE and remained intact until Attila the Hun sacked the city during the fifth century. Uncovered during the 1970s, it was first opened for tourists in 1981 after further excavation supervised by architect Vera Kolarova. Raicheski, *Plovdivska entsiklopediya*, 10.

4. The original Hotel Bulgaria was built in 1881 and designed by Czech architect Anton Kolar, who was the modeler of many of the most famous landmarks conceived during the Battenberg regime, including the City Garden (1879) and the monument to Vasil Levski (1895). The hotel became Sofia's version of the Waldorf-Astoria in New York City, and anyone of fame or repute in Sofia at that time lodged at the Grand Hotel. In his memoir, Dragan Tenev gives a list of notables who stayed there between roughly 1918 and 1937: Russian revolutionary Maxim Litvinov Maksimovich Kamò, American journalist and author John Reed, Irish journalist James David Bourchier, Indian poet and philosopher Rabindrath Tagore, and Chilean classical pianist Claudio Arrau (in the book Tenev mistakenly refers to Arrau as a Brazilian). Tenev, *Tristahiliyada Sofia*, 103–7. The hotel was featured prominently in photos and lithographs before the First World War as a landmark of Sofia's urban landscape. When the original building began to deteriorate in the late 1920s, coupled with competition from the nearby hotel called Slavyanska Beseda (which opened in 1935), plans for a replacement building were made to go near Battenberg Square and the Tsar Osvoboditel monument in central Sofia. The newer, larger Hotel Bulgaria, designed by architects Stancho Belkovski and Ivan Dancho, was opened in 1938 at its present location on Tsar Osvoboditel Boulevard, as part of a complex incorporating two existing buildings to stretch between the boulevard and the adjoining Aksakov Street. In addition to the hotel, the complex was home to the Bulgaria Café (Kafene Bulgariya), a gathering spot for writers and intellectuals, and the Bulgaria Hall (Zala Bulgariya), the largest concert hall in the city.

5. Markov, *Truth That Killed*, 109.

6. Boyadzhiev (1903–1976) was a painter and native of Plovdiv whose works captured the landscape and heart of the city better than any other twentieth-century Bulgarian artist. Trained at the Khudozhestvena akademiya (Arts Academy) in Sofia, he was best known for works like *Zima v Plovdiv* (*Winter in Plovdiv*, 1939) and *Iz stariya Plovdiv* (*From Old Plovdiv*, 1958). In addition to the paintings themselves, Boyadzhiev was also famous for painting with a paralyzed right hand, a condition he suffered from 1951 until his death. Raichevski, *Plovdivska entsiklopediya*, 25.

7. Bikova, "Amerikanski emigranti."

8. Ivy, *Discourses of the Vanishing*, 22.

9. Ihde, *Listening and Voice*, 50–51.

10. Cage, *Silence*, 13.

11. For Derrida, it was the interiorized voice; for Salomé Voegelin, the human body; for Heidegger (as put forth by David Nowell Smith), poetry; for Philip Bohlman and Jeffers Engelhardt, the state of transcendence. Then there are the institutional devices reflecting the power and presence of the

state that can serve of these borders. Sheila Whiteley provides a compelling example with copyright law serving as a boundary. This institutional emphasis expands to include the myriad of other perspectives focusing on the systemic and everyday traumas of racism, sexism, political violence, and religious intolerance working as mechanisms of silence. See Derrida, *Of Grammatology*, 140; Voegelin, *Listening to Noise and Silence*, 83–84; Smith, *Sounding/Silence*; Bohlman and Engelhardt, "Resounding Transcendence," 1–25; Whiteley, "'Sound of Silence,'" 220–22.

12. See McCormack, "Bulgarian Bulge" and "Technologies of Dismemberment," 99–113.

13. The bombing at Sveta Nedelya on April 26, 1925, remains one of the single deadliest acts of political violence in Bulgarian history. Conceived by the Soviet Comintern as a means to assassinate Tsar Boris III while attending a state funeral, the explosion killed 123 people and left several hundred wounded (the tsar was not in attendance). A subsequent government crackdown on dissident parties like the Agrarian Union and the BCP as a result of the bombing led to a long period in which there was no open political activity under the banner of communism in Bulgaria. Many were arrested and/or killed, and those who escaped fled to the protective custody of the Soviet Union as exiles.

14. Dimitrov, "Bulgarian Neutrality," 192–216.

15. Reed, *War in Eastern Europe*, 311.

16. Slavov, *Zlatnata Reshetka*, 11.

17. Gadzhev, *Dzhazut na Bulgaria*, 140–41. It is important to note from the outset that what fell under the term *jazz* in Bulgaria from an ideological standpoint around 1950 was far ranging and included many styles not normally considered part of the jazz canon today. The American swing popularized by the bands of Benny Goodman, Glenn Miller, and Duke Ellington was certainly included, as was the older New Orleans–style of polyphonic group improvisation and popular songs produced by Tin Pan Alley. But the label "jazz" could also refer to repertoire as diverse as French chansons, sentimental European ballads, Argentinean tangos, ragtime pieces for piano or brass band, and popular theatrical and light opera songs from European shows. "Modern jazz" popular since the end of the war, like American bebop, had little impact in Bulgaria until the late 1950s and thus was not likely part of the BCP's broader conceptualization and definition of "jazz" for ideological purposes. In fact, as late as 1964, a "jazz band" was defined in the *Kratka bulgarskata entsiklopediya* (Little Bulgarian Encyclopedia) as a large ensemble of twelve to eighteen instruments, with variations consisting of smaller (quartet, etc.) and larger ("symphonic jazz") incarnations—in effect reinforcing the "big band" as the primary vehicle for jazz in Bulgaria at a time when the trio and quartet were more dominant elsewhere.

18. Dellin, *Bulgaria*, 168.

19. See Dunham, *In Stalin's Time*, and Yurchak, *Everything Was Forever*.

20. Markov, *Truth That Killed*, 50–56.

21. See Gadzhev, *Dzhazut na Bulgaria*, 137–79, for profiles of some other Bulgarians working as bandleaders and sidemen in jazz and theater orchestras at that time, including Emil Georgiev, Stanimir Stanev, Angel Mikhailov, and Nikola Ianev.

22. Moskov, "Bulgaria e bila parviyat."

23. Popular prewar vocalist Asparuh "Ari" Leshnikov (1898–1978) was a prime example of a musician whose Communist-era career was ruined by prior success. As one of the finest male tenors of his time, Leshnikov had a fruitful career in interwar Germany as a member of the Comedian Harmonists, a popular vocal sextet that broke up in 1934 amid pressures from the Nazis toward their three Jewish members. With the other three, Leshnikov formed another sextet named Das Meister that continued performing in Germany until 1941, but with limited success. When he returned to Bulgaria after the war, he spent most of his remaining years working manual labor jobs and singing for almost no pay in pubs.

24. Starr, *Red and Hot*, 173–74.

25. Ibid., 190.

26. Moskov, "Bulgaria e bila parviyat." There was also a jazz group called Optimistite (the Optimists) active in Sofia during the early years of the Second World War, made up primarily of Bulgarian Jews who emigrated from Bulgaria soon after the end of the war. Although Nikolov was likely

aware of the existence of this prior group, it is unknown whether his supposed naming of the Hotel Bulgaria house band was a subtle homage to the Optimists or simply a coincidence.

27. See Gadzhev, *Dzhazut na Bulgaria*, 43–46, and 504–5.

28. Shumnaliev, *Sotsroman*, 196.

29. Accounts of colloquial terminology (like *stilyagi*) in Communist youth culture can be found in Yurchak, *Everything Was Forever* and Taylor, *Let's Twist Again*, 71.

30. Timothy Ryback cites a 1953 issue of the Sofian newspaper *Literaturen front* (Literary Front) that lambastes a group of young, aimless Bulgarian *stilyagi* led by "Petur," a twenty-six-year-old Sofian, who carried a "bored, expressionless face, languid gestures and downcast eyes" and "pass[ed] their time telling jokes, playing bridge, and discussing the latest care models." Ryback, *Rock Around the Bloc*, 10. Another example is an article entitled "Vidinski neblagopoluchiya" (Vidin's Failures), written for the periodical *Bulgarska muzika* (Bulgarian Music), the official journal of the Union of Bulgarian Composers in 1953. The author catalogues a particular incident involving professional musicians in the city of Vidin and their descent into the depravities offered by playing jazz. The article is quoted in Guentcheva, "Sounds and Noise," 228.

31. Todorov, "Plovdiv vdiga pametnik."

32. Bikova, "Amerikantski emigranti."

33. Bell, *Bulgarian Communist Party*, 113. Following the lead of the Soviet Union, the Congress preempted a reexamination of the aesthetic tenets of socialist realism at the highest levels of the BCP. Notable examples of this "thaw" in the arts included Chervenkov's defense of the controversial Dimitar Dimov novel *Tyutyun* (*Tobacco*), a new "anti-dogmatic" approach to the evaluation of literature headed by the Union of Bulgarian Writers, and the restoration of the works of many historically "bourgeois" writers to the Bulgarian literary canon.

34. Gadzhev, *Dzhazut na Bulgaria*, 151–52.

35. The Hungarian Uprising and the artistic intelligentsia's role in that conflict with the Soviet Union had a profound effect on the BCP's strategy toward unionized writers, artists, and musicians during the 1960s. For historical context on the Hungarian Uprising, see Barber, *Seven Days of Freedom*, and Lendvai, *One Day*. For a timeline of pertinent events leading up to the Soviet military intervention, see Békés, *1956 Hungarian Uprising*.

36. Milev, "Pomnite li Sasho Sladura?"

37. Slavov, *Zlatnata Reshetka*, 13.

38. Bikova, "Amerikantski emigranti."

39. Stoiyanova and Iliev, *Politicheski opasni litsa*, 33–34.

40. The horrors of the *kontslagera* and the everyday toll taken on their inhabitants are catalogued in a series of essays found in Todorov, *Voices from the Gulag*. Although the infamous Belene was closed in 1953 as part of the gradual shift away from hardline Stalinist policies, the camp reopened several times over the next couple of decades: in 1956 during the mass suppression of the intelligentsia after the Hungarian Uprising, and again in the mid-1980s as part of the forced "Bulgarization" of the Turkish minority. For a pointed critique of Todorov's text arguing that he appropriates and recontextualizes the prisoner narratives to reinforce a sense of Western moral superiority toward Communism, see Kaneva, "Remembering Communist Violence," 44–61.

41. Gerasimov, *Diplomatsiya*, 113–14.

42. Tenev, "Sasho Sladura."

43. Bikova, "Amerikantski emigranti."

44. Daskalov, *Debating the Past*, 272.

45. Todorov, *Voices from the Gulag*, 83–84.

46. Kapralov, "Zhivkov-Era Concentration Camp," 18–19.

47. In June of 2011 a woman named Mariya Palikarova, one of Sladura's living relatives, appeared in the studio of *Televiziya Plovdiv* and stated that Sladura had not been killed at Lovech but instead secretly exiled from Bulgaria. Her hypothesis was based on bits of circumstantial evidence: that the family could not publish a death certificate; that in 1974 a document arrived listing him as "missing" instead of dead; that some mysterious letters began arriving signed *Poliyaka* (the Pole) in handwriting eerily similar to Sasho's, and accompanied by chocolate bonbons favored by his mother. Her story, to my knowledge, has not been corroborated by any additional evidence yet remains a potent

conspiracy theory for some to this day. See, for example, "Uzhasna versiya."

48. Stoiyanova and Iliev, *Politicheski opasni litsa*, 100. The *kontslager* at Belene, located near the town of Pleven in western Bulgaria, was active for two different periods—from 1949 until 1953, and again from 1956 until 1959.

49. Daskalova (1921–2008) was a parliament secretary with the first government after the Communist takeover in September 1944 who was arrested in 1951 and imprisoned for one year. After her release, she worked for the Bulgarian Academy of Sciences until 1962 and was then Minister of Justice until 1990.

50. Tsonchev, *Preletni dushi*, 156.

51. Slavov, *Zlatnata Reshetka*, 11–13.

52. Korudzhiev, *Predi da se umre*, 150–51.

53. For an intriguing anthropological analysis about the agency of musical instruments within social, cultural, and political practices, see Bates, "Social Life of Musical Instruments," 363–95.

54. Barthes, *Mythologies*, 9.

55. Segesten, *Myth, Identity, and Conflict*, 1–2.

56. Taussig, *Walter Benjamin's Grave*, 6.

57. Ragussis, *Acts of Naming*, 219–22.

58. Cowan, "Walter Benjamin's Theory of Allegory," 115.

59. Ibid., 111–13.

60. Lehman, "Allegories of Rending," 236.

61. Cowan, "Walter Benjamin's Theory of Allegory," 112.

Chapter 7

1. Andrews, "Music of Sculpture," 31–32.

2. The Spinozan/Whitehead connection is especially important to the theory of ontological affect put forth in Goodman, *Sonic Warfare*, 83–102.

3. Kane, "Sound Studies," 6–8.

4. Trower, *Senses of Vibration*, 39–40. This rhetorical recourse to sound implied by multiplicities of vibration found use within spectroscopy and thermodynamics as well. Writing about the emission spectrum of gases in the 1870s, the famed Scottish physicist James Clerk Maxwell described the resonance emanating from molecules after colliding as analogous to the harmonic vibrations of a peal of bells. See Maxwell, *Scientific Papers*, 2:463–64, and Chalmers, *Scientist's Atom*, 249.

5. Tamm coined the term *phonon* in 1932 to describe a collective mode of quantum vibration among arrangements of molecules in matter, drawn from the Greek word *phoné* due to their role in the creation of physical sound. He based this concept not only on Einstein's photon but on earlier work by Dutch physicist Peter Debye, who conceived of a similar theory in 1912 with regard to thermodynamics.

6. Exploring the idea that these forms could manifest simultaneously in the particles themselves, Werner Heisenberg developed a theory that the positions of these wave-particle entities in space could not be ascertained until they were detected, meaning that their motion could not be effectively measured (known as his Uncertainty Principle). This theory played out during attempts at detection, as the wave function collapsed, leaving only the particle function observable and making the wave a theoretical construct whose dynamics could not be directly ascertained. Erwin Schrödinger (he of the famous living dead cat), who understood these waves to be mathematical constructs, developed an equation to predict how they would manifest prior to collapse at the moment of detection. De Broglie held that the Schrödinger equation not only predicted the properties of these waves but also constituted the actual physical form of a wave within the molecule that drove particle movement, even when unobserved.

7. De Broglie, *Heisenberg's Uncertainties*, xii.

8. Alexander, *Jazz of Physics*, 166.

9. Andrews, *Symphony of Life*, 17.

10. This philosophical trajectory that would inform Andrews's later work was on display in a commencement speech he delivered to the midyear graduating class of Bloomsburg State Teachers College in Pennsylvania on January 13, 1949. See "Mid Year Commencement."

11. Andrews, *Symphony of Life*, 147.

12. Quoting Russolo, "Art of Noises," 12–13:

We want to give pitches to these diverse noises, regulating them harmonically and rhythmically. Giving pitch to noises does

not mean depriving them of all irregular movements and vibrations of time and intensity but rather assigning a degree or pitch to the strongest and most prominent of these vibrations. Noise differs from sound, in fact, only to the extent that the vibrations that produce it are confused and irregular. Every noise has a pitch, some even a chord, which predominates among the whole of its irregular vibrations. Now, from this predominant characteristic pitch derives the practical possibility of assigning pitches to the noise as a whole. That is, there may be imparted to a given noise not only a single pitch but even a variety of pitches without sacrificing its character, by which I mean the timbre that distinguishes it. Thus, some noises obtained through a rotary motion can offer an entire chromatic scale ascending or descending, if the speed of the motion is increased or decreased.

See also Patch, "Art of Noise," 303–6.

13. For more on Russolo's interest in such matters, and how the occult may have shaped his philosophy of futurism more than previously thought, see Chessa, *Luigi Russolo*, 1–12.

14. Ananthaswamy, "Quantum Weirdness."

15. "James Joyce: Earl Street North." Talking Statues Dublin, http://www.talkingstatuesdublin.ie/statues/jamesjoyce.

16. "Abraham Lincoln: Lincoln Park." Statue Stories Chicago, http://www.statuestorieschicago.com/statues/statuelincoln.

17. Whitmarsh, "'Greece Is the World,'" 295.

Conclusion

1. Neely, "Knoxville: Summer 1979."

2. This includes the compositions Symphony No. 1, Op. 13 (1895); Symphony No. 2, Op. 27 (1906–7); Symphony No. 3, Op. 44 (1935–36); *Isle of the Dead*, Op. 29 (1908); *The Bells* choral symphony, Op. 35 (1915); *Rhapsody on a Theme of Paganini*, Op. 43 (1934); and *Symphonic Dances*, Op. 45 (1940).

3. Sherrod, "Metro Pulse."

4. Cousineau, *Coincidence or Destiny*, 157.

5. Stewart, *Space on the Side of the Road*, 58.

Bibliography

Abert, Hermann. *W. A. Mozart*. Translated by Stewart Spencer, edited by Cliff Eisen. New Haven: Yale University Press, 2007.

Adichie, Chimamanda Ngozi. *Purple Hibiscus*. Chapel Hill, NC: Algonquin Books, 2012.

Adorno, Theodor. "The Curves of the Needle." In *Essays on Music*, translated by Susan Gillespie, 271–76. Berkeley: University of California Press, 2002.

Agamben, Giorgio. *Stanzas: Word and Phantasm in Western Culture*. Translated by Ronald Martinez. Minneapolis: University of Minnesota Press, 1993.

Albright, Daniel. *Untwisting the Serpent: Modernism in Music, Literature, and Other Arts*. Chicago: University of Chicago Press, 2000.

Alexander, Stephon. *The Jazz of Physics: The Secret Link Between Music and the Structure of the Universe*. New York: Basic Books, 2016.

Almeida, Hermione de, and George Gilpin. *Indian Renaissance: British Romantic Art and the Prospect of India*. Burlington, VT: Ashgate, 2005.

Alpert, Michael. *London, 1849: A Victorian Murder Story*. New York: Routledge, 2014.

Ananthaswamy, Anil. "Quantum Weirdness May Hide an Orderly Reality After All." *New Scientist*, February 19, 2016. https://www.newscientist.com/article/2078251quantumweirdnessmayhideanorderlyrealityafterall.

Andrews, Donald Hatch. "The Music of Sculpture." *Main Currents in Modern Thought* 23, no. 2 (1966): 31–37.

———. *The Symphony of Life*. Lee's Summit, MO: Unity Books, 1966.

Archer, Mildred. *Tippoo's Tiger*. London: Her Majesty's Stationary Office, 1959.

Aristotle. *On the Life-Bearing Spirit (De spiritu): A Discussion with Plato and His Predecessors on Pneuma as the Instrumental Body of the Soul*. Translated by Abraham Bos and Rein Ferwerda. Leiden: Brill, 2008.

———. *On the Soul*. Translated by Mark Shiffman. Indianapolis, IN: Focus, 2011.

Bacon, Francis. *The Philosophical Works of Francis Bacon*. Vol. 3. Edited by Peter Shaw. London: Knapton, 1733.

Badiou, Alain. *Being and Event*. Translated by Oliver Feltham. New York: Continuum Books, 2005.

Baker, Egbert J. "Archaic Epigram and the Seal of Theognis." In *Dialect, Diction, and Style in Greek Literary and Inscribed Epigram*, edited by Evina Sistakou and Antonios Rengakos, 195–214. Berlin: Walter de Gruyter, 2016.

Baker, Jean-Claude, and Chris Chase. *Josephine: The Hungry Heart*. New York: Cooper Square Press, 1993.

Baker, Malcolm. "Odzooks! A Man of Stone." In *Don Giovanni: Myths of Seduction and Betrayal*, edited by Jonathan Miller, 62–69. Baltimore: Faber and Faber, 1990.

Barber, Noël. *Seven Days of Freedom: The Hungarian Uprising, 1956*. New York: Stein and Day, 1974.

Barkan, Leonard. *Unearthing the Past: Archaeology and Aesthetics in the Making of Renaissance Culture*. New Haven: Yale University Press, 1999.

Barker, Peter. "Stoic Contributions to Early Modern Science." In *Atoms, Pneuma, and Tranquility: Epicurean and Stoic Themes in European Thought*, edited by Margaret Osler, 135–54. New York: Cambridge University Press, 1991.

Barthes, Roland. *Mythologies*. Translated by Annette Levers. New York: Hill and Wang, 1972.

Bartmanski, Dominik, and Ian Woodward. *Vinyl: The Analogue Record in the Digital Age*. New York: Bloomsbury, 2015.

Bates, Eliot. "The Social Life of Musical Instruments." *Ethnomusicology* 56, no. 3 (2012): 363–95.

Baudelaire, Charles. "The Philosophy of Toys." Translated by Paul Keegan. In *On Dolls*, edited by Kenneth Gross, 11–21. London: Notting Hill, 2012.

Beaulieu, Elizabeth Ann. *Writing African American Women*. Westport, CT: Greenwood, 2006.

Bedini, Silvio. "The Role of Automata in the History of Technology." *Technology and Culture* 5, no. 1 (1964): 24–42.

Békés, Csaba, Malcolm Byrne, and János Rainer, eds. *The 1956 Hungarian Uprising: A History in Documents*. New York: Central European University Press, 2002.

Bell, John. *The Bulgarian Communist Party from Blagoev to Zhivkov*. Stanford, CA: Hoover Institution, 1986.

Benso, Silvia. "The Breathing of the Air: Presocratic Echoes in Levinas." In *Levinas and the Ancients*, edited by Brian Schroeder and Silvia Benso, 9–23. Bloomington: Indiana University Press, 2008.

Berchman, Robert. "Rationality and Ritual in Neoplatonism." In *Neoplatonism and Indian Philosophy*, edited by Paulos Mar Gregorios, 229–68. Albany: State University of New York Press, 2002.

Berkeley, George. *Three Dialogues Between Hylas and Philonus*. Chicago: Open Court, 1901.

Bertolini, John Anthony. *The Playwrighting Self of Bernard Shaw*. Carbondale and Edwardsville: Southern Illinois University Press, 1991.

Bhandar, Brenna, and Jonathan Goldberg-Hiller. "Introduction: Staging Encounters." In *Plastic Materialities: Politics, Legality, and Metamorphosis in the Work of Catherine Malabou*, edited by Brenna Bhandar and Jonathan Goldberg-Hiller, 1–34. Durham: Duke University Press, 2015.

Bikova, Diana. "Amerikanski emigranti vdigat pametnik na Sasho Sladura v Plovdiv." *Novinar*, August 22, 2002. http://novinar.bg/news/amerikanskiemigrantivdigatpametniknasashosladuravplovdiv_NjgwOzY3.html (site discontinued).

Bloom, Gina. *Voice in Motion: Staging Gender, Shaping Sound in Early Modern England*. Philadelphia: University of Pennsylvania Press, 2007.

Bloom, Michelle. *Waxworks: A Cultural Obsession*. Minneapolis: University of Minnesota Press, 2003.

Boehrer, Bruce. *Animal Characters: Nonhuman Beings in Early Modern Literature*. Philadelphia: University of Pennsylvania Press, 2010.

Bohlman, Philip, and Jeffers Engelhardt. "Resounding Transcendence—an Introduction." In *Resounding Transcendence: Transitions in Music, Religion, and Ritual*, edited by Philip Bolhman and Jeffers Engelhardt, 1–25. New York: Oxford University Press, 2016.

Boittin, Jennifer Anne. *Colonial Metropolis: The Urban Grounds of Anti-Imperialism and Feminism in Interwar Paris*. Lincoln: University of Nebraska Press, 2010.

Bond, Sarah. "Why We Need to Start Seeing the Classical World in Color." *Hyperallergic*, June 7, 2017. https://hyperallergic.com/383776/whyweneedtostartseeingtheclassicalworldincolor.

Brady, Erika. *A Spiral Way: How the Phonograph Changed Ethnography*. Jackson: University Press of Mississippi, 1999.

Brech, Martha. "New Technology—New Artistic Genres: Changes in the Concept and Aesthetic of Music." In *Music and Technology in the Twentieth Century*, edited by Hans-Joachim Braun, 207–22. Baltimore: The Johns Hopkins University Press, 2000.

Brilliant, Richard. *My Laocoön: Alternative Claims in the Interpretation of Artworks*. Berkeley: University of California Press, 2000.

Brittlebank, Kate. "Sakti and Barakat: The Power of Tipu's Tiger. An Examination of the Tiger Emblem of Tipu Sultan of Mysore." *Modern Asian Studies* 29, no. 2 (1995): 257–69.

Broglie, Louis de. *Heisenberg's Uncertainties and the Probabilistic Interpretation of Wave Mechanics*. Translated by Alwyn

van der Merwe. Boston: Kluwer Academic, 1990.

Brown, Thomas. *Anecdotes of the Animal Kingdom*. Glasgow: Archibald Fullerton, 1834.

Brown-Montesano, Kristi. "Holding Don Giovanni Accountable." *Musicology Now*, December 2017. http://musicologynow.amsnet.org/2017/12/holdingdongiovanniaccountable.html.

Cage, John. *Silence: Lectures and Writings*. Middletown: Wesleyan University Press, 2010.

Camden, Carroll. "Elizabethan Chiromancy." *Modern Language Notes* 62, no. 1 (1947): 1–7.

Caravantes, Peggy. *The Many Faces of Josephine Baker: Dancer, Singer, Activist, Spy*. Chicago: Chicago Review Press, 2015.

Carlson, Roy. "Don Giovanni on Eccles Street." *Texas Studies in Literature and Language* 51, no. 4 (2009): 383–99.

Carr, J. L. "Pygmalion and the Philosophes: The Animated Statue in Eighteenth-Century France." *Journal of the Warburg and Courtauld Institutes* 23, nos. 3/4 (1960): 239–55.

Casati, Roberto, and Achille Varzi. "Events." *Stanford Encyclopedia of Philosophy*. https://plato.stanford.edu/entries/events.

Caverero, Adriana. *For More Than One Voice: Toward a Philosophy of Vocal Expression*. Translated by Paul Kottman. Stanford: Stanford University Press, 2005.

Chakraborty, Ayusman. "'That Disgrace in Human Form': Tipu Sultan and the Politics of Representation in Three Nineteenth-Century English Novels." *Rupkatha Journal on Interdisciplinary Studies in Humanities* 5, no. 1 (2013): 55–66.

Chalmers, Alan. *The Scientist's Atom and the Philosopher's Stone: How Science Succeeded and Philosophy Failed to Gain Knowledge of Atoms*. New York: Springer, 2009.

Chattopadhyay, Budhaditya. "Beyond Matter: Object-Disoriented Sound Art." *Seismograf*, November 15, 2017. https://seismograf.org/fokus/soundartmatters/beyondmatterobjectdisorientedsoundart.

Cheng, Anne Anlin. *Second Skin: Josephine Baker and the Modern Surface*. New York: Oxford University Press, 2011.

Chessa, Luciano. *Luigi Russolo, Futurist: Noise, Visual Arts, and the Occult*. Berkeley: University of California Press, 2012.

Chiero. *Palmistry for All: Containing New Information on the Study of the Hand Never Before Published*. New York: G. P. Putman, 1916.

Chion, Michel. *The Voice in Cinema*. Translated by Claudia Gorbman. New York: Columbia University Press, 1999.

Christian, Kathleen Wren. "Poetry and 'Spirited' Ancient Sculpture in Renaissance Rome." In *Aeolian Winds and the Spirit in Renaissance Architecture*, edited by Barbara Kenda, 103–24. New York: Routledge, 2006.

Chrystal, Paul. *In Bed with the Romans*. Gloucestershire: Amberley, 2015.

Chua, Daniel. "Music as the Mouthpiece of Theology." In *Resonant Witness: Conversations Between Music and Theology*, edited by Jeremy Begbie and Steven Guthrie, 137–61. Grand Rapids, MI: William B. Eerdmans, 2011.

Classen, Constance. "Fingerprints: Writing About Touch." In *The Book of Touch*, edited by Constance Classen, 1–9. New York: Berg, 2005.

Cohen, H. Floris. *The Rise of Modern Science Explained: A Comparative History*. New York: Cambridge University Press, 2015.

Cohon, Rachel. *Hume's Morality: Feeling and Fabrication*. New York: Oxford University Press, 2008.

Colley, Linda. *Captives: Britain, Empire, and the World, 1600–1850*. New York: Anchor Books, 2004.

Condillac, Étienne Bonnot de. *Philosophical Writings of Étienne Bonnot, Abbé de Condillac*. Translated by Franklin Philip and Harlan Lane. Hillsdale, NJ: Lawrence Erlbaum, 1982.

Connor, Steven. *The Book of Skin*. Ithaca: Cornell University Press, 2004.

Cousineau, Phil. *Coincidence or Destiny? Stories of Synchronicity That Illuminate Our Lives*. York Beach, ME: Conari Press, 1997.

Cowan, Bainard. "Walter Benjamin's Theory of Allegory." *New German Critique* 22 (1981): 109–22.

Craig, Maxine Leeds. "The Color of an Ideal Negro Beauty Queen." In *Shades of Difference: Why Skin Color Matters*, edited by Evelyn Glenn, 81–94. Stanford: Stanford University Press, 2009.

Da Ponte, Lorenzo. *Memoirs*. Translated by Elisabeth Abbot, edited by Arthur Livingston. New York: New York Review of Books, 2000.

Darwin, Charles. *The Expression of the Emotions in Man and Animals*. Edited by Francis Darwin. Vol. 23 of *The Works of Charles Darwin*, edited by Paul H. Barrett and R. B. Freeman. New York: New York University Press, 1989.

Daskalov, Rumen. *Debating the Past: Modern Bulgarian History from Stambolov to Zhivkov*. New York: Central European University Press, 2011.

Daub, Adrian. *Tristan's Shadow: Sexuality and the Total Work of Art After Wagner*. Chicago: University of Chicago Press, 2014.

Davis, Richard. *Lives of Indian Images*. Princeton: Princeton University Press, 1997.

Deleuze, Gilles. *The Fold: Leibniz and the Baroque*. Translated by Tom Conley. Minneapolis: University of Minnesota Press, 1993.

Deleuze, Gilles, and Felix Guattari. *A Thousand Plateaus: Capitalism and Schizophrenia*. Translated by Brian Massumi. New York: Continuum Books, 2004.

Dellin, L. A. D. *Bulgaria: East-Central Europe Under the Communists*. New York: Praeger Press, 1957.

Derrida, Jacques. *Of Grammatology*. Translated by Gayatri Chakravorty Spivak. Baltimore: The Johns Hopkins University Press, 1997.

Descartes, René. *Meditations on First Philosophy: With Selections from the Objections and Replies*. Translated and edited by John Cottingham. New York: Cambridge University Press, 2013.

Desmond, Ray. *The India Museum, 1801–1879*. London: Her Majesty's Stationary Office, 1982.

Didi-Huberman, Georges. "Viscosities and Survivals: Art History Put to the Test by the Material." In *Ephemeral Bodies: Wax Sculpture and the Human Figure*, edited by Roberta Panzanelli, 154–69. Los Angeles: Getty Research Institute, 2008.

Dimitrov, Vesselin. "Bulgarian Neutrality: Domestic and International Perspectives." In *European Neutrals and Non-Belligerents During the Second World War*, edited by Neville Wylie, 192–216. New York: Cambridge University Press, 2002.

Draasima, Douwe. *Metaphors of Memory: A History of Ideas About the Mind*. Translated by Paul Vincent. New York: Cambridge University Press, 2000.

Dunham, Vera. *In Stalin's Time: Middle Class Values in Soviet Fiction*. Durham: Duke University Press, 1990.

Dyson, Frances. *Sounding New Media: Immersion and Embodiment in Arts and Culture*. Berkeley: University of California Press, 2009.

Echevarria, Roberto González. *The Voice of the Masters: Writing and Authority in Modern Latin American Literature*. Austin: University of Texas Press, 1985.

Economakis, Richard. "Chasma gês: Delphic Pneuma and the Cult of Asklepios." In *Aeolian Winds and the Spirit in Renaissance Architecture*, edited by Barbara Kenda, 22–43. New York: Routledge, 2006.

Erlmann, Veit. *Reason and Resonance: A History of Modern Aurality*. New York: Zone Books, 2010.

Ernst, Wolfgang. "Not Seeing the Laocoön: Lessing in the Archive of the Eighteenth Century." In *Regimes of Description: In the Archive of the Eighteenth Century*, edited by John Bender and Michael Marinan, 118–34. Stanford: Stanford University Press, 2005.

Evans, Henry Ridgely. "Introduction: The Mysteries of Modern Magic." In *Magic, Stage Illusions, and Scientific Diversions, Including Trick Photography*, edited by Albert Allis Hopkins, 1–26. New York: Munn, 1901.

Fallon, Stephen. *Milton Among the Philosophers: Poetry and Materialism in Seventeenth-Century England*. Ithaca: Cornell University Press, 1991.

Faulkner, Christopher. "Musical Automata, La Régle du jeu, and the Cinema." *South Central Review* 28, no. 3 (2011): 6–25.

Forbes, James. *Oriental Memoirs Selected and Abridged from a Series of Familiar Letters Written During Seventeen Years Residence in India: Including Observations on Parts of Africa and South America, and a Narrative of Occurrences in Four India Voyages*. Vol. 4. London: White and Cochrane, 1813.

Foucault, Michel. *Discipline and Punish: The Birth of the Prison*. New York: Pantheon Books, 1977.

Gadzhev, Vladimir. *Dzhazut na Bulgaria, Bulgarite na Dzhaza*. Sofia: Istok/Zapad, 2010.

Gay, Peter. "The Father's Revenge." In *Don Giovanni: Myths of Seduction and Betrayal*, edited by Jonathan Miller, 70–80. Baltimore: Faber and Faber, 1990.

———. *Modernism: The Lure of Heresy; From Baudelaire to Beckett and Beyond*. New York: W. W. Norton, 2008.

Gebauer, Gunter, and Christoph Wulf. *Mimesis: Culture, Art, Society*. Translated by Don Reneau. Berkeley: University of California Press, 1995.

Gerasimov, Bogomil. *Diplomatsiya v zonata na kaktusa*. Sofia: Trud, 1998.

Golan, Romy. *Modernity and Nostalgia: Art and Politics in France Between the Wars*. New Haven: Yale University Press, 1995.

Goodman, Steve. *Sonic Warfare: Sound, Affect, and the Ecology of Fear*. Cambridge, MA: MIT Press, 2012.

Gordon, Hayim, and Rivca Gordon. *Sophistry and Twentieth-Century Art*. Amsterdam: Rodopi Press, 2002.

Goswami, Supriya. *Colonial India in Children's Literature*. New York: Routledge, 2012.

Goto-Jones, Chris. *Conjuring Asia: Magic, Orientalism, and the Making of the Modern World*. New York: Cambridge University Press, 2016.

Gross, Kenneth. *The Dream of a Moving Statue*. Ithaca: Cornell University Press, 1992.

Grosz, Elizabeth. *The Incorporeal: Ontology, Ethics, and the Limits of Materialism*. New York: Columbia University Press, 2017.

Guentcheva, Rossitza. "Sounds and Noise in Socialist Bulgaria." In *Ideologies and National Identities: The Case of Twentieth-Century Southeastern Europe*, edited by John Lampe and Mark Mazower, 211–34. New York: Central European University Press, 2004.

Guteri, Matthew Pratt. *Josephine Baker and the Rainbow Tribe*. Cambridge, MA: Harvard University Press, 2014.

Guyer, Paul. "Beauty, Freedom, and Morality: Kant's Lectures on Anthropology and the Development of His Aesthetic Theory." In *Essays on Kant's Anthropology*, edited by Brian Jacobs and Patrick Kain, 135–63. New York: Cambridge University Press, 2003.

Hack, Roy Kenneth. *God in Greek Philosophy to the Time of Socrates*. Princeton: Princeton University Press, 1931.

Hale, Edward. *Ninety Days' Worth of Europe*. Boston: Walker and Wise, 1861.

Hankins, Thomas. *Science and the Enlightenment*. New York: Cambridge University Press, 1985.

Havell, E. B. *Indian Sculpture and Painting*. London: John Murray, 1908.

Heffernan, Carol Falvo. *The Phoenix at the Fountain: Images of Woman and Eternity in Lactantius's Carmen de Ave Phonice and the Old English Phoenix*. Newark: University of Delaware Press, 1988.

Hegel, Georg Wilhelm Friedrich. "Complete Symbolism—Memnons, Isis, and Osiris, the Sphinx." In *Aesthetics: Lectures on Fine Art*, translated by T. M. Knox. Vol. 1, 357–61. New York: Oxford University Press, 1975.

———. *Hegel, on the Arts: Selections from G. W. F. Hegel's Aesthetics, or The Philosophy of Fine Art*. Translated and edited by Henry Paolucci. Smyrna, DE: Griffon House, 2001.

Heller, Agnes. "Mozart's Don Giovanni in Shaw's Comedy." In *The Don Giovanni Moment: Essays on the Legacy of an Opera*, edited by Lydia Goehr and Daniel Herwitz, 181–92. New York: Columbia University Press, 2006.

Henty, G. A. "Excerpts from The Tiger of Mysore." In *From the East India Company to the Suez Canal*, vol. 1, *Archives of Empire*, edited by Barbara Harlow and Mia Carter, 173. Durham: Duke University Press, 2003.

Herder, Johann Gottfried. *Sculpture: Some Observations on Shape and Form from Pygmalion's Creative Dream*. Translated by Jason Gaiger. Chicago: University of Chicago Press, 2002.

Hertel, Christiane. *Pygmalion in Bavaria: The Sculptor Ignaz Günther and Eighteenth-Century Aesthetic Art Theory*. University Park: Pennsylvania State University Press, 2011.

Holmes, John Jaynes. "Bronze and Plaster." *Crisis* 39, no. 11 (1932): 345.

Hugo, Victor. *Les Misérables*. Translated by Christine Donougher. New York: Penguin Books, 2015.

Husain, Iqbal, trans. "The Diplomatic Vision of Tipu Sultan: Briefs for Embassies to Turkey and France, 1785–86." In *State Diplomacy under Tipu Sultan: Documents and Essays*, edited by Irfan Habib, 19–65. New Dehli: Tulika Books, 2001.

Ihde, Don. *Listening and Voice: A Phenomenology of Sound*. Athens: Ohio University Press, 1976.

Ivy, Marilyn. *Discourses of the Vanishing: Modernity, Phantasm, Japan*. Chicago: University of Chicago Press, 1995.

Jakobson, Roman. *Pushkin and His Sculptural Myth*. Translated by John Burbank. The Hague: Mouton, 1975.

Jasanoff, Maya. *Edge of Empire: Lives, Culture, and Conquest in the East, 1750–1850*. New York: Alfred A. Knopf, 2005.

Johnston, Sarah Iles. "Fiat Lux, Fiat Ritus: Divine Light and the Late Antique Defense of Ritual." In *The Presence of Light: Divine Radiance and Transformative Vision*, edited by Matthew Kapstein, 5–24. Chicago: University of Chicago Press, 2004.

Joshua, Essaka. *Pygmalion and Galatea: The History of a Narrative in English Literature*. New York: Ashgate, 2001.

Jules-Rosette, Bennetta. *Josephine Baker in Art and Life: The Icon and the Image*. Urbana: University of Illinois Press, 2007.

Kahn, Douglas. "The Arts of Sound Art and Music." *Iowa Review Web* 8, no. 1 (2006). http://www.douglaskahn.com/writings/douglas_kahnsound_art.pdf.

Kane, Brian. "Musicophobia, or Sound Art and the Demands of Art Theory." *Nonsite* 8, January 20, 2013. https://nonsite.org/article/musicophobiaorsoundartandthedemandsofarttheory.

———. "Sound Studies Without Auditory Culture: A Critique of the Ontological Turn." *Sound Studies* 1, no. 1 (2015): 2–21.

———. *Sound Unseen: Acousmatic Sound in Theory and Practice*. New York: Oxford University Press, 2014.

Kaneva, Nadia. "Remembering Communist Violence: The Bulgarian Gulag and the Conscience of the West." *Journal of Communication Inquiry* 31, no. 1 (2007): 44–61.

Kaplan, Paul H. D. "Italy, 1490–1700." In *The Image of the Black in Western Art*. Vol. 3, *From the "Age of Discovery" to the Age of Abolition*, part 1, *Artists of the Renaissance and Baroque*, edited by David Bindman and Henry Louis Gates Jr., 93–190. Cambridge: Belknap Press of Harvard University, 2010.

Kapralov, A. "Zhivkov-Era Concentration Camp." *Current Digest of the Soviet Press* 42, no. 16 (1990): 18–19.

Karavelov, Liuben. "Plovdiv." Translated by Wendy Bracewell. In *Orientations: An Anthology of East Europe Travel Writing, ca. 1550–2000*, edited by Wendy Bracewell, 237–38. New York: Central European University Press, 2009.

Karsten, Gustav. "Germanic Philology." *Journal of English and Germanic Philology* 7, no. 2 (1908): 4–21.

Kausar, Kabir, ed. *Secret Correspondence of Tipu Sultan*. New Dehli: Light and Life, 1980.

Keats, John. *The Complete Poems of John Keats*. Vol. 2. New York: Random House, 1994.

Kierkegaard, Søren. *Either/Or: A Fragment of Life*. Translated by Alastair Hannay, edited by Victor Eremita. New York: Penguin Books, 1992.

Kim-Cohen, Seth. *In the Blink of an Ear: Toward a Non-Cochlear Sonic Art*. New York: Continuum Books, 2009.

King, Moses. *King's How to See New York: A Complete Trustworthy Guide Book*. New York: Moses King, 1914.

Korudzhiev, Dimitar. *Predi da se umre: fantaziya za Sasho Sladura*. Sofia: Literaturen forum, 1995.

Koshul, Basit Bilal. *The Postmodern Significance of Max Weber's Legacy: Disenchanting Disenchantment*. New York: Palgrave Macmillan, 2005.

Kramer, Lawrence. *Opera and Modern Culture: Wagner and Strauss*. Berkeley: University of California Press, 2007.

Krauss, Rosalind. "Sculpture in the Expanded Field." *October* 8 (1979): 30–44.

LaBelle, Brandon. *Background Noise: Perspectives on Sound Art*. New York: Continuum Books, 2006.

Lafont, Jean-Marie, trans. "The *Mémoires* of Lieutenant-Colonel Russel concerning Mysore: In the Service Historique de l'Armée de Terre, Château de Vincennes, Paris." In *State Diplomacy Under Tipu Sultan*, edited by Irfan Habib, 82–107. New Dehli: Tulika, 2001.

Lampe, John, and Marvin Jackson. *Balkan Economic History, 1550–1950: From Imperial Borderlands to Developing Nations*. Bloomington: Indiana University Press, 1982.

Lapidge, Michael. "Stoic Cosmology." In *The Stoics*, edited by John Rist, 161–86. Berkeley: University of California Press, 1978.

Layher, William. *Queenship and Voice in Medieval Northern Europe*. New York: Palgrave Macmillan, 2010.

Lehman, Robert. "Allegories of Rending: Killing Time with Walter Benjamin." *New Literary History* 39, no. 2 (2008): 233–50.

Leijenhorst, Cornelis Hendrik. *The Mechanisation of Aristotelianism: The Late Aristotelian Setting of Thomas Hobbes' Natural Philosophy*. Boston: Brill, 2002.

Lemke, Seglinde. *Primitivist Modernism: Black Culture and the Origins of Transatlantic Modernism*. New York: Oxford University Press, 1998.

Lendvai, Paul. *One Day That Shook the Communist World: The 1956 Uprising and Its Legacy*. Translated by Ann Major. Princeton: Princeton University Press, 2008.

Lessing, Gotthold Ephraim. *Laocoön*. Translated by Robert Philmore. London: Macmillan, 1874.

Licht, Alan. "Sound Art: Origins, Development, and Ambiguities." *Organized Sound* 14, no. 1 (2009): 3–10.

Locke, John. *An Essay Concerning Human Understanding: Abridged and Edited, with an Introduction and Notes*. Edited by Kenneth Winkler. Indianapolis: Hackett, 1996.

Lokke, Havard. "The Active Principle in Stoic Philosophy." In *The World as Active Power: Studies in the History of European Reason*, edited by Juhani Pietarinen and Valtteri Viljanen, 49–70. Boston: Brill, 2009.

Loughridge, Deirdre. *Haydn's Sunrise, Beethoven's Shadow: Audiovisual Culture and the Emergence of Musical Romanticism*. Chicago: University of Chicago Press, 2016.

Losseff, Nicky. "The Voice, the Breath, and the Soul: Song and Poverty in *Thyrza*, *Mary Barton*, *Alton Locke*, and *A Child of Jago*." In *The Idea of Music in Victorian Fiction*, edited by Sophie Fuller and Nicky Losseff, 3–26. New York: Routledge, 2016.

Lynch, Michael. "Ontography: Investigating the Production of Things, Deflating

Ontology." *Social Studies of Science* 43, no. 3 (2013): 444–62.

Malhotra, Ashok. *Making British Indian Fictions: 1772–1823*. New York: Palgrave Macmillan, 2012.

Marciano, Alain. "The Historical and Philosophical Foundations of New Political Economy." In *The Elgar Companion to Economics and Philosophy*, edited by John Davis, Alain Marciano, and Jochen Runde, 24–41. Northampton, MA: Edward Elgar, 2004.

Markov, Georgi. *The Truth That Killed*. Translated by Liliana Brisby. New York: Ticknor and Fields, 1984.

Mason, Peter. *The Colossal: From Ancient Greece to Giacometti*. London: Reaktion Books, 2013.

Mawer, Deborah. *French Music and Jazz in Conversation: From Debussy to Brubeck*. New York: Cambridge University Press, 2014.

Maxwell, James Clerk. *The Scientific Papers of James Clerk Maxwell*. Vol. 2. Edited by W. D. Niven. Mineola, NY: Dover Press, 2003.

McCormack, Ryan. "Bulgarian Bulge: Jazz, Modernity, and Subjectivity in Bulgaria." PhD diss., University of Texas at Austin, 2011.

———. "The Colossus of Memnon and Phonography." *Sound Studies* 2, no. 2 (2016): 165–87.

———. "Technologies of Dismemberment: Orpheus, Fascination, and Bulgarian Etnodzhaz." *TDR / The Drama Review* 61, no. 1 (2017): 99–113.

McDermott, Lydia. *Liminal Bodies, Reproductive Health, and Feminist Rhetoric: Searching the Negative Spaces in Histories of Rhetoric*. New York: Lexington Books, 2016.

Métraux, Guy. *Sculptors and Physicians in Fifth-Century Greece: A Preliminary Study*. Montreal: McGill-Queen's University Press, 1995.

Metzner, Paul. *Crescendo of the Virtuoso: Spectacle, Skill, and Self-Promotion in Paris During the Age of Revolution*. Berkeley: University of California Press, 1998.

"Mid Year Commencement." *Alumni Quarterly* 50, no. 1 (1949). https://archive.org/stream/alumniquarterly100bloo_21/alumniquarterly100bloo_21_djvu.txt.

Milev, Emil. "Pomnite li Sasho Sladura?" *Plovdiv utre*, October 25, 2011. http://www.plovdivutre.bg/kultura/25718pomnitelisashosladura (site discontinued).

Mishra, Vijay. *The Gothic Sublime*. Albany: State University of New York Press, 1994.

Mitchell, Andrew. *Heidegger Among the Sculptors: Body, Space, and the Art of Dwelling*. Stanford: Stanford University Press, 2010.

Mitchell, W. J. T. *Picture Theory*. Chicago: University of Chicago Press, 1994.

Moskov, Nikolai. "Bulgaria e bila parviyat mol na Sofia." *24 Chasa*, May 1, 2009. https://www.24chasa.bg/Article/94528.

Moten, Fred. *Consent Not to Be a Single Being: Black and Blur*. Durham: Duke University Press, 2017.

———. *Into the Break: The Aesthetics of the Black Radical Tradition*. Minneapolis: University of Minnesota Press, 2003.

Narasimha, Roddam. "Rockets in Mysore and Britain, 1750–1850." National Aeronautical Laboratory, Project Document DU 8503, April 2, 1985. https://www.researchgate.net/publication/37179995_Rockets_in_Mysore_and_Britain_17501850_AD.

Narrative sketches of the conquest of the Mysore, effected by the British troops and their allies, in the Capture of Seringapatam, and the Death of Tippoo Sultaun; May 4, 1799. 2nd ed. London: West and Hughes, 1800.

Neely, Jack. "Knoxville: Summer 1979." *Knoxville Mercury*, August 5, 2015. http://www.knoxmercury.com/2015/08/05/knoxvillesummer1979.

Nelson, Charmaine. *The Color of Stone: Sculpting the Black Female Subject in Nineteenth-Century America*. Minneapolis: University of Minnesota Press, 2007.

North, Michael. *The Dialectic of Modernism: Race, Language, and Twentieth-Century Literature*. New York: Oxford University Press, 1994.

"On the Inconveniences of Barrel Organ." *Christian Observer* 5 (1834): 333.

Ord-Hume, Arthur. "Barrel Organ." In *Continuum Encyclopedia of Popular Music of the World*, edited by John Shepherd, vol. 11, 327–29. New York: Continuum Books, 2003.

———. "Tipu's Tiger—Its History and Description, Part II." *Music and Automata* 3, no. 10 (1987): 64–80.

Osborne, Charles. *The Complete Operas of Mozart: A Critical Guide*. New York: Indigo Books, 1997.

Ouzounian, Gascia. "Sound Art and Spatial Practices: Situating Sound Installation Art Since 1958." PhD diss., University of California, San Diego, 2008.

Panzanelli, Roberta. "Introduction: The Body in Wax, the Body of Wax." In *Ephemeral Bodies: Wax Sculpture and the Human Figure*, edited by Roberta Panzanelli, 1–12. Los Angeles: Getty Research Institute, 2008.

Patch, Justin. "The Art of Noise: Hearing, Feeling, and Experiencing the Sound of Democracy." *Soundings* 92, nos. 3/4 (2009): 303–29.

Paterson, Mark. *The Senses of Touch: Haptics, Affects, Technologies*. New York: Berg, 2007.

Pentcheva, Bissera. *The Sensual Icon: Space, Ritual, and the Senses in Byzantium*. University Park: Pennsylvania State University Press, 2010.

Petry, Ann. "Mother Africa." In *Miss Muriel and Other Stories*, 126–62. New York: Dafina Books, 2008.

Picker, John. *Victorian Soundscapes*. New York: Oxford University Press, 2003.

Platt, J. C. "The East India House." In *London*, vol. 5, edited by Charles Knight, 49–64. London: Charles Knight, 1843.

Pliny the Elder. *Natural History*. Vol. 10. Edited by Harold Rackham. Cambridge, MA: Harvard University Press, 1989.

Plumly, Stanley. "This Mortal Body." *Kenyon Review* 29, no. 3 (2007): 164–202.

Plutarch. *Morals*. Edited by William Watson Goodwin. Boston: Little and Brown, 1874.

Poizat, Michel. *The Angel's Cry: Beyond the Pleasure Principle in Opera*. Translated by Arthur Denner. Ithaca: Cornell University Press, 1992.

Potts, Alex. *The Sculptural Imagination: Figurative, Modernist, Minimalist*. New Haven: Yale University Press, 2000.

Prager, Brad. *Aesthetic Vision and German Romanticism: Writing Images*. Rochester: Camden House, 2007.

Ragussis, Michael. *Acts of Naming: The Family Plot in Fiction*. New York: Oxford University Press, 1987.

Raicheski, Georgi. *Plovdivska entsiklopediya*. Plovdiv: Zhanet 45, 1999.

Rancière, Jacques. *Aisthesis: Scenes from the Aesthetic Regime of Art*. Translated by Zakir Paul. New York: Verso Books, 2013.

Reed, John. *The War in Eastern Europe*. New York: Charles Scribner's Sons, 1916.

Reid, Robert. "Introduction: Pushkin; Myth and Monument." In *Alexander Pushkin: Myth and Monument*, vol. 2, *Two Hundred Years of Pushkin*, edited by Robert Reid and Joe Andrew, 1–14. New York: Rodopi Books, 2003.

Richards, David. *Masks of Difference: Cultural Representations in Literature, Anthropology, and Art*. New York: Cambridge University Press, 1994.

Riethmüller, Albrecht. "From Vox alias Phoné to Voice: A Few Terminological Observations." In *On Voice*, edited by Walter Bernhart and Lawrence Kramer, 77–90. New York: Rodopi Books, 2014.

Roberts, Nora Ruth. "Artistic Discourse in Three Short Stories by Ann Petry." In *Ann Petry's Short Fiction: Critical Essays*, edited by Hazel Arnett Ervin and Hilary Holladay, 31–48. Westport, CT: Praeger Books, 2004.

Robinson, Keith. "Deleuze, Whitehead, and Creativity." In *The Lure of Whitehead*, edited by Nicholas Gaskill and A. J. Nocek, 207–31. Minneapolis: University of Minnesota Press, 2014.

Romanska, Magda. "Don Giovanni: The Law of the Father." *Boston Lyric Opera* (blog). http://blog.blo.org/dongiovannilawoffather.

Roulier, Scott. *Kantian Virtue at the Intersection of Politics and Nature: The Vale of*

Soul-Making. Rochester: University of Rochester Press, 2004.

Rowland, Ingrid. "Don Giovanni: 'And What Communion Hath Light with Darkness?'" In *The Don Giovanni Moment: Essays on the Legacy of an Opera*, edited by Lydia Goehr and Daniel Herwitz, 1–17. New York: Columbia University Press, 2006.

Roy, Kaushik. *War, Culture, and Society in Early Modern South Asia, 1740–1849*. New York: Routledge, 2011.

Rumph, Stephen. *Mozart and Enlightenment Semiotics*. Berkeley: University of California Press, 2012.

Russolo, Luigi. "The Art of Noises: Futurist Manifesto." In *Audio Culture, Revised Edition: Readings in Modern Music*, edited by Christoph Cox and Daniel Warner, 11–16. New York: Bloomsbury, 2017.

Ryback, Timothy. *Rock Around the Bloc: History of Rock Music in Eastern Europe and the Soviet Union*. New York: Oxford University Press, 1990.

Sandberg, Mark. *Living Pictures, Missing Persons: Mannequins, Museums, and Modernity*. Princeton: Princeton University Press, 2003.

Savage, George. *A Concise History of Bronzes*. London: Thames and Hudson, 1968.

Savage, Kirk. *Standing Soldiers, Kneeling Slaves: Race, War, and Monument in the Nineteenth Century*. Princeton: Princeton University Press, 1999.

Schenker, Alexander. *The Bronze Horseman: Falconet's Monument to Peter the Great*. New Haven: Yale University Press, 2003.

Schmid, Rebecca. "Claus Guth's Forest-Bound 'Don Giovanni' at the Staatsoper; Musikfestspiele Potsdam's New Pleasure Garden." *Musical America* (blog), June 29, 2012. http://www.musicalamerica.com/mablogs/?p=5768.

Schroeder, David. *Mozart in Revolt: Strategies of Resistance, Mischief, and Deception*. New Haven: Yale University Press, 1999.

Schroeder, Ian, and Heather Lehr Vagner. *Josephine Baker: Entertainer*. New York: Infobase, 2006.

Schulze, Holger. *The Sonic Persona: An Anthropology of Sound*. New York: Bloomsbury, 2018.

Schwartz, Howard. *Tree of Souls: The Mythology of Judaism*. New York: Oxford University Press, 2004.

Scott, Walter. *The Complete Works of Sir Walter Scott; with a Biography and His Last Additions and Illustrations*. Vol. 7. New York: Connor and Cooke, 1833.

Seelig, Lorenz. "Christoph Jamnitzer's 'Moor's Head.'" In *Black Africans in Renaissance Europe*, edited by T. F. Earle and K. J. P. Lowe, 181–212. New York: Cambridge University Press, 2005.

Segesten, Anamaria Dutceac. *Myth, Identity, and Conflict: A Comparative Analysis of Romanian and Serbian Historical Textbooks*. Lanham, MD: Lexington Press, 2011.

Serres, Michel. *The Five Senses: A Philosophy of Mingled Bodies*. Translated by Margaret Sankey and Peter Cowley. New York: Continuum Books, 2008.

———. *Statues: The Second Book of Foundations*. Translated by Randolph Burks. New York: Bloomsbury, 2016.

Serres, Michel, and Bruno Latour. *Conversations on Science, Culture, and Time*. Translated by Roxanne Lapidius. Ann Arbor: University of Michigan Press, 1995.

Shaw, George Bernard. *Man and Superman: A Comedy and a Philosophy*. New York: Bretano's, 1904.

Sheriff, Mary. *Moved by Love: Inspired Artists and Deviant Women in Eighteenth-Century France*. Chicago: University of Chicago Press, 2004.

Sherrod, Alan. "In Metro Pulse: Review of 'Rachmaninoff Remembered.'" *Classical Journal* (blog), February 19, 2013. https://classicaljournal.wordpress.com/2013/02/19/inmetropulsereviewofrachmaninoffremembered.

"Should Organ Grinders Be Expelled?" *Punch, or The London Charivari*, November 18, 1903, 350.

Shumnaliev, Dimitar. *Sotsroman*. Sofia: Trud, 2007.

Slavov, Ivan. *Zlatnata Reshetka: Vitsove ot totalitarno i posttotalitarno vreme*.

Sofia: Universitat izdadenie Svetut Kliment Ohridski, 2003.
Smith, Bruce. *The Acoustic World of Early Modern England: Attending to the O-Factor*. Chicago: University of Chicago Press, 1999.
Smith, David Nowell. *Sounding/Silence: Martin Heidegger and the Limits of Poetics*. New York: Fordham University Press, 2013.
Smith, Mark M. *The Smell of Battle, the Taste of Siege: A Sensory History of the Civil War*. New York: Oxford University Press, 2015.
Solla Price, Derek de. "Automata and the Origins of Mechanism and Mechanistic Philosophy." *Technology and Culture* 5, no. 1 (1964): 9–23.
Spivey, Nigel. "Bionic Statues." In *The Greek World*, edited by Anton Powell, 442–60. New York: Routledge, 1995.
———. *Enduring Creation: Art, Pain, and Fortitude*. Berkeley: University of California Press, 2001.
Staden, Heinrich von. "Anatomy and Physiology." In *Encyclopedia of Ancient Greece*, edited by Nigel Wilson, 44–46. New York: Routledge, 2006.
Starr, S. Frederick. *Red and Hot: Jazz in the Soviet Union, 1917–1991*. New York: Limelight Editions, 1994.
Steinberg, Michael. *Listening to Reason: Culture, Subjectivity, and Nineteenth-Century Music*. Princeton: Princeton University Press, 2004.
Steiner, Deborah. *Images in Mind: Statues in Archaic and Classical Greek Literature and Thought*. Princeton: Princeton University Press, 2001.
Sterne, Jonathan. *The Audible Past: Cultural Origins of Sound Reproduction*. Durham: Duke University Press, 2003.
Stewart, Kathleen. *A Space on the Side of the Road: Cultural Poetics of an "Other" America*. Princeton: Princeton University Press, 1996.
Stoever, Jennifer Lynn. *The Sonic Color Line: Race and the Cultural Politics of Listening*. New York: New York University Press, 2016.
Stoichita, Victor. *The Pygmalion Effect: From Ovid to Hitchcock*. Translated by Alison Anderson. Chicago: University of Chicago Press, 2008.
Stoiyanova, Penka, and Emil Iliev. *Politicheski opasni litsa: Vudvoriavaniya, trudova mobilizatsiya, izsledvaniya v Bulgariya sled 1944 g.* Sofia: Univ. izd-vo Sv. Kliment Okhridski, 1991.
"A Stopless Organ." *Musical Times* 41, no. 1 (1900): 52.
Stronge, Susan. *Tipu's Tigers*. London: Victoria and Albert Museum, 2009.
Strozek, Przemyslaw. "Futurist Responses to African American Cultures." In *Afromodernisms: Paris, Harlem, and the Avant-Garde*, edited by Fionnghuala Sweeney and Kate Marsh, 43–61. Edinburgh: Edinburgh University Press, 2013.
"Subtyll and Crafty Devices." *British Medical Journal* 1 (1898): 295–96.
Szendy, Peter. "The Auditory Re-Turn (The Point of Listening)." In *Thresholds of Listening: Sound, Technics, Space*, edited by Sander van Maas, 18–29. New York: Fordham University Press, 2015.
———. *Listen: A History of Our Ears*. Translated by Charlotte Mandell. New York: Fordham University Press, 2008.
Taussig, Michael. *Walter Benjamin's Grave*. Chicago: University of Chicago Press, 2006.
Taylor, Karin. *Let's Twist Again: Youth and Leisure in Socialist Bulgaria*. Brunswick, NJ: Transaction Press, 2006.
Tenev, Dragan. *Tristahilyada Sofia i az mezhdu dvete boini*. Sofia: Bulgarski Pisatel, 1997.
Tenev, Stanomir. "Sasho Sladura bil interniran zarai 'zhilesta' replika kam Bai Tosho." *Razkritiya*, July 9, 2010. http://www.razkritiya.com/45584 (site discontinued).
Till, Nicholas. *Mozart and the Enlightenment: Truth, Virtue, and Beauty in Mozart's Operas*. New York: W. W. Norton, 1993.
"Tippoo's Tiger." *Penny Magazine of the Society for the Diffusion of Useful Knowledge*, August 15, 1835, 319–20.
Todorov, Todor. "Plovdiv vdiga pametnik na Sasho Sladura." *Maritza Dnes* 116, no.

3435 (2002). http://www.eunet.bg/media/show_story.html?issue=255259808 (site discontinued).

Todorov, Tsvetan. *Voices from the Gulag: Life and Death in Communist Bulgaria*. Translated by Robert Zaretsky. University Park: Pennsylvania State University Press, 1999.

Tomlinson, Gary. *Metaphysical Song: An Essay on Opera*. Princeton: Princeton University Press, 1999.

Toulmin, Stephen, and June Goodfield. *The Architecture of Matter*. Chicago: University of Chicago Press, 1982.

Trower, Shelley. *Senses of Vibration: A History of the Pleasure and Pain of Sound*. New York: Continuum Books, 2012.

Tsonchev, Doncho. *Preletni dushi: Portretcheta*. Sofia: Trud, 2000.

Uzadinys, Algis. "Animation of Statues in Ancient Civilization and Neoplatonism." In *Late Antique Epistemology: Other Ways to Truth*, edited by Panayiota Vassilopoulou and Stephen Clark, 118–40. New York: Palgrave Macmillan, 2009.

"Uzhasna versiya: Koi e Sasho Sladura i zashto negova statuya e izdignata nad Amfiteatura v Plovdiv." *Blitz*, August 27, 2017. https://blitz.bg/obshtestvo/regioni/uzhasnaversiyakoyesashosladuraizashchonegovastatuyaeizdignatanadamfiteatravplovdiv_news539312.html.

Vanderheyden, Jennifer. *The Function of the Dream and the Body in Diderot's Works*. New York: Peter Lang, 2004.

Verdery, Katherine. *The Political Lives of Dead Bodies: Reburial and Postsocialist Change*. New York: Columbia University Press, 1999.

Vitz, Paul. *Sigmund Freud's Christian Unconscious*. Grand Rapids, MI: William B. Eerdmans, 1993.

Vizcaíno-Alemán, Melina. "Counter-Modernity, Black Masculinity, and Female Silence in Ann Petry's Fiction." In *Revising the Blueprint: Ann Petry and the Literary Left*, edited by Alex Lubin, 120–36. Jackson: University Press of Mississippi, 2007.

Voegelin, Salomé. *Listening to Noise and Silence: Toward a Philosophy of Sound Art*. New York: Continuum Books, 2010.

Voskuhl, Adelheid. *Androids in the Enlightenment: Mechanics, Artisans, and Cultures of the Self*. Chicago: University of Chicago Press, 2013.

Walter, Brenda Gardenour. "Corrupt Air, Poisonous Places, and the Toxic Breath of Witches in Late Medieval Medicine and Theology." In *Toxic Airs: Body, Place, Planet in Historical Perspective*, edited by James Rodger Fleming and Ann Johnson, 1–22. Pittsburgh: University of Pittsburgh Press, 2014.

———. *Our Old Monsters: Witches, Werewolves, and Vampires from Medieval Theology to Horror Cinema*. Jefferson, NC: McFarland, 2015.

Warner, Marina. *Phantasmagoria: Spirit Visions, Metaphors, and Media into the Twenty-First Century*. New York: Oxford University Press, 2006.

Warwick, Genevieve. "Making Statues Speak: Bernini and Pasquino." In *Articulate Objects: Voice, Sculpture, and Performance*, edited by Aura Satz and Jon Wood, 29–46. New York: Peter Lang, 2009.

Wells, Marion. *The Secret Wound: Love-Melancholy and Early Modern Romance*. Stanford: Stanford University Press, 2007.

West, Cornel. "A Genealogy of Modern Racism." In *From Modernism to Postmodernism: An Anthology*, 2nd ed., edited by Lawrence Cahone, 298–309. Malden, MA: Blackwell Books, 2003.

Whiteley, Sheila. "'The Sound of Silence': Academic Freedom and Copyright." *Popular Music* 16, no. 2 (1997): 220–22.

Whitmarsh, Tim. "'Greece Is the World': Exile and Identity in the Second Sophistic." In *Being Greek Under Rome: Cultural Identity, the Second Sophistic, and the Development of Empire*, edited by Simon Goldhill, 269–305. New York: Cambridge University Press, 2001.

Williams, Bernard. *On Opera*. New Haven: Yale University Press, 2006.

Wills, Martin. *Mesmerists, Monsters, and Machines: Science Fiction and the Cultures of Science in the Nineteenth Century*. Kent: Kent State University Press, 2006.

Winckelmann, Johann Joachim. *History of the Art of Antiquity*. Translated by Harry Francis Mallgrave. Los Angeles: Getty Research Institute, 2006.

Yurchak, Alexei. "Bodies of Lenin: The Hidden Science of Communist Sovereignty." *Representations* 129, no. 1 (2015): 116–57.

———. *Everything Was Forever, Until It Was No More: The Last Soviet Generation*. Princeton: Princeton University Press, 2006.

Zabalo, Jacobo. "Don Juan (Don Giovanni): Seduction and Its Absolute Medium in Music." In *Agamemnon to Guadalquivir*. Vol. 1, 141–58, of *Kierkegaard's Literary Figures and Motifs*. Kierkegaard Research: Sources, Reception, and Resources 16. New York: Routledge, 2016.

Zeiss, Laurel. "Permeable Boundaries in Mozart's 'Don Giovanni.'" *Cambridge Opera Journal* 13, no. 2 (2001): 115–39.

Ziarek, Krzysztof. *Language After Heidegger*. Bloomington: Indiana University Press, 2013.

Index

acousmatic voice, 180
 as evidence of spiritual inhabitation, 41
 in opera staging and orchestration, 99, 104
 pneumatic connections of, 55–56
 sound technology and, 34
 speculative cosmology and, 165
 as supplement to statuary, 18
 See also voice/vocality
Adichie, Chimamanda Ngozi, 122
aether, 41, 52, 54, 109, 164–65
Agamben, Giorgio, 40, 42–44, 48
Alexander, Stephon, 166
Alighieri, Dante, 42–43, 89
allegory, 157–59
Anaximenes of Miletus, 44–45, 56
Andrews, Donald Hatch, 12–13, 166–70, 173–74
Apollo and Daphne, 35
Aquinas, Thomas, 19, 34
Aristotle, 49–51, 55, 76, 134, 164
Athenaeum (magazine), 79
audiovisual litany, 8, 13
auditory litany, 13
aurality, 3–4, 6–7, 10–13, 58, 173
automaton/automata, 10, 19
 Condillac and, 92–93
 head of Albertus Magnus, 181n3
 relationship to touch, 33
 technology/magic dichotomy and, 65, 74–78
 Vaucanson and Jaquet-Droz making, 186n39
 weirdifact and, 84, 86

Baal Hammon. *See* Moloch
Badiou, Alain, 5
Baker, Josephine, 11–12, 175
 career in Paris, 112, 114–15, 123
 Château des Milandes and, 111–12, 133–34
 Chouski sculpture of, 134
 Jorama exhibit, 112–13, 130, 133
 race and performance, 113–15, 123, 128
 represented in wax, 133–34
 vocal silencing of, 128–30
Baker, Malcolm, 90

Bamforth, Nigel, 85
barrel organ, 69–70, 74–78, 185n23, 186n40–41
Baudelaire, Charles, 18
Bell, Alexander Graham, 132
Benjamin, Walter, 156–59
Berkeley, George, 92
Bernini, Gian Lorenzo, 35
Black Sea, 143, 146, 150–51
body
 anthropocentrism of non-statues and, 29
 black femininity and, 11, 112–14, 124–30
 color and, 115–17
 empiricism and, 91–95
 hearing and, 13–14, 163
 molecular signatures of, 167
 naming and, 154–60
 performative reanimation of, 178, 180
 pneuma and, 41–53, 56–57
 racial representations of, 119–23
 sensory experience of, 31, 33, 90–91
 silence/death and, 137–40
 sound as becoming, 26–27, 109
 sound representing castration of, 82
 statues as representing the, 19–20, 22–23, 39–40, 55, 176
 stone artifice as, 97, 102–3
 vibrational affect and, 12, 24–25, 96–97, 123–24, 164
 wax and, 131–33
 See also embodiment
Boehrer, Bruce, 20
Bohm, David, 166, 169
Bokarov, Viktor, 177
Bond, Sarah, 122
Boris III, 141, 153, 191n13
Boureau-Deslandes, André-François, 94–95, 97
Brach, Paul, 114
Brakhman, Evgeny, 178–80
Brancusi, Constantin, 23
British Empire, 11, 64–68, 73, 77–80, 85–6
Bulgarian Agrarian National Union (BANU), 141
Bulgarian Communist Party (BCP), 137, 142–44, 146–48, 150

INDEX

Bulgarian Socialist Party (BSP), 137
Burke, Edmund, 72
bronze
 blackness and, 11–12, 113, 117–20, 123–25, 128, 130
 Bronze Horseman and, 60–61
 comparison with wax, 131–33
 Hellenic examples of, 36–37, 57–58, 61, 182n2
 materiality of statues and, 29
 Moloch sacrifices and, 20
 Newhart statue as, 173–74
 Rachmaninoff statue as, 177–78
 silence and, 158
 Sladura statue as, 136, 140
 vibration of, 33–34, 123, 162
 whiteness and, 122
The Bronze Horseman (*Mednyi Vsadnik*), 59–61, 184n66

Cage, John, 25, 139
Carlson, Roy, 108
Campanella, Thomasino, 51
Carlyle, Thomas, 77
Caverero, Adriana, 48
Charlottesville, 122–23
Chattopadhyay, Budhaditya, 26
Chervenkov, Borislav, 150
Chervenkov, Valko, 143, 147–48, 150–51, 155
Cheng, Anne Anlin, 112, 115, 129
Chicago, 170–73
Chillida, Eduardo, 24–25
Chion, Michel, 99
Christian, Kathleen Wren, 58
Christian Observer, 76
Chrysostom, Dio, 172
Chua, Daniel, 96
Classen, Constance, 33
Cohen, H. Floris, 51–52
Colley, Linda, 81
Colossus of Memnon, 6–8, 172
Commendatore, 11, 29, 97–98, 175
 empiricist connections to, 93
 Guth's presentation of, 89, 108–10
 in *Man and Superman*, 105–7
 modern incarnations of, 108
 musical aspects of, 100–104
 representative of *ancien regime*, 89–90
 vocal presence of, 91
Condillac, Éttiene Bonnot de, 92–94, 97, 103
Connor, Steven, 116–17
Coote, Sir Eyre, 80
Cordier, Charles-Henri-Joseph, 119

corps sonore, 96–97, 109
cosmopolitanism, 67, 86, 138
Cowan, Bainard, 158
Craig, Maxine Leeds, 118
Cummings, E. E., 114

Dafinov, Nikolas, 151, 154
Dankov, Danko, 137–38
Da Ponte, Lorenzo, 89–90, 98, 102, 107, 109, 188n25
Darwin, Charles, 37
Darzhaven Sigurnost (DS), 148
Daskalova, Svetla, 152, 193n49
Davis, Richard, 73
De Broglie, Louis, 165–66, 169
Deleuze, Gilles, 4–5, 9, 116, 163
Derrida, Jacques, 56, 190n11
Descartes, René, 4, 22
 mechanistic concepts of 52, 74, 91
 mind/body dualism, 91–93, 115–16
 soul in pineal gland, 53
 on wax, 132
Dickens, Charles, 76–77
Diderot, Denis, 94–95, 97
Didi-Huberman, Georges, 131
Dimbleby, David, 85
Doinov, Emanuil, 150
Don Giovanni (character), 87–91, 100–103, 105–10, 173
Don Giovanni (opera), 11, 60, 89–90
 influences upon, 187–88n7
 Mozart's enthusiasm for writing, 98
 modern settings of, 105–9
 orchestration for, 100–103
Dunaevskii, Isak, 145
Dyson, Frances, 55
Dzhaz na Mladite (Jazz of the Youth), 148
Dzhaz na Optimistite (Jazz of the Optimists), 144–47, 191n26

East India Company, 63–64, 70–72, 80–81
Echevarria, Roberto González, 124
Eisler, Hans, 145
Elizabeth I, 75
Elvis statue, 17, 34
 comparison to Statue Stories Chicago, 171, 173
 philosophical implications of, 3–4, 6, 29
 theft and recovery of, 1–2, 181n1
 pretext for Rachmaninoff event, 176–77
embodiment
 Cartesian theory of, 91
 color and, 117

embodiment (*continued*)
 Condillac on, 92
 connection between voice and self, 13
 sculpture and, 22–23, 90, 154
 sound art and, 26–27
 pneumatic voice and, 49
 race and, 123
Enders, Katerina, 140
Enlightenment, The, 7
 animated statue in, 92–95, 97
 animating power of breath and, 38–40
 aristocratic power and, 60–61, 89–91
 demystification of statues in, 21–22, 27, 29
 eclipse of pneumaticism in, 10, 52, 54–55, 183n50
 French modernism as reaction to 115
 mapped onto medieval thought, 43
 Mozart and, 98, 103
 post-WWI failure of, 23
 racial representation and, 122
 rationalism of automata in, 10, 76
 sense of touch and, 33
Estrada za khumor i satira, 146
Evans, Henry Ridgely, 77
event
 definition of, 4–6, 181n2
 hearing and, 14
 pneuma and, 60
 resonance and, 113–14
 Serres on, 28
 sensory transcendence as, 162
 silence as, 161
 social possibilities of, 13, 164, 179–80
 sounding statue as, 8–9, 16, 34–35, 64, 175–76
 sound manifesting as, 30–31

Falconet, Étienne Maurice, 21, 59, 94
Flaubert, Gustave, 28
Fletcher, Harvey, 30
Forbes, James, 72
Forrest, Nathan Bedford, 122
Foucault, Michel, 74
Fried, Michael, 24

Galatea, 33, 94–97, 103, 105
Galen, 47, 53–54
Ganev, Dimitar, 145, 149
Gay, Peter, 23
Gentleman's Magazine, 80
Georgiev, Lyudmil, 152
Gerasimov, Bogomil, 150

Gibson, John, 120
golem, 17, 184n65
Goswami, Supriya, 82
Greeley, Horace, 33
Greenberg, Clement, 23
Gross, Kenneth, 17–19, 56–57, 59
Guth, Claus, 89, 108–9

Haidar Ali, 65, 67, 81, 185n19, 187n53
Hale, Edward, 119–20, 122
Harris, George, 63
Havell, E. B., 73
hearing
 anthropological framework for, 35
 aurality as manifestation of, 3–4
 Commendatore's voice and, 90–91
 comparison with sight, 8
 comparison with touch, 33
 dichotomy with listening, 9, 13–14
 embodied sense of, 162–64, 169–70
 grasping materiality through, 47, 97
 pneuma and, 10, 42
 public sounding statuary and, 171, 173–74
 sculpted ear in dialogue with, 8, 62, 175, 180
 silence as part of, 12
Heidegger, Martin, 14, 24–25, 29–30, 78, 163, 190n11
Hegel, Georg Friedrich Wilhelm, 21
Helmholtz, Hermann von, 30, 167
Herder, Johann Gottfried, 21–22, 25, 29, 33, 77, 95
Heyer, Heather, 122
Hoffman, E. T. A., 19, 76
Hofland, Barbara, 82, 84–85
Horowitz, Vladmir, 179
Hugo, Victor, 104–5
Hume, David, 92
Hunter, James, 69, 71, 186n27

Idomeneo (1781), 98–102, 104
Ihde, Don, 139
Internal Macedonian Revolutionary Organization (IMRO), 141
Ivanova, Lea, 147, 152–53
Ivy, Marilyn, 138

Jaquet-Droz, Henri-Louis, 75–76, 186n39
Janasoff, Maya, 64
Jarves, James Jackson, 119
jazz, 137, 139–40, 142–48, 191n17
Joyce, James, 108, 171, 188n47

Kahn, Douglas, 26
Kane, Brian, 26, 163, 182n30
Kant, Immanuel, 21–22, 71, 74, 131
Karavelov, Liuben, 135
Keats, John, 72, 83–85
Kempeler, Wolfgang, 74
Kierkegaard, Søren, 89, 101
Kim-Cohen, Seth, 34
Kirkpatrick, William, 68, 184n9
Knoxville, 34, 177–79
kontslager, 145, 148, 150, 152, 192n40, 193n48
Korabov, Nikola, 140
Korudzhiev, Dimitar, 140, 152–54
Kramer, Lawrence, 89
Krauss, Rosalind, 23–25

LaBelle, Brandon, 25, 163
La Création du Monde (Milhaud), 114
Landrieu, Mitch, 122
Laocoön, 9, 29, 37–40, 62–63, 120, 175
Laocoön and his Sons, 36–39, 61, 182n2, 182n5–6
Laocoön (essay), 60
Latour, Bruno, 27
Layher, William, 50
Le Corbusier, 129
Lee, Robert E., 121–22
Leibniz, Gottfried Wilhelm, 4, 33, 98
Lenin, Vladimir, 20, 131, 143
Leporello, 89–90, 100–101, 103, 105, 108–9
Lessing, Gotthold Ephraim, 9–10, 37–41, 55, 60–63, 120, 182n4–6
Licht, Alan, 26
listening (to), 9, 13–14, 26, 30, 171, 176
Locke, John, 21–22, 33, 92
London
 automata and, 75
 barrel organ and, 76–77, 185n23, 187n46
 Joyce's *Ulysses* and, 108
 Madame Tussaud museum in, 112, 132
 Man or Superman premiere in, 105
 melodramas featuring Tipu in, 68
 Tipu's Tiger in, 10, 64, 69–71, 79, 82
Loughridge, Deirdre, 76
Lynch, Michael, 31

magic of naming, 157, 159
Magnus, Albertus, 19, 34, 76, 181n3
Malabou, Catherine, 29, 182n28
Malhotra, Ashok, 68
Manolov, Emanuil, 150, 152
Maratha Empire, 65–66

marble
 animation of, 95–96
 automata compared to, 77
 Commendatore performing as, 101, 106
 epigram carved into, 58
 Greek pneumaticism and, 61
 Hume referencing, 92
 Laocoön and his Sons as, 36–37
 statues made of, 29, 33
 wax compared to, 131
 whiteness and, 118–23, 125
 Winckelmann on, 39
 vibration of, 162
Markov, Georgi, 137, 143
Mehmet III, 75
Merleau-Ponty, Maurice, 33
Meyerbeer, Giacomo, 104–5
Michelson and Morley, 40, 54, 165
Miller, Evelyn, 177–78
Milton, John, 51
Mishra, Vijay, 72
Miss Bronze pageant, 118
Mitchell, Andrew, 25
modernism, 23, 105, 115, 123, 133
modernity, 176, 180
 African American experience of, 124, 128
 automata as technologically rational in, 65
 Bulgaria and, 136
 crisis of subjectivity within, 89
 decline of *pneuma* within, 54, 164
 fragmentation of experience in, 23
 Galatea as *cause célèbre* in, 94
 Heideggerian radiance as response to, 24
 problem of sounding statues in, 3
 Russolo's *intonarumuri* and, 169
 statue as ritual object and, 29
 Tipu Sultan and, 67
 weirdifact and, 78–79
Moloch, 20–21, 28
Moten, Fred, 133
Mozart, Wolfgang Amadeus, 11, 60, 89–91, 97–107, 109
Mughal Empire, 66–67
Munro, Hugh, 79–82, 187n55
Munro, Sir Hector, 80–81, 187n53
Musée Grévin, 112
Musée d'Histoire Naturelle, 119
Musical Times, 75
Mysore, 10, 63–68, 70–71, 80–81

nachträglichkeit, 138, 140, 155, 159
naturophilosophie, 104

Neely, Jack, 177–78
Nelson, Charmaine, 119
Neoplatonism, 43, 48–50, 183n50
Neuhaus, Max, 25
Newhart, Bob, 13, 171–74
Nikolov, Aleksandar, *See* Sladura, Sasho
Nikolov, Georgi, 140–41
Nott and Glidden, *Types of Mankind* (1854), 120, 122

ontography, 31
opera seria, 98
Ord-Hume, Arthur J. G., 69, 84, 185n23, 186n40
Ottoman Empire, 66
Ovcharov, Asen, 142, 144–45
Ovid, 17, 40, 94

Palmistry, 83–84
Panzanelli, Roberta, 131
Paris, 98, 112, 114–15, 119, 123
Patty Duke Show, The, 156
Petry, Ann, 124–26, 189n33
Philo of Alexandria, 49
phonography, 7–8, 18, 132
Picasso, Pablo, 114, 123
Plath, Sylvia, 159
Plato, 20, 40, 52, 155, 170
Platt, J. C., 71
Pliny the Elder, 36, 182n2
Plovdiv, 12, 135–37, 140–41, 143, 145–46, 160
Plutarch, 47
pneuma, 10, 109, 163, 176
 Aquinas on, 49–51
 Aristotle on, 43, 45–48
 Bacon on, 53–54
 breath and, 40, 43–46, 48–50, 53–57, 60–61
 early modern science on, 183n38
 epigrams and, 56–59
 Galen on, 47, 53–54
 musical sound and, 96
 Neoplatonism and, 43, 48–50, 183n50
 Oracle of Delphi and, 183n49
 sounding statue and, 41, 44
 Stoicism and, 43, 46–51, 52
 relationship with *spiritus* and *ruah*, 48
 vibration and, 164
 voice and, 41–42, 44–62
Poizat, Michel, 102
post-communist era, 140, 155
Prampolini, Enrico, 114
primitivism, 112–13, 128, 133

Pushkin, Aleksandar, 59–60, 184n66
Pygmalion
 desire of, 35
 French adaptations of, 94–98, 108
 influence on *Don Giovanni*, 11, 103, 105
 Mother Africa and, 126
 Ovid's version of, 17, 40, 94
 sense of touch and, 33, 95–96, 182n11
 Shaw and, 107
 transformation and, 109

Quaglio, Lorenzo, 99

Rachmaninoff, Sergei, 177–80
Ragussis, Michael, 157
Rameau, Jean-Phillipe, 96
Reed, John, 142
Reinhardt, Ad, 22
Renaissance, The
 automata from, 74
 influence of *Laocoön and his Sons* on, 36–37
 pneumatological epigrams from, 58
 race and statuary during, 118
 rationalization of aesthetics in, 21, 26
resonance, 13
 between subject and object, 25
 between wave and particle, 169
 bronze and, 113, 123, 174
 cosmology and, 168, 170, 193n4
 creation in performance, 109
 pneuma and, 53–4
 sonic event and, 30
 vibration of material and, 163, 166
Rodin, Auguste, 23, 168
Rodó, José Enrique, 123–24, 126–27
Romanska, Magda, 90
Romanticism, 22, 59, 89
Rousseau, Jean-Jacques, 73, 95–98, 108, 188n21
Rumph, Steven, 91, 103
Russel, Lieutenant-Colonel, 67
Russolo, Luigi, 169, 193n12, 194n13

Salzburg, 89, 98
Sandberg, Mark, 133
Savage, Kirk, 120–21
Schaeffer, Pierre, 25
Schmid, Rebecca, 89
Schroeder, David, 98
Schulze, Holger, 30–31, 163
Scott, Walter, 67–68
sculpted ear, 6, 8, 86, 133, 161, 175–76

Seattle, 1–3, 34, 171, 173
Segesten, Anamaria Dutceac, 155
Sepoy Mutiny of 1857, 64, 79
Seringapatam (Sri Rangapattana), 63, 67–69, 71, 184n1, 185n25
Serres, Michel, 28–31, 33–34, 115–17
Shaho, 153
Shaw, George Bernard, 105–8
Sherrod, Alan, 179
silence/silencing, 138–40, 175, 190–91n11
 as allegorical presence, 158–60
 death as form of, 152
 epigrams and, 58
 mouth of *Laocoön* embodying, 36–40, 182n6
 operatic manifestations of, 99–100
 political repression and, 154–55
 race and, 12, 130, 189n34
 relationship to sounding, 161–62
 sound art and, 27, 36
 statuary and, 9, 12, 61, 113, 128
Simeonov, Dimitar, 144–46
Simpson, Homer, 15–17, 35, 176
Sing London, 170
skin
 Baker, Josephine, and, 113–15, 123, 130, 134
 bronze as analogous to, 12, 113, 117–18, 123, 125, 134
 concept of "second skin" and, 115, 129
 etymology of color and, 116–17
 hearing through, 25
 locus of the soul in, 115–16
 Pygmalion and, 126
 representations of race through, 117–20
 wax as representation of, 113, 130–33
Sladura, Sasho, 12, 161, 175, 176
 allegory and, 158–60
 background and career of, 140–42
 duality of naming, 155–57
 imprisonment and death of, 149–54, 192n47
 statue of, 136–39
Smith, Bruce, 52
Sofia, 136, 140–43, 145–49, 151, 153, 190n4
sound art, 9, 13, 25–27, 32–34, 163
sounding statue, 3–6, 8–11, 13–14
sound studies, 3, 12, 30, 162–63
Spasov, Mircho, 148–50
Spinoza, Baruch, 4, 162
Statue Stories Chicago, 13, 170–73, 175
Steinberg, Michael, 102
Sterne, Jonathan, 7–8, 13

Stewart, Kathleen, 179–80
stilyagi, 147
Sveta Nedelya, 141, 149, 191n13
Sydenham, Benjamin, 69
syrrhesis, 30–31
Szendy, Peter, 14, 102

Taussig, Michael, 156–57, 159, 179
Théâtre des Champs-Elysées, 114
Tipu Sultan Fath Ali Khan, 10
 British political imagination and, 67–68
 British popular culture and, 64, 78, 82–86, 184n4
 collections of objects, 64, 66, 184n9, 184n10
 death at Seringapatam, 63
 knowledge of Hugh Munro's death, 80–81, 187n55
 rise to power, rule, and political sensibilities, 65–67, 184n11, 184–85n12, 185n17, 187n53
 Tipu's Tiger and, 70–72, 185n23, 185n25
Tipu's Tiger, 10–11, 64–65, 175
 acquisition and display in London, 70
 description of mechanisms, 69–70, 185n22, 185n23, 186n35
 Regency-era literature and poetry and, 82–84
 related to concept of the sublime, 72–73
 relationship to automata, 74–75
 relationship to barrel organ, 75–76
 speculation of origins, 71–72, 185n25, 186n27, 187n55
 weirdifact and, 77–79, 81, 84–86
Tomlinson, Gary, 102
Trower, Shelley, 164
Tsonchev, Doncho, 152
Tussaud, Madame, 112, 131–32

Wagner, Richard, 99
Wales, James, 72
Walter, Brenda Gardenour, 50
Warner, William John ("Chiero"), 84
Waugh, Edwin, 75
wax, 11–12, 112–14, 130–33, 190n49, 190n53, 190n54
weird, 78
weirdifact, 78–81, 84–86
Wellesley, Arthur, 63
Wellesley, Richard, 63, 67, 70
Whitehead, Alfred North, 4–5, 162, 193n2
Williams, Bernard, 105

Winckelmann, Johann Joachim, 21, 38–40, 77, 182n11

Varesco, Giambattista, 98
Vaucanson, Jacques, 74–76, 186n39
Verdery, Katherine, 19
vibration
 affect and, 12, 124, 162–63
 Andrews on, 166–69
 human body creating, 96
 science of, 164–66, 193n4, 193n5
 sculpture and, 24–25
 performance of, 109, 193–94n12
Vienna, 98
Voegelin, Salomé, 14, 190n11
voice/vocality
 aurality and, 3
 death scream and, 82–83, 154
 embodiment and representation of, 84
 interpreting sound from statue as, 19–20, 35
 materiality and, 11, 91, 96–97, 101–10, 123, 126–30
 metaphysical manifestations of, 7, 13, 101–2
 pneumatological implications of, 10, 40–42, 44–62
 sculptural exhibtion and, 133, 170–73
 sensory perception and, 91
 silencing of, 12
 vibration and, 124, 168, 173
 See also acousmatic voice

Zhivkov, Todor, 148–50, 155
Zlatnata Reshetka, 152
Zlatni Piasutsi, 150

CPSIA information can be obtained
at www.ICGtesting.com
Printed in the USA
BVHW032031180420
577890BV00004B/6